DAVID SHEPHERD
AN ARTIST IN CONSERVATION

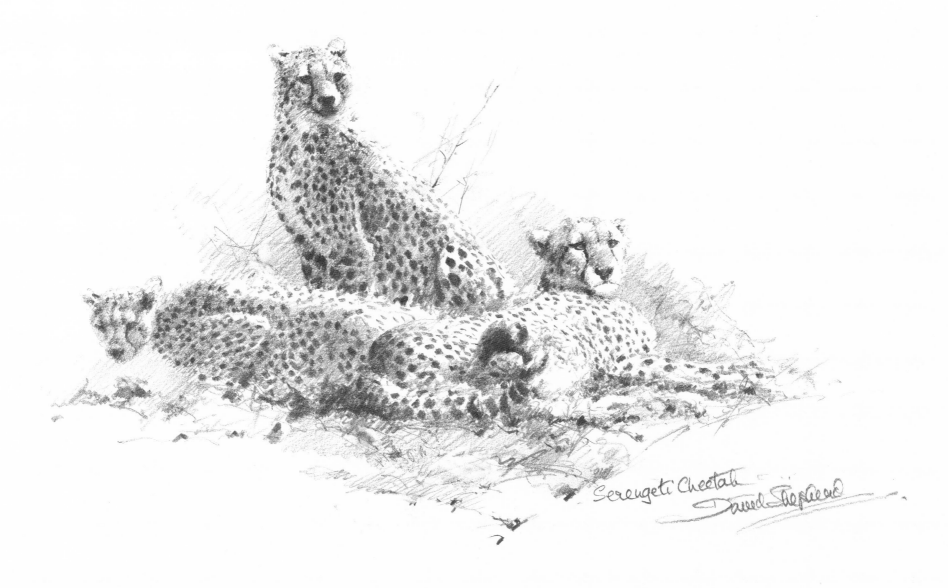

Serengeti Cheetah

David Shepherd

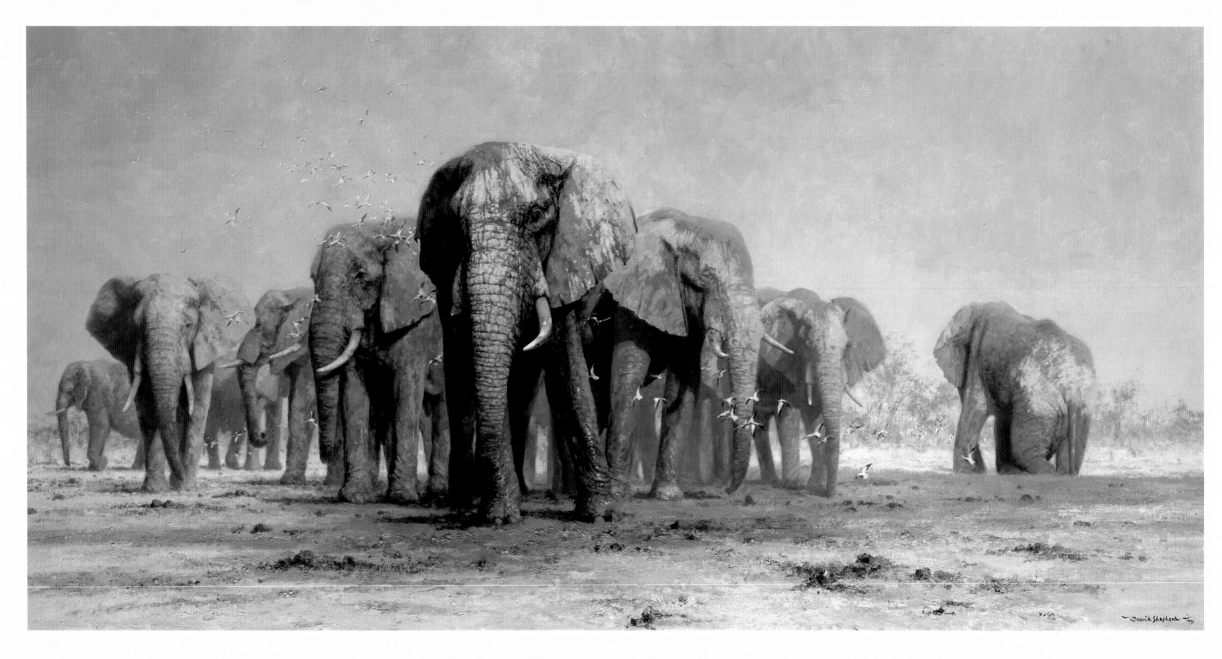

Savuti Waterhole

DAVID SHEPHERD
AN ARTIST IN CONSERVATION

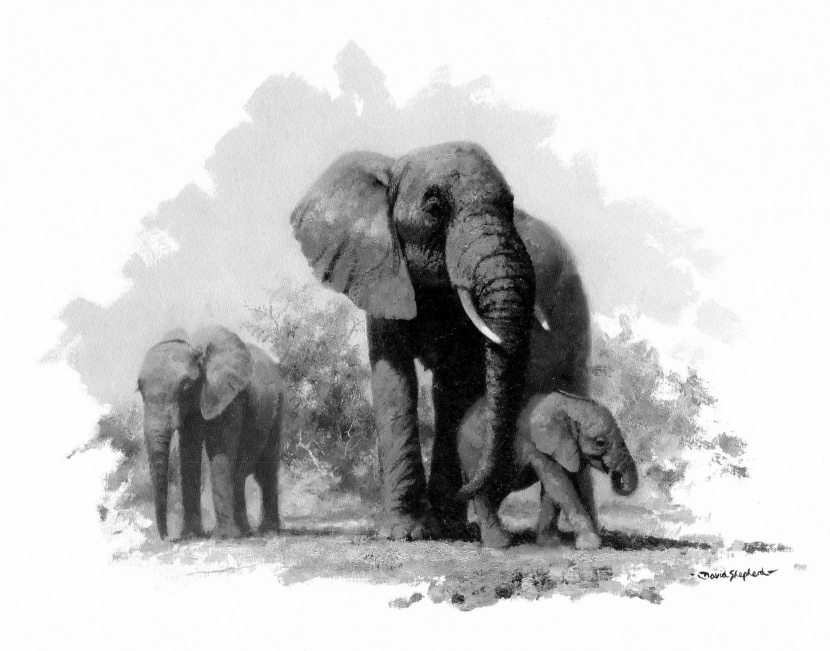

David & Charles

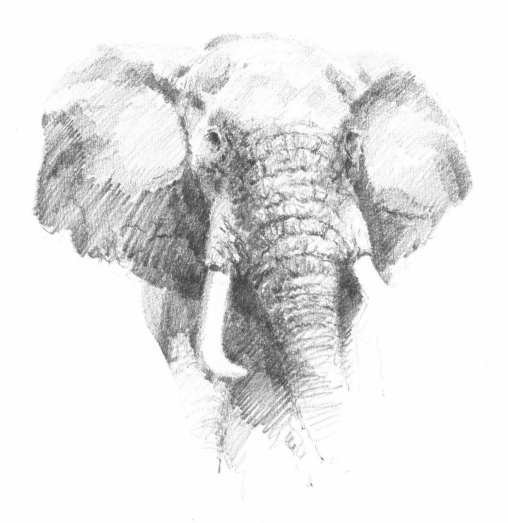

British Library Cataloguing in Publication Data
Shepherd, David
 An artist in conservation.
 I. Title
 759.2

 ISBN 0-7153-9459-2

Typeset by ABM Typographics Ltd, Hull
and printed in Singapore by Saik Wah Press Pte Ltd
for David & Charles
Brunel House Newton Abbot Devon

CONTENTS

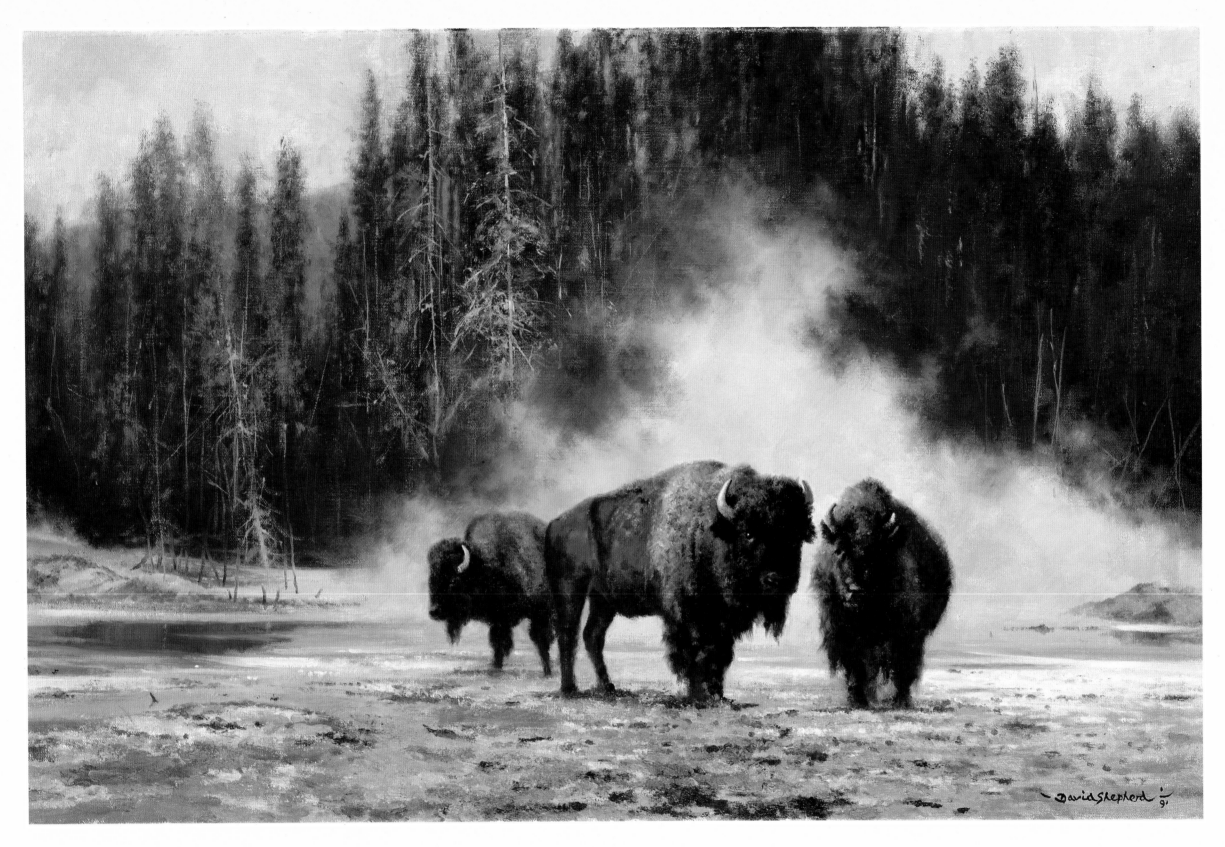

The Hot Springs of Yellowstone National Park

FOREWORD

I HAVE LONG ADMIRED David Shepherd's works and his passionate fight in defence of our natural environment, and am delighted to be Patron of his charity, the David Shepherd Conservation Foundation. .

David has described himself as 'just' an emotional painter, and certainly the outspoken rage he feels at what man is doing to this fragile world comes out strongly in these pages. He mixes it with amusing anecdotes as well as offering possible solutions to the major environmental issues of our time.

Most people will, however, have bought this book for the many reproductions of paintings and sketches it contains, all recent examples of the talent and energy that have made it possible for the artist to do so much for the animals and habitats with which we share this planet.

I hope all of you who read this book will derive as much pleasure and inspiration from it as I have.

HRH PRINCE MICHAEL OF KENT
Patron, The David Shepherd
Conservation Foundation

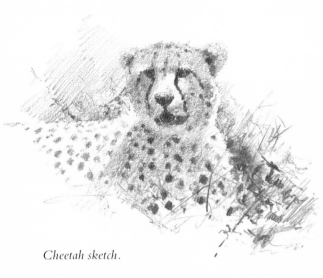

Cheetah sketch.

IT WAS THE VICTORIAN WRITERS who described Africa as the 'Dark Continent'. As a wildlife artist, I cannot think of a more inappropriate description of a landscape that is surely a blaze of sunlight.

The early pioneers and explorers who wrote in such a way seemed to think that a primitive and dangerous savage armed to the teeth, or a man-eating lion, lurked behind every bush. The early Hollywood movies did not help either; whenever the 'star' of the film was up to his knees in a swamp and about to step on a log, it inevitably turned out to be a crocodile of quite impossible size; and there was always a giant python ready to drop out of a tree onto the unsuspecting traveller. Now, happily, we are more enlightened.

As I grew up in the 1930s, I read books written by the big game hunters of the period, with avid interest and enthusiasm. Their adventures 'opening up the Dark Continent' were enough to inspire any small boy, and they were one long tale of excitement; conservation certainly meant nothing to me in those days. Now, of course, I see these stories in a totally different light. It seems that every page was one gory tale of slaughter. 'Had a bad day today — charged by an angry rhino and it took four shots to down the brute'. Why did these writers have to refer to these animals as 'dangerous brutes'? Did they really stop to think about the consequences? Probably not. There was so much wildlife around in those days and, in any case, the philosophy seemed to be that, if it moved, you shot it. No wonder there are very few rhinos left. Now, thank heavens, people are stopping to think, but we are paying the penalty.

Reading those books inspired me perhaps more than I realised at the time. David Shepherd had to be a Game Warden in East Africa! In the impetuous enthusiasm of youth, I could only see the job as highly romantic; walking around in the hot sunlight of Kenya in shorts, with suntanned knees, wearing a bush hat with a leopard skin around the brim.

I certainly had an abundance of arrogance in those days. For example, I had only left the shores of the United Kingdom once. That was to cross the English Channel in a paddle steamer to Calais and back, in 1936, but I seemed to think, nevertheless, that that qualified me to be a Game Warden! Believing myself to be God's gift to the Kenya National Parks I flew out to Kenya in 1950 for the great adventure and, so I therefore thought, a long-lasting career. I knocked on Colonel Mervyn Cowie's door. He was the head of the Kenya National Parks at the time and I fully expected him to welcome me with open arms. He didn't; I was sent packing, politely; but at least I was allowed to experience the thrill of seeing my very first elephants in the wild. 'Tuffy' Marshall was then Warden for the Nairobi National Park. Although 'Tuffy' had the appearance of the archetypal British Colonel, there was nothing romantic about his approach to the job. He had a hard job to do and he did it well, and he did *not* wear leopard skin around the brim of his bush hat! He was always well turned out and disciplined, the effect softened by his beloved pipe. However, he was one of the first of that marvellous band of truly great people, the original Game Wardens of East Africa, whom my wife and I were and are privileged to know and regard as some of our greatest friends.

'Tuffy' was driving down to Amboseli on an assignment and he offered to take me down there with him. Amboseli is now, of course, one of the great tourist places of East Africa. In those days, there was no camp of any sort and there was an abundance of wildlife. We slept on the ground under the stars with only a mosquito net, with the awesome majesty of Mount Kilimanjaro, ('my' mountain, because I have painted it so often), as an unbelievably beautiful backcloth. Lions actually walked between our beds during the night, and we found their pug marks to prove it in the morning! That day, we drove out and, later, on foot, were confronted by a herd of possibly fifty elephants. I felt very small. I am sure that I had no realisation in those days, so many years before I became an artist specialising in wildlife, and a conservationist, just how those marvellous animals were going to shape my life and influence my whole thinking.

Having been rejected by the National Parks of Kenya, my world seemed to be in ruins. I was stranded in Nairobi. My father would not let me come home because he had spent a fortune on sending me out in the first place. I even took my bicycle with me. (Didn't it occur to either of us that they did have quite a few bicycles in Africa?) I certainly grew up. I had to get a job, and worked in a hotel, at Malindi on the coast, for a pound a week which they said was a very bad bargain — for them! I had no interest in, or talent for, art in those days, but I did manage to paint ten unspeakably awful paintings of birds, and sold these, for ten pounds each, to the culture-starved but very generous people of Malindi, and these paid my passage home.

Back in England, I was faced with two choices; either living reasonably comfortably as a bus driver or starving as an artist. (I believed in those days, as far too many people still do, that all artists starved!) I thought the lesser of two evils was the artistic one so I entered for an art school, and was promptly thrown out, as being 'untrainable'. They said I wasn't worth teaching. I suppose I must have been on the point of getting a job with the local bus company when I happened to go to a cocktail party in London, and met the great man who changed my life. Robin Goodwin was a professional artist who, for some reason which I will never understand, took me on as his sole student at that time. I owe all my success to him. I had three intensive years with Robin, ending in 1953.

I first decided to specialise in aviation work, because I have always been fascinated by aeroplanes (and steam trains). I have never served in the Royal Air Force, but they gradually noticed my work and began to fly me around the world as their guest, painting pictures for various RAF Squadrons and stations. It was in 1960 that they flew me, via Aden, to Kenya. This was my second trip to that part of the world and when I arrived in Nairobi, they decided to commission two paintings; 'But we don't want aeroplanes. Do you paint local things like elephants?' And so it was that I painted my very first wildlife painting and I have never looked back from that moment.

It is surely impossible to write about Africa or India in just a few words. In any case, to someone who has been there and who has been touched by the magic of it all, words from someone else are unnecessary; he already knows. The beauty and tranquillity of experiencing wildlife in its natural environment will call the traveller back again and again. It is nothing less than refreshing to the very spirit. In a bush camp, at night, one can feel totally at peace with nature under an African sky impossibly filled with stars. Then one can always remember the smell of an early morning in the bush when it is still cool. The sun is just rising in that so certain moment before immediate and full daylight, when life begins to stir for another day. The very enormity of it all brings man down to size. That is why I so vividly remember that first occasion when I saw those elephants at Amboseli.

On the occasion of one of my many visits to East Africa, 'Tuffy' Marshall was not aware that I was in Kenya at this particular time. Without any advance warning, I took the liberty of driving straight down from Nairobi to his office which was by then in the Tsavo National Park. It was around lunchtime when I arrived and I went straight up and knocked on his door. 'Come in,' was the very gruff welcome from within. He was obviously very busy, buried in paperwork — a large part of a game warden's job. As I entered the room, 'Tuffy' didn't say a word. With the ever-present pipe filling the room with blue tobacco smoke, he immediately swept the papers in front of him onto the floor and, as though he had been expecting me, said, 'Come on, let's go!' Within minutes, we were in his battered Landrover, driving out into the park.

I am sure that all of us who specialise in painting wildlife have our own special 'love'. For me, it is the thick bush, the hot dusty yellow thorn scrub through which one can always imagine eyes peering at the intruder. It is the great sweeping cloudscapes and the feeling of infinite space. It is impossible to forget the experience of standing on the edge of an escarpment and looking across mile upon endless mile of Africa, straining one's eyes to the limits for a hint of movement. Can that be an elephant so far down below, going about its daily business undisturbed and unhurried?

I have been privileged and lucky over many years to have visited many wild and beautiful places. The Luangwa Valley in Zambia has always been very special to the Shepherd family. I have painted in 'my' beloved valley many times and it is to this place that my wife and I took our four daughters when they were young. I felt that it was altogether a more worthwhile holiday experience for them than building sandcastles on the beach in Kent! It was, because they have all become conservationists as a result. A little piece of the Valley has brushed off on each of them. This is a place which draws us back again and again. In the dry season, we have stood on the bank of the wonderful and wild Luangwa River and have seen elephants, hippo, croc, puku, impala, kudu, zebra, waterbuck, buffalo and wart-hog, all at the same time! — and there will probably be lion, and a few leopards around too!

Here today, in spite of the havoc wreaked by man, there is still a profusion of game the like of which I know almost nowhere else. The Luangwa River, when it has dwindled from an angry flood to a shallow, sluggish stream, meanders its indecisive way down to the Zambezi, changing its course every year. All the way along the river is the wreckage of countless trees washed down by the previous season's rains, stranded on the wide sandbanks. On these, in the oven heat of midday, there basks possibly one of the greatest concentrations of crocodile in all Africa.

One of the features of the Luangwa Valley is the daily two-way journey that the elephants make across the river. These highly intelligent animals have come to know over the years that if they remain in the 'controlled hunting area' on one side of the river, during daylight hours, they could well be shot by hunters. So, as regular as clockwork, they cross in the morning into the safety of the National Park. In the evening they will return to the controlled hunting area where they will feed peacefully during the night. In

Warthogs — nothing like a good mud wallow.

9

the morning, the whole process will be reversed, and the 'Shepherd Family' have enjoyed many memorable and amusing moments when we have sat quietly on the bank of the river just a few feet away from the procession, watching the pageant unfold before our eyes.

Norman Carr was often with us on these occasions. To anyone who knows Zambia, Norman 'is' the Luangwa Valley and he is of the same mould as 'Tuffy' Marshall, Bill Woodley, Peter Jenkins, the late David Sheldrick and so many other great people with whom many of my readers may well be familiar; all men 'tall and true' who have Africa in their blood and who share a passionate concern for the future of its wildlife.

After so many visits to Africa, I have become thoroughly spoiled, and I know it. The friends that I have mentioned have always understood that, for my wildlife work, I have always needed to explore new environments. They have often taken me far from the confines of the more obvious tourist venues and into more wild places.

Whilst I still go to Tsavo and the Luangwa, I have come to know places perhaps more remote. Savuti, in Botswana, is certainly one such place. Here, one can still see a pride of lions on a kill without being accompanied by a fleet of zebra-striped minibuses.

The camp, remote and wild, is one of the perfect places to which one can still escape to experience the real Africa. Savuti is perhaps unique in that one can get closer to bull elephants here than almost anywhere else. The camp is owned by two English friends of ours, Lloyd and June Wilmot, and word reached them that I badly wanted a photograph of myself really close to elephants, for this book.

We had just one day to spare. We had been staying with Alan Elliot in Zimbabwe. Alan had never been to Savuti and so flew with us to Botswana and landed at Lloyd's camp. It was the very hottest time, in October, following what happened to be a particularly dry season. There was no standing water. We watched a very moving sight. A large herd of bull elephants, together with a pride of lions, some impala and a couple of hyena came down together to what was left of the waterhole, with just one thought: somehow to quench their desperate thirst. All they met was slimy mud.

We filled a small depression with fresh water from a tanker truck and there followed a scene worthy of twenty paintings. Within minutes, Alan and my wife Avril took some two hundred photographs of me sitting, standing, walking, and laughing within a few feet of these magnificent animals. They were not in the least interested in me and they knew I was not going to disturb them. I knew too that they were not going to harm me. We succeeded in

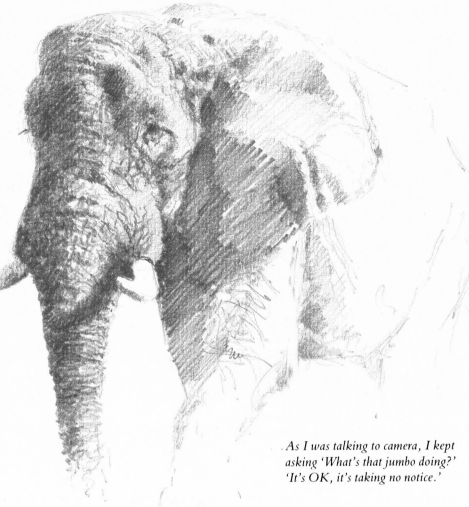

As I was talking to camera, I kept asking 'What's that jumbo doing?' 'It's OK, it's taking no notice.'

getting our photographs and I don't suppose I will ever get closer to elephants than that. On one occasion, I was just five feet away from a huge bull and he accidentally knocked me with his trunk — it winded me momentarily, because a blow from the trunk of an elephant that size is no joke! But he meant me no harm.

A South African Television team came with me to Savuti and it was there that I was interviewed with an elephant standing just behind me. As I was talking to camera, I kept asking, 'What's that jumbo doing?' 'It's OK, it's taking no notice!' came the reply. Little did I realise at the time that this particular elephant was to feature in my painting 'The Ivory is Theirs', painted solely to raise funds for the conservation of the African Elephant.

The research for this painting took me, first, to Zimbabwe, and this visit featured in one of the films in the Thames Television series 'Naturewatch', with Julian Pettifer. On one delightful morning, we got up before it was daylight and I was filmed sketching as the sun came up, beside a waterhole in the Hwange National Park. Then, as I wanted the 8ft × 4ft painting to emphasise the fight for survival of the elephant, we decided to film

For the Naturewatch film, with Julian Pettifer; on one delightful morning, we got up before it was daylight and I was filmed sketching as the sun came up beside a waterhole in the Hwange National Park.

viable populations of Black Rhino, numbering some hundred, each one known and looked after round the clock by a conservationist who spends virtually her entire life living in her Landrover.

But I had come to see the desert elephant. This remarkable animal lives, somehow, in this area where one would think it was impossible for such a large animal to survive. I was told that the few remaining elephants have been known to walk from one watering point to another, seventy kilometres over the sand-dunes and rock-strewn landscape. And they have to dig for the water when they get there as no water lies on the surface. Somehow they know where to find it.

The Kaokoveld elephant has adapted to survive in this harsh desert landscape and a great deal of effort has to be expended even to see one, in an area five times the size of the Kruger National

Julian Pettifer and me in Zimbabwe.

in one of the most remote and wild parts of the entire African Continent, the Kaokoveld.

It was here also that I was to gain material for another fundraising painting, this time for the 'desert elephant'. The Kaokoveld, in South-West Africa, is surely one of the most arid and barren parts of the entire continent. It probably only rains with any significance on a couple of occasions annually, and whatever rain falls soaks straight into the ground. This is desert country and quite different from any other scenery I have seen.

With some of my conservation friends, we flew from Johannesburg to Windhoek. We then chartered a light aircraft which flew us for two hours over what can only be described as a lunar landscape. Landing on a gravel airstrip, seemingly in the middle of nowhere at a place called Palmweg, it was hard to imagine anywhere more remote. This beautiful safari camp sleeps only eight or ten people in little thatched rondavels, with a swimming-pool, a bar, five or six palm-trees and a couple of vehicles; that's all there is. We were told that there was no living person of any race or colour within probably a hundred miles in any direction, apart from the ever-present poacher and a handful of dedicated conservationists.

In spite of the desert nature of the landscape, there is an amazing wealth of wildlife in the Kaokoveld: springbok, giraffe, and, almost unbelievably, possibly one of the last remaining really

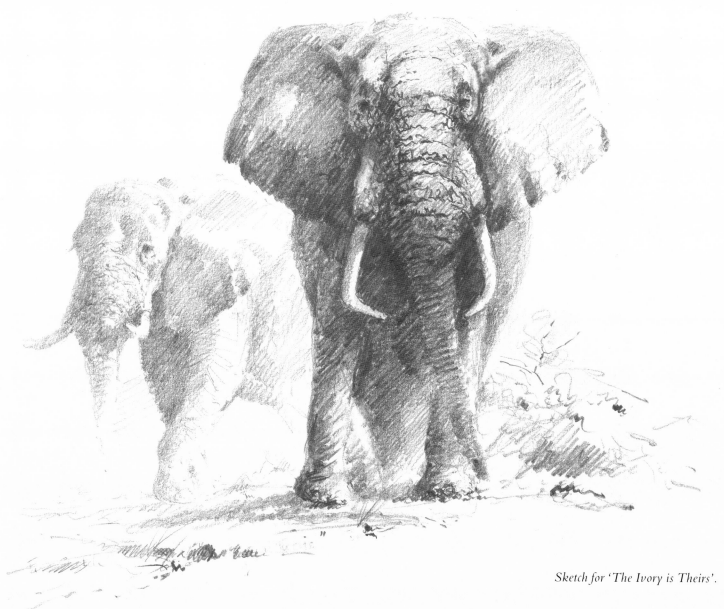

Sketch for 'The Ivory is Theirs'.

Park. I was lucky. We found one on the very first day of my four-day visit. I always talk of 'my jumbos' and on this occasion, my affection for and affinity with these gentle giants was never stronger; it seemed to carry across to the elephant which allowed me to get very close to him. For a while I was able to share a few precious moments with this marvellous animal.

It was a privilege to study and sketch at such close quarters and to watch the desert-adapted elephant plucking at the grass. It was as though he knew that food was scarce and not to be abused. It seems very different from the behaviour of many elephants I have seen elsewhere who all too easily destroy trees just to get a few tasty morsels.

I do not think I would have been able to attempt the painting had I not been there to share the environment with this wonderful animal. In the bush that I love so much, I have to get my hands into the soil, breathe in the dust, and share their world. All this gives me an immense understanding and respect for the wild animals that I paint, and a burning desire to preserve their environment in any way that I am able through my paintings.

I went to India for the very first time in 1973, to obtain material for my first painting of a tiger, 'Tiger Fire'. This was to raise funds for 'Operation Tiger'. Although I spent three weeks in the country, I failed to see a tiger. At that time there were just 1,827 left in the entire country. I came home again and, from a tame tiger,

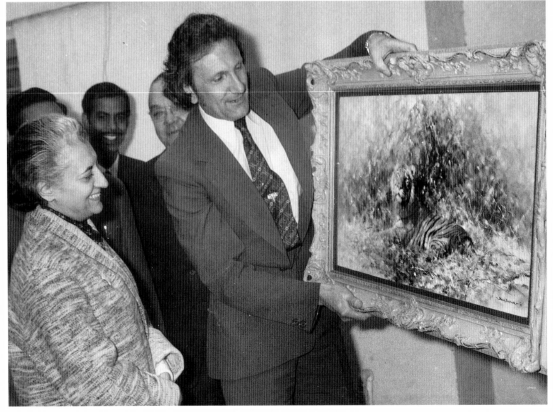

Presenting a painting of a tiger to the late Mrs Indira Gandhi in April 1972 to raise funds for the conservation of the tiger in India.

painted the picture which raised some £127,000, so it made all the effort worthwhile.

Following the success of this project, I was invited to paint a further tiger picture to raise funds within India itself. I returned, therefore, a few years later, and had the honour of showing the painting to the late Mrs Indira Gandhi. This great lady was a dedicated conservationist and did a great deal in her time to raise awareness of the need for the cause of conservation amongst her people. The painting was subsequently auctioned and raised further funds, and it was during the research for the painting that I had the excitement of seeing my very first tiger in the wild, at 'Tiger Haven'.

Tiger Haven is the Wildlife Reserve initiated and protected solely through the efforts of Billy Arjan Singh. He is another of those great conservationists who prefer to work quietly for what they believe in, with enormous reserves of persistence and dedication. Tiger Haven was eventually gazetted officially by Mrs Gandhi as a National Park.

This precious area of some eighty square miles of virgin forest in which, at the time of my visit, Billy reckoned there were eight tigers, is entirely surrounded by teeming humanity. Like many other wildlife reserves in India, the pressures upon Tiger Haven are enormous, the demands of cattle for grazing and the needs of firewood for the villagers increasing daily.

I had only three days in Tiger Haven, and until early afternoon of the very last day I had not even seen any evidence of the tigers. It was then that Billy excitedly told me that there had been a kill on the edge of the forest. He was sure that if I was to see a tiger it would be that evening or after dark that night, if I was prepared to make a little effort; this 'effort', as Billy casually stated it, meant 'sitting by yourself in a tree hide in the jungle in the dark'! My spirits sank at the very suggestion! The thought of sitting alone up a tree 'surrounded by tigers', in the pitch black, was enough to make my heart drop to my boots.

The whole afternoon was spent with Billy and his staff building the tiniest of little platforms in a rather shaky-looking tree. During the operation, I kept suggesting as tactfully as I could that 'Surely it would be better to make the hide a little bigger so that you, Billy, could sit with me?' — 'No,' he said, 'if I sit with you there will be two of us and it will double the chances of us making a noise. You have to be absolutely silent.'

It was almost dark as the operation was completed and the last rungs of a rather temporary-looking ladder up which I was to climb were put into place. The kill, a young bullock, was tied to the base of the tree with a strong manila rope. 'Up you go,' said Billy. 'Sit there as quiet as you possibly can. You may not hear anything and nothing may happen at all. However, you may

suddenly hear an angry roar at the foot of the tree (just twelve feet below me). It may be a leopard. When you hear the noise, give whatever animal it may be some ten minutes to settle down. Then, very slowly and quietly, flash your torch below the tree from where the sound is coming. If you are lucky, it may be a tiger. It will almost certainly take off, but at least you can go home and tell your grandchildren that you have seen a wild tiger on a kill in India.'

I climbed the tree and sat there for what seemed like hours. Every time a leaf fell off a tree, or there was the slightest sound, I nearly leapt ten feet out of the platform. All sounds seem to be magnified a hundredfold in the dark of the jungle. After what seemed an eternity, and when my nerves were frayed to the very limits, there was an angry explosion of sound at the foot of the tree, just as Billy had described. To say that I was shaking with excitement would be an understatement. I sat there quivering, waiting to press the button on my flashlight. I finally leaned very carefully and slowly over the edge of the platform and pressed the button. There, in the circle of light, seemed to me to be the very largest tiger on God's earth. He was standing astride the kill with the entrails hanging like spaghetti from his mouth and all down his beautifully striped front. Far from immediately leaping away into the dark, he looked up at me in disdain at the unnecessary disturbance, eyes glowing in the torchlight, and then carried on eating! I carefully looked at my watch. The time was 7.20. I had only been in the platform for one hour. I watched that tiger for some twenty-five minutes until, rather bored with the whole situation, he ambled into the darkness.

By now, I was completely relaxed and all anxiety had left me. Billy had told me that, at midnight, he would walk along the jungle track from his house to come and fetch me. He would gently whistle to me and, if I had seen a tiger, I was to whistle back. Exactly on time, I heard Billy coming but I was far too excited; I yelled, 'I've seen one,' and nearly fell out of the platform.

We walked back to Billy's home together. When we were sitting around the fire having a cup of coffee, I asked him what he was discussing with his friends when I was alone in my tree. 'We were all wondering whether you were OK, and whether we should go and rescue you.' Such are the thrills of seeing wildlife in its natural environment.

An American friend of mine once said to me, 'David, you don't want to paint Indian Elephants. You won't want to look at them after seeing so many African ones.' How wrong he was. In 1983 I was invited out by the Wildlife Society of Sri Lanka to paint the Indian elephant and this visit introduced me to the Yala National Park, a glorious place situated in the wild south-east part of this beautiful island.

My hosts and I had only been in the Park for a matter of hours when, as always, luck was on my side. A magnificent bull elephant strode out of the bushes and walked straight into a pool covered with water-lilies. As is often the case, I could never have imagined such a scene. I had a strange feeling on seeing an Indian elephant in the wild for the first time; he seemed rather more gentle and sophisticated than his African cousin. Perhaps this is so, but I love all elephants, wherever they come from.

Relatively few visitors go to Yala and those who do are not allowed out of their vehicles. However, as I was with the wildlife authorities in Sri Lanka to raise funds for their Wildlife Society, I was given special treatment. We got out and walked onto the shore line. Here was a beach the like of which I had never seen in my life. I stood looking at mile upon endless mile of rolling sand-dunes and rocks stretching as far as the eye could see, with the sound in the background of the huge breakers coming in from an ocean stretching down to the Antarctic. It may not be very subtle but I immediately thought of Robinson Crusoe, and there were footprints in the sand — of elephants! They actually come down to bathe in the sea!

There is a wealth of wildlife in the Yala Park. I saw more leopards in Yala in one day than I have seen on all my very many visits to Africa. Peacocks strut around displaying their glorious plumage and, if one is lucky, one can see the honey bear.

There are huge numbers of Indian waterbuffalo in Yala and this animal presents a particular problem to an artist. It is very difficult to distinguish between the domestic animal and the wild one. I have seen these impressive animals, with their magnificent curving horns, many times. On one occasion, my impetuosity, as it so often does, got the better of me, and I got out of the vehicle and began walking up to a herd of waterbuffalo. It was only when I noticed that there was no herdsman with them that I realised that they were in fact wild!

I am sure that my other wildlife artist friends get asked the same questions: 'How do you actually work? Do you use a camera?' I feel sure that they will give the same answer as I do. It is obviously impossible to set an easel up in front of a tiger or a bull elephant and ask it to stand still for five days while you paint its portrait! The only approach, I believe, is to work from a combination of sketches and photographs but, above all, it is essential to go to the location. Without this, there is no hope of getting 'atmosphere', and it is this that counts. We have to get the 'feel' of the place, to see the rocks, the trees, the waterholes, the mud, the dust, the sand, all of which make up the environment in which the wildlife lives.

If I am known by anyone at all, I do get a little frustrated when I am labelled as a wildlife artist. I am not. I am a landscape painter. To me, all life is a landscape, and this encompasses all the other

Tiger sketch.

'As a rhino is looking suspiciously at him through the bushes'.

subjects which excite me equally, but which, sadly, I have little time to paint these days. The same philosophy applies: the artist has to 'live' his subject, whether it is an aircraft, a portrait, a landscape, ship or steam locomotive. (Although I do not actually think it is essential to own three mammoth locomotives, as I do, but that is another story.)

In Johannesburg, many years ago, a client purchased one of my very large African pictures, depicting a herd of elephants. He asked me to tell him about the picture and, without realising it, in fact paid me a great compliment. 'David, why did you put those elephants in the picture?' He was suggesting that the painting, as a landscape, would have stood up on its own. That satisfied me very much. The environment around the animal is just as interesting as the animal itself, and the African scene on its own is surely worthy of a lifetime's painting.

I am perfectly happy to give an honest answer when I am asked how I achieve the end result. 'Yes, I do use a camera.' What a pity it is, some people seem to be disillusioned when told this. I cannot understand it. There is nothing wrong with using a camera providing one does not become a slave to it. After all, Degas sometimes used a camera to assist with his ballet pictures. If he did, then I don't see why I shouldn't! However, the all-important factor is that I have to take the photographs myself. I am there. The lens of a camera is valuable but is only a mechanical device. It has no brain. Because it can record the shape of something, whether it be the backside of an elephant or a piece of dead wood, it is a convenient tool, but it can never be a substitute for the sensitive eye of a well-trained and experienced painter.

I pour film through the camera but no one ever sees my photographs, because they are not meant to see them. I don't bother about composition, because composition in the photograph is totally irrelevant. All the camera is doing for me is to record the scene in front of me.

'Tuffy' Marshall soon came to understand the way I work and, although he may have regarded me as somewhat eccentric at times, I nevertheless think that it was quite a change for him to take me out. Although I may flatter myself, I think he enjoyed it because it was different. On one occasion we had been out in the Tsavo National Park all day and we were tired. We were longing to get back to camp, to chat about good times around the camp-fire. Perhaps 'Tuffy' was driving just a little bit faster than he should have been and, suddenly, without any warning, I shouted, 'Stop!' 'What is it, is it an elephant?' asked Tuffy. 'No,' I explained, 'there's a lovely piece of dead wood beside the track — I must photograph it.' I could have sketched that piece of dead wood. However, in the time that that would have taken, I was able to take some dozen different photographs from all angles of the same piece

of wood. That gave me far more material which, possibly, might be useful for a painting one day. Most important of all, I was 'seeing' and 'feeling' that piece of dead wood. There was actually a large bull elephant on the other side of the road watching us, but I was much more interested in the piece of wood because I had been watching elephants all day! Meanwhile, 'Tuffy' sat smoking his pipe, patiently waiting in the Landrover. I had no need to apologise. 'Tuffy' liked nothing better than to sit in his Landrover, watching Africa.

Concerning photography, we perhaps do not realise just how fortunate we are in this modern age of technology, with automatic cameras and all their associated equipment. I am reminded here of a magnificent book that I purchased in the 1930s, which is a happier one than the ones that I have earlier described. This magnificent and massive volume is entitled 'Stalking Big Game with a Camera in Equatorial Africa'. It is a collection of photographs by one of the early pioneer photographers, Maurius Maxwell, and the book was published in 1925. He went out into the bush, but not with a rifle to kill, and how refreshing this was. He went with a magnificent plate camera covered in brass fittings, with a tripod, to photograph his wildlife. His camera would now be in a museum. He had none of the facilities that we now have and is it not a brave man who has to place a large glass plate carefully into the camera on a tripod as a rhino is looking suspiciously at him through the bushes! That takes real nerve; and furthermore, he only had a horse or Model T Ford for transport!

Sketching in oils in the heat and dust of Africa is really a waste of time. In the Luangwa, I had put quite a lot of effort into a canvas, a landscape sketch; when it was finished, I put it in the back of the Landrover. Driving over a particularly deep Luangwa pot-hole in the track, the canvas 'took off' out of the back and fell, face downwards (naturally!) onto the dusty track. When I picked it up, it was like a piece of sandpaper.

In 1971, I actually painted the portraits of two bull elephants from life, in oils, but this is not a practice that I would recommend to members of the local Art Society! The BBC decided to make a 60-minute television documentary about my life, entitled 'The Man Who Loves Giants', a film which was subsequently seen in many different countries. Some footage portrayed my activities with the Royal Air Force and steam engines, both in the United Kingdom and South Africa. We had eight weeks of intensive filming every day and, inevitably, we ended up in Africa. It was during the planning of the film that the producer suggested that 'We would love to have some footage of you painting elephants from life.' 'Don't be ridiculous, no one would be stupid enough to walk up to an elephant and ask it to stand for its portrait,' I said. As far as I remember, their answer was something like this; '*You*

would probably be stupid enough, let's try it!' It seems to me, in retrospect, rather to typify the British 'stiff upper lip' attitude of, 'we'll all probably get killed but it will be jolly good fun'.

During the making of the film we were in Zambia filming steam locomotives and the Victoria Falls (what a marvellous mixture!). It seemed, therefore, to be convenient to go into the Luangwa Valley National Park to see if we could get some film of what could, at the worst, be a potentially dangerous situation. The behaviour of many elephants in the Valley is now unpredictable due to the fact that they have been so disturbed by man's interference and have suffered at the hands of the poacher.

As there is always the possibility of an accident and the unexpected happening, we therefore had to be sensible. We were fortunate in obtaining the services of two friends of mine who would take us out and look after us. One, Rolf Rohwer, was at that time working for a safari company. The other, Johnny Uys, was the Senior Game Warden for the Game Department in Zambia. These two people 'knew' the bush. They were cool-headed and I knew that they would be absolutely stable and reliable if any dangerous situation did suddenly arise. We were also lucky to have the services of Nelson, an African, who was Norman Carr's senior 'tracker'.

The first day's filming consisted of a fairly gentle and low-key exercise, quite near the safari camp in which we were all staying. A lot of elephants were playing in the river, just getting on with the business of being elephants. They walked out of the river and up the bank on their great rubber-like legs and they were making the most revolting series of noises, rather like a motorbike rally, as food in enormous quantities was going in one end and coming out the other. But we wanted to get closer to elephants than this and so, the next day, we were down to more serious business.

A large number of people are involved in making a film documentary on this scale. With all our equipment, it was quite a party and we needed three Landrover pick-up trucks to carry us all off into the bush, full of hope, enthusiasm, and, perhaps, not a little rashness.

It was a lovely hot afternoon, and we finally came upon two bull elephants, minding their own business. They were totally unaware of us, as they stood under a tree flapping their ears to cool themselves. I was sitting in the back of Rolf's Landrover, with my easel and canvas. He slowly drew to a halt and whispered, 'Will those ones do?' 'I suppose so,' I said. I couldn't even see them without my glasses!

We parked the three vehicles behind a large tree where they would not be seen by the elephants. All the equipment now had to be prepared. I squeezed the fourteen tubes of oil paint out onto the palette, poured the turpentine and linseed oil into the container and

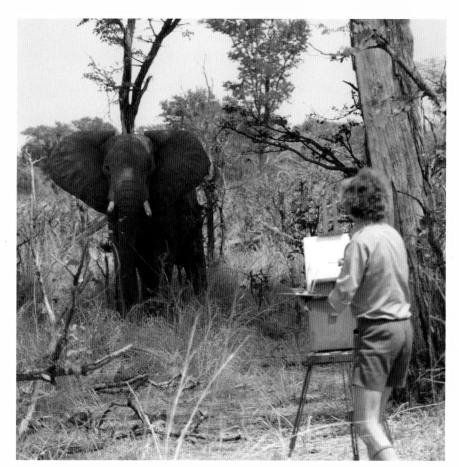

Painting elephants in the Luangwa Valley in Zambia.

drew out the telescopic legs of the easel. The canvas measured 36 × 24 inches and I had to make sure the dazzling sunlight on such a large white expanse was not seen by the elephants.

Most important of all, we had to ensure that the elephants had no idea that we were there. Elephants have an extremely acute sense of smell. However, they do have very poor eyesight so, if the wind is reliable and in one's favour and one is absolutely quiet, it is relatively easy to get very close to them. We had first of all to test the wind and this is done in the time-honoured way of kicking the sand and seeing which way it blows. We were lucky; the gentle breeze was blowing from the elephants towards us and showing no sign of deviation.

And so the trek up to our elephants began. If a Landrover full of tourists had happened upon the scene at that particular moment, I have no doubt that those travellers would have come to the conclusion that everybody in Zambia was completely mad! They would have seen a scene reminiscent of the old pack-train days, only very much more strange. They would have seen twelve people, all walking in a long line towards two completely unsuspecting elephants under a tree, carrying an enormous variety of equipment from cameras to tape recorders and sound equipment, with an artist following up the rear carrying an easel, with a large canvas on it, above his head! I had to carry it above my

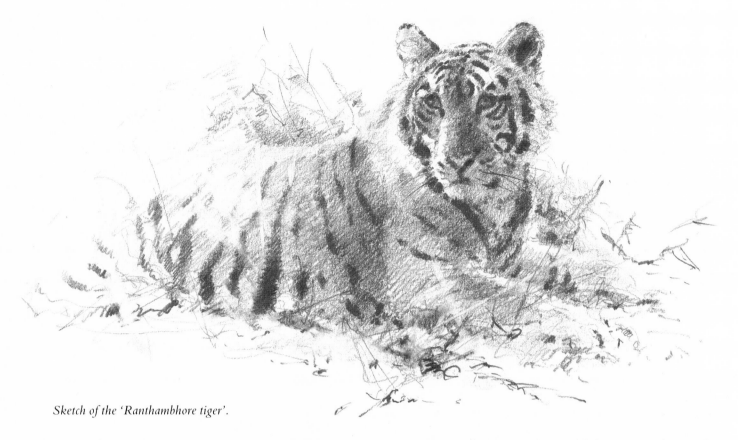

Sketch of the 'Ranthambhore tiger'.

dead in her tracks with astonishment and disgust, dumbfounded by the torrent of abuse that was coming her way. Rolf told me afterwards that he was not sure at the time whether the elephant thought that the instructions were directed at her or to me. Either way, it worked. She gave up and veered off into the bush. I shall always be grateful that we did not have to resort to more violent methods of stopping her. I would never ever have lived with myself had we had to shoot her simply to make a film. That is why I would never repeat this exercise again.

When it was all over, we drove back to camp. It was then that I asked Rolf what I would have done had I been on my own. 'You would have run, and you would probably be dead.' It was a sobering thought. If I had been on my own I would certainly have run. I would never have had the courage to have stood my ground. I asked Rolf what I should do in such circumstances. Rolf said, 'First of all, you take your shirt off and hurl it at the elephant, screaming and shouting as loud as you can. Then you run towards the elephant. The elephant is so surprised to find that the man she is charging is actually charging her that she does not really know what to do, so she stops.' Rolf made it sound so easy! 'If none of that works, you climb a tree.' 'You must be joking. I could never climb a tree if I tried,' I said. 'Yes you could. However old or infirm you are, it is quite astonishing what you can achieve if you have an elephant charging you flat out. You can find yourself up the top of the tallest tree before you know what's happening.' I have yet to be put to the test. I hope I never will be.

It is easy to become too familiar with wildlife and take liberties. This is when one can get into a very dangerous situation and I have often tended to be too blasé about the behaviour of my beloved elephants. The sadness and tragedy of modern Africa is that so often, now, the unexpected can happen. That cow elephant had probably been shot at by poachers. An elephant in that frame of mind will very naturally and understandably charge the first person it sees. Moreover, poor old Johnny, who was as passionately in love with the bush and elephants as I am, was killed by an elephant in just such a circumstance, a few years later. Nelson has also been killed, by a buffalo that had been wounded by a poacher.

It was in 1987 that I was commissioned to narrate and feature in a series of six half-hour programmes for Thames Television. These films opened up whole new horizons for me, taught me a very great deal about conservation issues and I found myself painting animals that I never even considered seeing in the wild.

We went to Ranthambhore National Park in India to feature the tiger. This lovely Park is some seventy miles from Jaipur and I just wish that more people knew about it. India has to promote the enormous .potential that she has for developing her tourist

head, otherwise the legs of the easel would have caught in the undergrowth and the 'jumbos' would have heard the brushes knocking together.

When we had come to within some sixty paces of the two elephants, Rolf, silently, by a hand signal, indicated that that was close enough. (Sixty paces is not very far. Even my long legs would have been completely inadequate had the elephants decided to investigate what was going on.)

I started painting but it was almost impossible to concentrate because it was all so funny. All I heard was the gentle whirr of the camera behind me and we got some very interesting and unusual footage.

The following day, we were not so lucky. We tried to repeat the exercise but it was only a matter of seconds after I had started painting when I heard a shout from Rolf beside me — 'leave your easel and run.' I dropped my palette onto the easel, nearly knocking my wife over, and we both 'took off'. I looked over my shoulder and I saw a very angry cow elephant charging flat out past my very lonely-looking canvas, straight for Rolf. Rolf stood his ground. Wardens and rangers act in different ways in these difficult circumstances. Rolf believes in shouting. The obscenity of his language does not merit recording here; suffice to say that they were well chosen words and I am certain that that cow elephant understood perfect English. I swear to this day that she stopped

industry, and her wildlife must be one of the main attractions. Far too many people think that all the wildlife worth seeing is in Africa. How wrong they are.

Ranthambhore is a lovely unspoilt area of bushland and lakes, with an abundance of game, and at the latest count there were forty-four tigers. Moreover, there is an added bonus which has given the Park the name of 'Tiger City'. The tigers roam freely in the ruins of huge temples, palaces and rotundas. These were built hundreds of years ago by the Mogul emperors and the whole place presents the most romantic picture, the giant forest trees intertwining their roots in and out of the huge stone blocks of the crumbling frescoed walls. One is strongly reminded of Rudyard Kipling's *Jungle Book*.

It was almost too easy to see tigers. Fateh Singh, who worked for the Indian Wildlife Service, was our host and his house was just outside the Park. Fateh is so full of fun that we hardly ever stopped laughing; but he has a vast knowledge of the bush. It was fascinating, for example, to watch him minutely examine the pug marks of a tigress in the dusty track, ascertaining when she had walked down the road and where she was going.

We arrived at Ranthambhore in the early afternoon, after a seven-hour train journey from Delhi, and went straight to Fateh Singh's house. After a cup of tea, it was the early evening when he said, 'Let's just take a quick run into the Park to see if we can see some tigers.' We were soon in the jeep and some twenty minutes later were driving through the ancient fortress entrance to the Park. In another ten minutes, we had found three tigers lying right beside the road, taking absolutely no notice of us.

Another of the films took me to the United States to film a story on the Florida Alligator. This is an animal which was on the 'endangered list' but, through the advent of commercial ranching, has now been saved; there is no longer such an incentive for the poacher to kill them in the wild. We were filming from an airboat, riding across a lake filled with alligators. Going out at night with miner's lamps on our helmets, we were able to locate alligators' nests in the dark. I picked five delightful little six-inch-long babies out of the water and we examined them before putting them back. I never thought I would ever do that! I then met the Wildlife Service people whose lives are often threatened, and who are fighting hard to stop the illegal import into the United States, through Miami, of skins and other trophies, from endangered species.

Another film took us down to Baja Lagoon, off the coast of Southern California, to film the Grey Whale. All species of whales have suffered, as we know only too well, from the hands of man over far too many decades. These warm-blooded mammals have been butchered in their hundreds of thousands in conditions of

Painting on location in Florida for Thames Television.

barbaric cruelty, and I pray that the day may come, before it is too late, when we realise that 'whale-watching' must be the alternative to the slaughter of these gentle giants of the ocean. To be in an inflatable boat, surrounded by whales, cavorting and playing in the ocean with their young, and to watch in awe as they leap out of the sea for what, it seems, is the sheer joy of living, to crash back again in an explosion of sea spray, is something I shall never forget. But the high point of the film for me was to actually touch a forty-foot-long Grey Whale. We had been in the inflatable for three afternoons

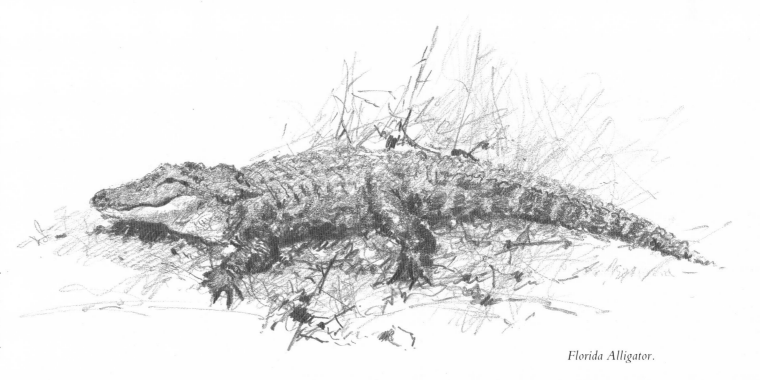

Florida Alligator.

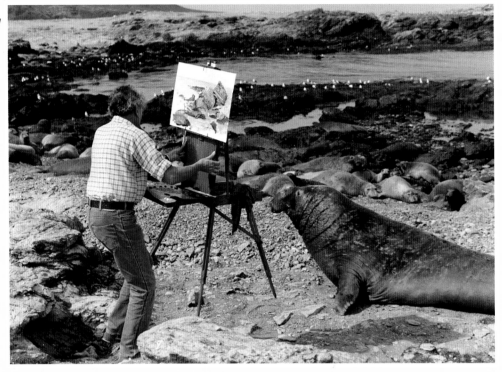

from the inflatable onto the shore, almost landing on a seal in the process. I was watched by dozens of bobbing heads of sea-lions wondering what on earth was happening. I set up my equipment on the edge of a group of elephant seals, and once again, found myself painting in a very strange setting indeed! These enormous animals, weighing many hundredweight, were grunting, heaving, rolling about, and generally behaving in a thoroughly obscene fashion right in front of my easel. They were completely unafraid because they had never been disturbed, and took no notice of me whatsoever. One seal actually waddled in between the tripod legs of my easel as I was working.

Loving the sun and hot places as I do, I wondered what was in store for me when I was told that one of the films was to feature the polar bear. (My life is certainly one of contrasts.) We flew to Churchill in northern Manitoba, on the southern shores of Hudson Bay. This remote town, only accessible by sea or air, is where, for many years, the polar bears have been coming into the town, to eat the garbage off the rubbish tips! It all sounds rather unreal, but I was told that only three people had actually been killed by polar bears. Apparently one had had one drink too many and, in coming out of the bar in the early hours of the morning, had walked straight into a big male polar bear. The bear was rather cross about it! The schoolchildren actually walk to school within yards of the polar bears and neither takes any notice of the other. However, because of the fear of possible accidents, the authorities decided several years ago to humanely trap the polar bears, and take them out onto the ice where they belong. However, some of them come straight back into the town again because they prefer it!

After filming the trapping sequences and the rest of the story, we drove out onto the frozen tundra to see if we could find a wild polar bear. Once again, luck was on my side. We saw a huge male and drove to within a safe distance. I was then allowed to get out of the vehicle and, with the ecologist who was with us (to see that I didn't do anything stupid) we walked up to the animal. He was quite undisturbed – being far more preoccupied with digging holes in the snow. The wind chill factor was much too high to allow any sketching but it was a nerve-tingling experience to watch a wild polar bear at such close quarters, a matter of a few yards away. (Steve, the ecologist, knew what he was doing; I think he had measured the distance between the polar bear and the vehicle and reckoned that my long legs would get me back just in time if the untoward happened!) And the sun came out for just a few brief moments while I was watching the polar bear. It was the only time it came out during the whole eight days that we were in Churchill, but I obtained all the material that I could have hoped for, for my first paintings of polar bears. Luck was still with me for, just as we were getting into the vehicle to leave, a beautiful arctic fox came up to see what was going on.

of filming. It was almost time to depart when the sea suddenly became disturbed a few feet away from the boat. Steve, the American ecologist with us, told me to be quiet and behave myself. This was extremely difficult, because I always get so excited that I can scarcely contain myself. I sat down in the boat and watched as the whale swam slowly up to us, some three feet under the surface, until I was able, in one moment of sheer bliss, to put my arm under the water and touch it. It was like a great huge rubber mattress. Its eye was just a few feet away looking at me. It is hard to find words to describe such a thrill as this. It was just one of sheer wonderment when one considers what man has done to these wonderful animals; that this whale was so trusting. It gave me a lot to think about as we flew home, particularly as I read on the aircraft that the Japanese were about to commence the killing of another 300 whales, for 'scientific purposes', that very day.

It was on our return from whale-watching that we stopped off on San Benitos Island. This is an island sanctuary given over entirely to elephant seals and other species, and it is only in very special circumstances that people are allowed off the boat onto the island. We were given permission to film and, with my easel, I leapt

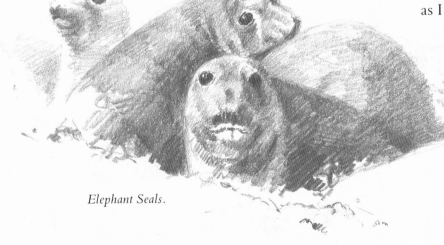

Elephant Seals.

The story of the Arabian oryx must be one of the great successes of conservation. It was in the early 1960s, coincidentally when I happened to be in Aden as a guest of the Royal Air Force, that the RAF flew into the desert and, with the aid of a rescue team, played a significant part in saving these beautiful animals from the brink of extinction.

It has been the tradition of the Bedouin Arabs to hunt the Arabian oryx and it was perhaps 'fair game' in the past because they were hunted from camels. Then, with the discovery of oil, and the consequent wealth from it, the animals were hunted from Mercedes trucks and gunned down with automatic weapons. They did not stand a chance. In the early 1960s it was reckoned that there were scarcely more than a dozen Arabian oryx left in the wild. Five examples were darted by the tranquillizing team and I was told that all the remainder were wiped out by one hunting party shortly afterwards. So it was a case of 'just in time'.

The five animals were taken across to the United States. In San Diego Wildlife Park, and Phoenix Zoo in Arizona, they have multiplied to several hundred and have therefore provided a viable nucleus of breeding animals. Over the years, they have been flown from the United States to the Sultanate of Muscat and Oman. Then, through the good offices of the Sultan, they have been flown into the desert in his own aircraft where, after a few weeks in holding pens, they have been released back into the wild.

After filming in the United States we finally arrived at Yalooni. This remote little encampment of cabins, in the sunbaked and burning desert, miles from anywhere, is the centre for the rehabilitation programme. The thrill for me was to go out actually into the desert and try to find some wild oryx in their natural environment. At that time, just forty-one animals had been released into the wild, in an area covering some four thousand square kilometres. The desert here was an almost featureless gravel plain stretching into endless horizons. Occasionally, there is a small bush or tree and, miraculously, our trackers knew exactly where to go. Before long, we came across eight of these exquisitely beautiful white antelope, resting in the all too precious shade that a tree gave them in the heat of an Arabian midday. In contrast to Churchill, it was now far too hot even to attempt to sketch; I had burnt my arm just leaning on the vehicle. However, it gave me a very special feeling to know that I was watching and observing such rare animals and, as I write, a few years later, I have now been told that there are over a hundred Arabian oryx in the wild. It is surely a true conservation success story.

If an artist wants to study an animal at really close quarters, there is surely no better way than to find a tame one, and I have known many tame ones of infinite variety over the years, from pythons and Mexican bird-eating spiders, to tigers and elephants. I have

had a nine-foot python (called Rosemary) wrapped around me. I have handled a very friendly Mexican bird-eating spider. I have ridden on the back of an enormous black-maned lion. However, in studying tame animals for a painting, there are pitfalls. A lion in a zoo is very different from one in the wild. The former will be flabby and indolent, losing a lot of muscle power through inactivity. On the other hand, an old male lion, in the bush, will possibly be covered in scars from fighting, and his mane will never look as luxuriant as his brother's in a zoo or wildlife park.

Some years ago, my wife and I were lucky enough to meet a couple of friends in Los Angeles whose business is the use of 'wild' animals for the Hollywood film industry. Their philosophy is that, through love and affection, any animal can be trained to do almost anything in front of a camera. Our friends certainly proved the point to us. When we arrived to stay the night, there was a tiger asleep at one end of the drawing-room and an Old English sheepdog at the other! They had a far-ranging collection of 'pets': a hippo, a camel, a tiger and a hyena, amongst others. They told me the story of when their twelve-year-old daughter went to a new school in Los Angeles. When asked what pets she had, she recounted her collection. The teacher promptly accused her of telling lies. She came home in tears and told her father. The next day, she was allowed to take all her pets to school. She made her point!

The leopard featured in my painting 'The Sentinel' belonged to this family and, happily, the purchaser of the picture didn't seem to

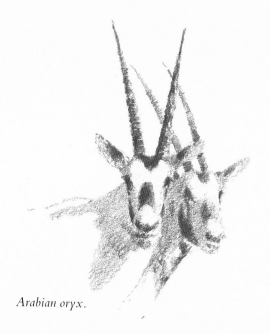

Arabian oryx.

Below left: *With the Thames Television team filming the Arabian oryx in the Omani Desert.*

Below: *Two of my Arab friends, who are looking after the Arabian oryx with such dedication.*

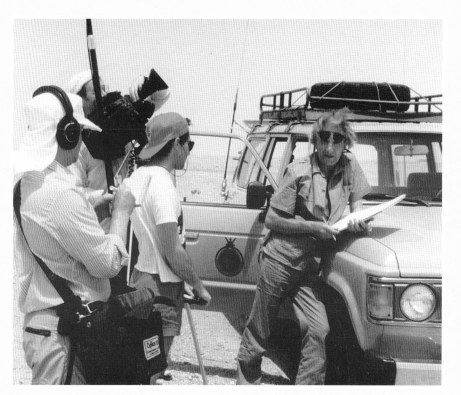

mind too much when I explained that the leopard lived in Hollywood. After all, surely no photographer would be so lucky as to find a beautiful leopard sitting in exactly the right position, in the right lighting conditions on a rock of his choice in Africa! But it is easy for an artist. He can create his own composition. I can find plenty of rocks in Africa which I can sketch and photograph to my heart's content without anything on them. And I knew that our friends had a tame leopard. In fact, it was so tame that you could do almost anything you liked with it. It sat patiently in their garden, rather bored with life in general, and I was able to photograph it and study it from all angles. I even moved its paws around to suit my composition and it didn't mind!

Daphne and David Sheldrick have also given me a wealth of material over the years. Avril and I first met them in the early 1960s when David was the warden of the Tsavo National Park. Through poaching and natural causes, tourists coming into the Park would all too often find orphaned animals, usually elephants, standing beside their dead mothers. The well-meaning tourists would inevitably bring these orphans in to Daphne and David and gradually the willing foster parents found themselves the guardians of an ever-growing collection of animals, from wart-hogs and kudu to eland, rhino, buffalo, zebra and of course elephants. I was therefore afforded an excellent opportunity to study these animals, usually in Daphne's garden — what was left of it!

David Sheldrick tragically died far too young and Daphne now

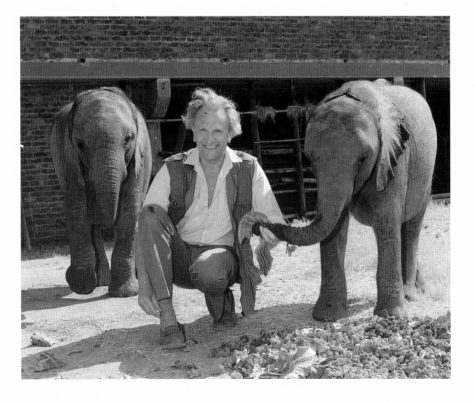

With two of my friends in Zimbabwe.

lives in Nairobi. She has since built up for herself a world-wide reputation for being the leading authority on rearing baby elephants. She has become known as 'The Elephant Mother'. There is something very special about a tiny baby elephant, and Daphne and I have spent countless happy hours together playing with these captivating creatures.

Daphne's orphans have featured in many of my paintings. Just as it is imperative for a wildlife artist to go to Africa or India and study the nuances of light and shade on a river bank, the colour of the sand, the texture of the rocks and undergrowth, it is equally essential to learn the curve of an elephant's tusk which varies from one country to another, their feet, their eyelashes, and so many other details, without which the painting will not look right. And it is easy when the elephant or rhino is just a couple of feet away, playing with you, and when a fully-grown elephant puts her trunk into your pocket looking for a banana, or a fully-grown rhino grunts in blissful contentment as you give him a mudbath.

A friend of ours once said to us that to experience the thrill of sitting in the jungle with a group of Mountain Gorillas was 'the ultimate wildlife experience'; and so in 1991 Avril and I did exactly that.

The Hollywood movie industry has done much harm, in my view; the blockbusting success of 'Jaws' did not exactly portray the shark in a very good light, and 'King Kong', one of the classic early movies emanating from Hollywood, portrayed a gorilla who climbed the Empire State building then destroyed New York. What a shame that wild animals have to be portrayed in such a way, but I believe we are learning. From a much more realistic and accurate film, 'Gorillas in the Mist', large numbers of people now know that the gentle and desperately endangered Mountain Gorilla has been misunderstood for far too long. The film told, beautifully, the story of Dian Fossey's work with these animals and how she had, with such patience, 'habituated' them to the point where, with certain groups, it is now possible literally to sit down with them in their own environment.

So much valuable research was done by her and it is still continuing at the Karisoke Research Centre. I would never have believed that my wife and I would be lucky enough to have the actual experience of meeting these marvellous animals in their natural habitat; or even more remarkably, that they would accept us, the intruders.

We flew out to Rwanda and met a young American, Craig Sholley. He was, at that time, the research officer and he had worked with Dian Fossey herself towards the end of her life. Craig knew a great deal about the intimate behaviour of gorillas in the wild and we were very fortunate to have him with us.

I had never been to this part of Africa before and here was

scenery that was in complete contrast to the hot yellow bush of the Luangwa Valley with which I am so familiar. This was the land of the Virunga Volcanoes, towering mountains with their heads in the clouds, clothed in tropical rain forest. With its mystical qualities, it seemed particularly suited to the Mountain Gorilla.

We had three days in this amazing region and it seemed that every minute of it was spent slithering, mostly up-hill, for some thirty-five miles altogether, but it was worth every minute of it and the effort was more than amply rewarded. Moreover, Avril and I both felt rather pleased with ourselves that we were physically able to do it!

We set off early each morning, our porters carrying our equipment, and with our trackers ahead of us – just Craig, Avril, and myself. As we struggled forever upwards, along the muddy tracks through the entanglement of bamboo, stinging thickets, and the great forest trees dripping from the mist and rain, the nerve-tingling excitement grew by the minute as we knew we were getting nearer to the gorillas. The trackers had gone on ahead and with their knowledge of the country, they always seemed to know where the gorillas were in the endless jungle landscape.

On coming upon our first gorilla, our excitement could hardly be contained. Indeed, we were just within a few hundred feet of the animals when we suddenly saw a mature female and her baby looking at us from the undergrowth. We sat down and for the next hour or so watched her and the rest of the family playing. These wonderful animals accepted us as though we were part of their environment. It was their world but they were sharing it with us. An infant, probably less than a year old, waddled right up to us and it was all that we could do to refrain from touching it. It was almost irresistible. However, Craig had told us that it was absolutely forbidden in any circumstances to touch gorillas in the wild. This is because of the danger of infection, from us to them. Several gorillas have caught and subsequently died from human diseases such as measles, which they would never normally encounter in their natural environment.

On the second day we found ourselves crawling and sliding through the stinging-nettles into a cavern created by the heavy undergrowth overhead. It was almost pitch dark inside but we could just make out in the dim light the shape of a huge male gorilla sitting looking at us just a few feet away. I was crawling behind Avril when I suddenly realised that there was another smaller animal sitting on top of the vegetation, just above her head! Avril had not seen it, and it was taking no notice of her. When we came out of the cavern, once more into the sun, we lay on our backs watching the scene. With no warning whatsoever, I suddenly heard a rustle in the undergrowth just beside me. A giant Silverback Gorilla weighing, Craig told me later, possibly twice

my own weight, was about to walk across my legs. To avoid contact, I drew them up quickly and, without even a sideways glance towards me, he wandered into the thicket on the other side of the glade. He was just a couple of feet away!

The following day, we made the long trek up the mountain to the Karisoke Research Centre. We then learned more of the marvellous work done by Dian Fossey. The anti-poaching patrols, for example, go out daily, destroying snares and pits dug by poachers to entrap the gorillas and any other animal that may be unfortunate enough to fall victim. The poaching still goes on although we hope and pray that with increasing awareness of the beauty and gentleness of these wonderful animals, it may decrease and finally die out altogether. With that awareness, can we not persuade people that it is the ultimate obscenity to kill a gorilla just so that his hands may be used as ashtrays? There are some very sick people in the world who demand this sort of thing.

The last day of our visit, and our departure, finally arrived. Africa is a land of sudden contrasts. One moment, one can experience the peace and tranquillity of the scenery and the wildlife. The next, one can come face to face with so much tragedy, often caused by political turmoil. When Avril and I had arrived in Rwanda we were met with the friendliest reception by the people. We had stayed in a simple little hotel in the town of Ruhengeri owned and run by Africans, and their hospitality was overwhelming. This made it all the more tragic, therefore, when we later heard that the hotel in which we had stayed had been shelled by the rebels the day after we left on the last flight out, in another coup. A considerable number of civilians in the town were shot, but we learned that Craig Sholley and our many new friends were fortunately able to leave in safety.

Everyone is now very concerned for the safety of the gorillas. Since our return, we have had conflicting information. One authoritative source had assured us that the terrorists avoided the area inhabited by the gorillas but I don't believe that we can escape the inevitable fact that the longer-term future of these animals must still be hanging in the balance. The beautiful landlocked country of Rwanda is desperately poor. Like so many other independent black countries in Africa, the development of a tourist industry is essential to generate the foreign exchange so badly needed by the people to improve their standard of living. For a number of years now, the Mountain Gorillas of Rwanda have been a major tourist attraction for people all over the world but it only needs one revolution for that tourist business to collapse overnight. It has happened all too often. Tourists will simply not go to a country if they risk being shot. This has now happened in Rwanda and the tragedy is that it will take years for the business to recover and, meanwhile, the gorilla is fighting to survive.

We must all be familiar with the highly coloured brochure photograph advertising holidays in Africa. The sun is always shining, and giraffe and zebra happily drink around a waterhole. All is peace and tranquillity. This is what 'sells' Africa to the tourist. The waterhole I came across in 1960 was very different. It had been poisoned by poachers, and 255 dead zebra were lying on the ground.

Earlier in my narrative I have written of my first abortive trip to Kenya in 1950 to attempt to be a Game Warden. I have also written of my second visit ten years later when, through the good offices of the Royal Air Force, I was commissioned to paint my very first wildlife painting, and I was to discover how wildlife was going to change my life through my paintings, in the material sense. It therefore had all the more impact on me when, around that waterhole, I discovered what man was capable of doing to the wildlife of the world. The motivation was born in me at that moment to return something of the huge debt that I owe to wildlife and the animals that I paint. I would only have been half a person if I had thought otherwise. In that single dramatic moment around that waterhole, I became a conservationist.

Up to that time, conservation had meant nothing to me. I don't think it meant much to anybody else, either, all those years ago. But I did realise suddenly what man, the most dangerous, stupid and arrogant animal on earth, was capable of doing.

I am not an ecologist and I have no scientific knowledge whatever. I have never even taken a degree in Biology; I had studied it half-heartedly at school, but then had given it up, because I was not particularly interested. However, I am a highly emotional person who paints the wildlife of the world to which I owe so much, and I have wept tears of anguish and outrage at the horrors that I have seen over the years. I have seen elephants dying from suppurating wounds caused by automatic weapons; I have watched baby seals being clubbed to death for their fur pelts on the ice floes of the Gulf of St Lawrence, while the sea ran red with blood. I do so wish that some of the unenlightened people who wear the products from those baby seals had been with me on the ice-floes. They might then think again. There seems no limit to the depths of depravity to which man will sink.

The beauties of nature are so uncomplicated and yet so finely balanced. She demands nothing and yet gives everything, and we are a part of this. This is a very small and fragile world floating in space and it is the only world we have. However clever man thinks he is, he can make it no bigger. He thinks he is all-powerful and can use it to his own ends. We cannot go on abusing it in the way we are, using up the world's finite resources to our own advantage. This is 'playing around' with nature in a way which is very dangerous, because nature will always win. We share this planet with all living creatures, the trees, insects, birds, and animals. We all depend on each other. Man destroys a species every day of the year. If we destroy everything around us at that rate, we are without any doubt whatsoever, I believe, on a self-destruct course, for we cannot survive on this world, alone, surrounded by concrete. So conservation must be important; it's our own survival that we are talking about.

I had the privilege of meeting Neil Armstrong many years ago in the United States. It was just after he had returned from the moon. It was an unforgettable experience to meet someone who has travelled away from this planet for a distance of some two hundred and fifty thousand miles, to walk on another planet and then come home again. Neil Armstrong indeed had more impact on me and my way of thinking than anyone else I have ever met. I was not introduced to him by my host as a wildlife artist, because he had no idea who I was. However, I was introduced as a conservationist and that seemed immediately to strike a degree of rapport between us. He said, 'David, I am a conservationist too. You have to be when you have been to the moon and back.' That is quite something to hear someone say. He continued, 'David, as I looked through the window of my space capsule at Planet Earth, and I saw it floating in space, about the size of a golf ball, I suddenly realised just how fragile it looked.' They were words to remember, coming as they did from such a man.

Up until a few years ago, I used to get very depressed when I saw the havoc we were creating around us. I really began to believe that conservation was a losing battle. Perhaps it still is. The giant teak and mahogany trees of the tropical rain forests are being destroyed at the rate of 200 acres a minute; in many cases simply so that they can be used for plywood shuttering, for the Japanese building industry. Whales, as I have mentioned, were being butchered in their hundreds by the Japanese and other nations. They still are. Now Iceland and Norway are killing whales again. Will they ever learn?

I knew nothing at that time about the ozone layer. I had never heard of the 'greenhouse effect'. Now, countless thousands of people all over the world are learning about these things and we are all getting very worried indeed.

Some years ago, I was talking to a group of African primary children in Zambia, who had come to listen to me talking about conservation. I tried an experiment for the first time. 'What's the most dangerous animal?' I asked them. 'I want a quick answer.' All

Gerenuk — The giraffe-necked antelope.

their little hands went up: elephant, leopard, crocodile, lion, buffalo. 'No,' I said. 'Man.' At that moment, one of the little children came up to me and said, 'You're not an animal, Mr Shepherd.' I was so pleased. It gave me the opportunity to qualify what I was saying. 'Of course I am,' I answered. 'The only difference between us and all the other animals, apart from the fact that we walk on two legs and most of them walk on four, is the fact that we all start the wars and drop bombs on each other. Do elephants do that? Lions have got more sense than to destroy everything around them.' Now, just a few years later, I very often get the correct answer from many children. It seems, therefore, that we are now really beginning to get the message through to the most important people of all, the young children. They have the awesome task of trying to repair the damage created by my own generation, in the last forty or fifty years. For it is in this time scale that man's rapacious appetite to destroy everything around him has grown by leaps and bounds. It is a challenge for these young people but I really do believe that they will meet it.

If I have a regret in my life now it is that whenever I go to Africa these days, I never seem to have the opportunity to see any wildlife. Time is spent on fundraising dinners and auctions in all the big hotels wherever I may be. However, it is well worthwhile. Whenever I leave from such a visit, I am inspired by the people I meet. Several years ago, I took part in a marathon fundraising effort, in Zimbabwe, Zambia and Malawi. The news of my visit seemed to reach Uganda. 'Will you please come out to help us? The world has forgotten Uganda.' The question came from a delightful African who ran the wildlife clubs of Uganda. I had not been to that beautiful country, known as the 'Pearl of Africa', since 1962.

Everyone is aware of the appalling and bloody troubles that befell the peoples of Uganda. However, they are making a supreme effort to forget the past and rebuild and they want the world to know about it. We had just one evening in Kampala. We arrived with the usual overweight in baggage, consisting of all the books and prints that I take with me on such occasions, and which generate the money. Before the dinner in the Sheraton Hotel, I asked my host how we could help most. 'Please help us with transport. We have just one motorcycle to cover all the 400 wildlife clubs over the whole country.' It seemed a desperate situation but one which from experience was not new to me. At the dinner that evening, we very nearly raised enough money to buy two brand new long-wheelbase Landrovers. Tears of excitement and gratitude were shed that evening, and some of them were mine. I met some of the wildlife club children and they too inspired me. Throughout all the worst times of bloodshed and turmoil, those African children kept the wildlife clubs going. It is those children who so deserve the support from people such as us who visit them.

In terms of conservation, there are moments when one feels like giving up, and then again, moments of exhilaration. We have a disaster which makes us once more realise just how fragile the environment is. An oil tanker can still be driven onto the rocks; I think of the *Exxon Valdez*. This giant oil tanker, owned by the Exxon Corporation of the United States, did such damage to the Alaskan coastline when 12,000,000 gallons of oil spewed onto the rocks from the wreck, that it may never be possible to evaluate it. It should never have happened. Whatever Exxon may say to the world, I believe that it was gross negligence.

At the same time as thinking of the *Exxon Valdez*, I want to think of a little girl in Zambia. A couple of years ago, I led a walk for twelve miles from Lusaka in the hottest part of the afternoon to raise funds for their wildlife. The line of children behind me seemed to stretch into the distance, even longer than the traffic jam that I inevitably created! There were about 1,500 children following me and the smallest of them were running to keep up. The last girl to complete the marathon had a deformed leg and one arm. Between them, these wonderful children raised nearly three thousand pounds. This was not in pound notes, because many of them live in tin huts. All the money was in copper coins!

Ignorance is such a sad facet of human nature. There are so many people that I meet in England and other relatively opulent countries in the West who still mistakenly believe that the peoples of Black Africa do not care about their wildlife. They do. When Zambia, for example, was a British Colony, there was one National Park; there are now nineteen. The children in these countries also care about conservation. They are learning because they want to learn. I broadcast that message far and wide whenever I can, and when I think of Exxon, I also remember that young girl in Zambia.

Poaching, one of the major threats to wildlife, still continues. In the Luangwa Valley, I have been out with the brave Africans who face death daily from gangs of poachers armed with automatic weapons. It is an all-out war and people get killed in war. At the time when I went out with them, there were just two patrols of fifteen men each, and these thirty people were responsible for an area the size of Wales; and they patrolled on foot. They did not even have proper uniforms, they were badly paid, and they were rationed to just three rounds of .303 ammunition each, due to a break-down in the management of the Game Department at that time.

Sketch for my painting of foxes.

23

These are the people who deserve our support.

All the blame does not lie on the shoulders of the poacher. If these people cannot make a living from the conservation of their wildlife, through tourism, controlled hunting, and other forms of game utilisation, then they have to turn to other means to survive. The poacher is all too often living on the breadline. One small tusk from an elephant, or a rhino horn, will keep him and his family for twelve months. He does not understand. He doesn't have the option. The people to blame are the mega-millionaires in Hong Kong and other places in the Far East, who are earning fortunes, bribing the poachers to do their filthy work for them. I equate

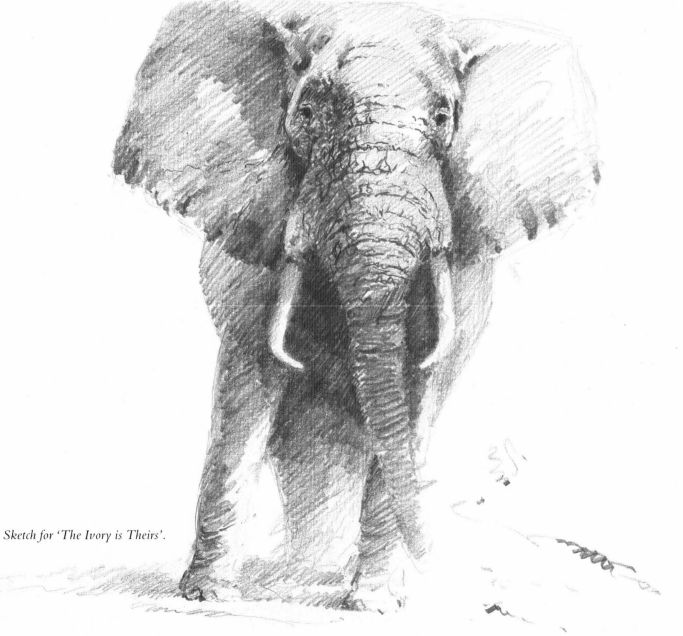

Sketch for 'The Ivory is Theirs'.

them in terms of crime on the same level as the drug kings of Miami. I have seen elephants dying in the most horrific conditions and these are the animals to whom I owe all my success. They deserve a better fate. Ivory looks best on elephants, where it belongs.

When I first went to Africa in 1950, there were probably three million elephants. There are now approximately six hundred thousand, and they are still being decimated at the rate of a hundred thousand a year. They could well have gone, therefore, except in a few isolated pockets in National Parks, within six to ten years. When I first went to Kenya, I saw an elephant with tusks so large that he had to hold his head up when walking to avoid touching the ground. Each tusk could well have weighed over one hundred and fifty pounds. Now, it is rare to see an elephant with tusks a quarter that weight. The majestic animals who carried such ivory are gone for ever. They can never be recreated. It is because of what I owe to the elephant that I have painted 'The Ivory is Theirs', featured in this book. We hope by The David Shepherd Conservation Foundation to raise £1,000,000 by the sale of the prints and the painting. With this painting, we hope we are playing just a small part in what could well be a last-ditch international effort to save elephants. Together with other conservation organisations, we are trying to raise £15,000,000. It is a drop in the ocean. It is probably the cost of just a couple of miles of motorway. Is that too much for such a worthy cause? I want my grandchildren to see elephants in the wild in Africa. They may not. When I first went to Zambia with my family, we saw eight rhino in one day. I have not seen a rhino in Zambia for eight years. I am told there are possibly only twenty left in the entire country. Why? Rhino horn is possibly worth three times its weight in gold, simply because the Chinese still believe that it has medicinal qualities, and the Arabs in the North Yemen traditionally use rhino horn for their dagger handles. Rhinos deserve a better fate.

I now believe that conservation is the most important issue of all. I was questioned by someone once when making that rather sweeping statement. 'What about cancer relief, for example? Can you say that conservation is more important than finding a cure for cancer?' I pointed out that some forty per cent of medicines come from plants. It is more than likely that many species of plants still remain undiscovered, in the rain forests which we are destroying at the rate of 200 acres a minute. Is it not possible that in those forests there is a plant still unknown to science, which could yet be a cure for the disease? It all seems so incredibly stupid.

Being able through my paintings to play my small part in the battle for conservation is now the greatest thrill of my life. The more material success I enjoy and the more I learn, the stronger the motivation. So, when I'm not fundraising for wildlife, I have to be

painting — I'm miserable if I'm not. The rewards are enormous, to be able to raise large amounts of money with a small painting which perhaps took only a few hours to paint. It is rewarding, too, to talk to five or six hundred people who I know have come to listen to me. I do not do it for money. I do it because I believe in what I am saying and if I can send away one small part of that audience thinking a little more about conservation and all the other issues which concern man's future and the part we play in this world, then I am happy.

People often ask me what they can actually do to help. It is very sad when many such people feel 'useless'. We can all play our part. 'People Power' is a very overworked cliché, but it does work. It is the politicians of this world who make the decisions but they are influenced by those who vote for them. We have the final say. One day, for example, we must convince the Japanese Government, joined now by Norway and Iceland, that in continuing to butcher whales in the oceans of the world, they are acting in the face of mounting feelings of revulsion amongst decent people. Do the Japanese really think we believe them when they tell the world that they have to kill 300 whales a year for 'scientific research'? They must think we are ignorant. They kill them because they have to keep a handful of people employed on just a tiny number of whaling factory ships, and because Japanese businessmen like eating whale steaks in Tokyo restaurants.

I do my best to give people an answer when they ask how they can help. 'Next time you go into a supermarket,' for example, 'and you want to buy some tinned fish, look at the label to see where it comes from. If it says, 'Product of Iceland', don't buy it. Leave it on the shelf.' By doing so, hopefully, the message will finally get through to the Icelandic politicians who still allow whales to be butchered. It is as simple as that.

So what of the future? Who can answer that question? We have, after all, in our infinite stupidity, an almost limitless ability to destroy everything around us. At the same time, in our infinite wisdom, we also have the ability to repair the damage but we have very little time left in which to do so. We ignore this at our peril. Conservation must now mean the environment. We must get away now from the 'cuddly animal' image. Pandas, koala bears and baby seals have universal appeal and immediately arouse the emotions in us. However, they are only one small part of the intricate pattern of nature, the balance of which we have disturbed to such a catastrophic degree. There are many totally unglamorous and almost unknown species that are just as rare as the panda and just as important in terms of conservation. A poster I once saw in Zambia drawing attention to the plight of the rhino bore the words, 'I am ugly, but I need saving too'. That poster said it all.

There is so little left in the world now which has not been desecrated by man. One has to search hard to find a true wildlife wilderness. I once read a report by the scientific correspondent of a leading national newspaper. He wrote of a new Russian ice-breaker which had just been designed. The ship would be able to break into the thickest ice. He described how this marvellous new invention would enable us to 'open up the hitherto unexploited wastes of the Arctic'. A chill went through me when I read those words. He should have known better. What did he mean by 'wastes'? Was a waste land, to him, simply an area inhabited by polar bears and penguins? I believe that if we were allowed to exploit the Arctic, it would then become a true waste land — an area desecrated by rusting machinery, rubbish, pollution and all the other degradation that man leaves behind him. That is a true waste land and, God forbid, may this never happen to the Arctic, one of the few little corners of this world remaining upon which we have not stamped our mark.

Concerning the future of wildlife today, it must generate hard cash to the local people who live with it. Whilst I am still emotional

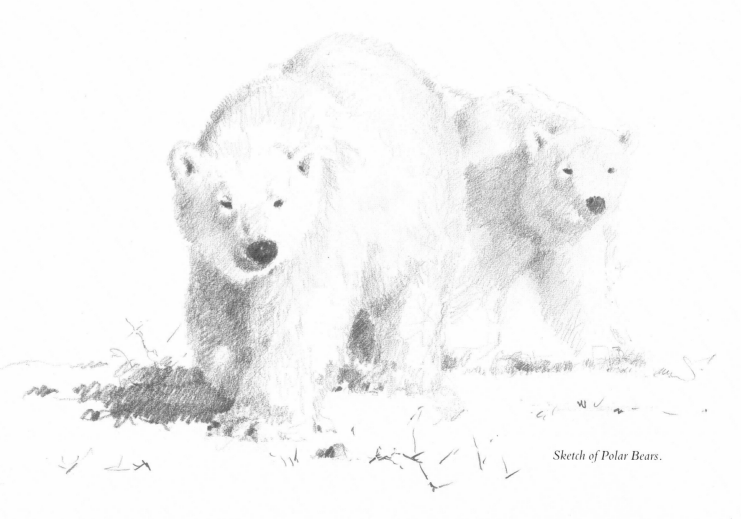

Sketch of Polar Bears.

about many conservation issues, I am much more pragmatic than I used to be, and money of course counts. The overriding fundamental issue is that of human pressure. Even inside a park, the wildlife will only survive against mounting human demands for more space if, at once, it can be seen to be a paying proposition to keep it alive for the benefit of those who live with it. The African or Indian villager scraping a humble living from his vegetable plot already feels resentment at seeing, a few yards away, buses filled with international tourists filming his wildlife with their expensive movie cameras. What does he get out of it all? We have to learn this lesson very quickly. The utilisation of wildlife must be the answer. Game can be utilised through ranching and farming, controlled tourism, and even hunting. Wildlife has to pay and there are examples now to prove that we are beginning to win the battle.

In Zambia at least, the villagers are now beginning to realise that the poachers are stealing their greatest national asset and they are beginning to do something about it.

Perhaps this lesson was never more forcibly brought home to me than when I was filming for Thames Television in the Ranthambhore National Park. We filmed less than a mile outside the park where the whole area was teeming with humanity, cattle and goats. There was scarcely a blade of green grass or a leaf on a bush. The people in the village came up to us, and said, 'It's all very well you coming out from England, filming our tigers. They are not doing us any good. We want that National Park for our cattle. They are starving.' I was told that unless something dramatic happens quickly, the whole Park could be lost for ever within twenty years.

I am indeed a lucky man. I am one of those still relatively privileged few who have experienced and been a small part of the great wildlife scene which will for ever leave an indelible mark on our memories. Memories of the glorious tigers of India, impala grazing peacefully and hippos basking in the heat of an African afternoon, or sixty elephants playing in a river a few feet away, completely undisturbed, are treasures that I shall always cherish. It's their world too, and I have always felt enriched sharing such a scene with the wildlife that I paint.

But have I been in on the final act? I cannot help but wonder; is there really room on earth for the magnificent elephant or the prehistoric rhino, at the rate we are using up so much of the room that is left? We must make that room. I have seen and experienced the still-unspoilt beauties of Africa and India. The greatest thrill of my life now is to be able in some small way to repay my enormous debt of gratitude to wildlife through The David Shepherd Conservation Foundation.

This small charity, based in my own farmhouse in England, with only six people working for it, is already becoming quite a major force internationally in the whole matter of raising funds and awareness for the conservation of wildlife and the environment throughout the world. If I am able through my paintings to do this, and also to enlighten just a few people and give pleasure to those who have not been as fortunate as I, then I am not only satisfied but a very happy and lucky man.

No discourtesy is intended if the ownership of the paintings in this book is not acknowledged. It is simply that over the years many of my paintings have changed hands and I no longer know where they are. The most appropriate thing, therefore, is to thank everyone and I hope that you are not too surprised if you suddenly find your painting in this book.

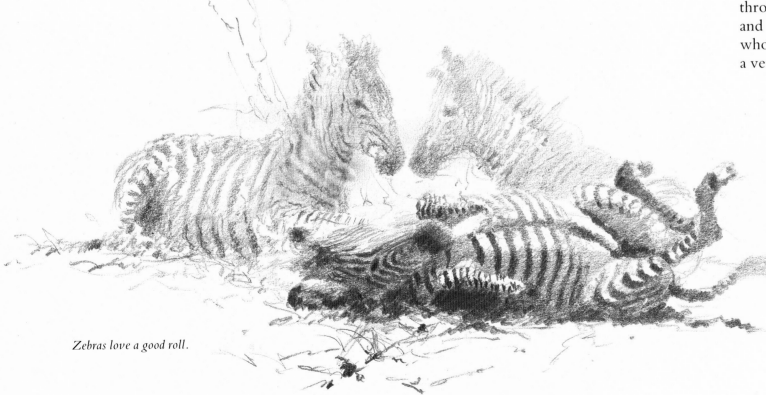

Zebras love a good roll.

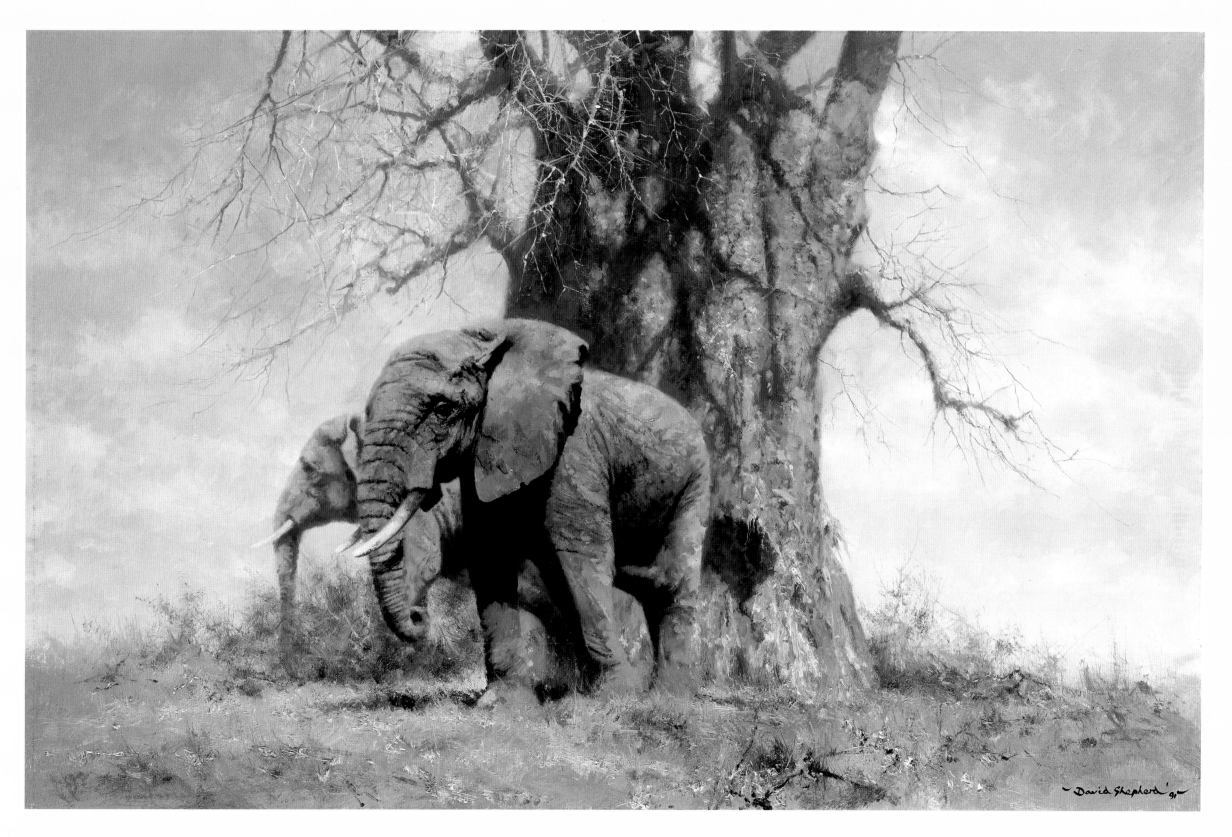

Baobab and Friends

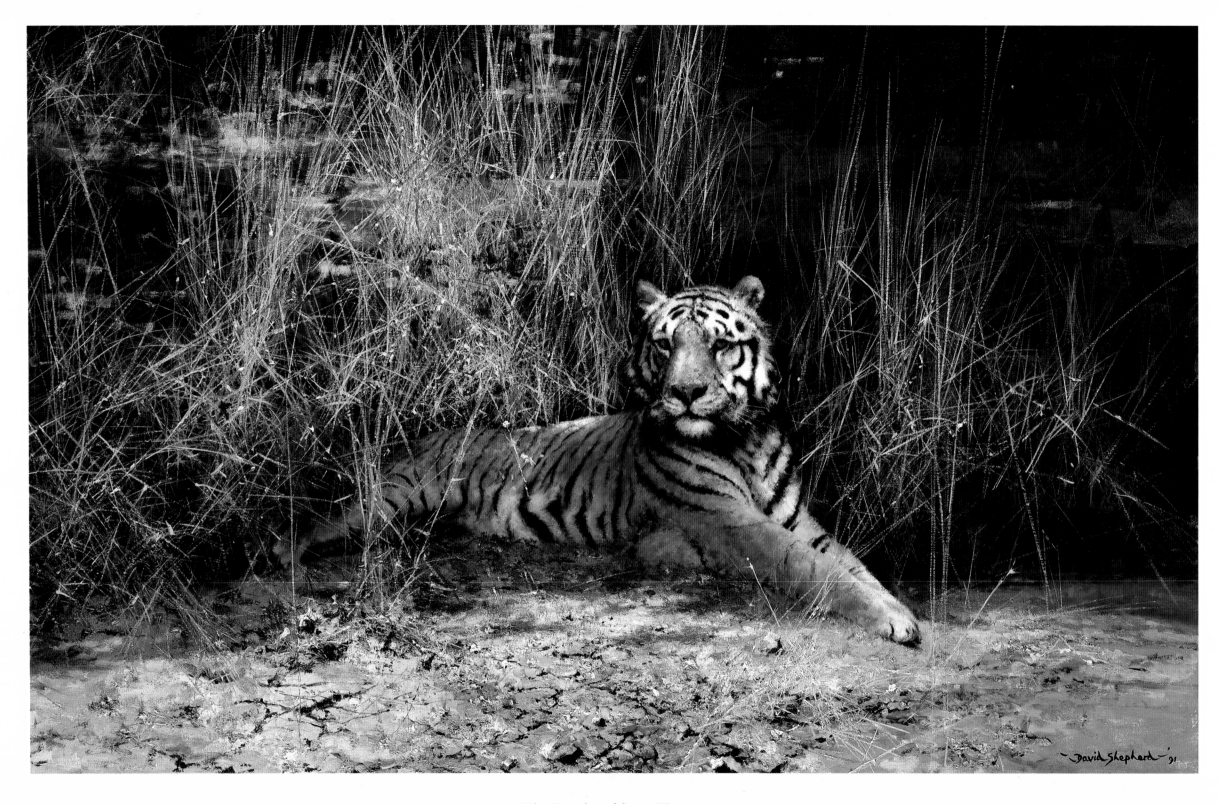

The Ranthambhore Tiger

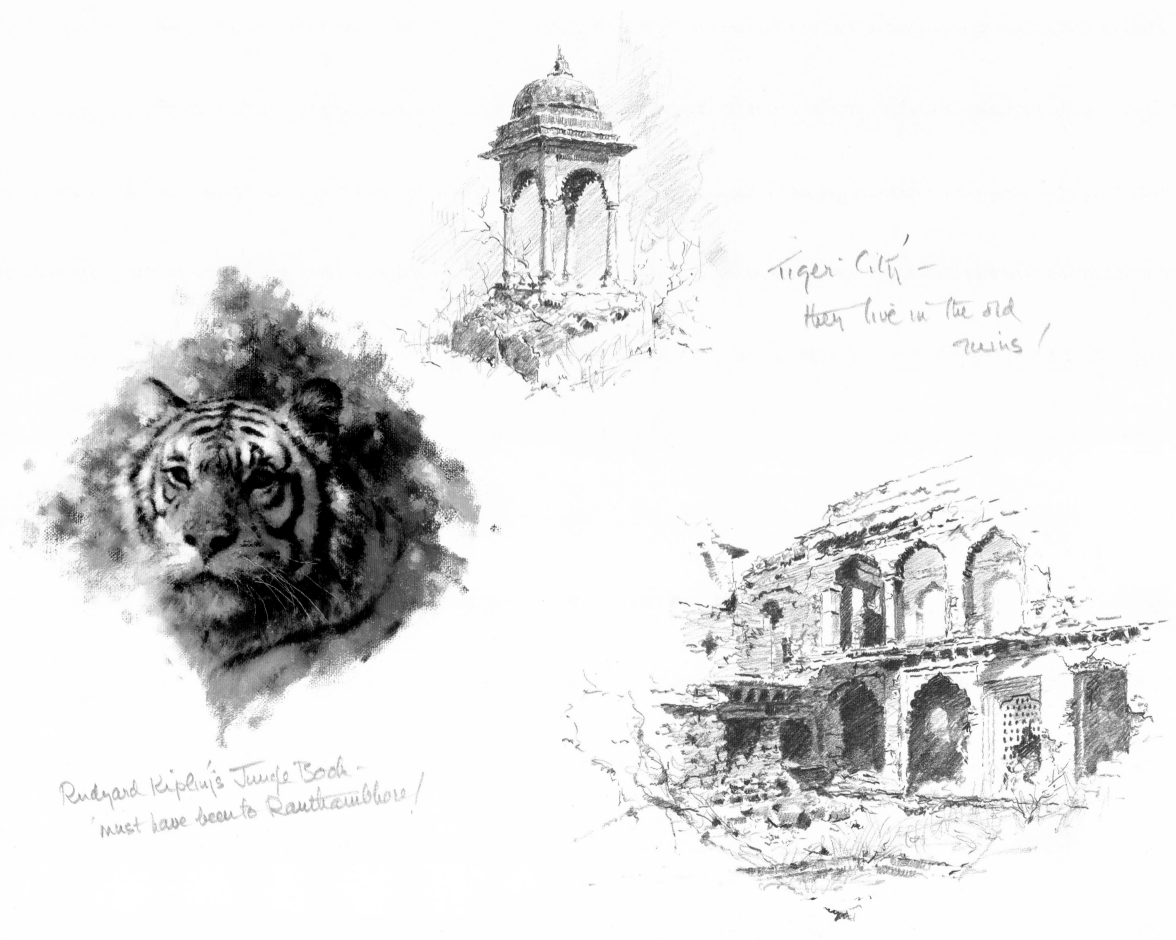

Tiger City —
They live in the old
ruins!

Rudyard Kipling's Jungle Book —
'must have been to Ranthambhore!'

29

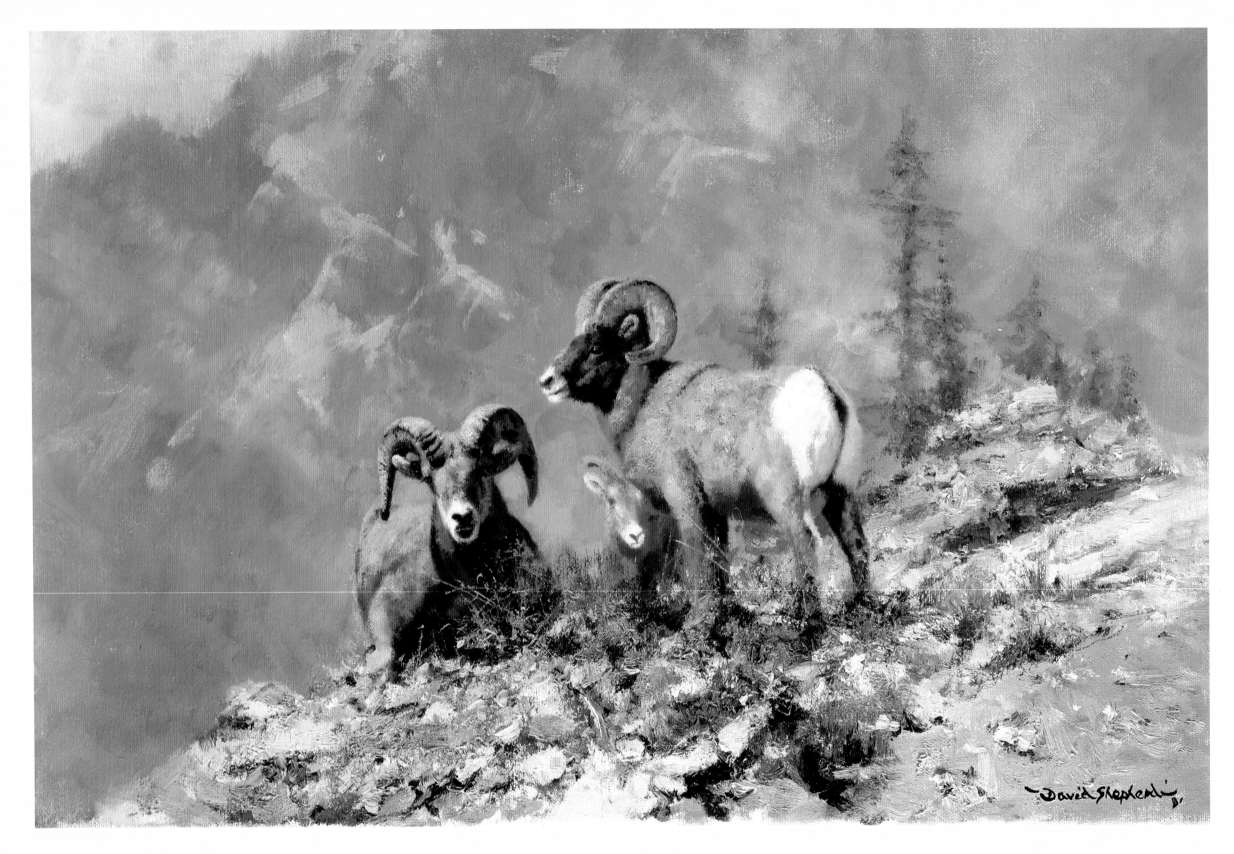

Big Horn Sheep

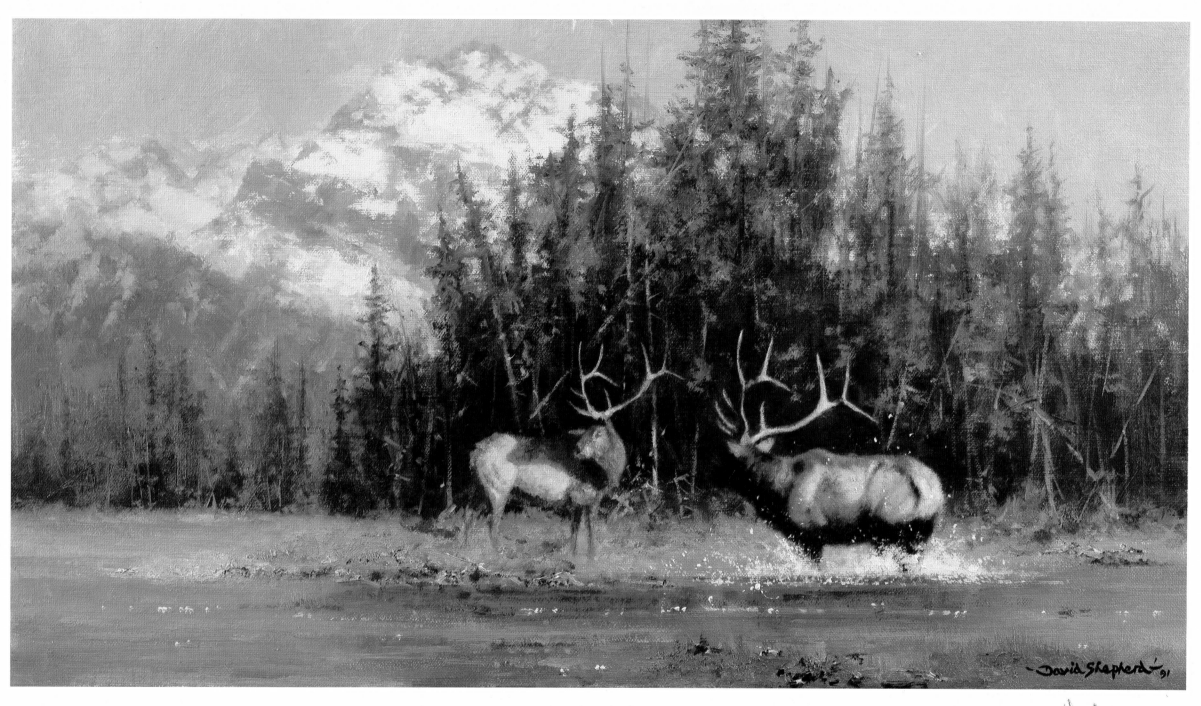

Elk in Banff National Park

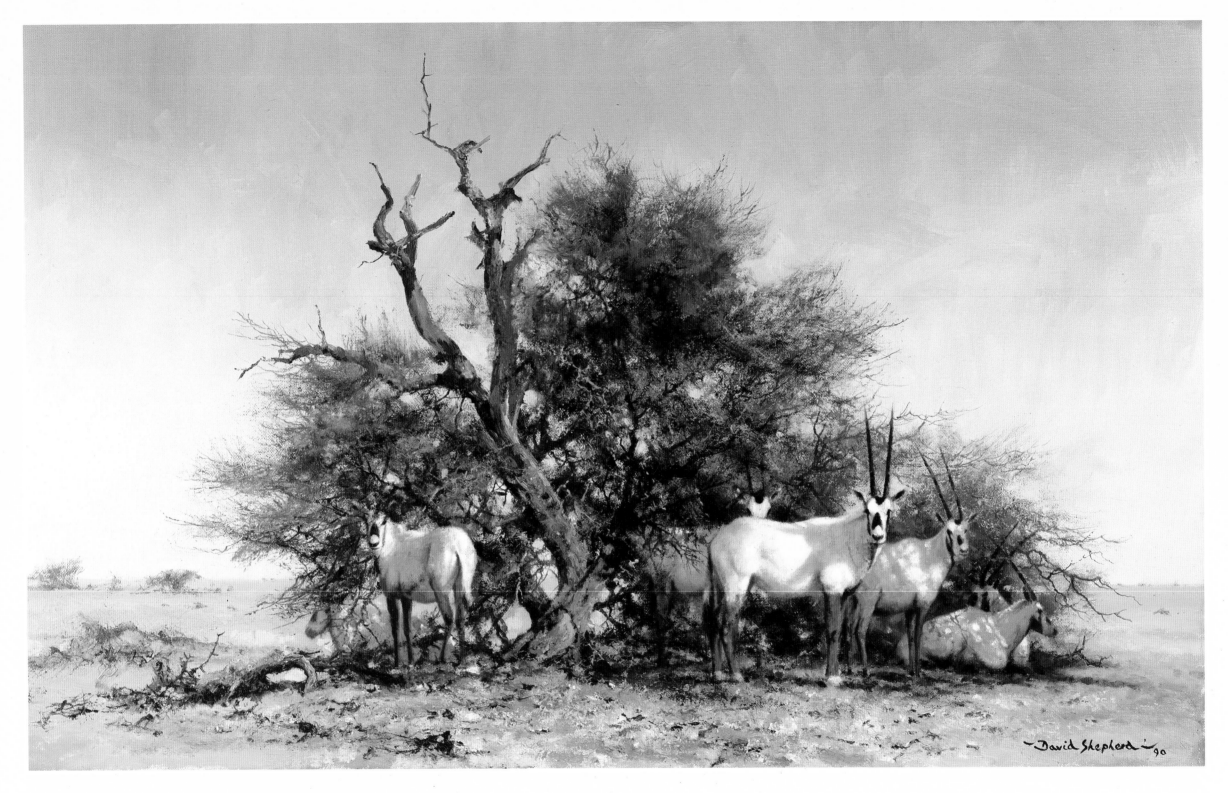

Arabian Oryx

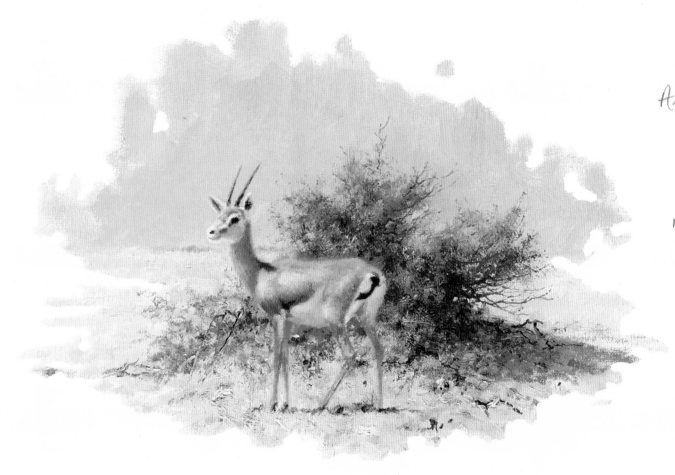

Arabian Oryx —— origin of the myth of the Unicorn.
one of the great conservation success stories.
reduced almost to extinction by hunting with AK47s
five examples rescued — sent to USA to 'breed up'—
now returned to the wild where they're looked after by
the Bedouin

Desert Gazelle — they seem
to live on nothing !

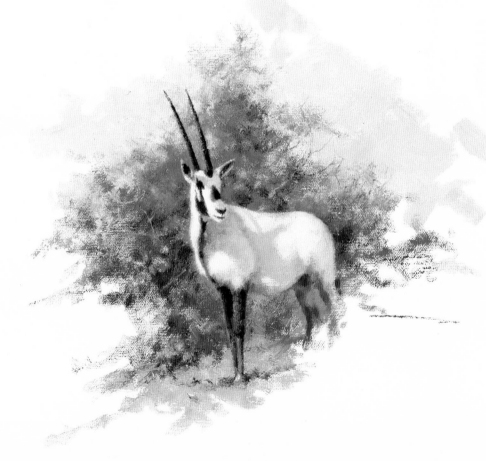

33

Elephant Seals on San Benitos Island - sketched for the Thames T.V. series
"In Search of Wildlife" --- no one allowed on island without special permit — whole place
seething mass of seals of all shapes and sizes — mostly making revolting noises —
obscene habits! ---

right under my easle while trying to paint — totally unafraid!

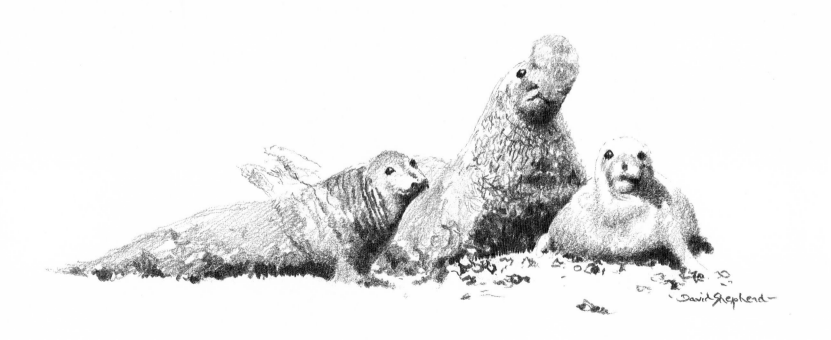

David Shepherd

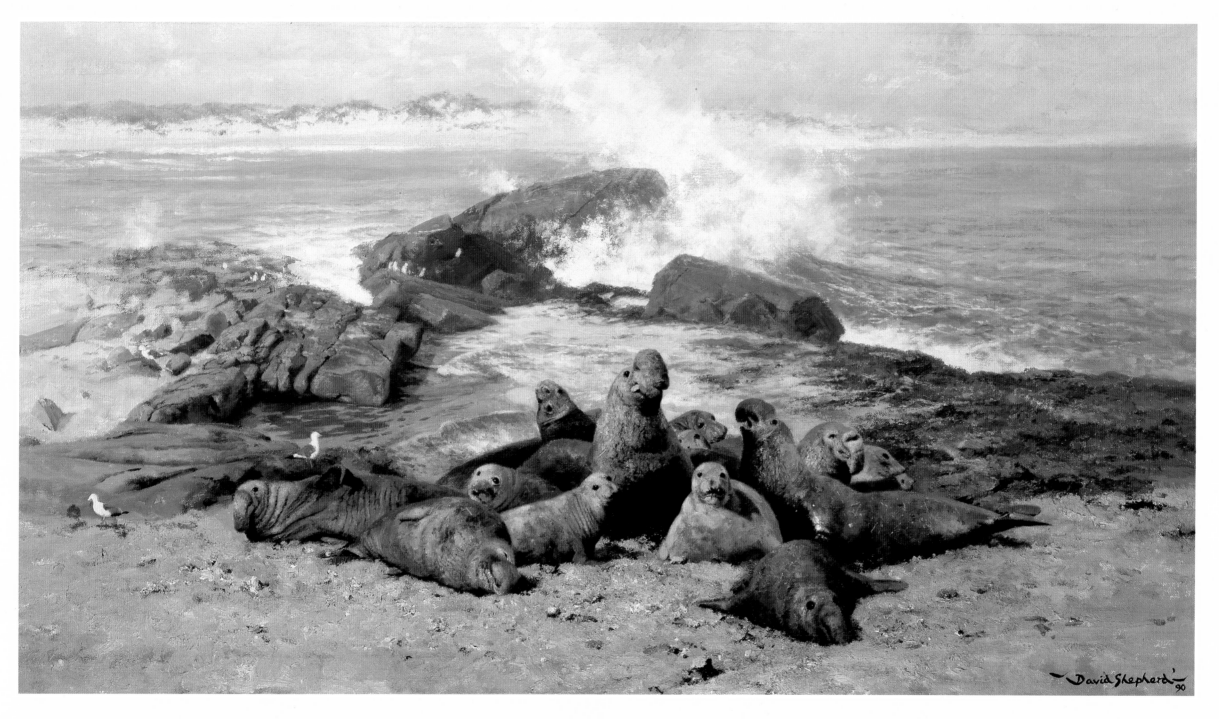

Elephant Seals

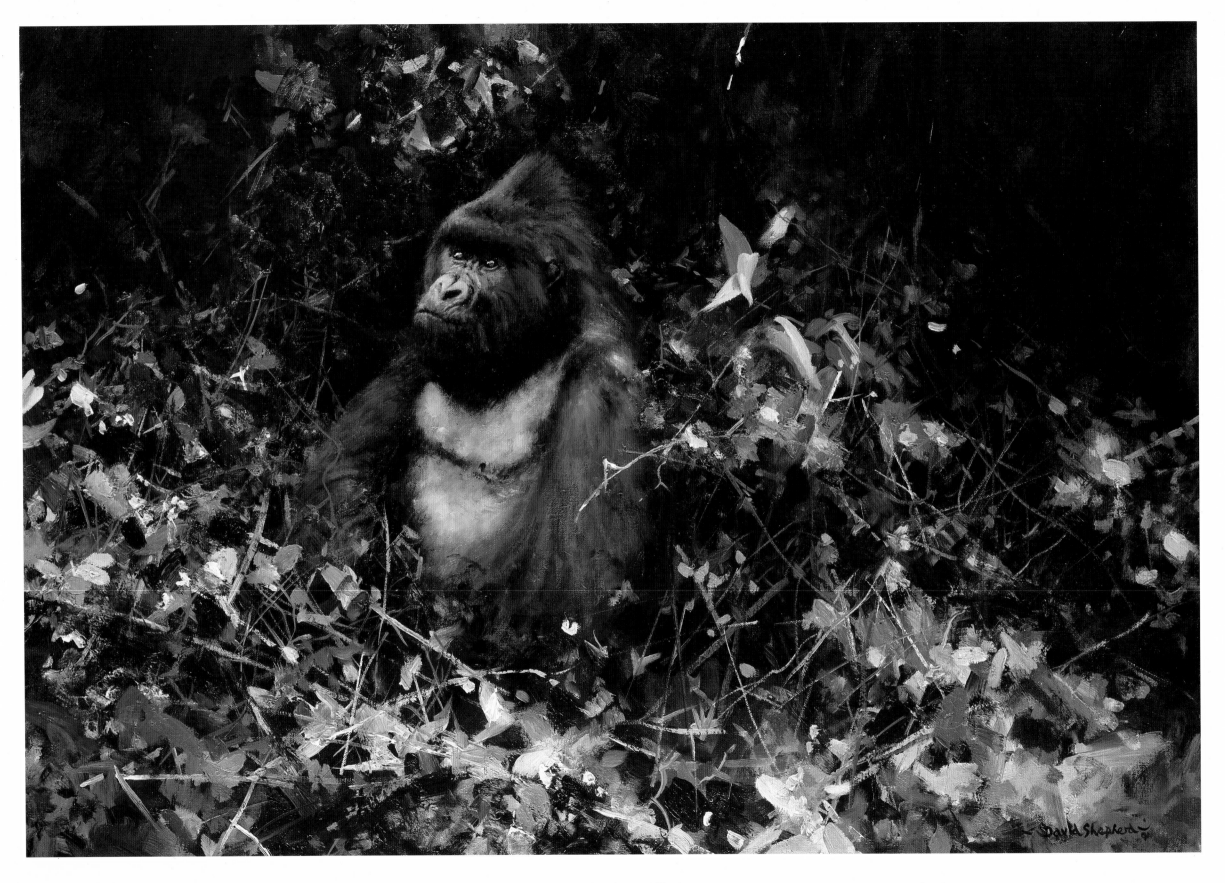

Silverback Gorilla

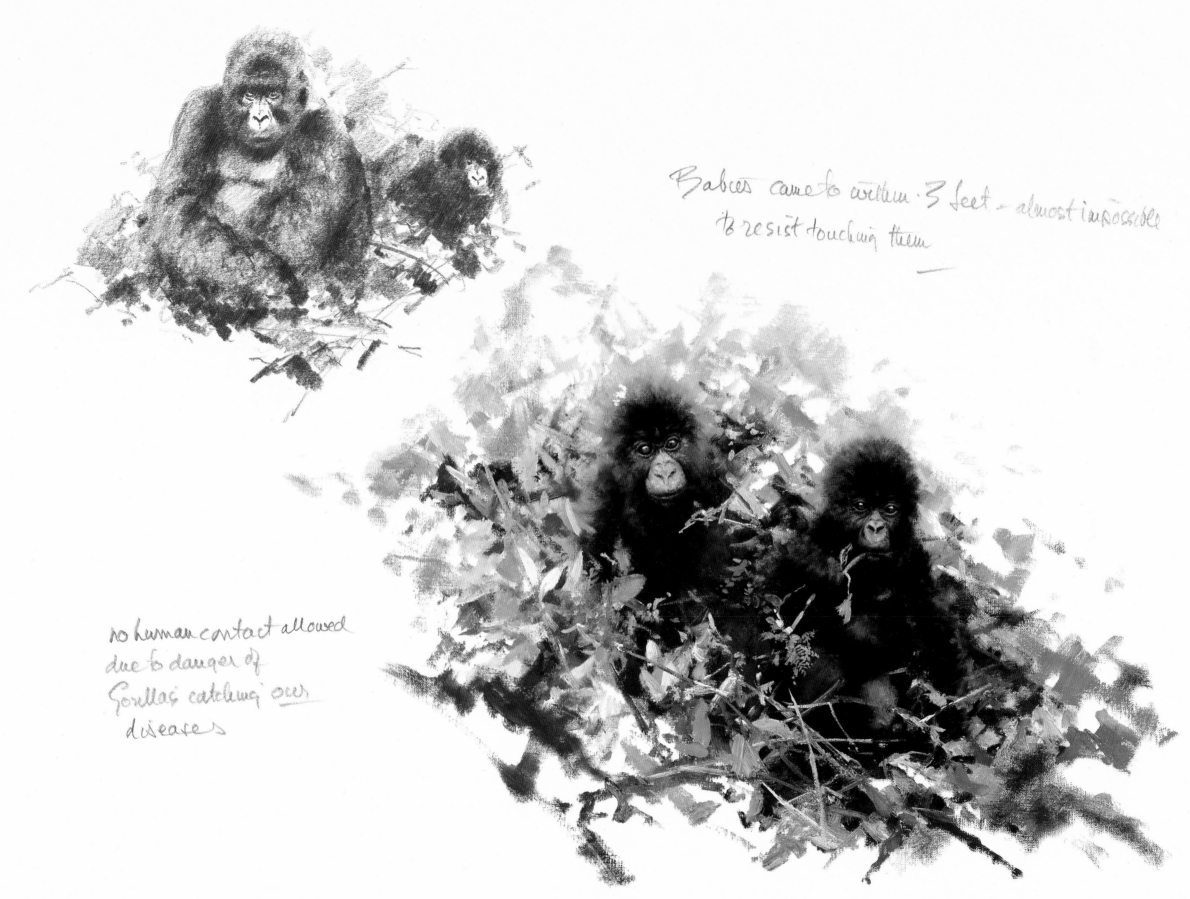

Babies came to within 3 feet – almost impossible
to resist touching them

no human contact allowed
due to danger of
Gorillas catching our
diseases

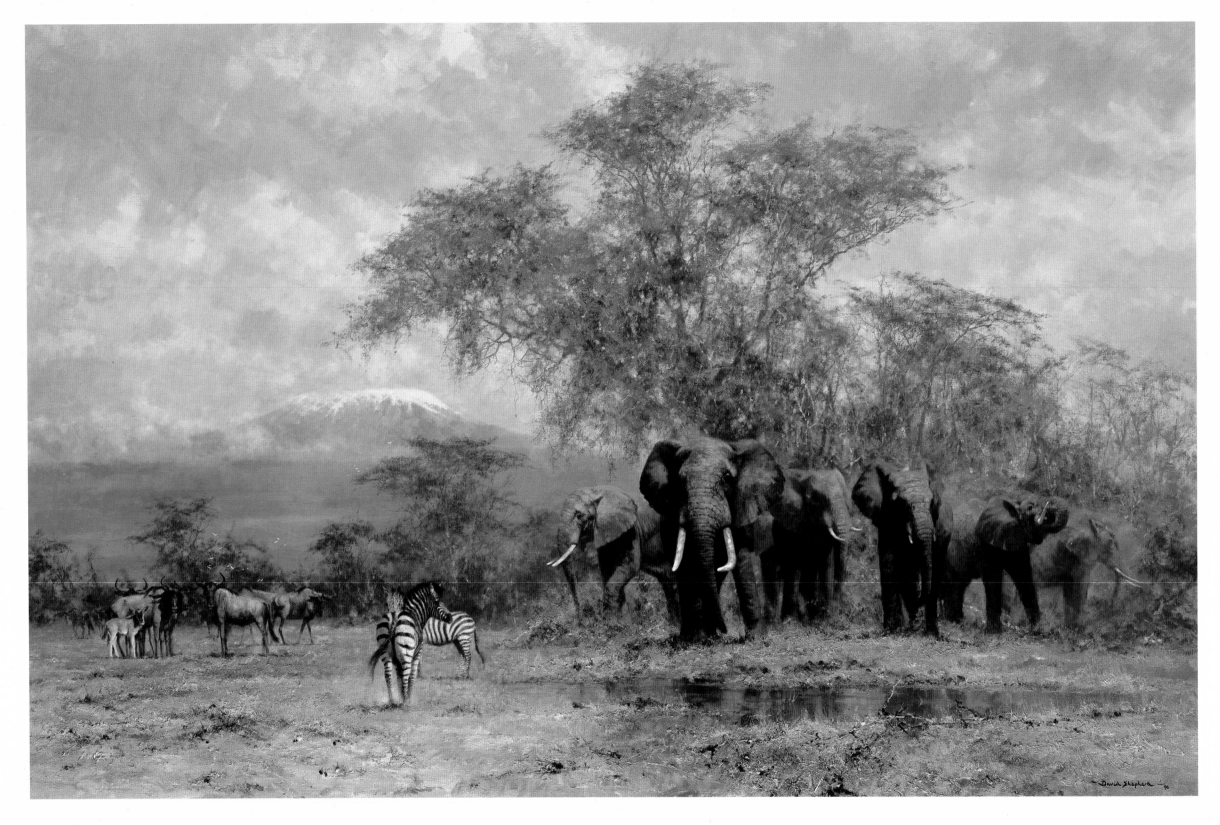

Amboseli

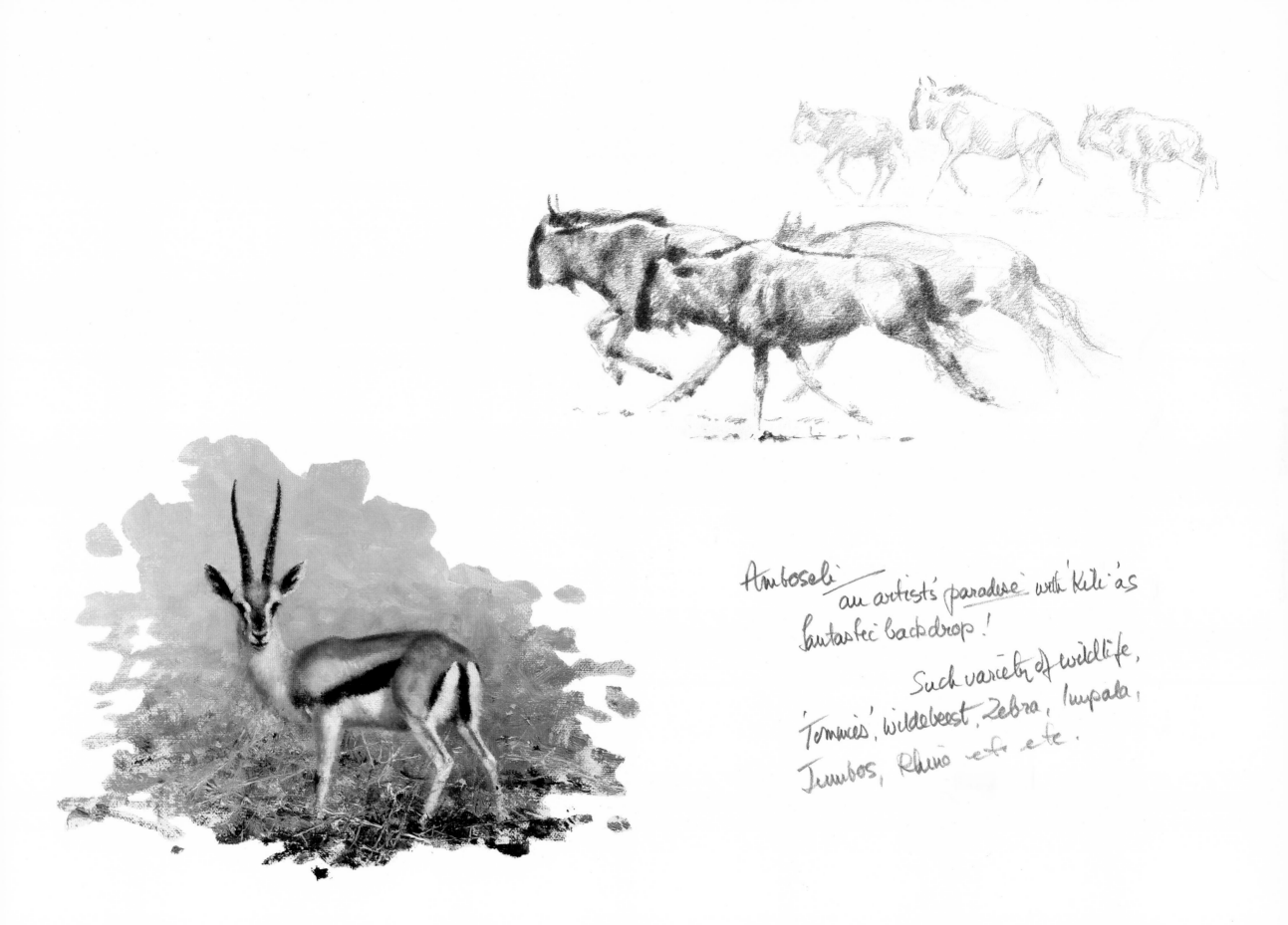

Amboseli — an artist's paradise with Kili'as
fantastic backdrop!

Such variety of wildlife,
'Tommies', wildebeest, Zebra, Impala,
Jumbos, Rhino etc etc.

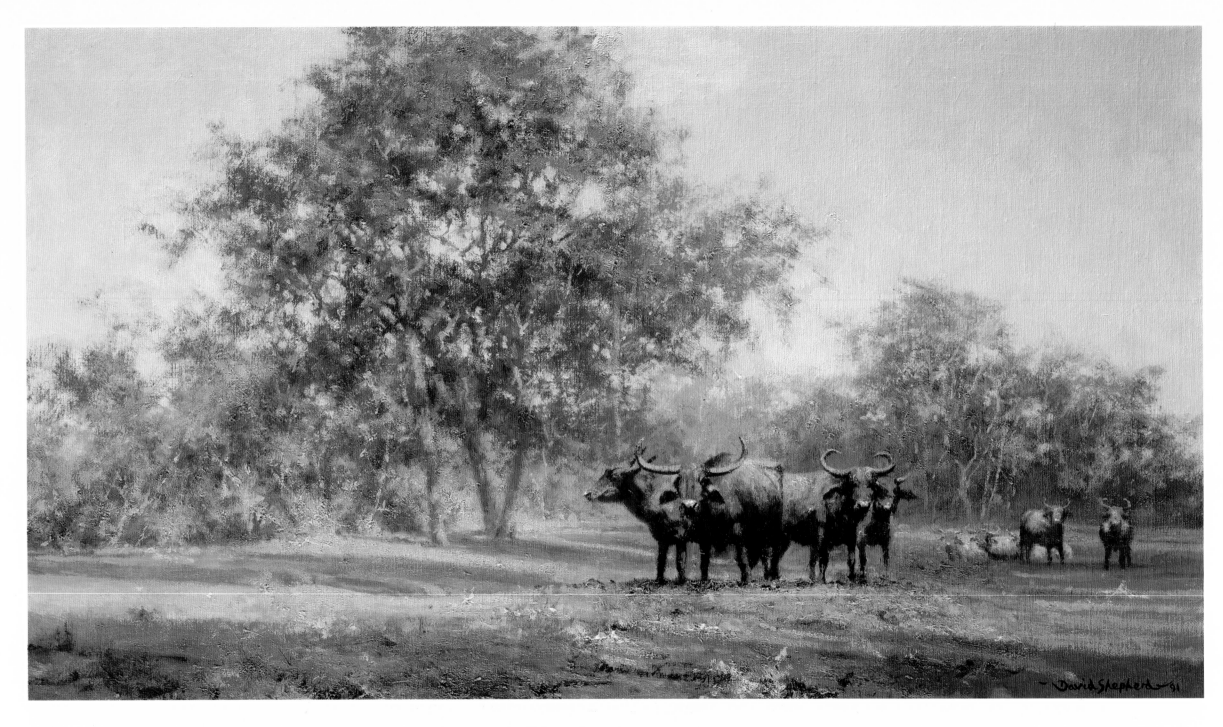

Indian Waterbuffalo in the Yala National Park, Sri Lanka

Indian Rhino - so rare
fantastic armour plating'
perfect seats for egrets !

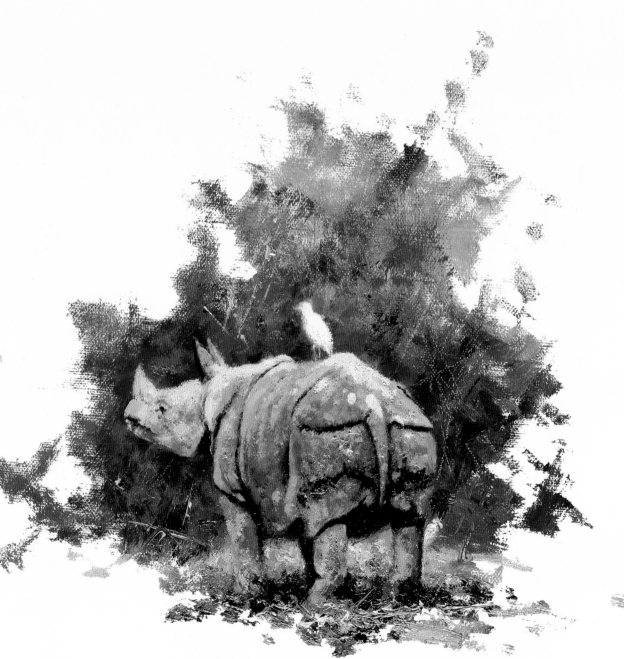

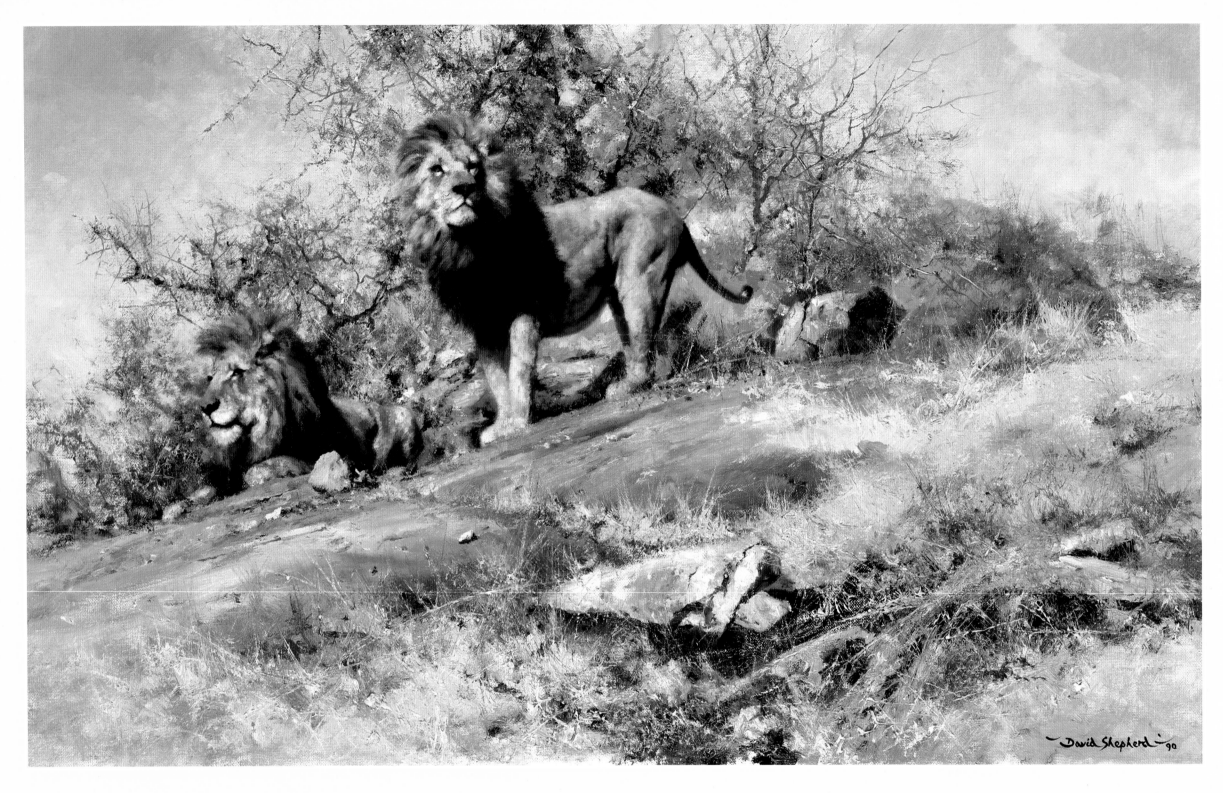

Two Gentlemen of Savuti

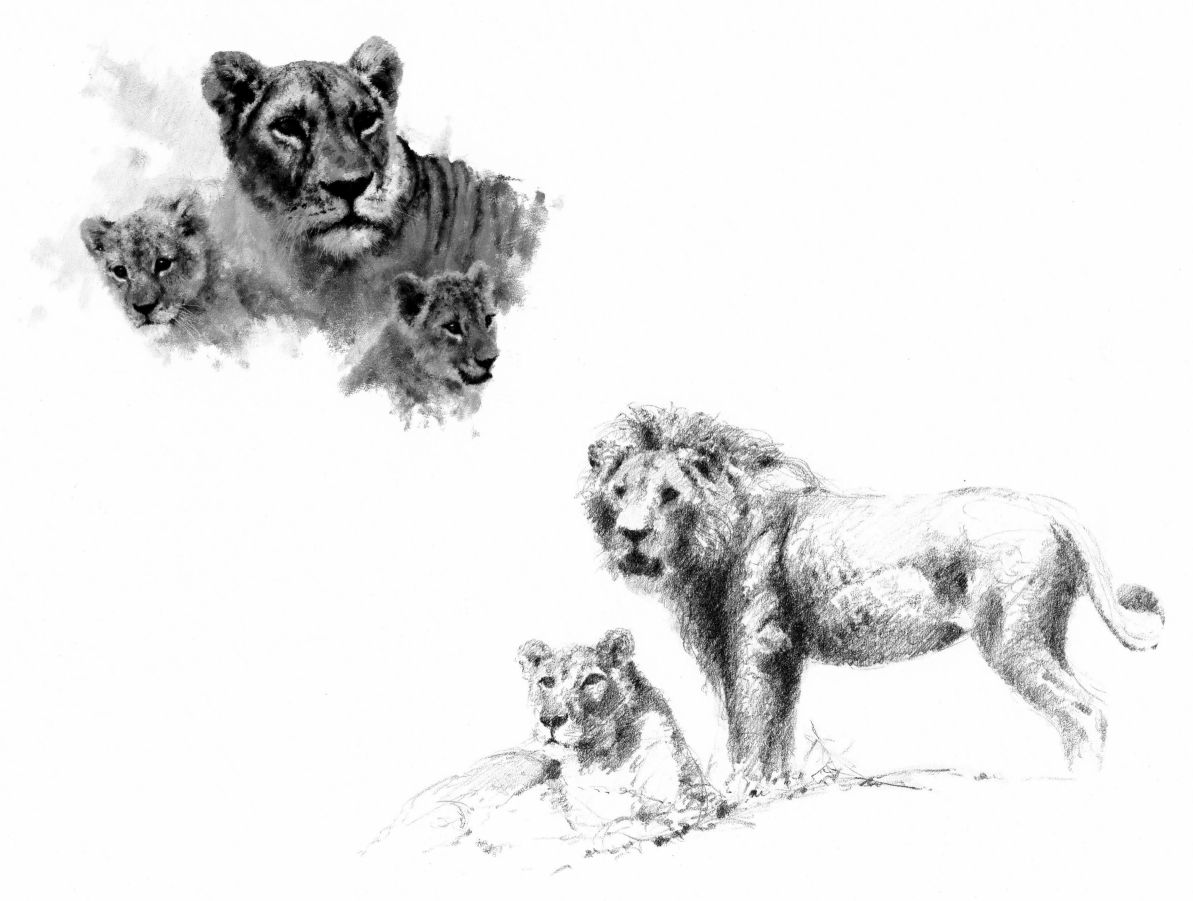

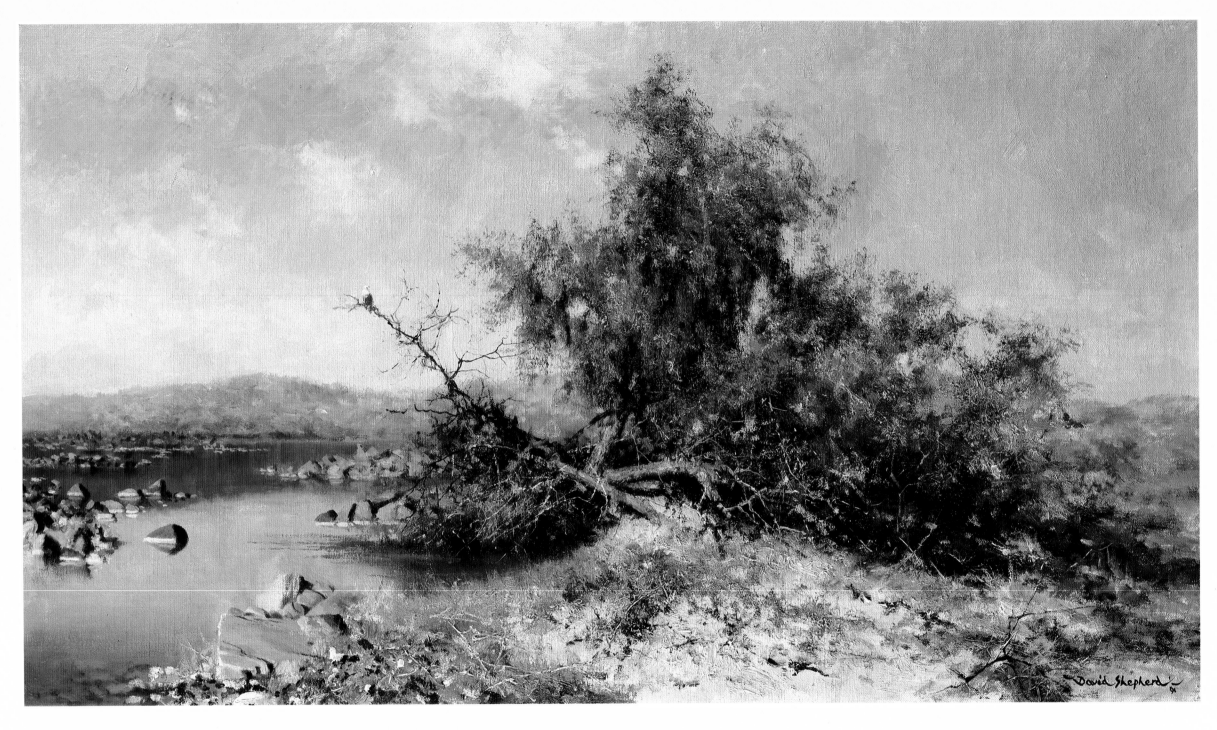

On the River Vaal – Is there a Rhino out there somewhere?

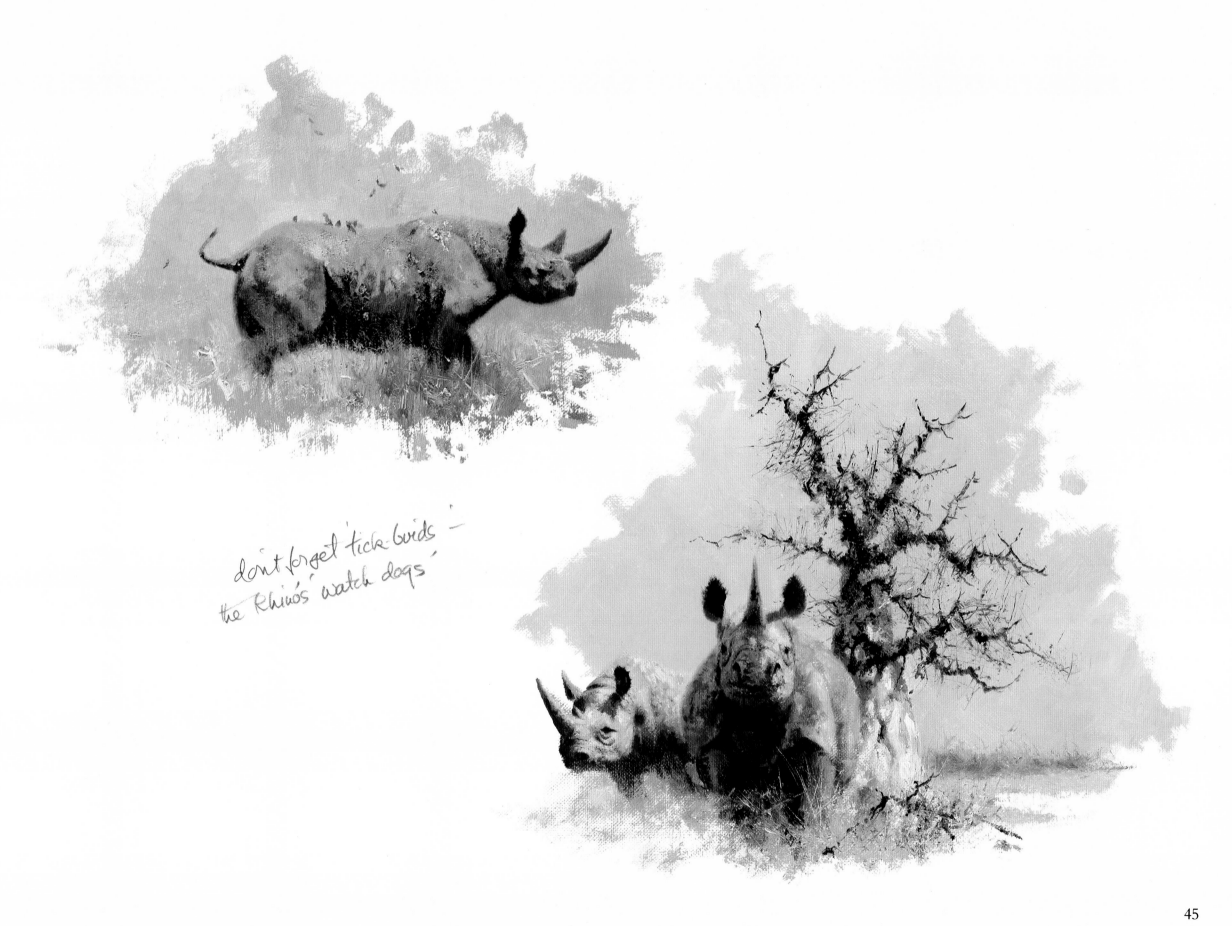

don't forget 'tick-birds' –
the Rhino's 'watch dogs'

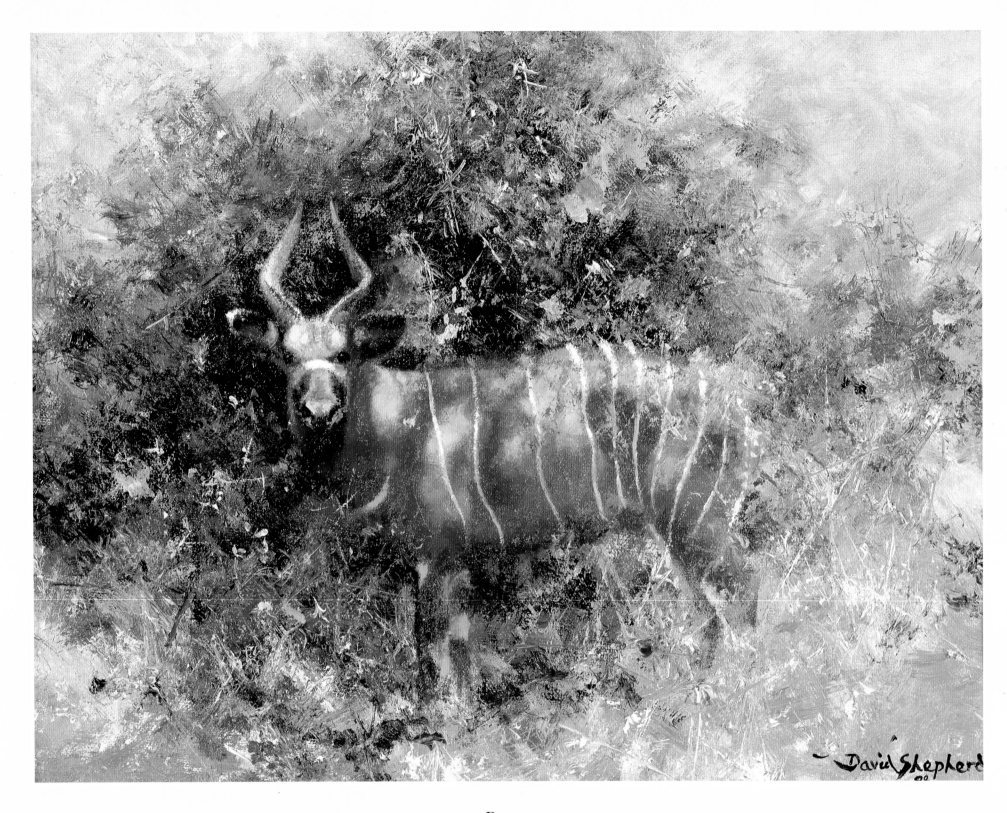

Bongo

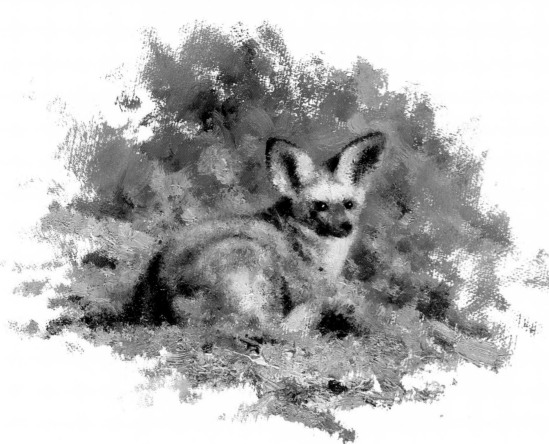

When I first took kids to Africa – youngest, Wendy, shouted – when seeing a Bat Eared Fox – "look, Dad, there's a fat eared box!" – we've called them that ever since.

Baby Nyala

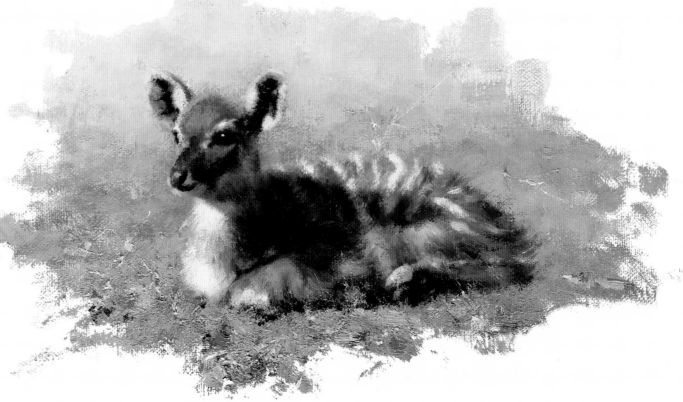

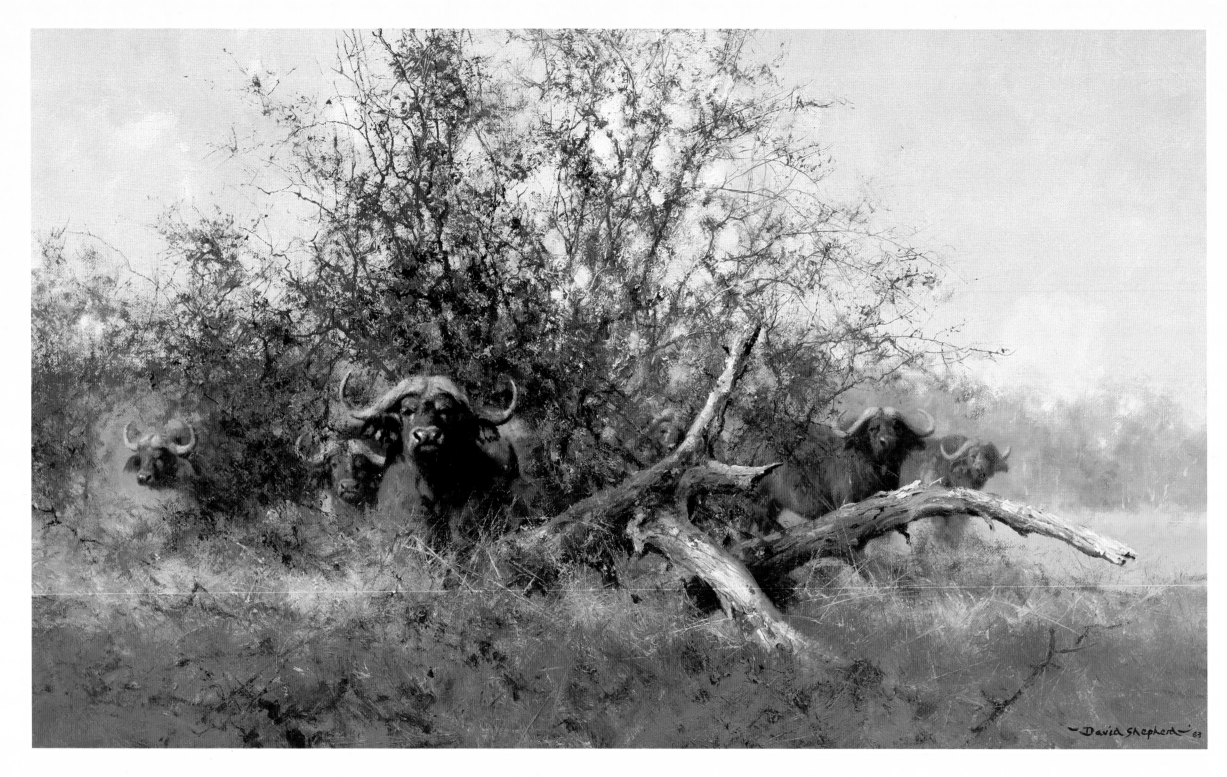

Peering at the Intruder from deep in the Undergrowth

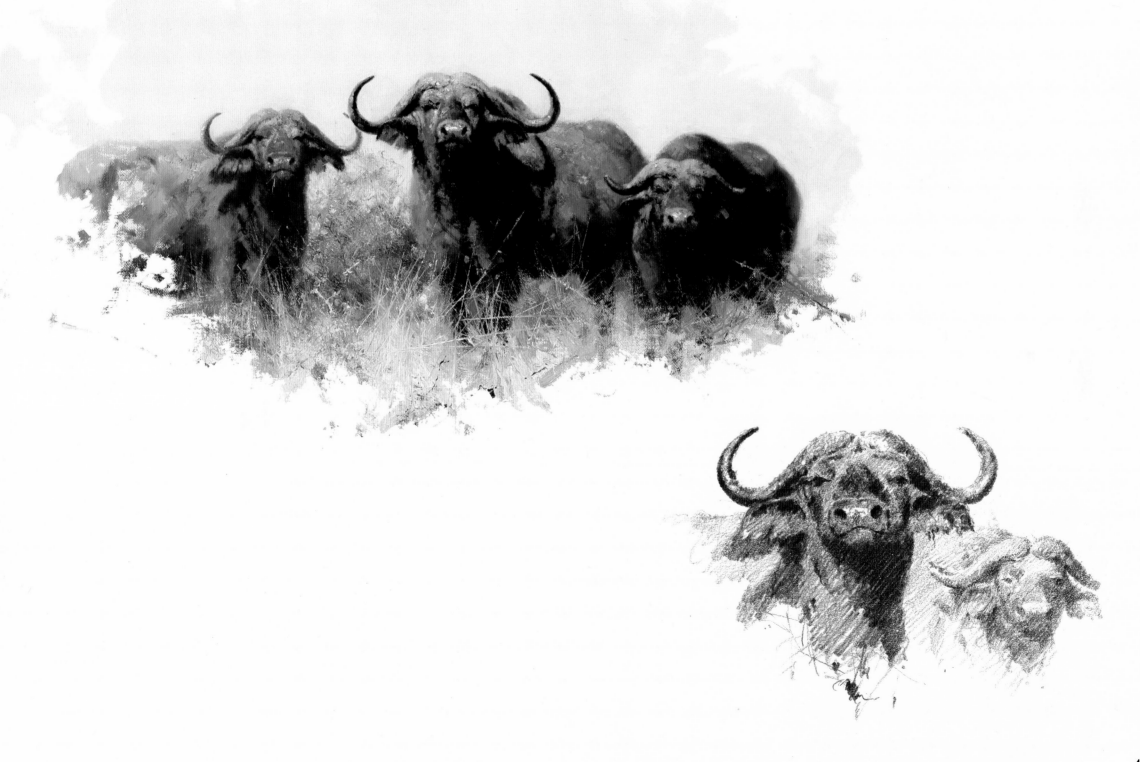

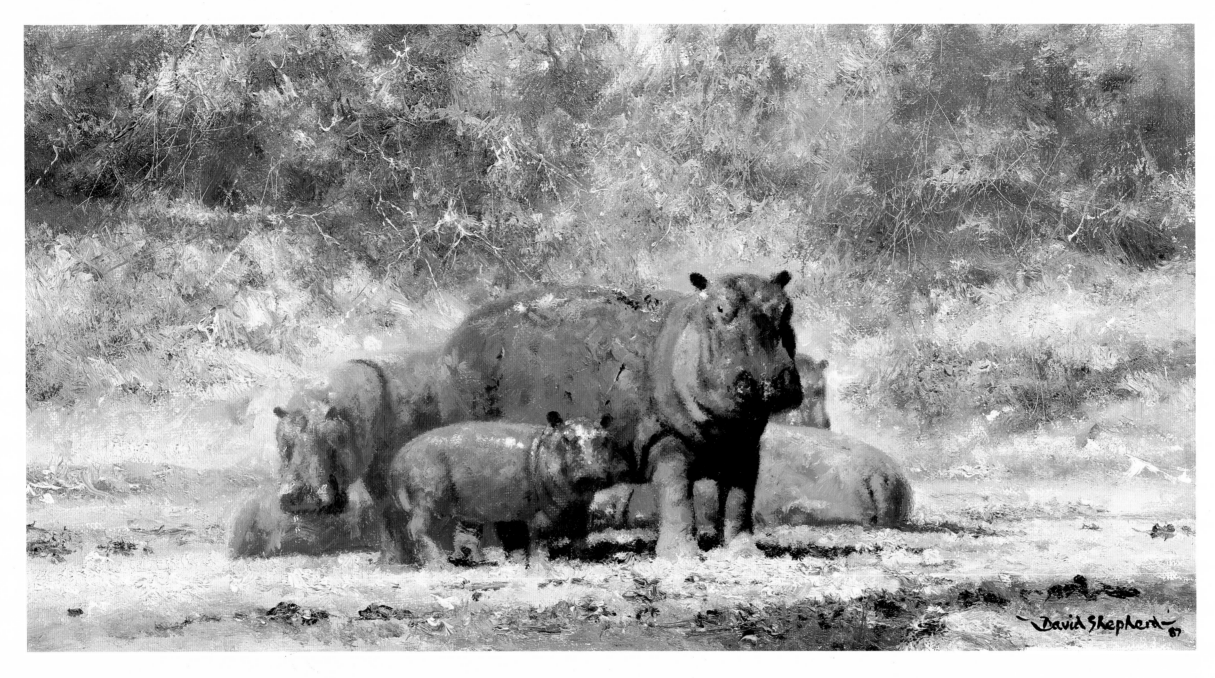

Sunday Afternoon on the Sands

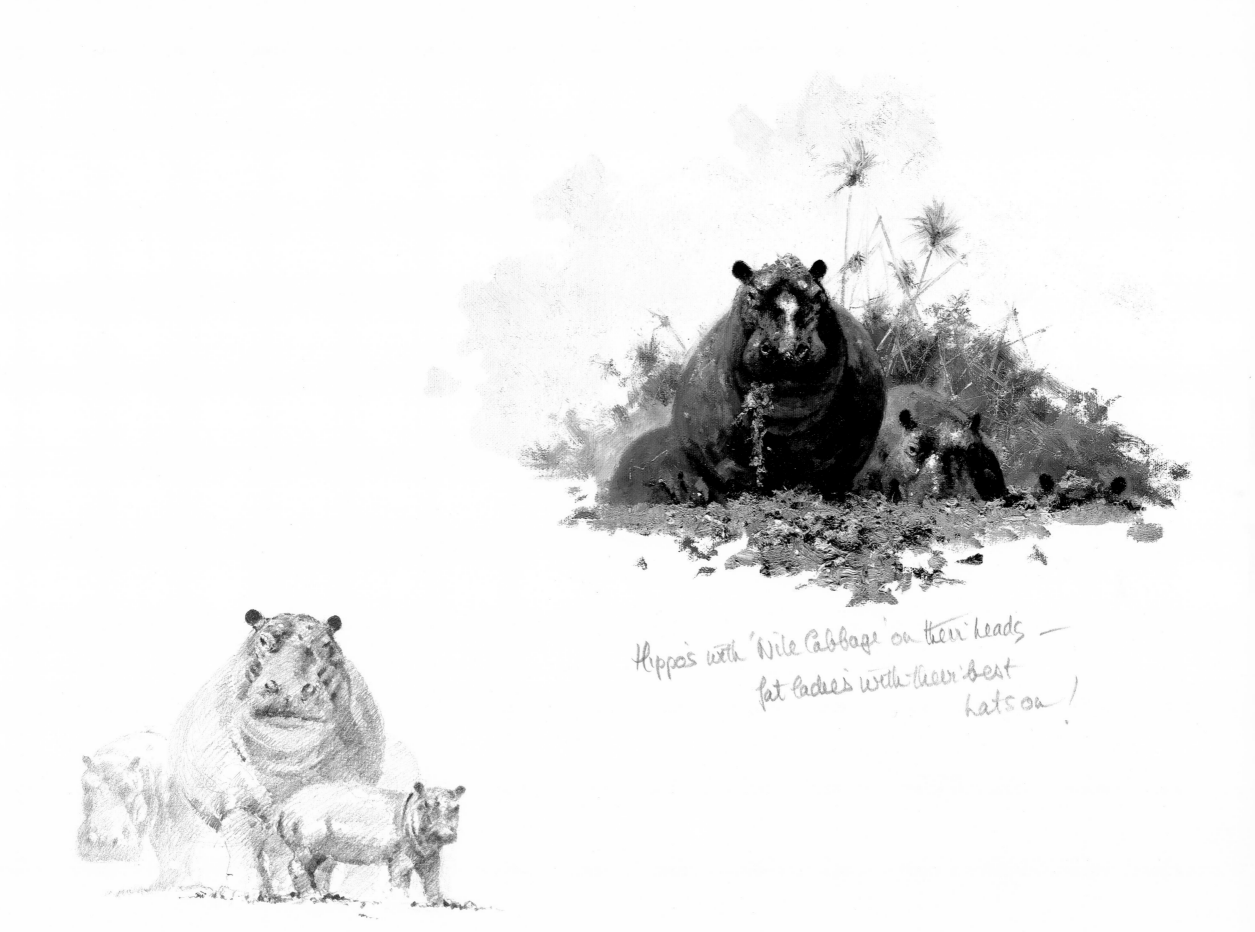

Hippos with 'Nile Cabbage' on their heads —
fat ladies with their best
hats on!

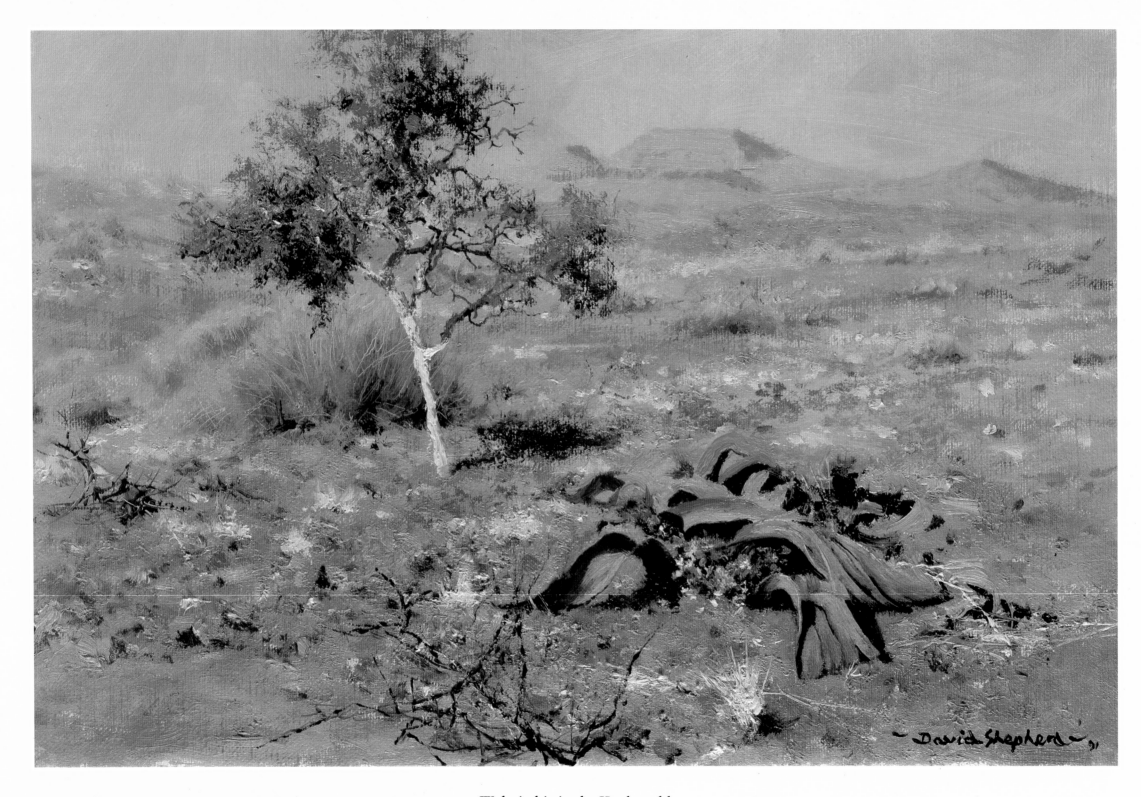

Welwitchia in the Kaokoveld

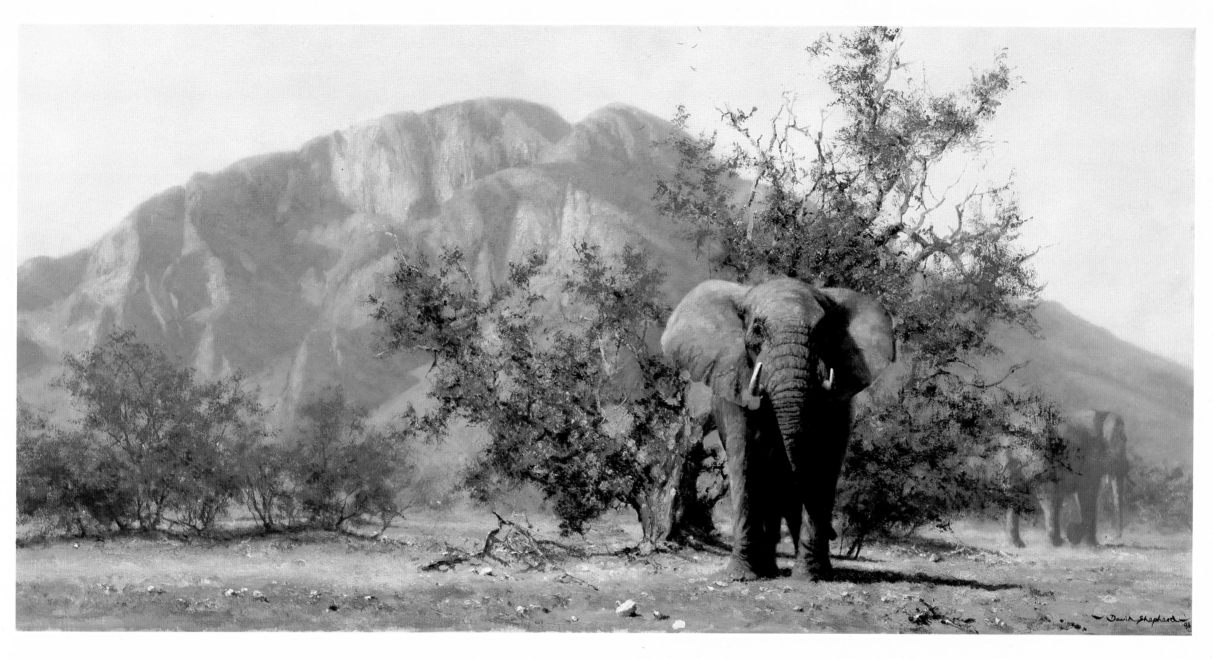

Desert Elephant – the Kaokoveld

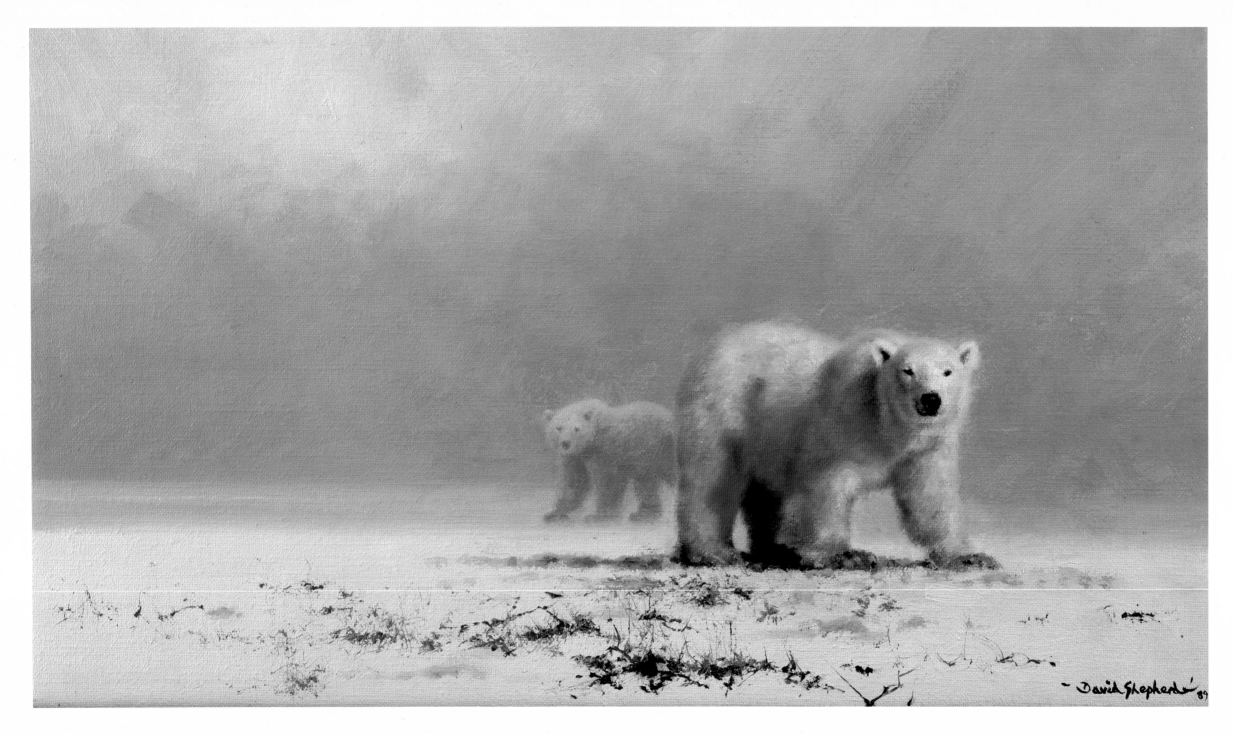

The Cold Arctic

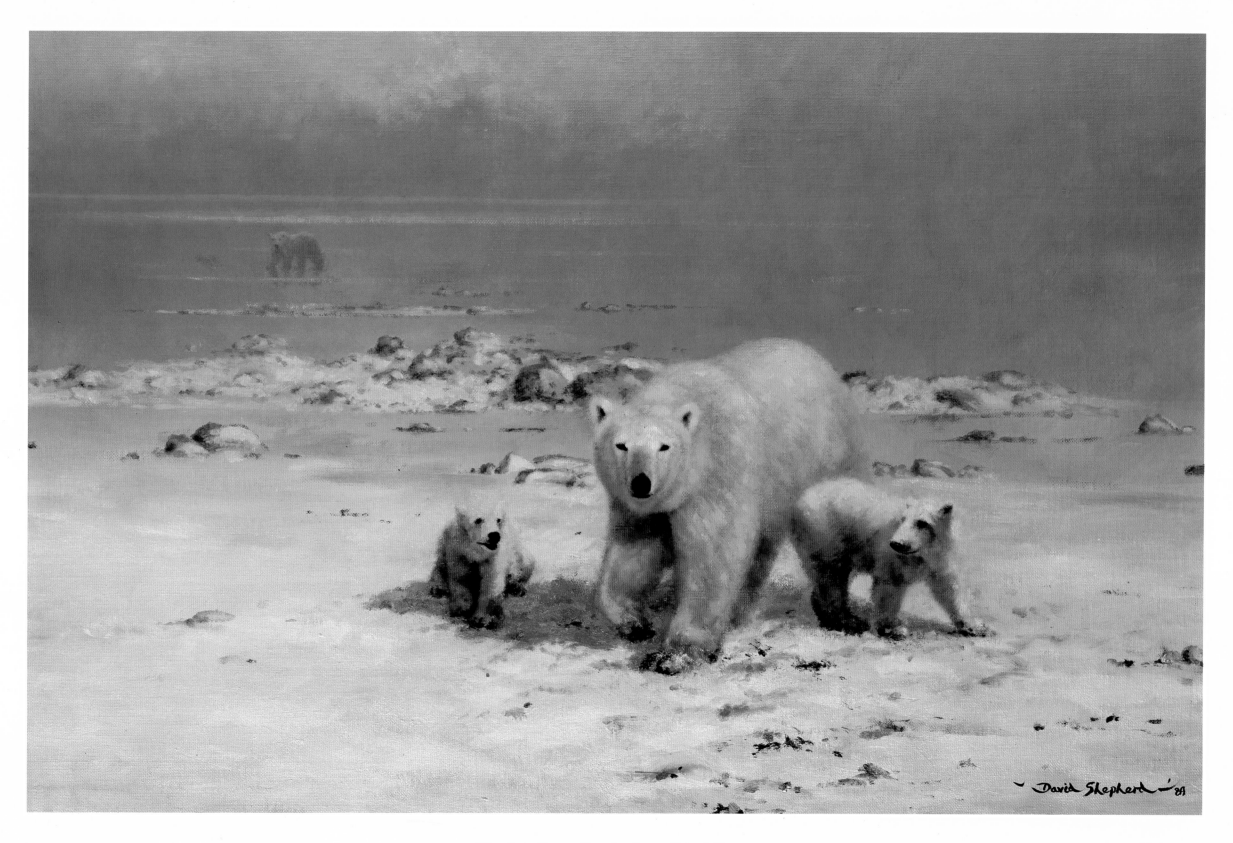

The Sun Came Out for Just a Few Minutes

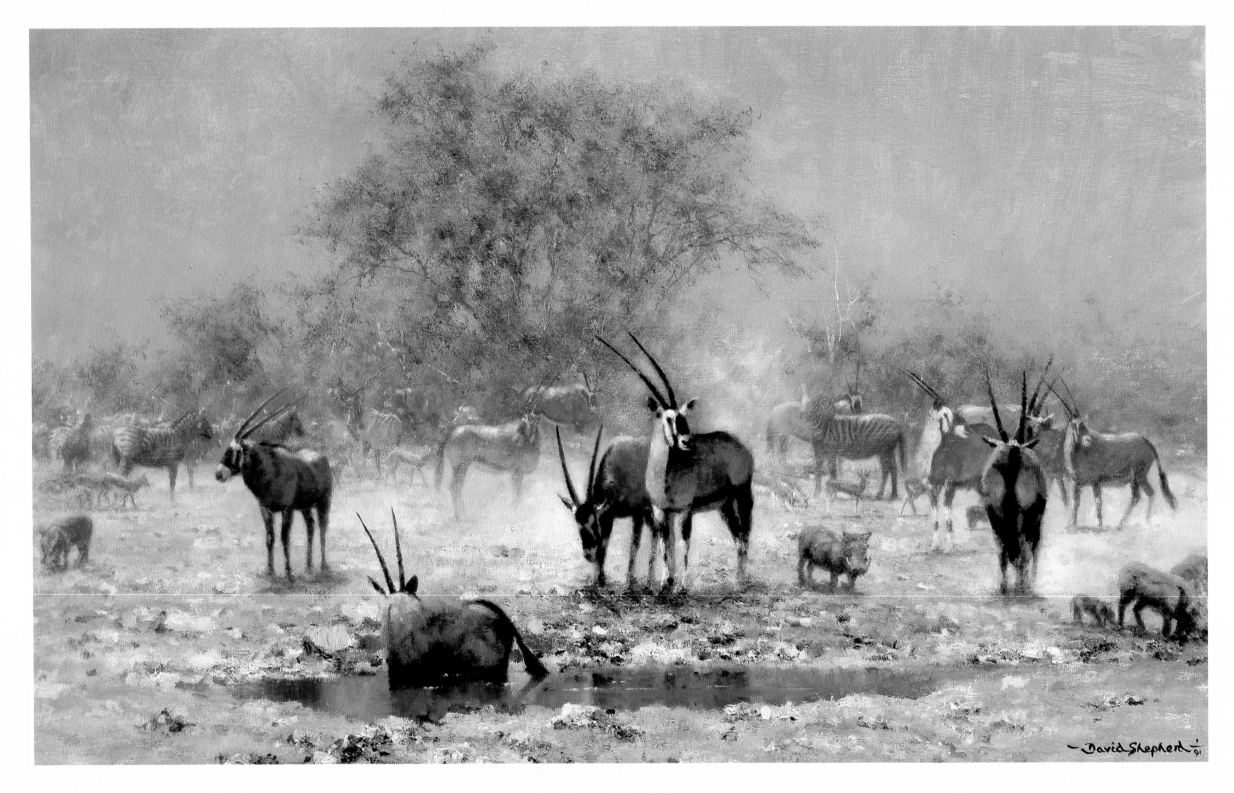

Etosha Waterhole

Etosha in South West A' — marvellous place —
white dust, unique colour sky, purplish blue — masses of wildlife
around the few waterholes
Gemsbok, Kudu, warthogs, Zebra, and Springbok
grey green trees —

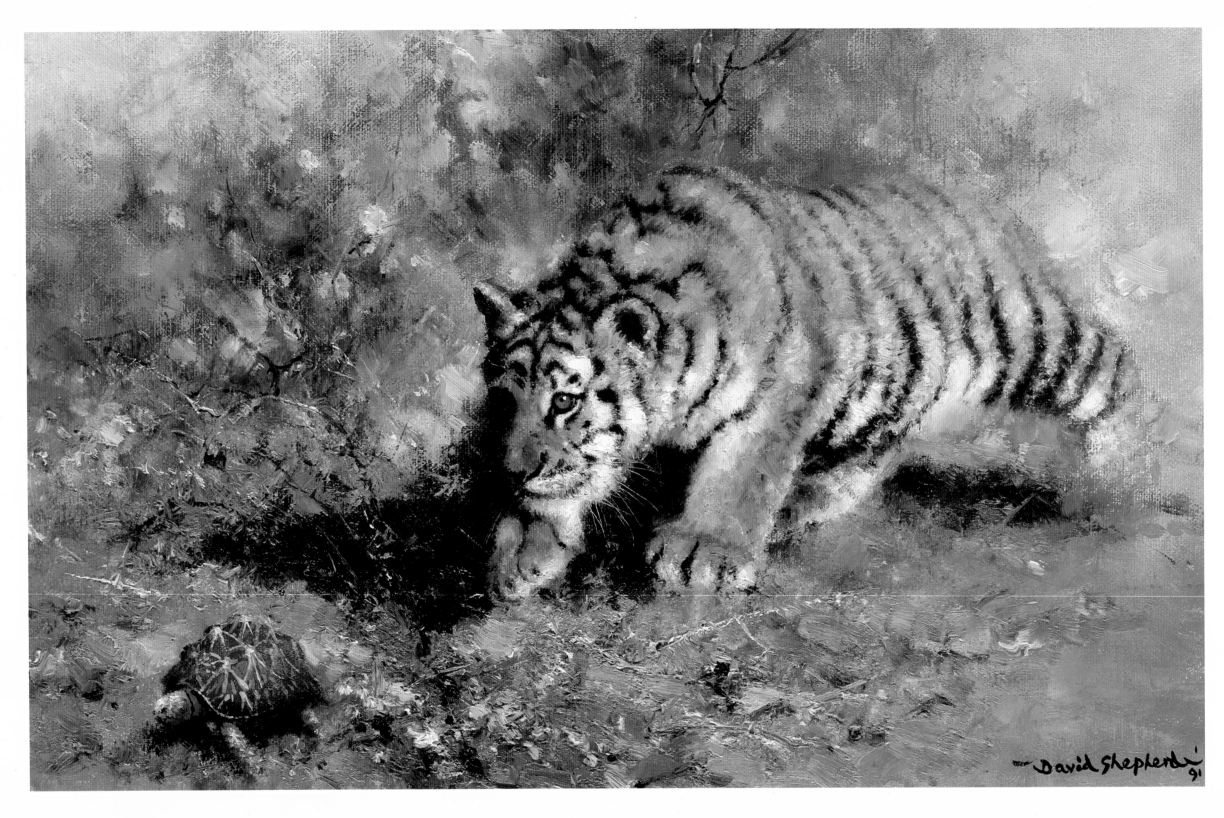

The Tortoise and the Tiger

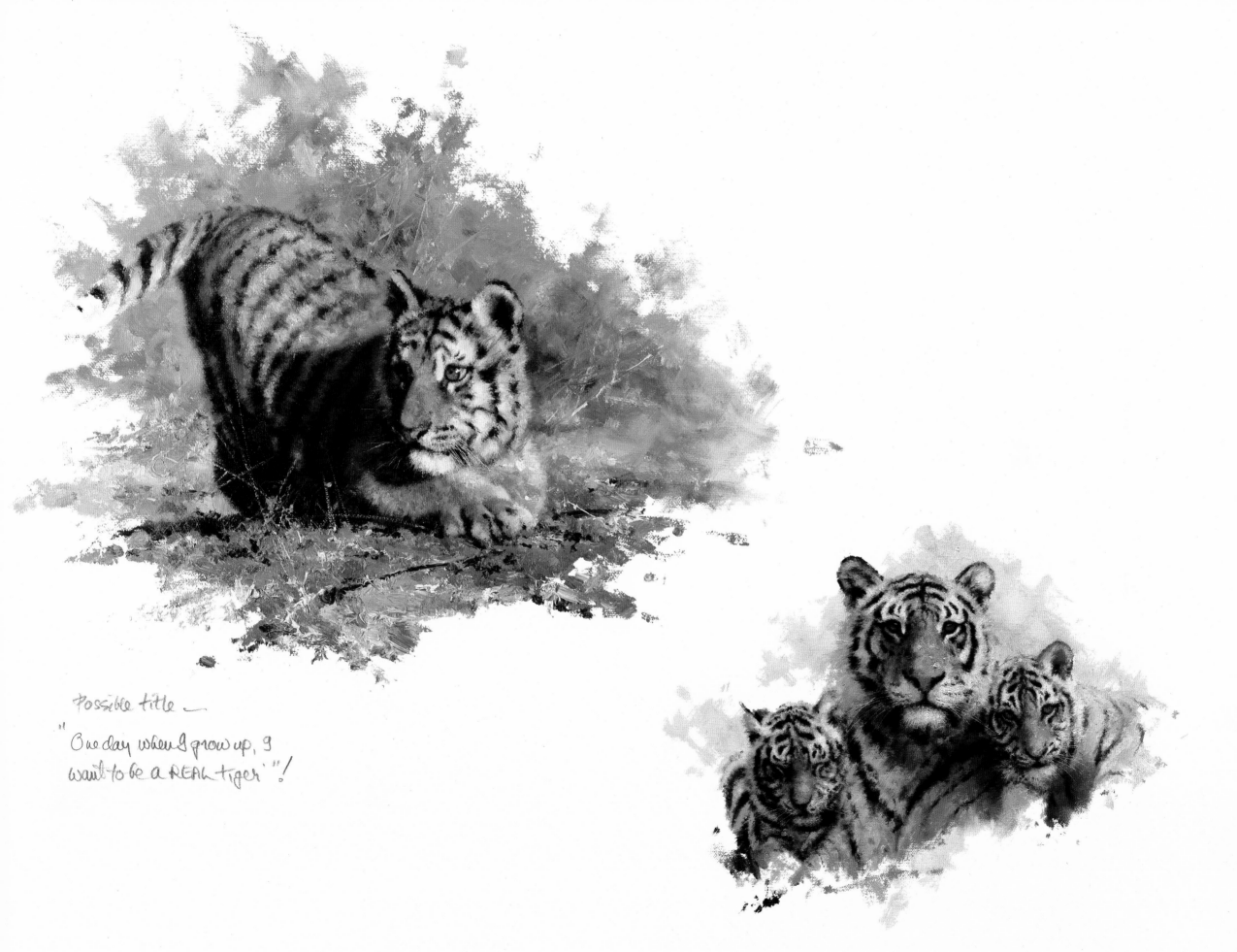

Possible title —

"One day when I grow up, I
want to be a REAL tiger"!

Aloes and the Spitzkop Mountain near Etosha

Some very strange plants in Namibia — no idea
of their names but great shapes to paint

61

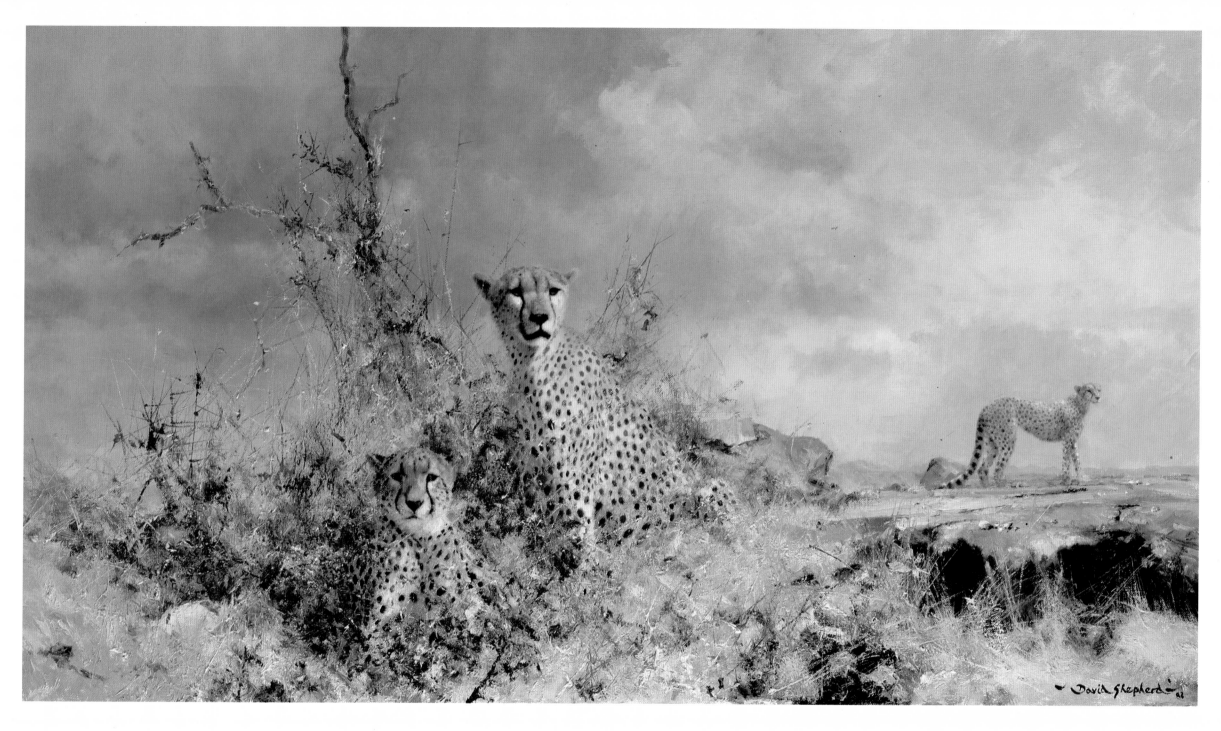

Cheetah

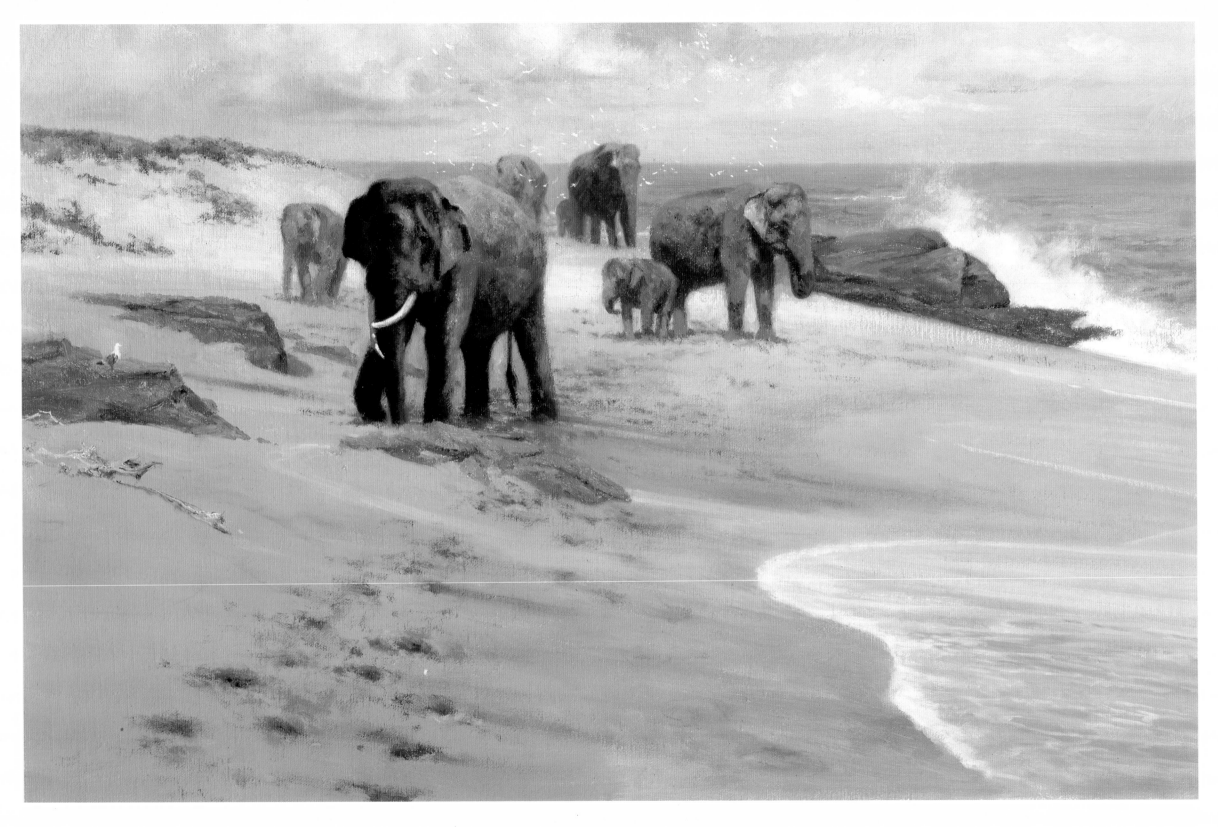

Indian Elephants in the Yala National Park, Sri Lanka

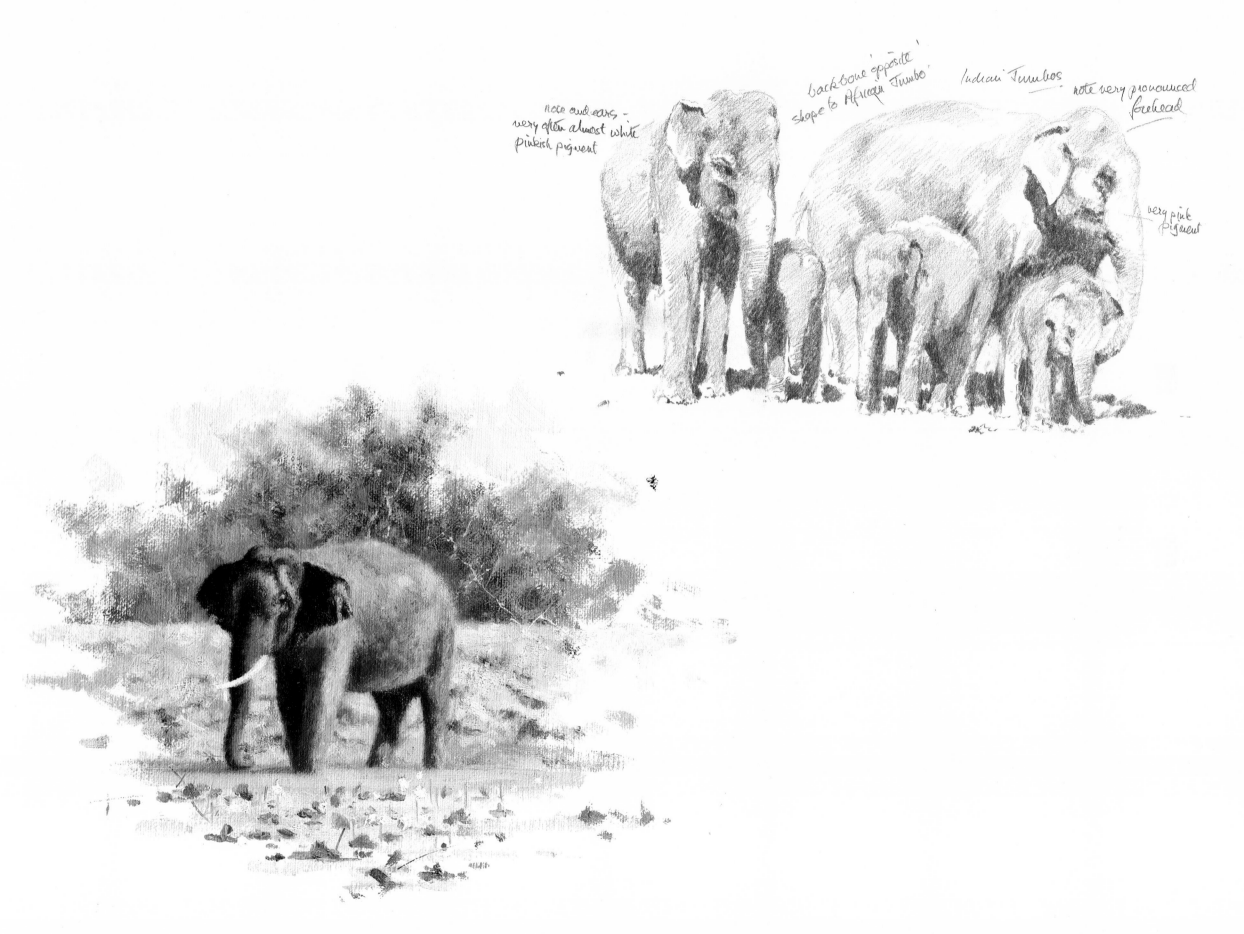

note one ears -
very often almost white
Pinkish pigment

backbone 'opposite'
shape to African Jumbo

Indian Jumbos

note very pronounced
forehead

very pink
Pigment

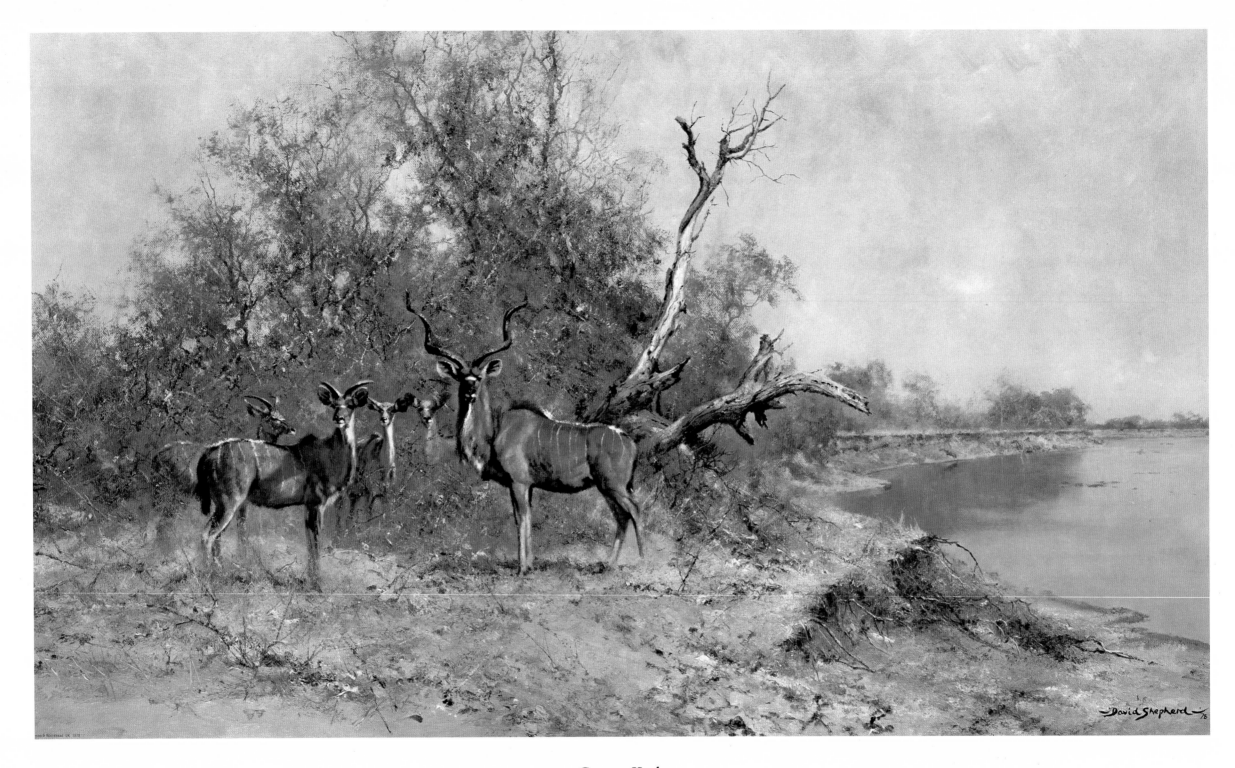

Greater Kudu

Greater Kudu — favourite Antelope —
Luangwa Valley particularly good
v. green 'Nile' Cabbage — good contrast to
silvery brown colours of Kudu

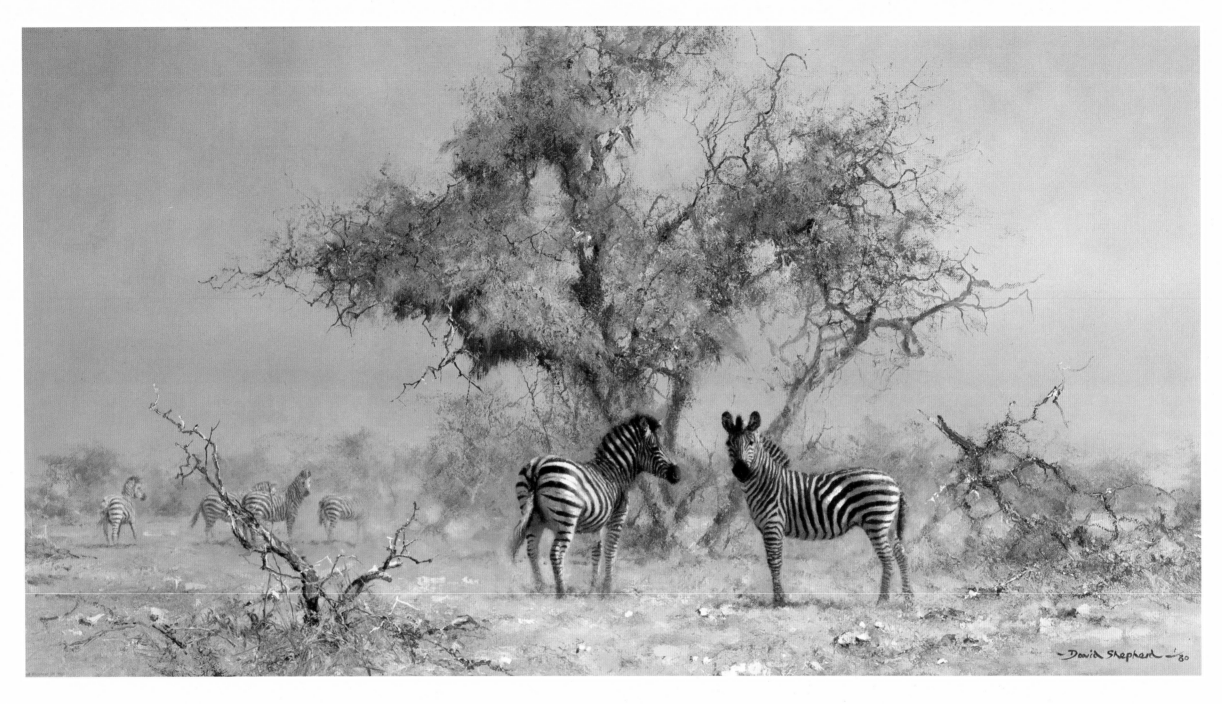

Zebra and Colony Weavers

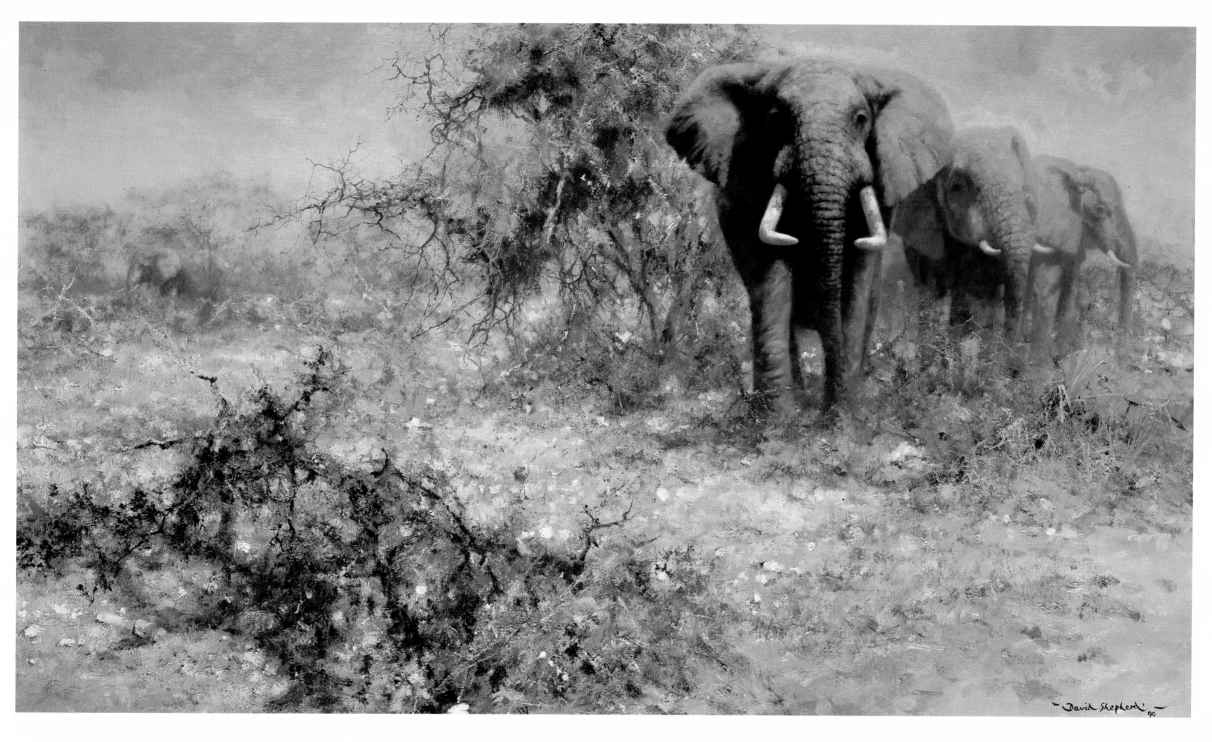

Elephants in the Etosha National Park

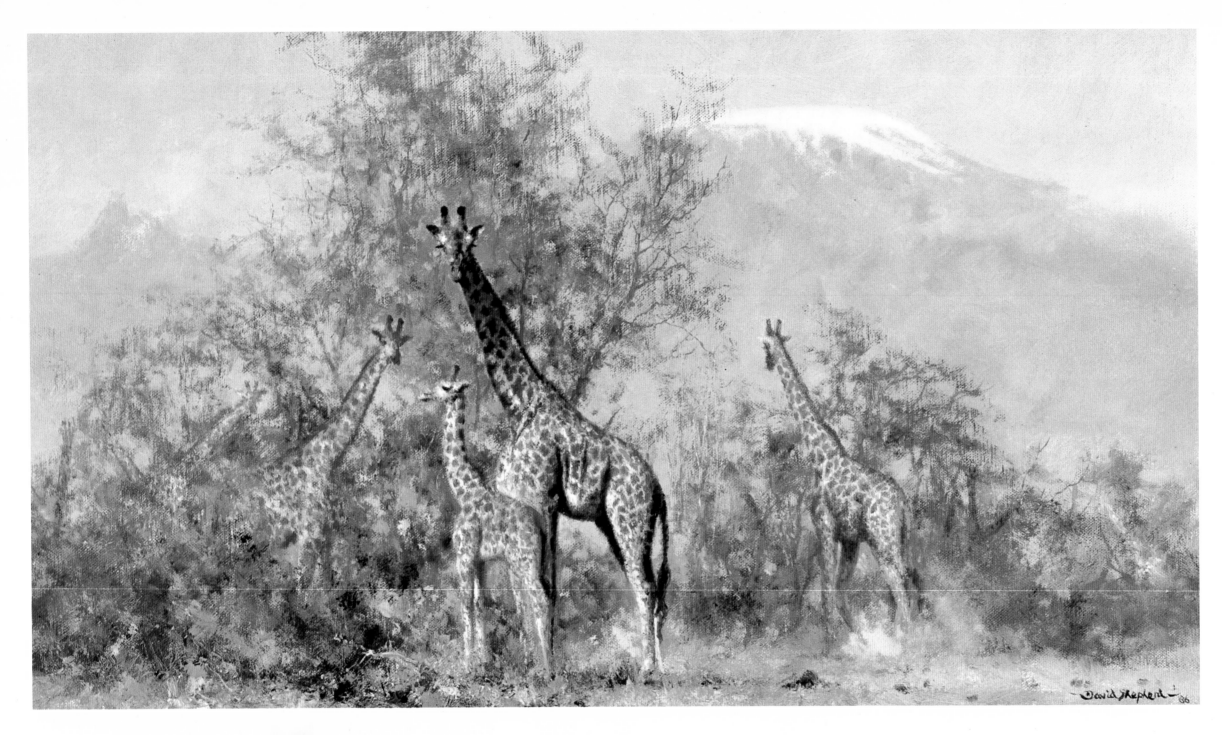

High and Mighty

Reticulated

'masai

two different species ?! —
can't tell the difference half the time

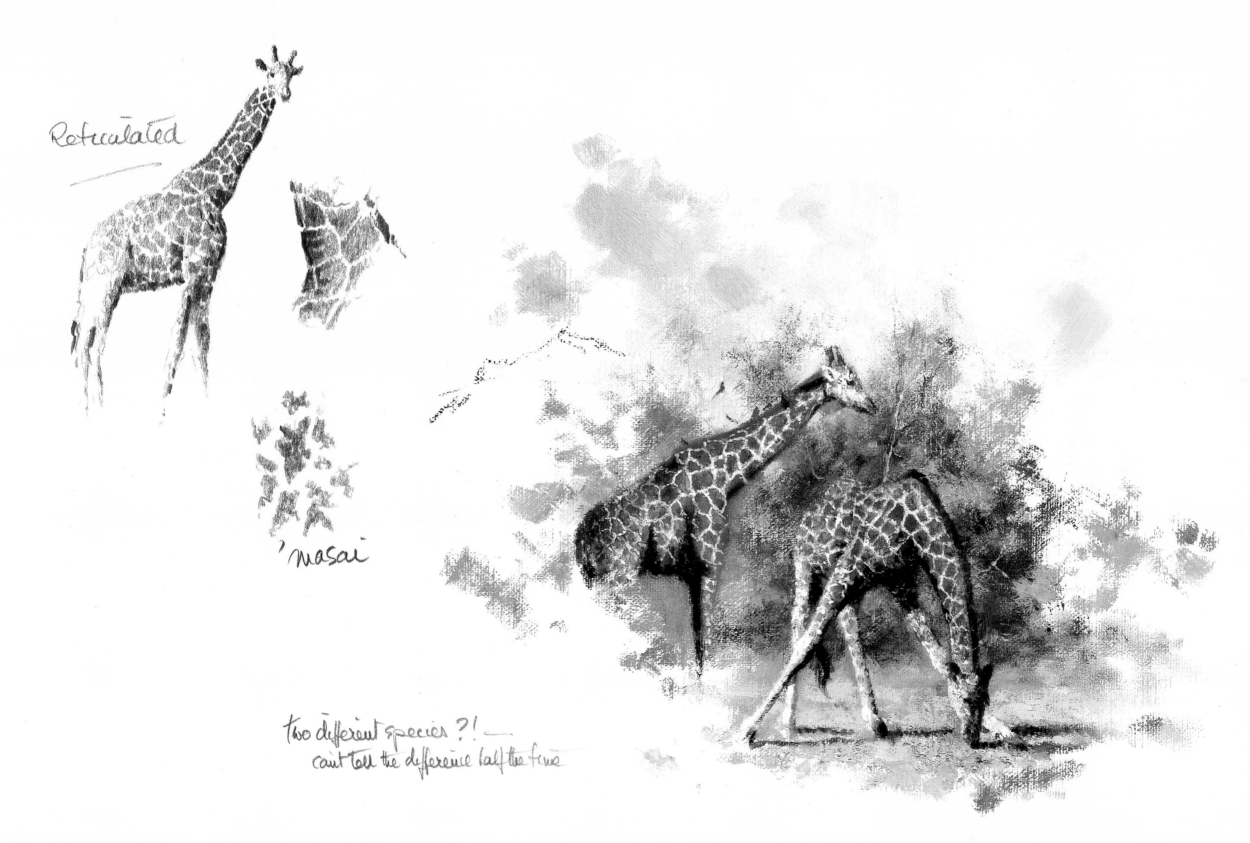

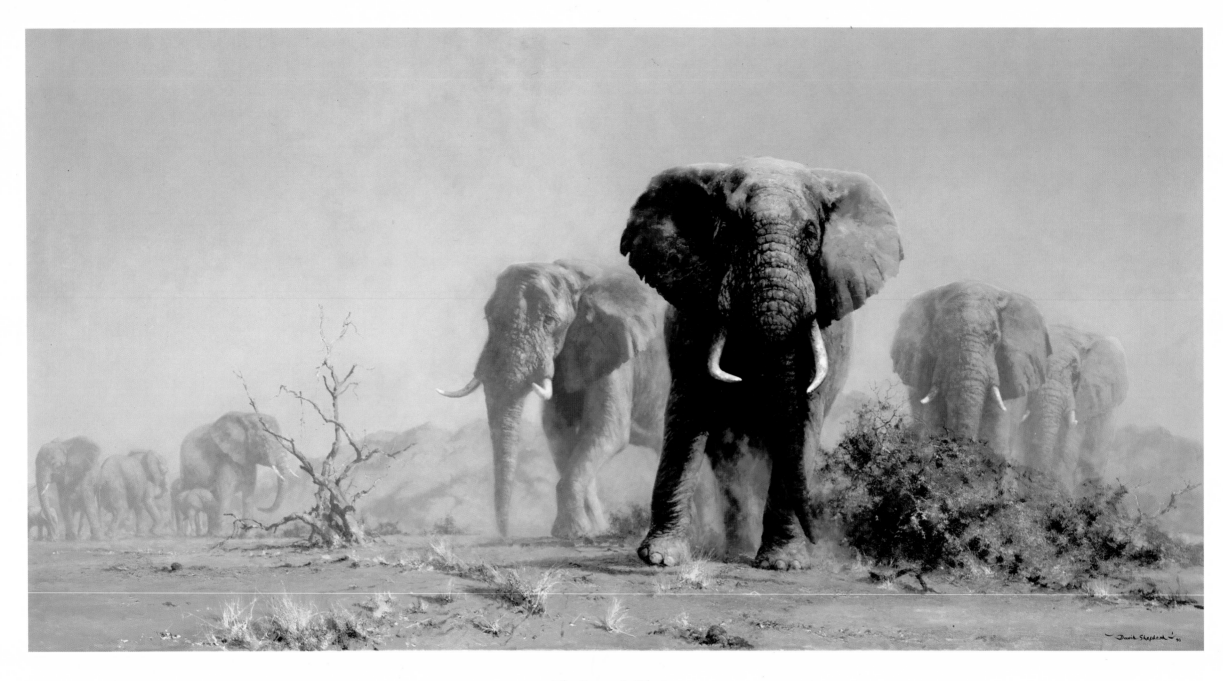

The Ivory is Theirs

Faint warm
dust – yellow ochre?

cool blue beads

very warm
evening light

Sky translucent Cerulean
blue down to dusty orange-yellow

but nte
light just
catching fold

shadow of dusk
across trunk

push back

distant hills v. purple
in shadows

very dusty
here

very dusty
all over

spiky

vivid green

push
into distance

spiky dead tree

strong shadows

Gold grass tufts

grey sand on gold.

Final Sketch for 'Ivory is Theirs'

shadows HOT
orange
but shadows of grass blue

73

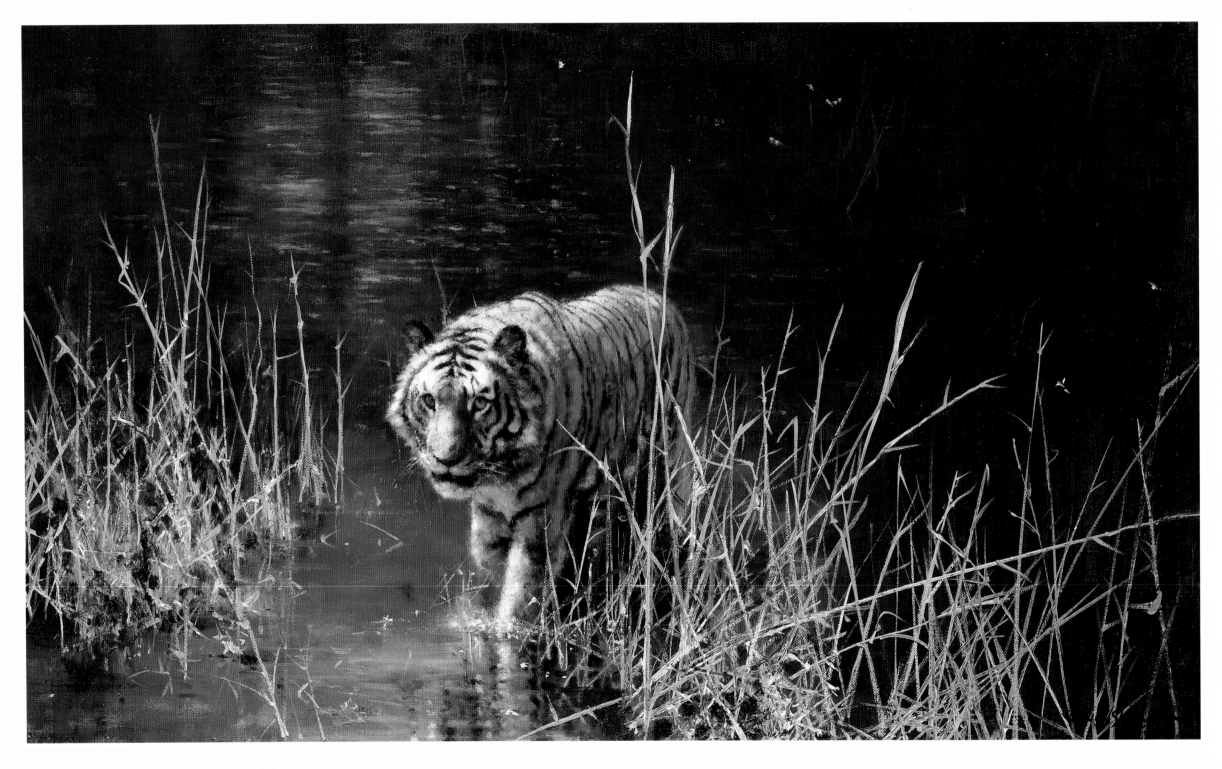

Jungle Gentleman

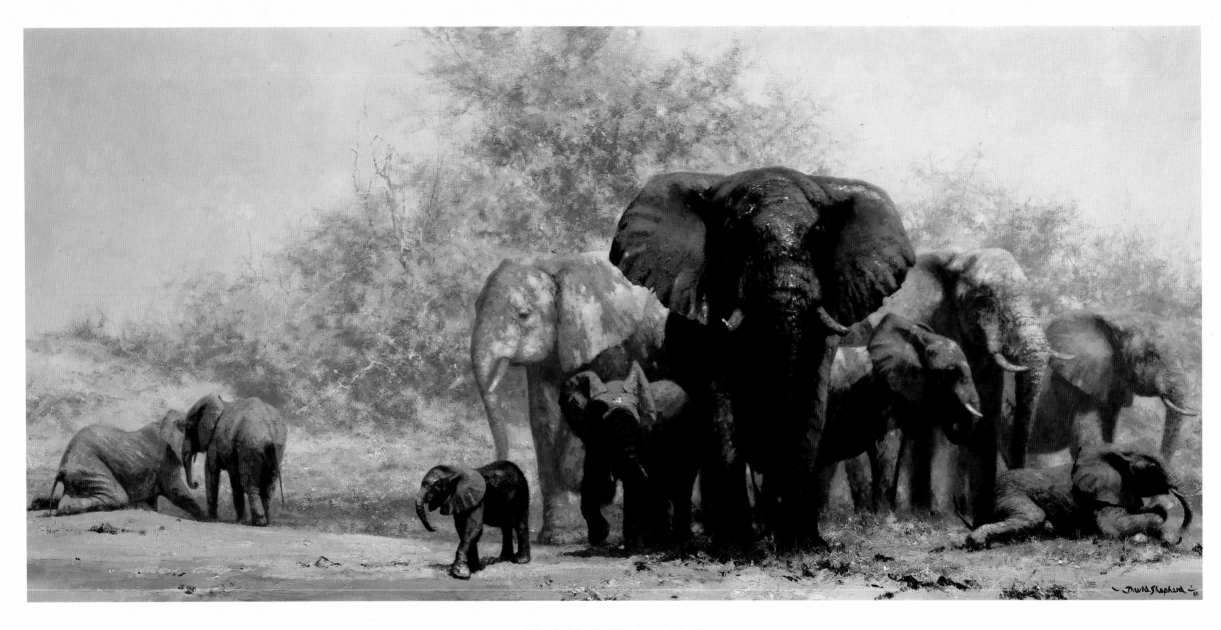

Mud, Mud, Glorious Mud

tuskless cow and 'tatty ear' with single tusk —
two of the 'President's Herd' in Zimbabwe.
They frightened the daylights out of me !

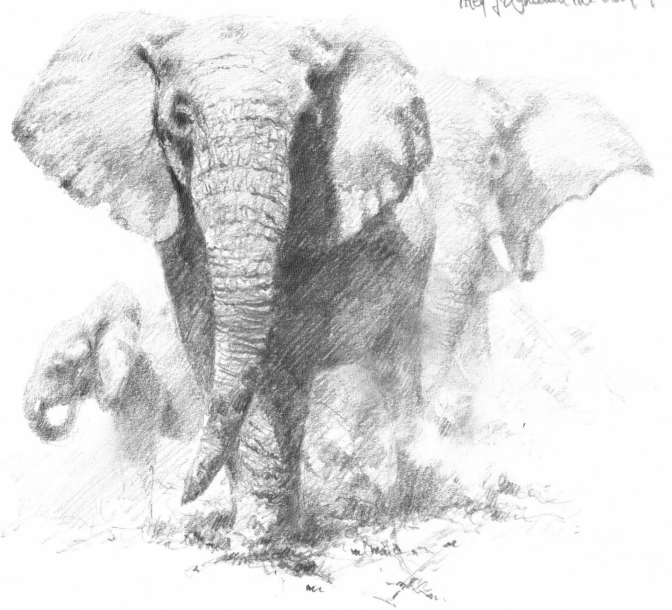

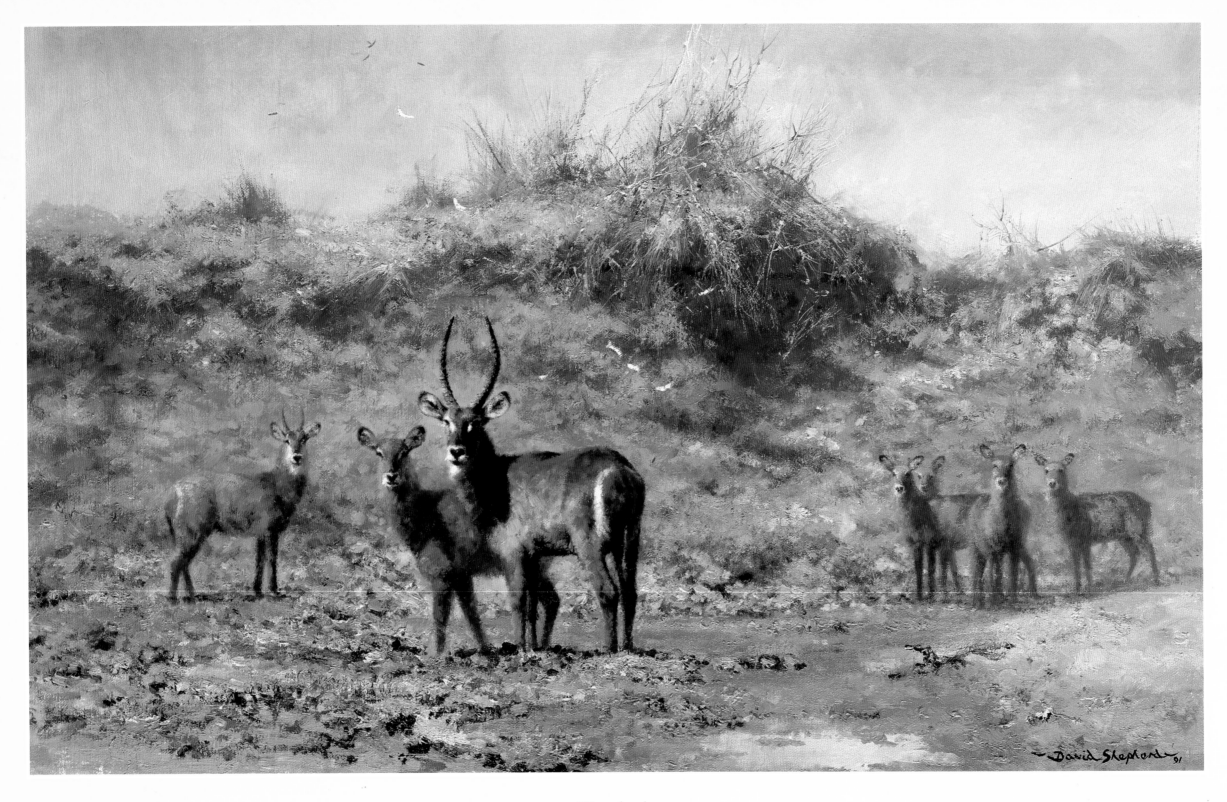

Waterbuck

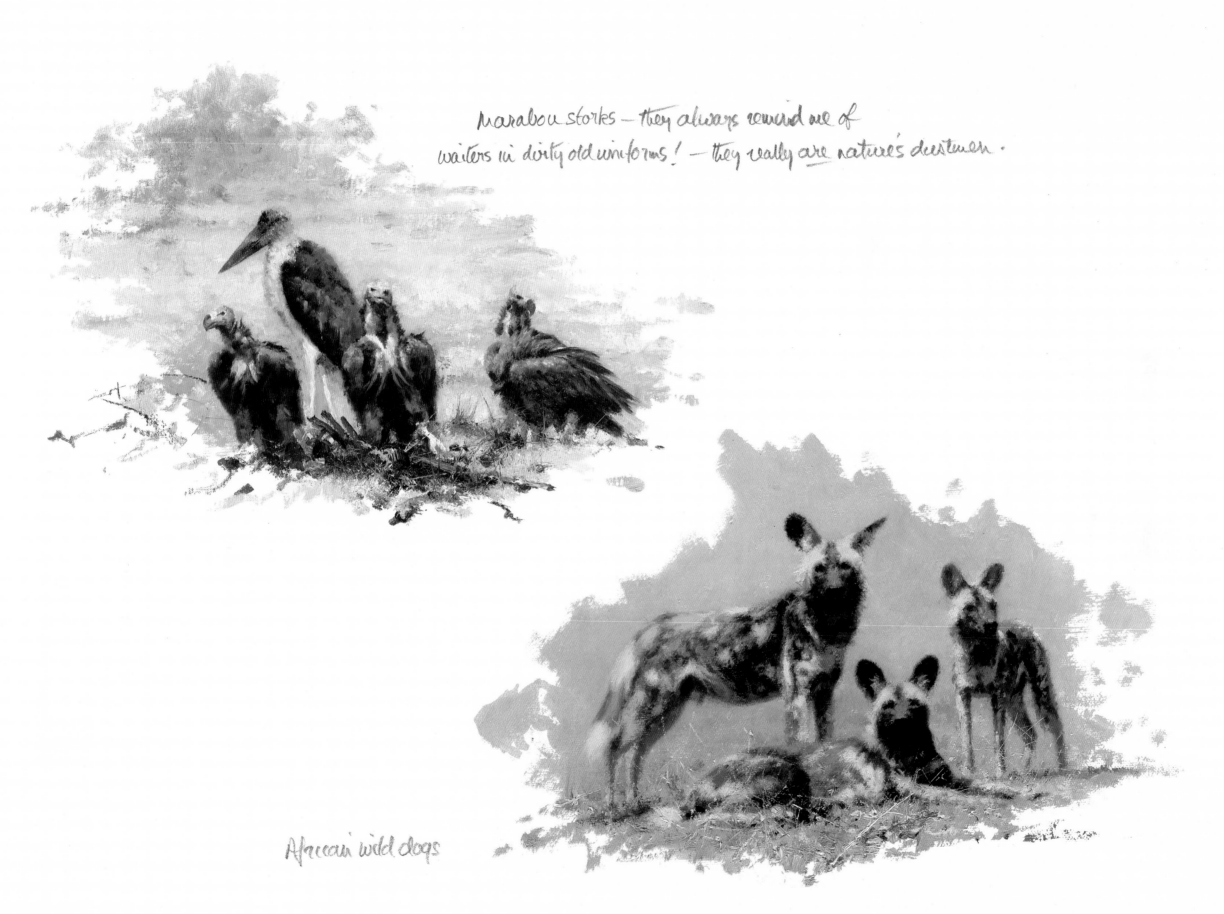

Marabou storks — they always remind me of
waiters in dirty old uniforms! — they really are nature's dustmen.

African wild dogs

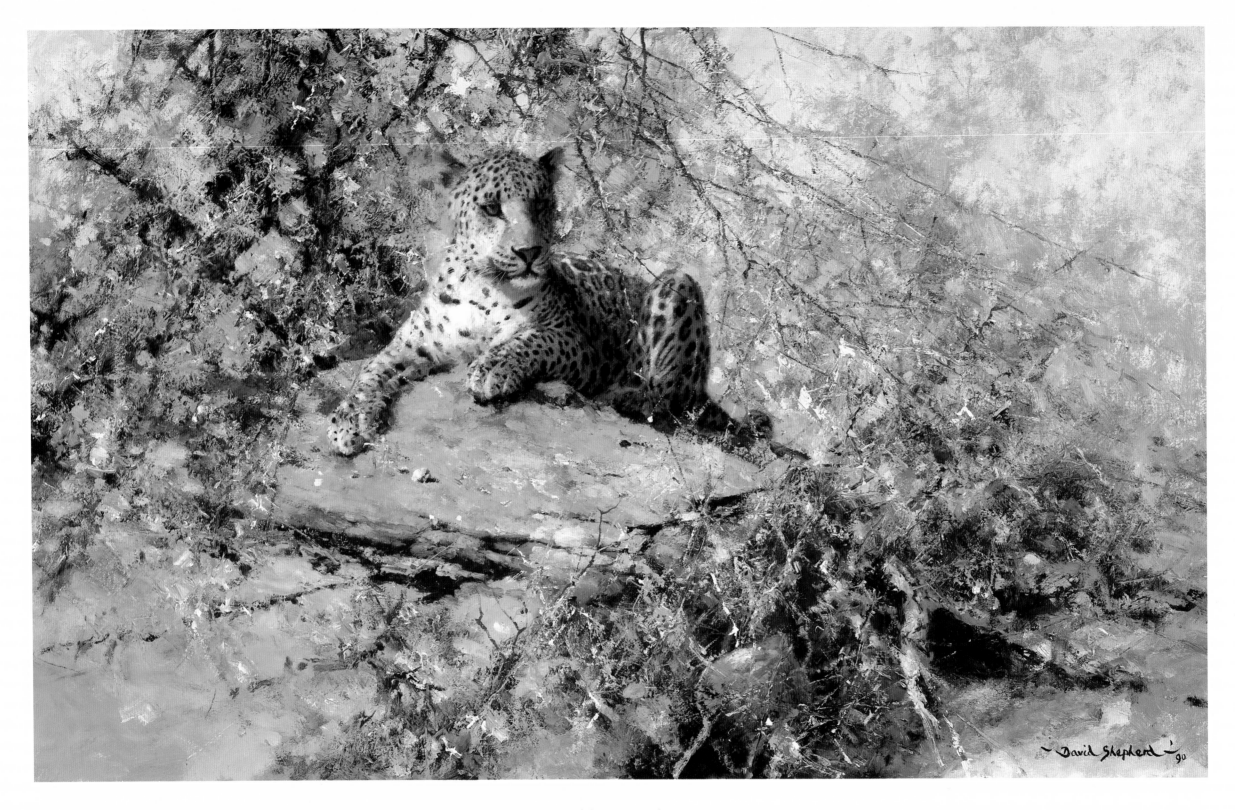

The Sentinel

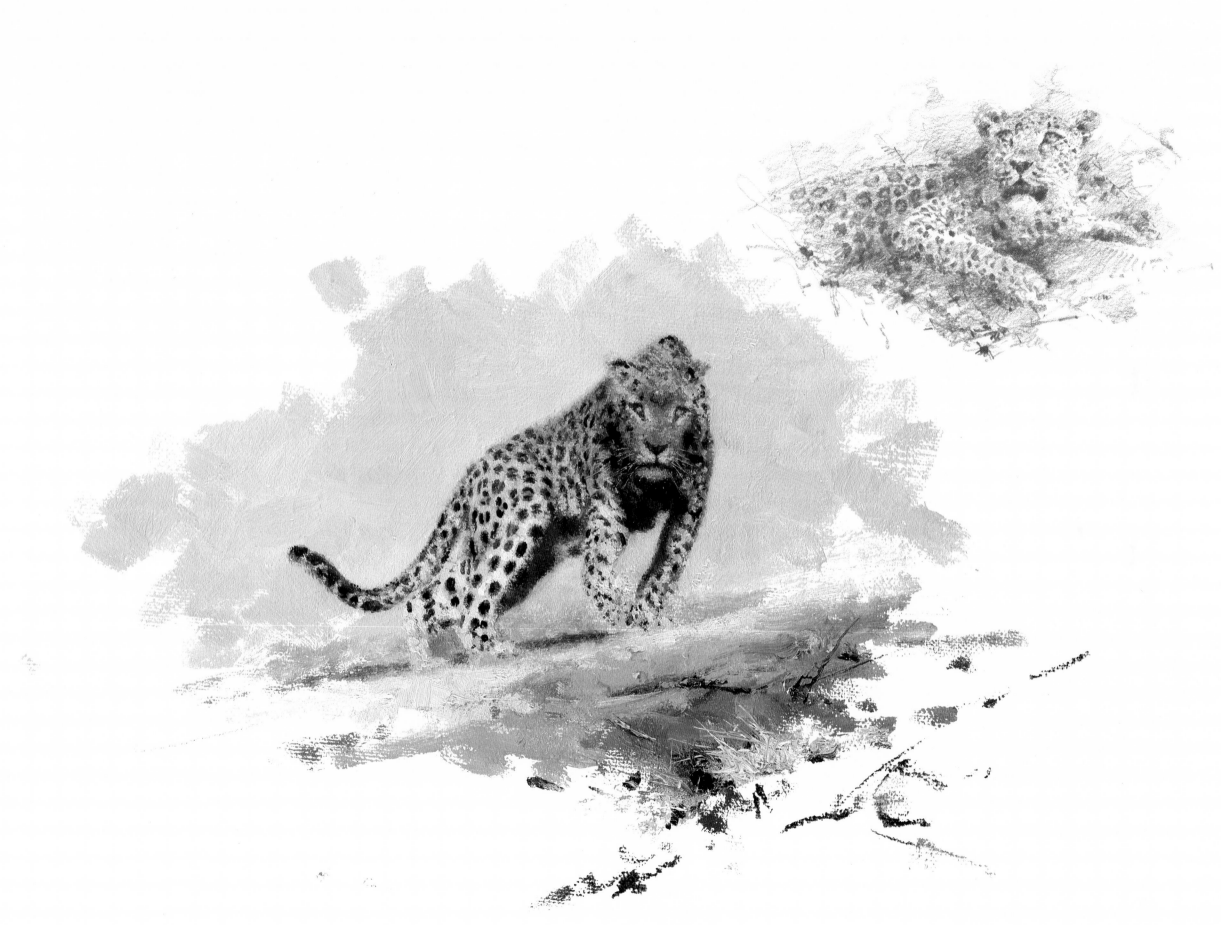

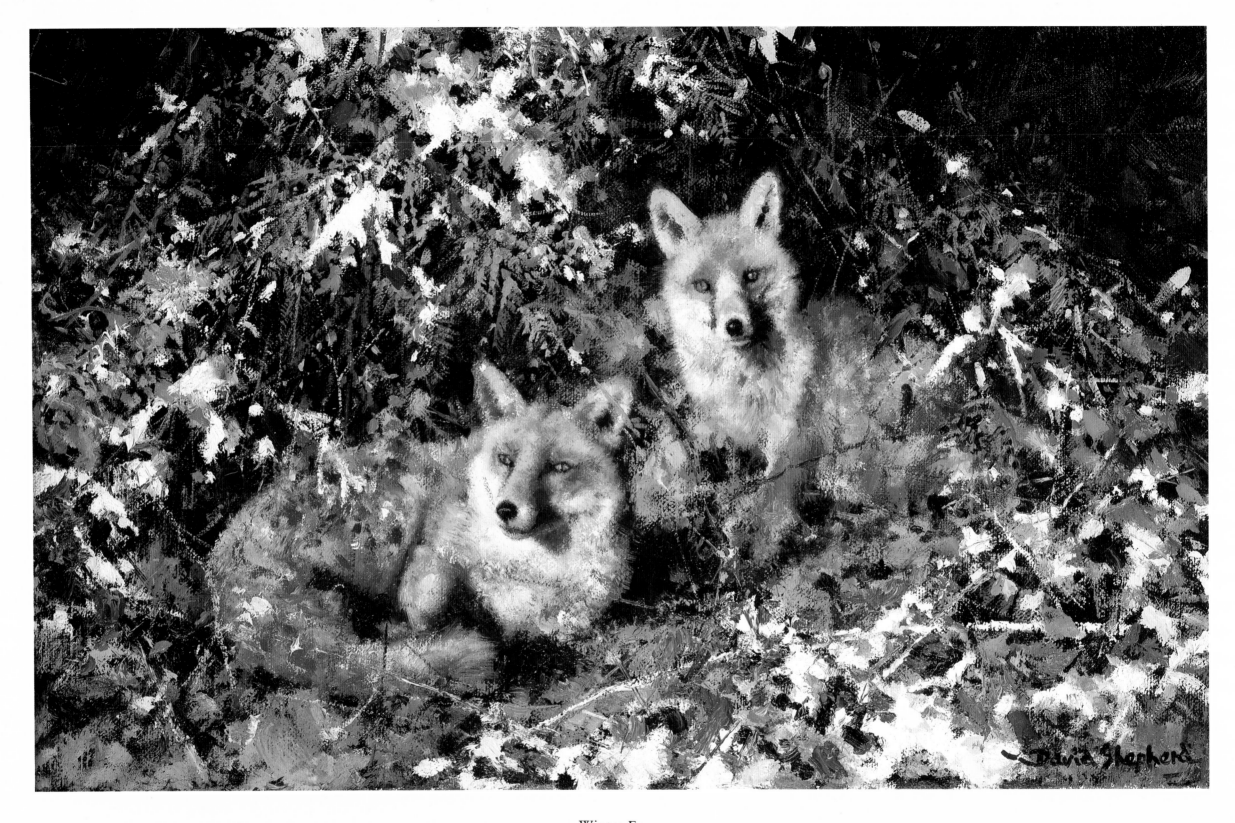

Winter Foxes

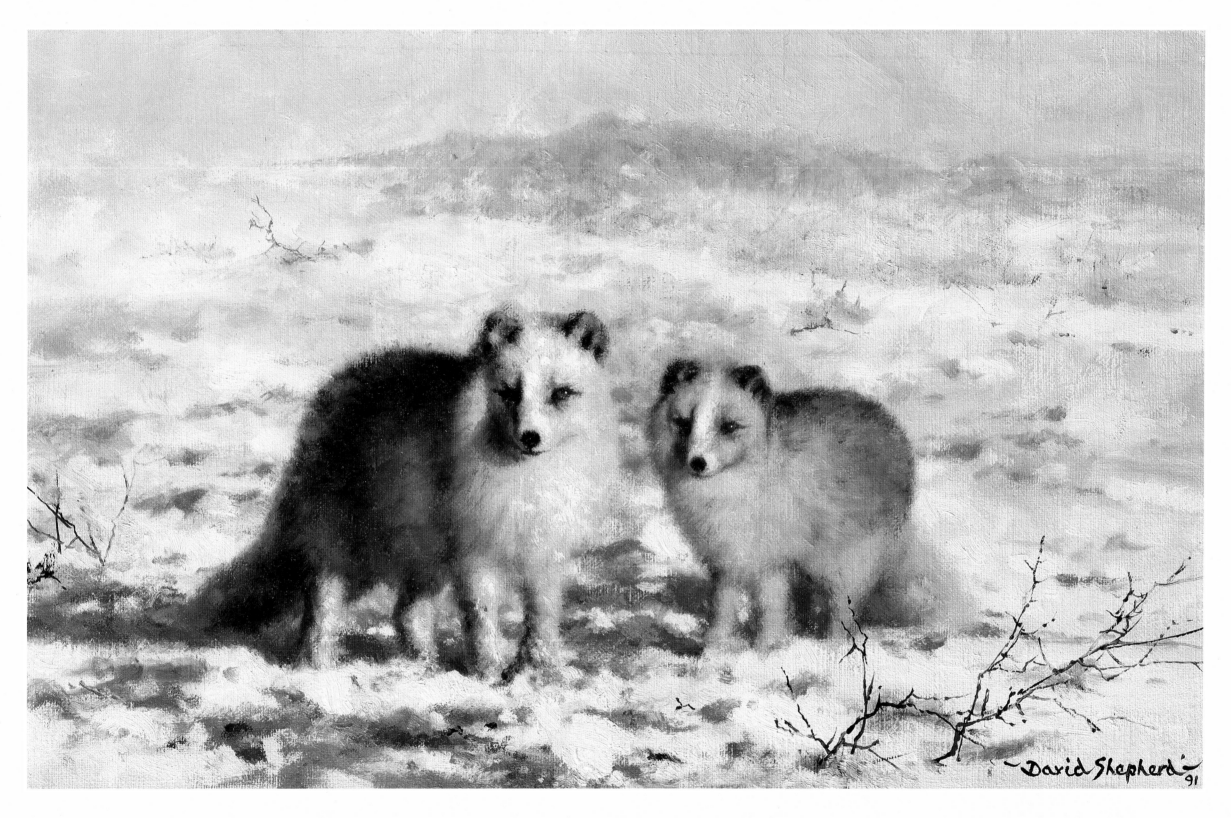

Arctic Foxes

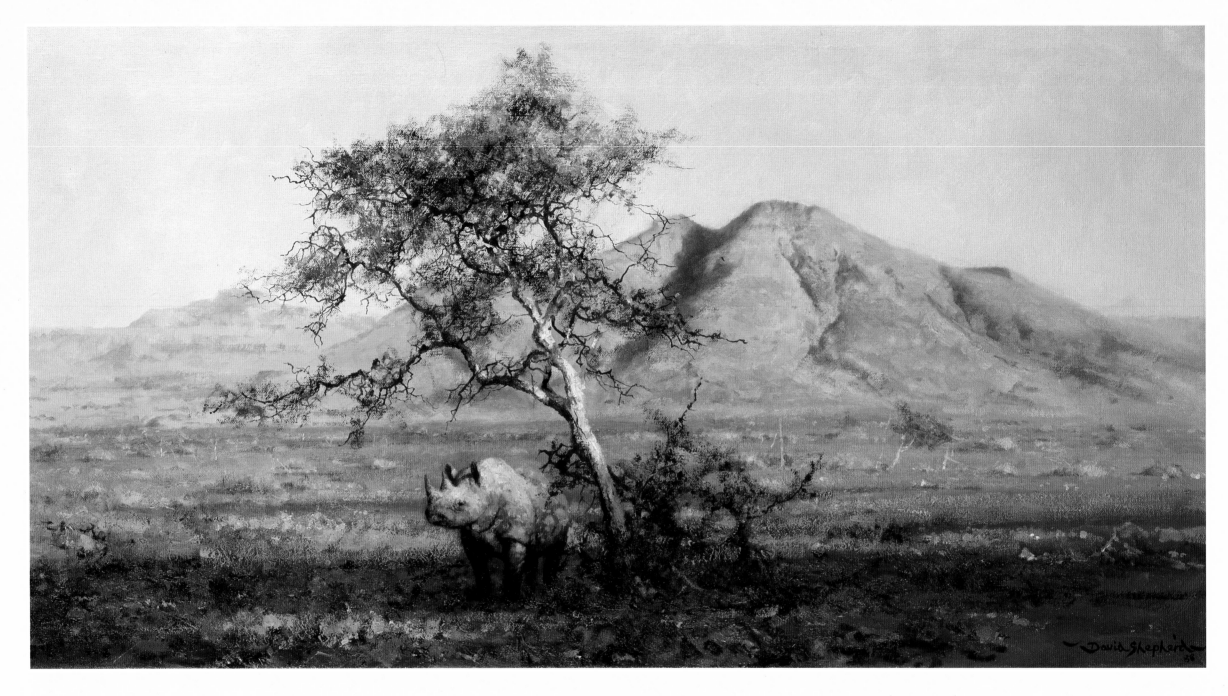

Evening in the Kaokoveld

Kaokoveld —
vast expance of nothingness, empty!

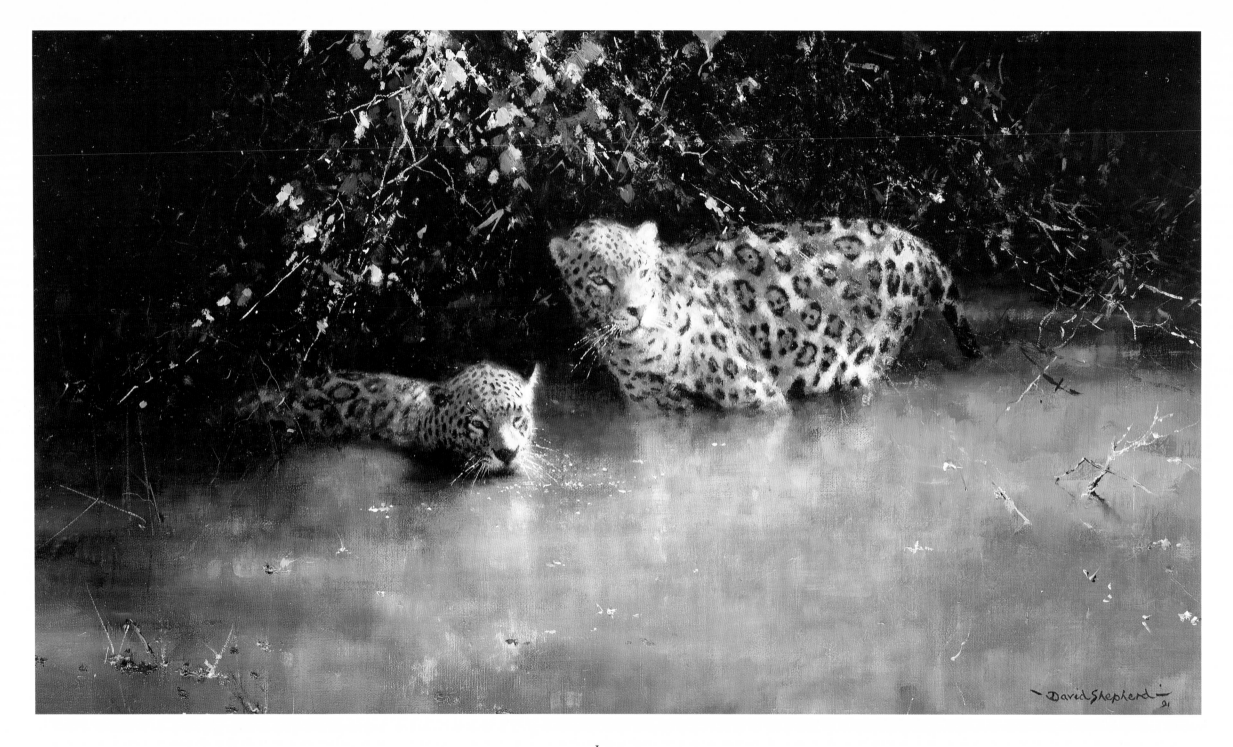

Jaguars

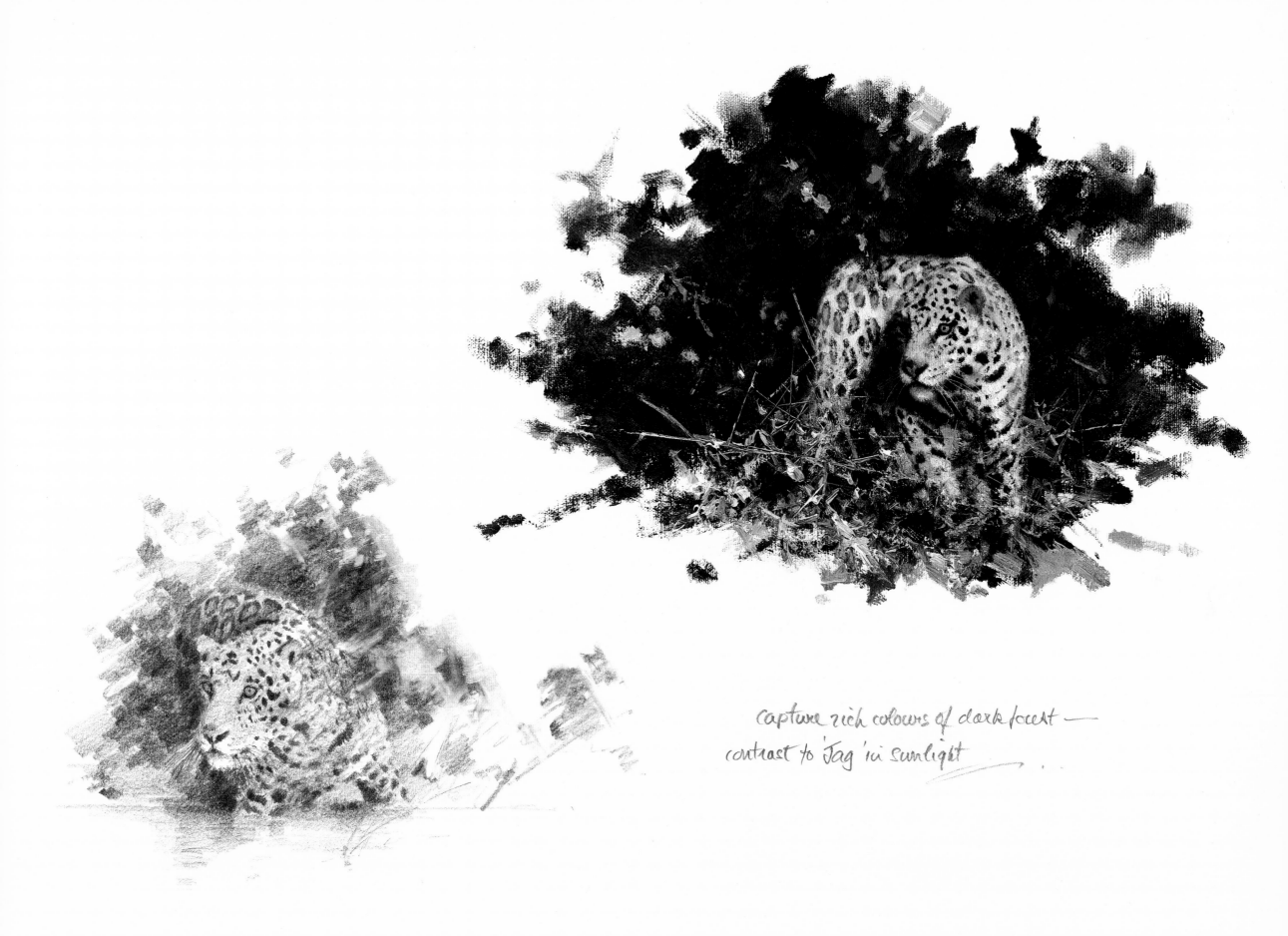

capture rich colours of dark forest —
contrast to 'Jag' in sunlight —

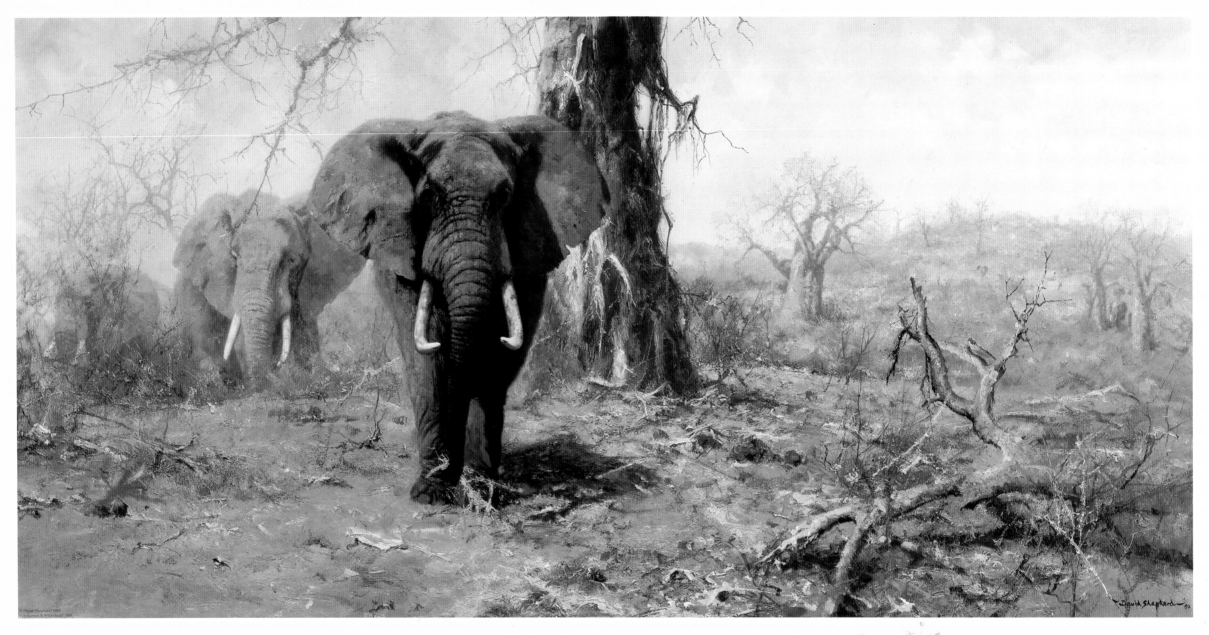

The Elephant and the Baobab

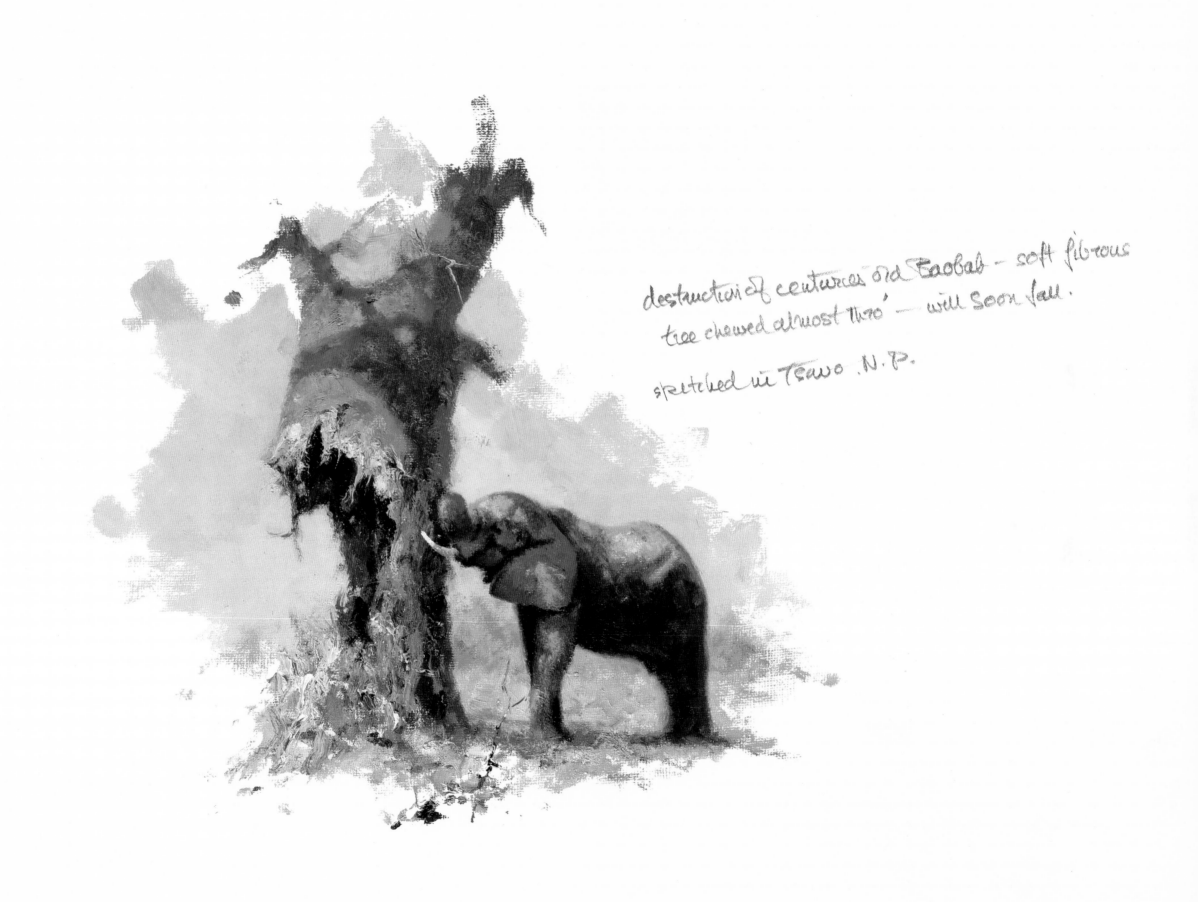

destruction of centuries old Baobab — soft fibrous
tree chewed almost thro' — will soon fall.

sketched in Tsavo. N.P.

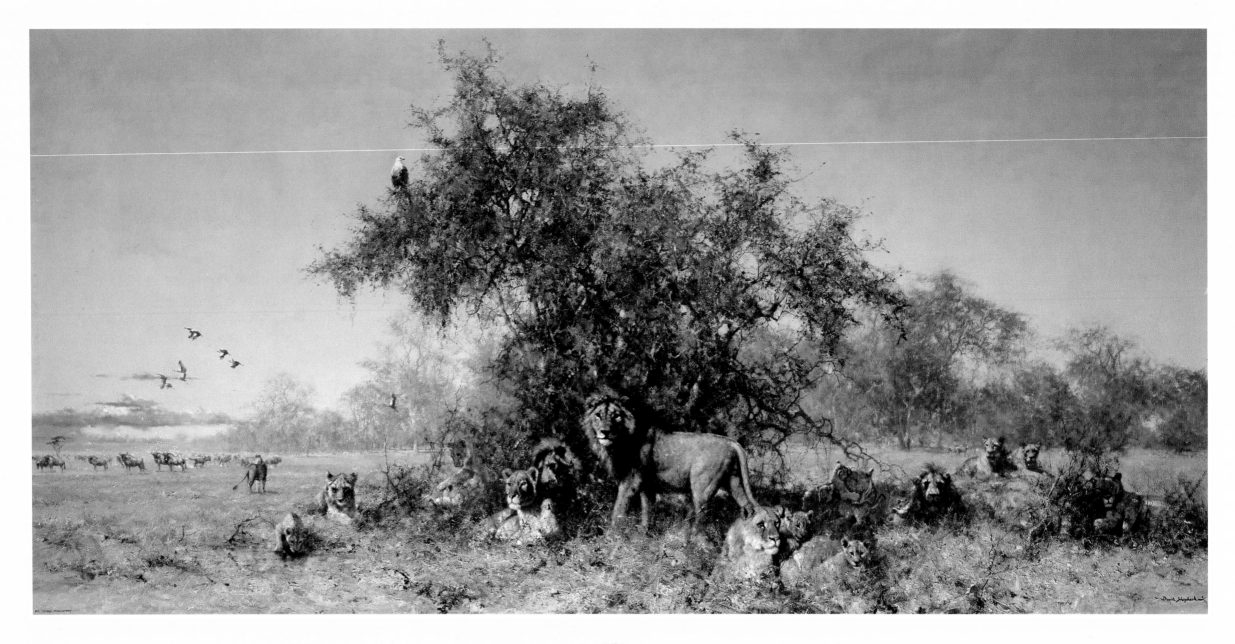

Africa

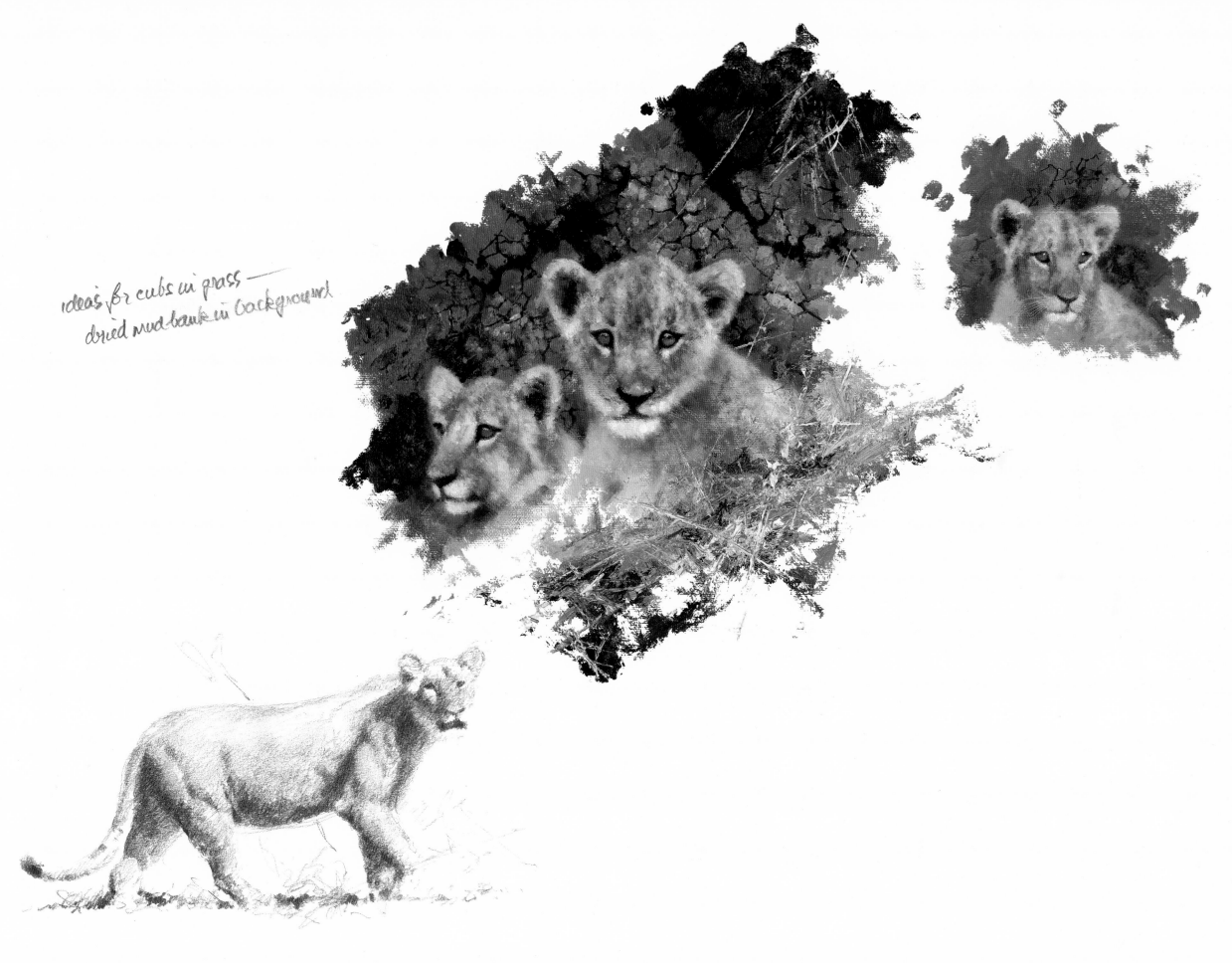

ideas for cubs in grass —
dried mud bank in background

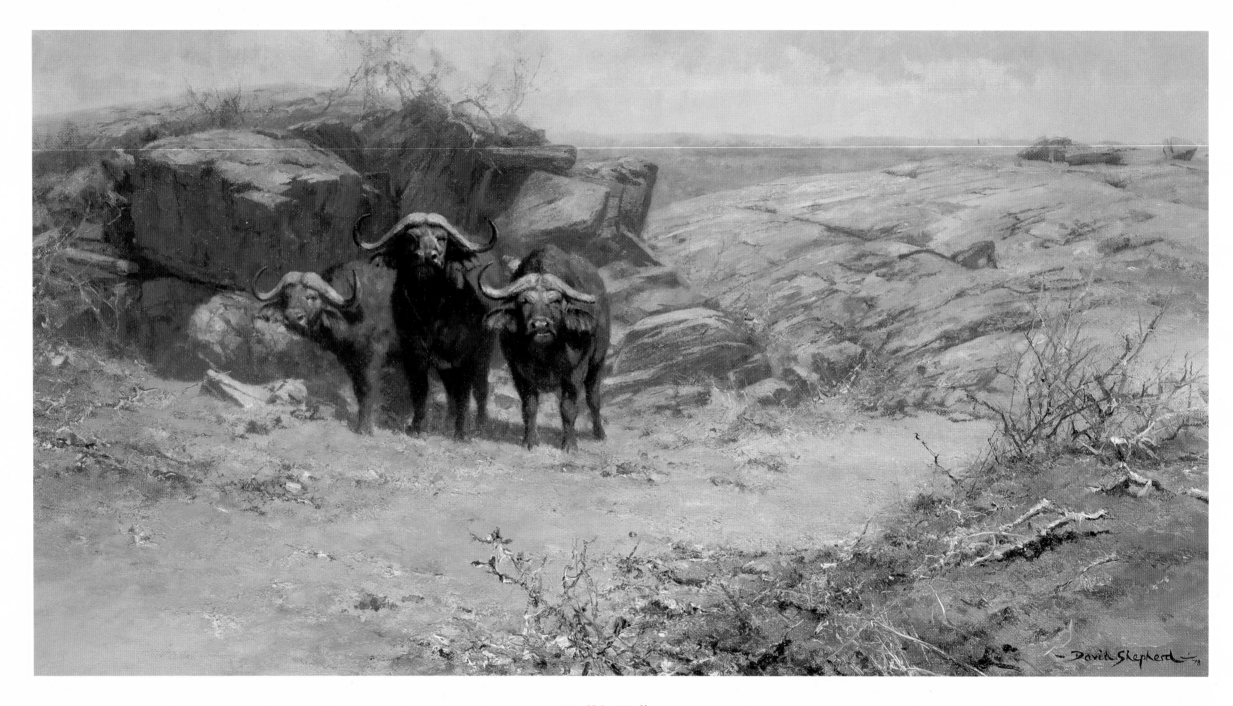

Buffalo Wallows

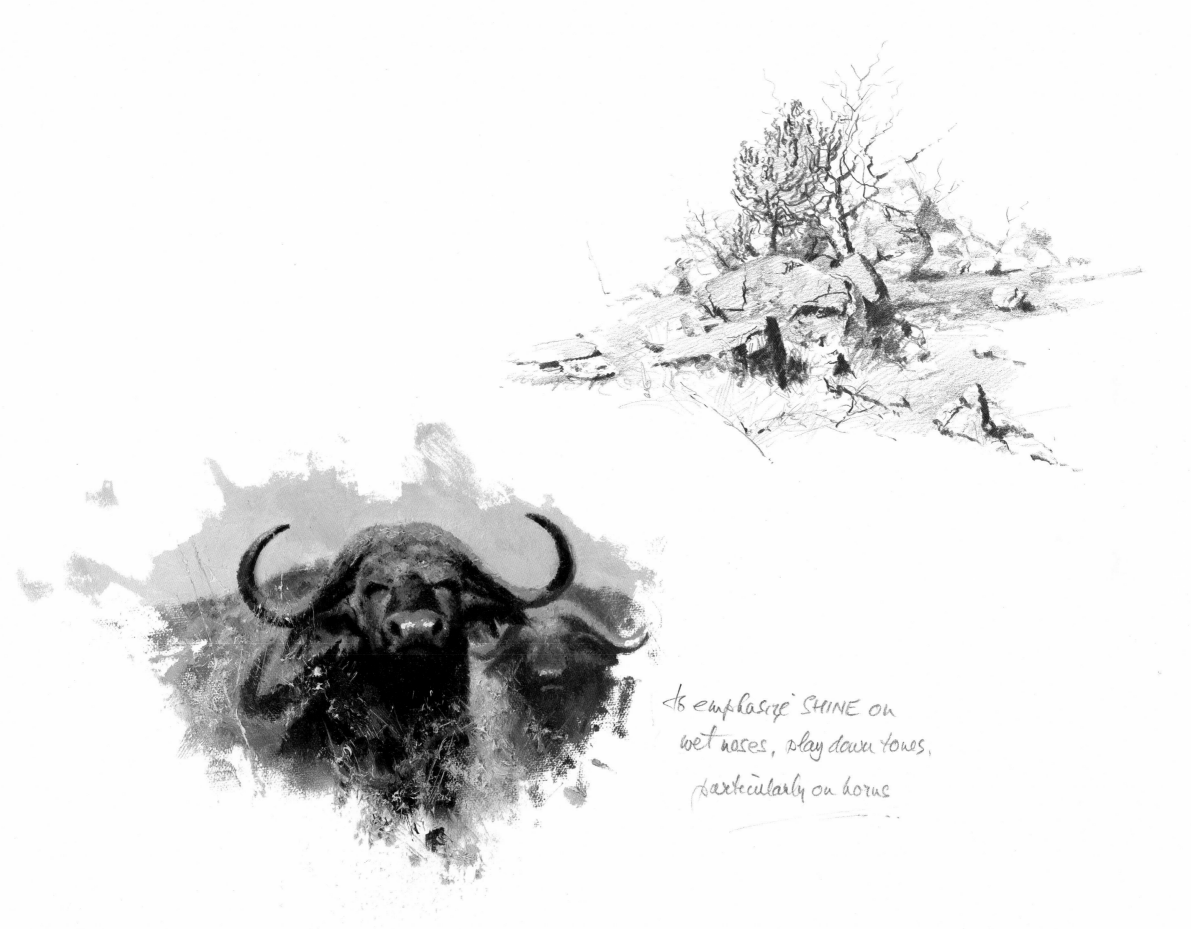

to emphasise SHINE on
wet noses, play down tones,
particularly on horns

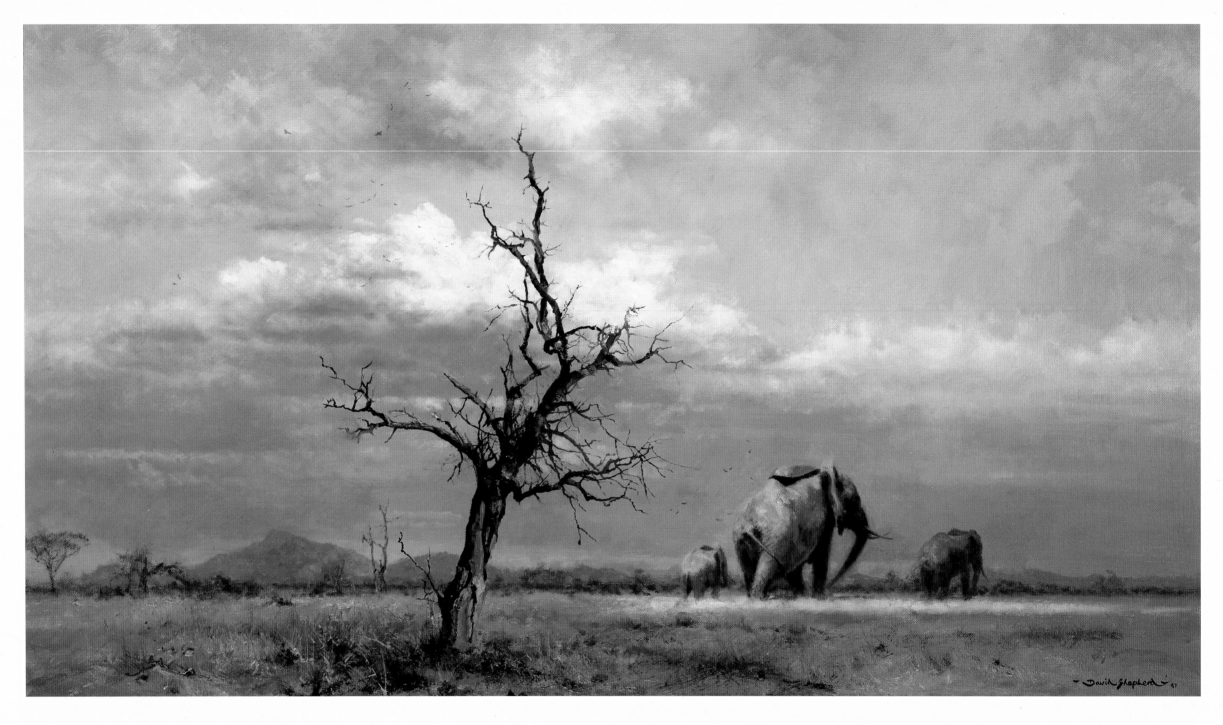

Stormy Evening

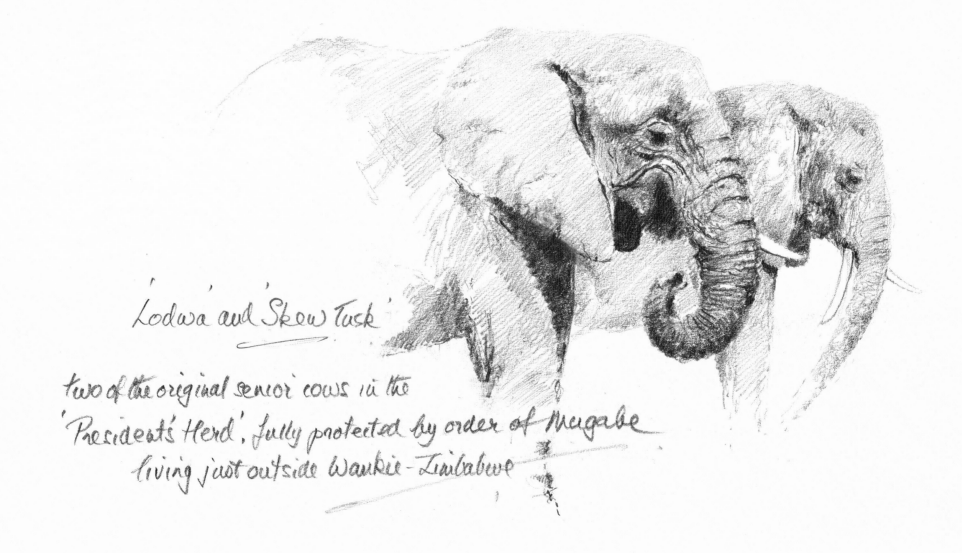

'Lodwa' and 'Skew Tusk'

two of the original senior cows in the
'President's Herd', fully protected by order of Mugabe
living just outside Wankie - Zimbabwe

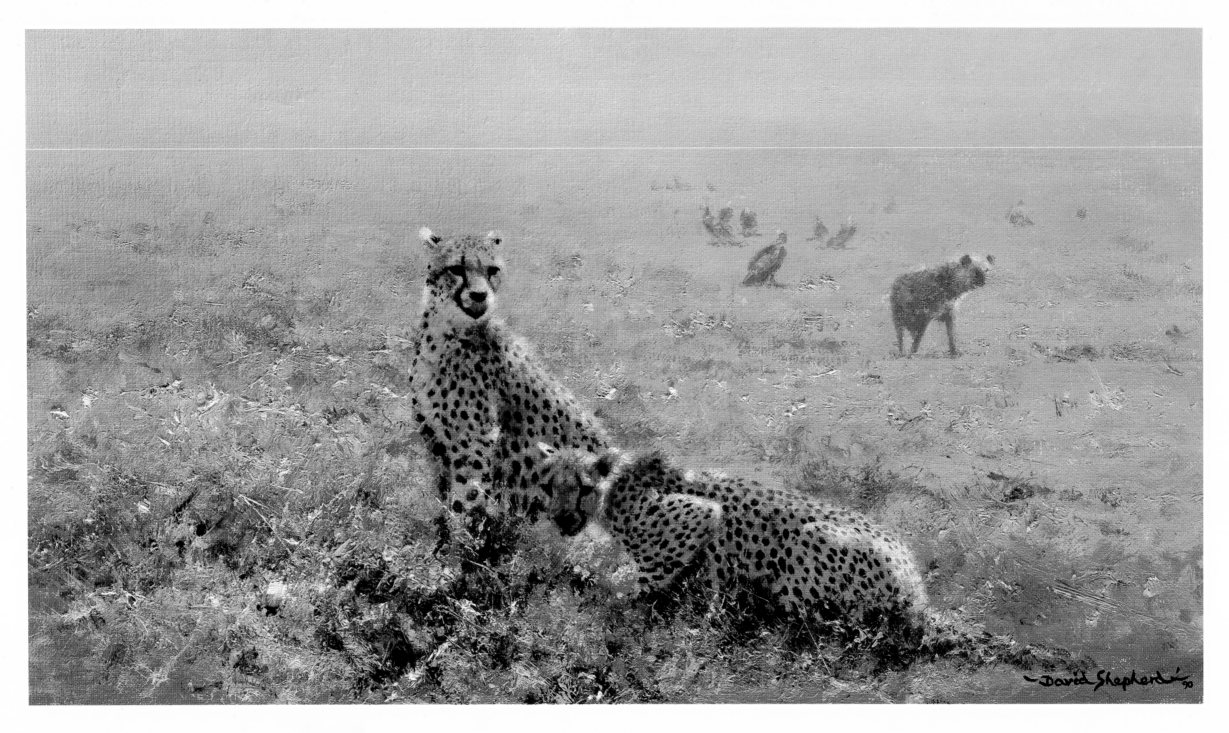

On the Kill – Serengeti

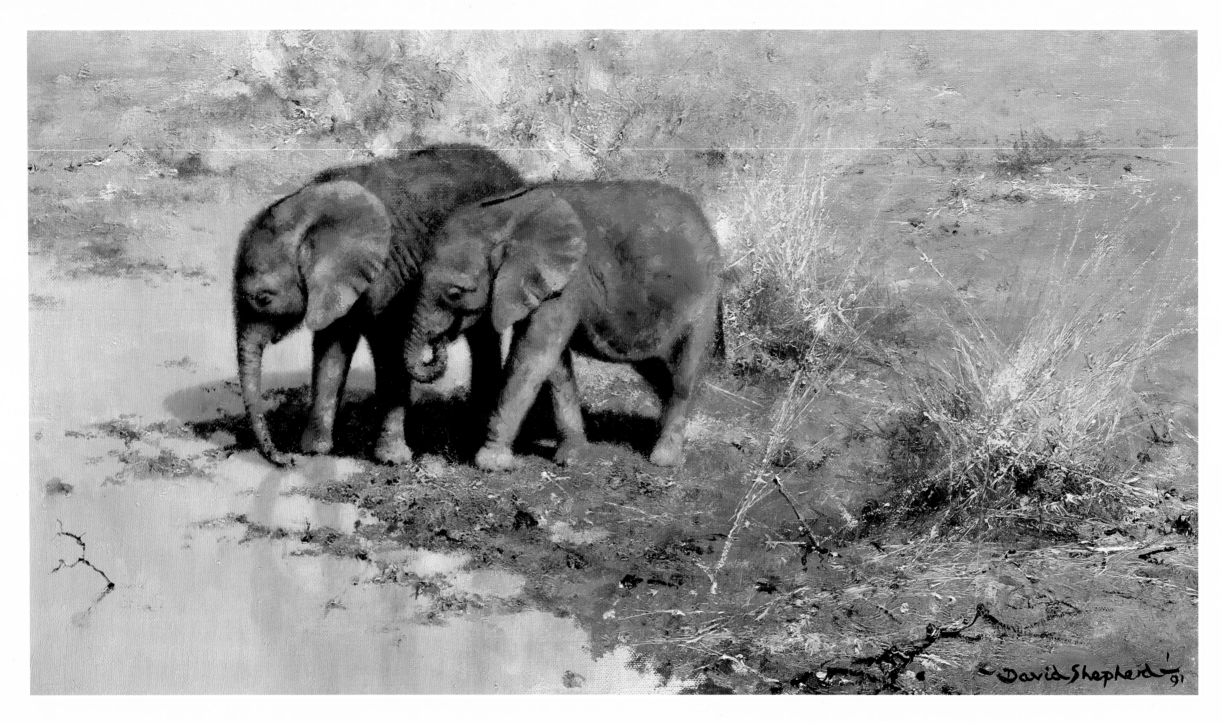

African Babies

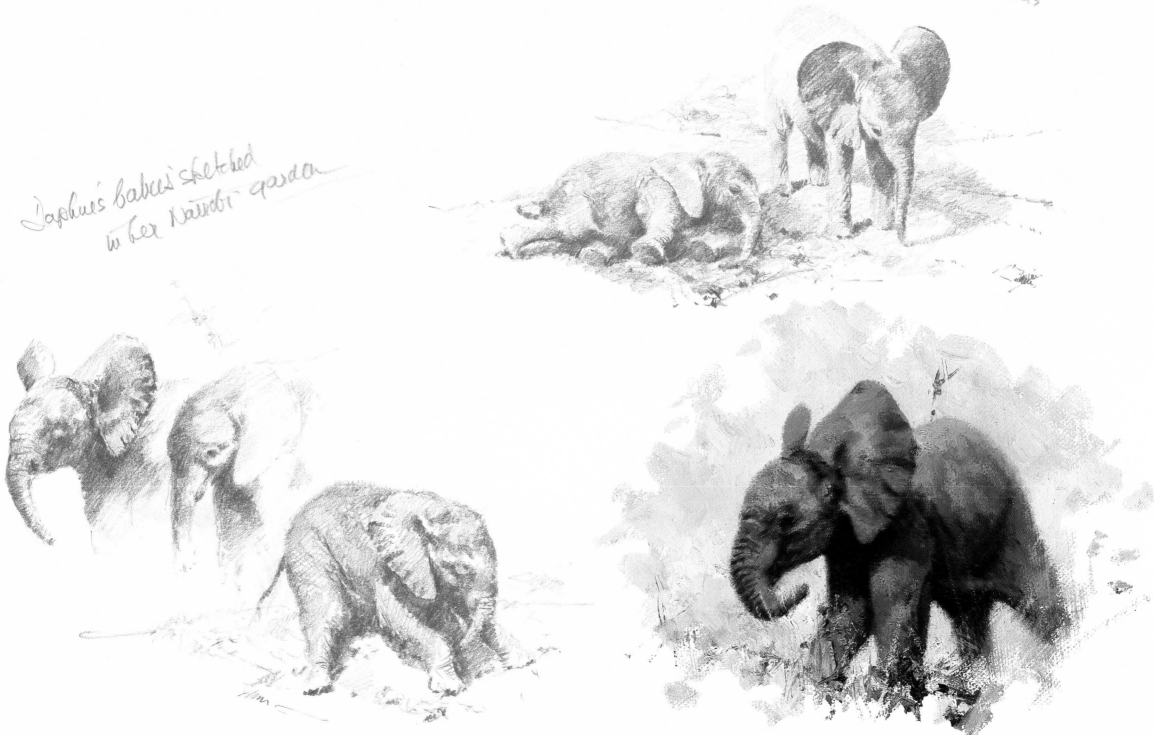

remember no overhang on back
& tiny Jumbo's ears

Daphne's babies sketched
in her Nairobi garden

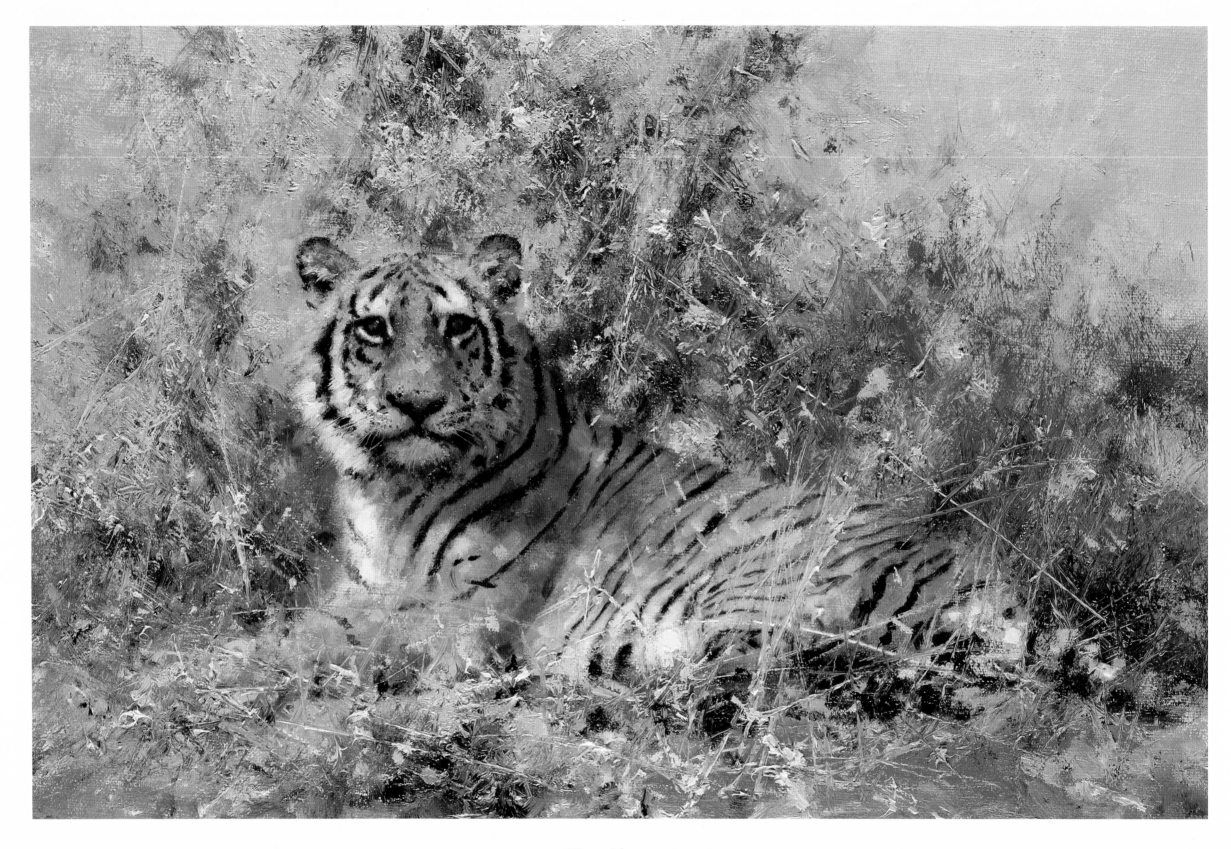

Tiger Alert

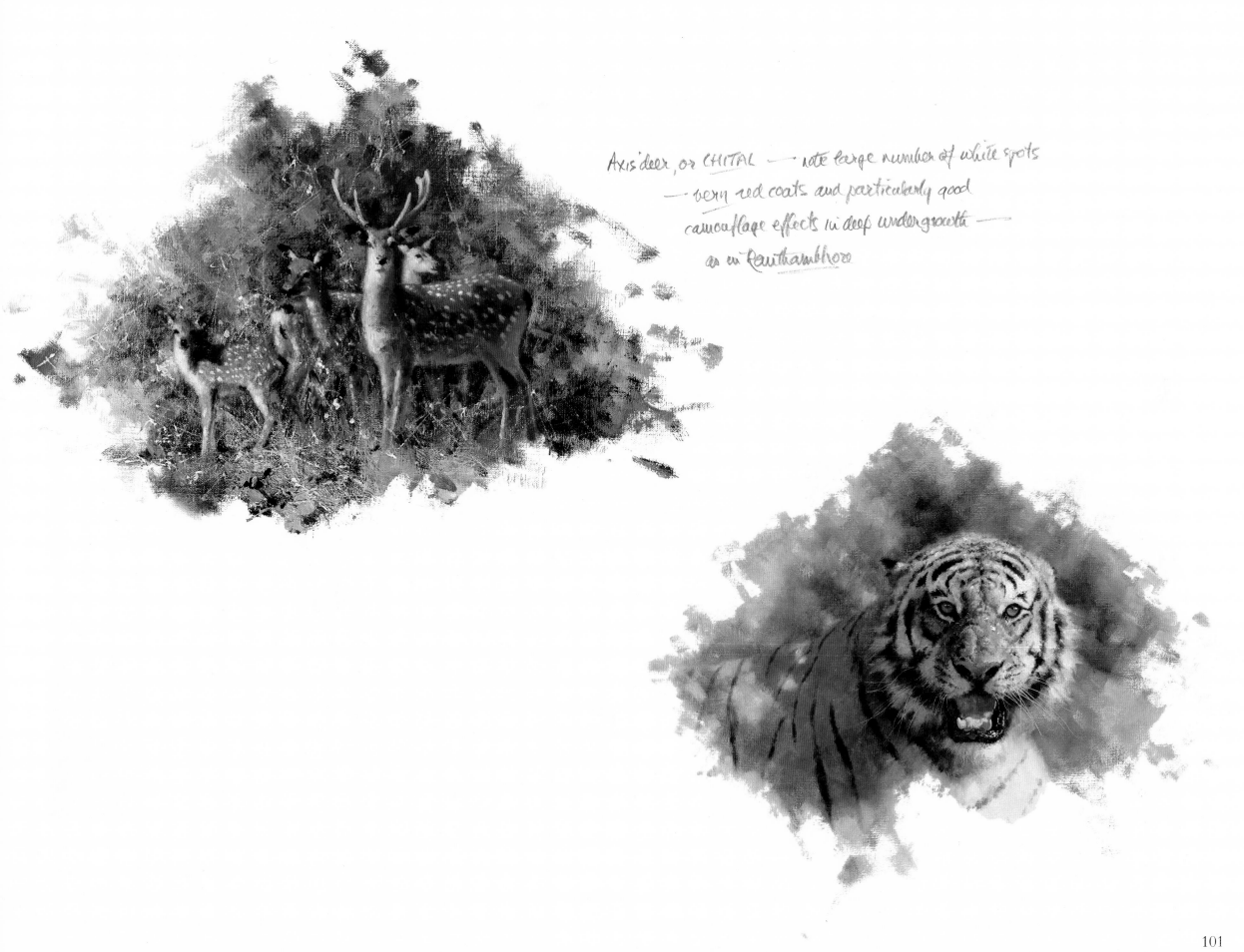

Axis deer, or CHITAL — note large number of white spots
— very red coats and particularly good
camouflage effects in deep undergrowth —
as in Ranthambhore

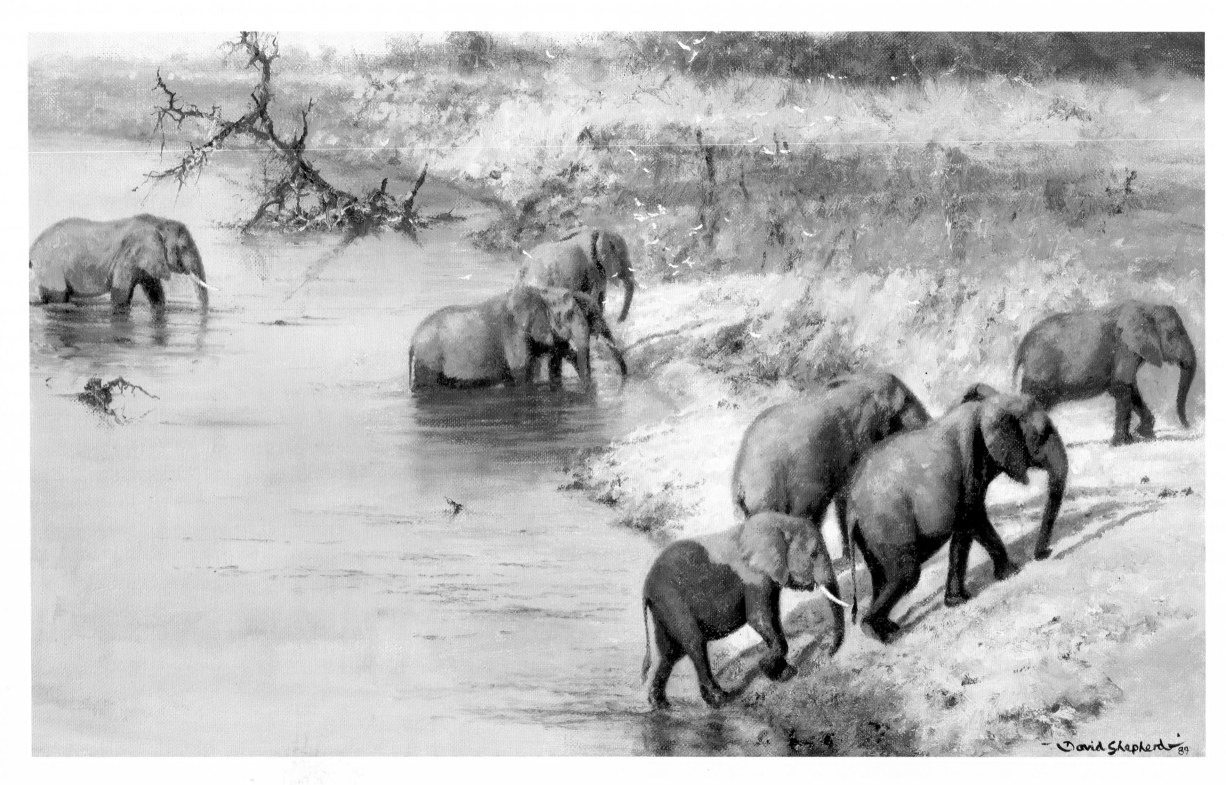

The Crossing

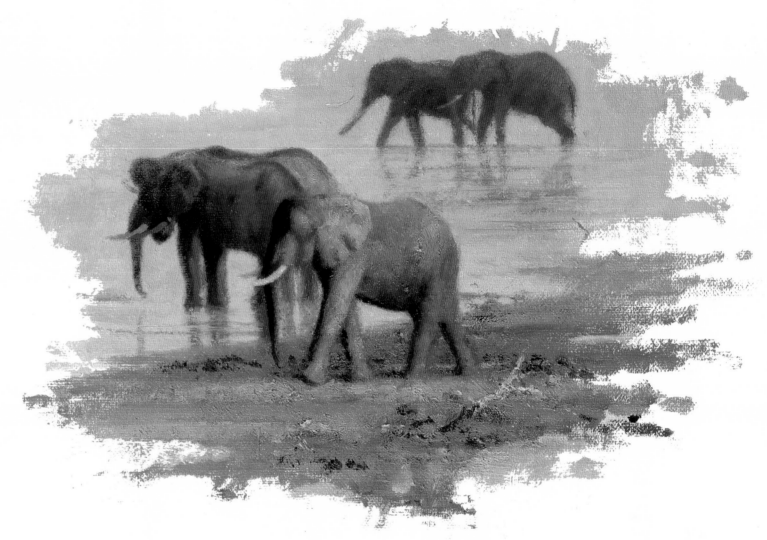

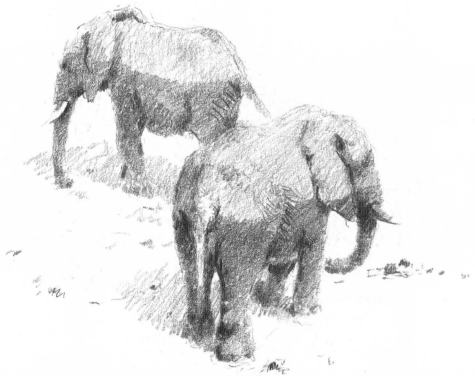

'wet and dry' Jumbos
note waterline after they've crossed river

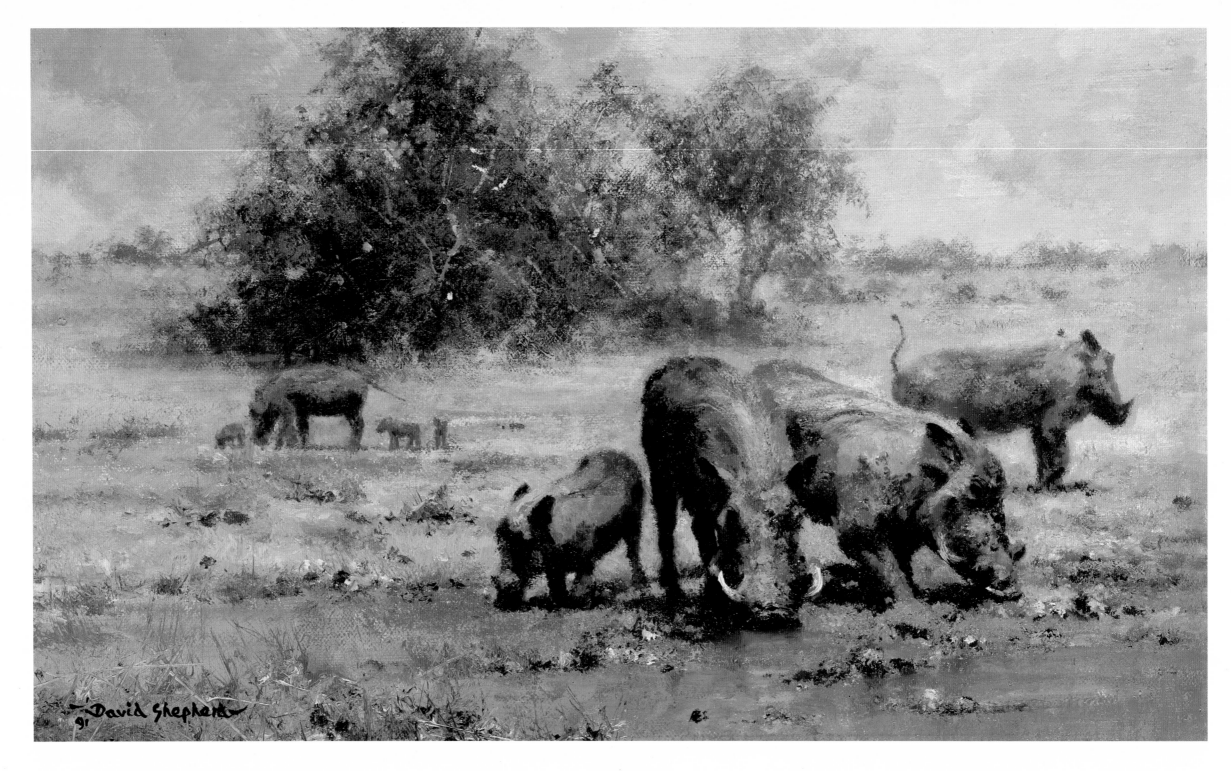

Warthogs

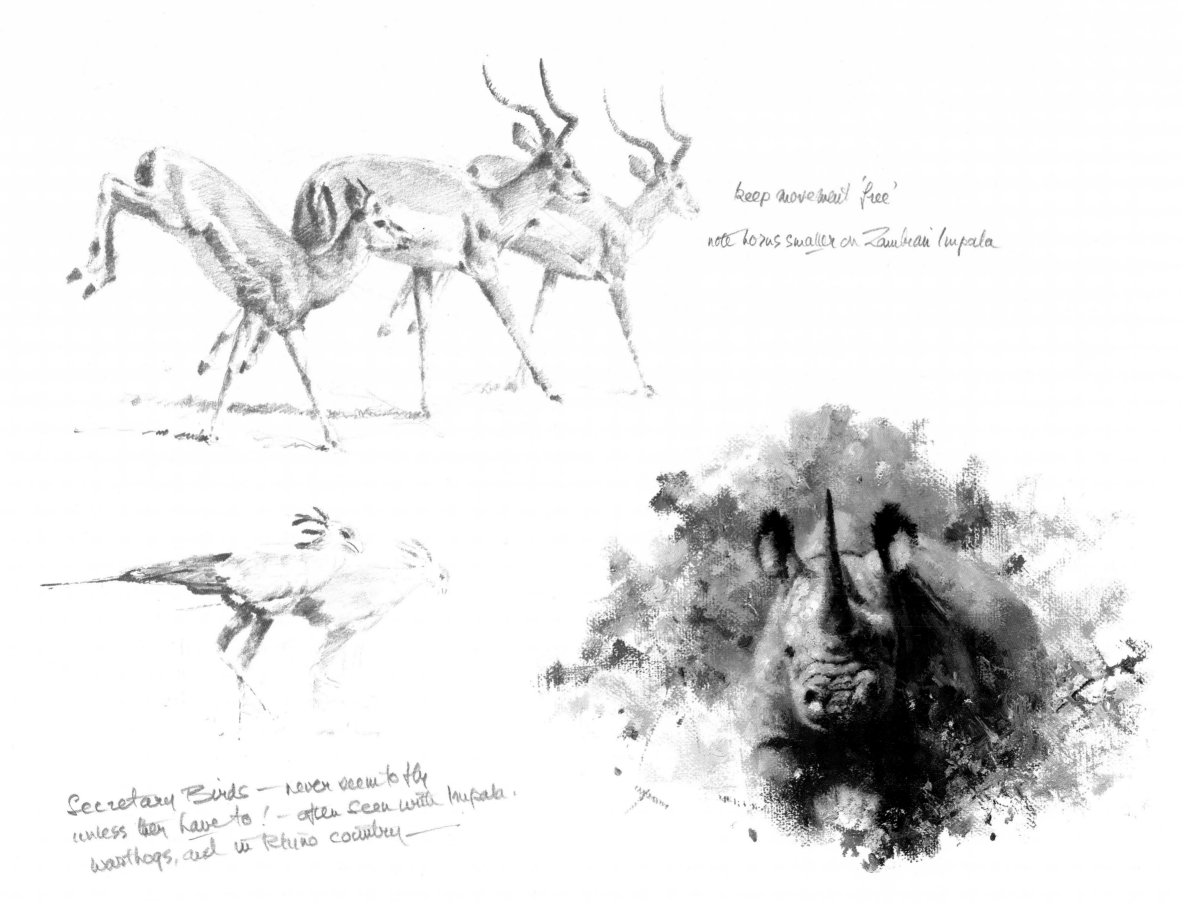

keep movement 'free'
note horns smaller on Zambean Impala

Secretary Birds – never seem to fly
unless they have to! – often seen with Impala.
warthogs, and in Rhino country –

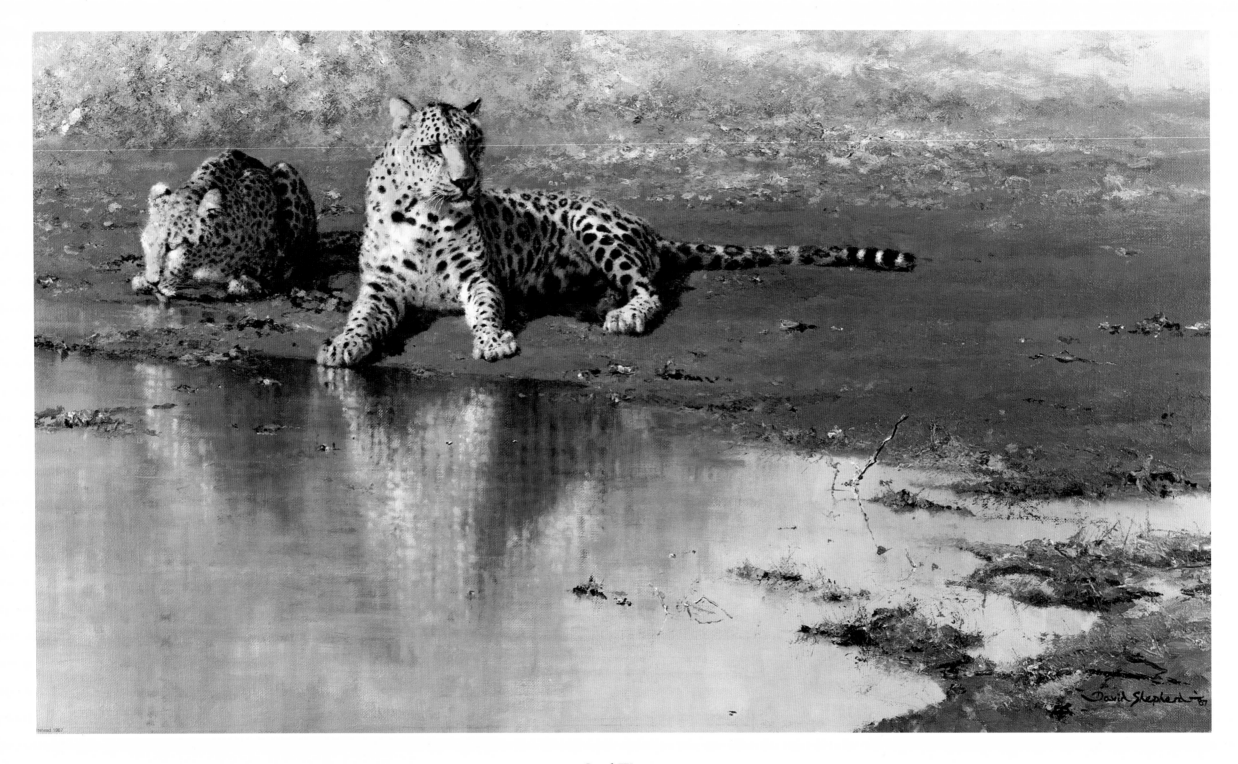

Cool Waters

'Saw this magnificent male Leopard sitting on the rocks in the evening light - but no time to sketch him as he 'took off' the moment he saw me.
'had to work from a tame one in Los Angeles' ?

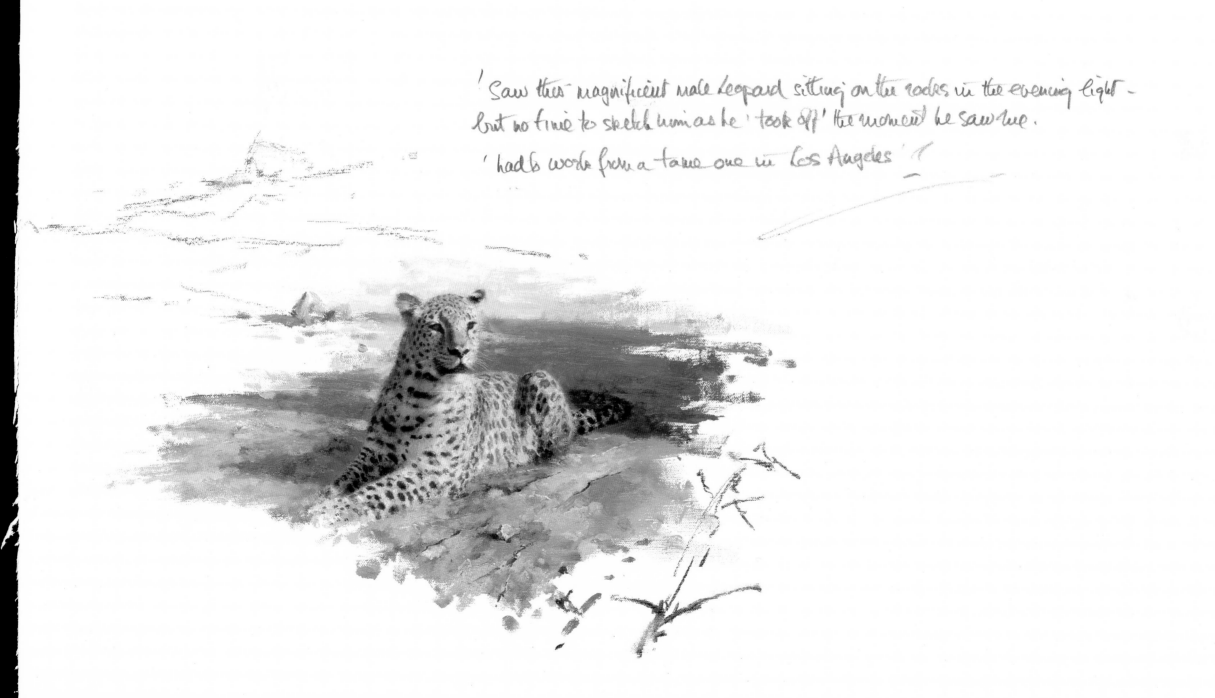

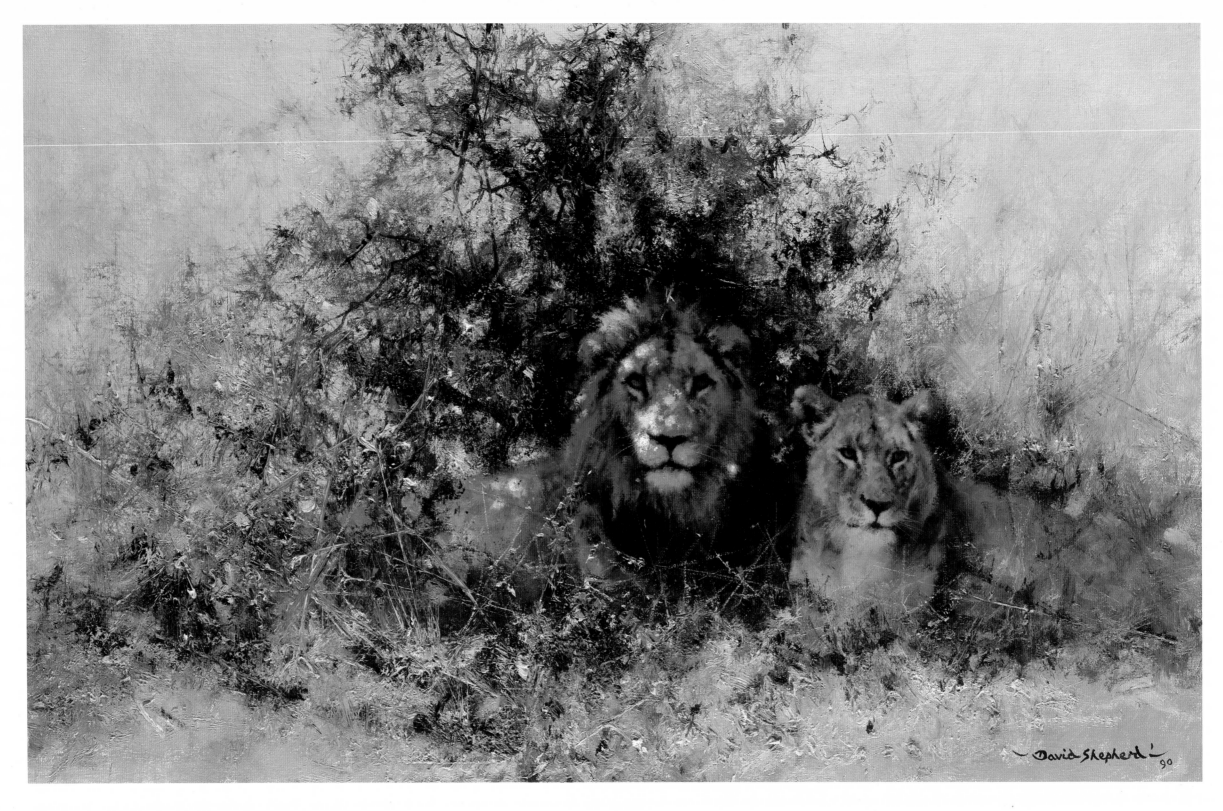

In the Shade

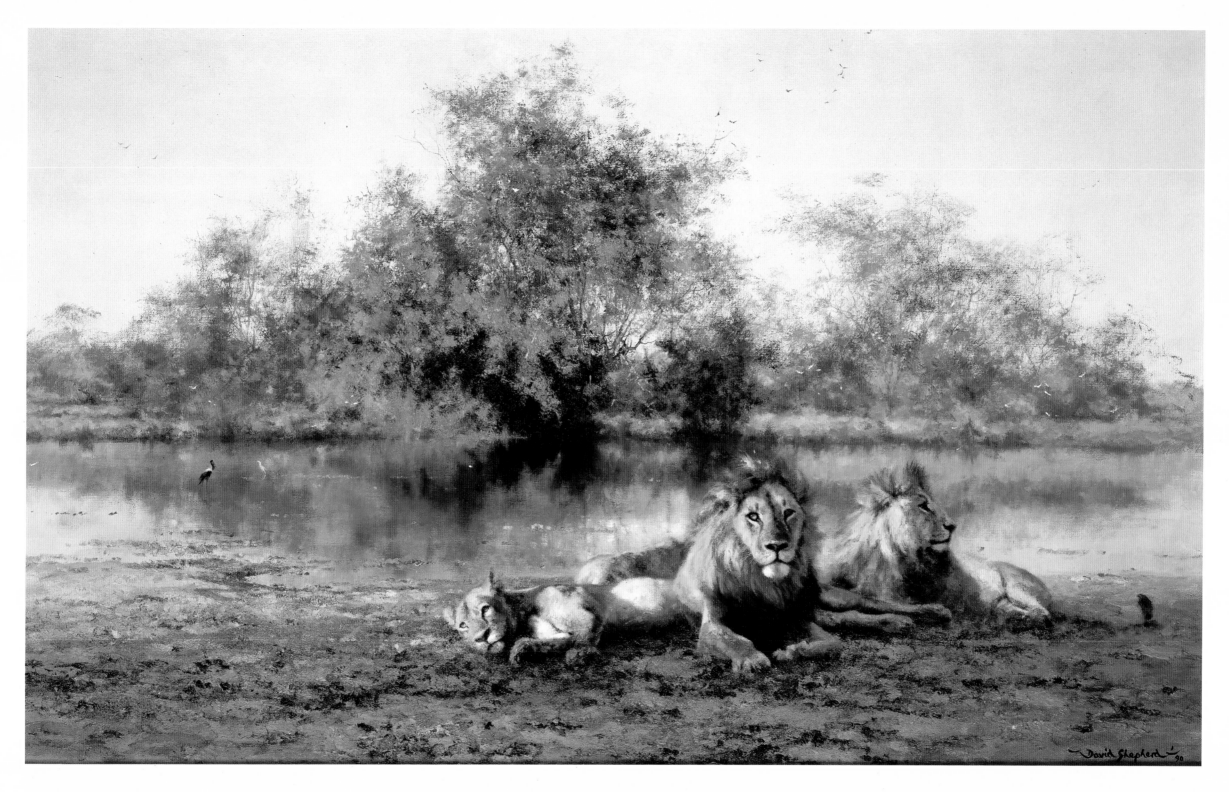

African Evening

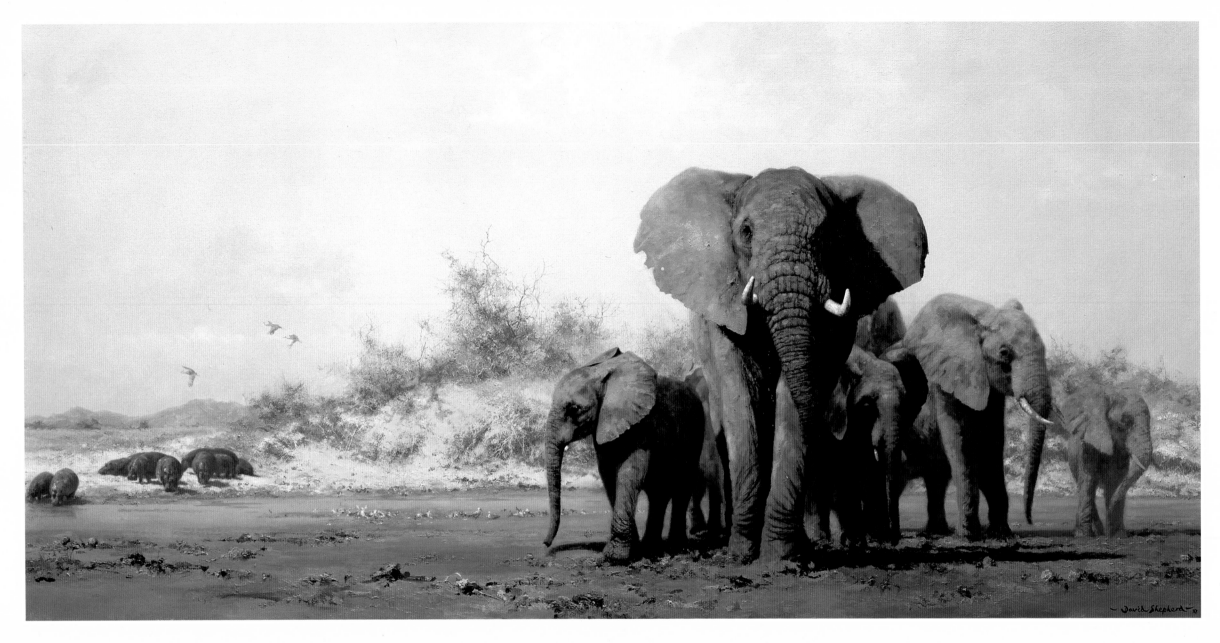

Evening in Africa

the loveliest time of the day —
and there really are red Jumbos in Africa!

— drinking at the water's edge in
the cool of the evening —
just getting on with the business
of 'being Elephants'

must they ALWAYS be running away from us?

INDEX

Indian Ocean

THE EARTH
BENEATH ME

DICK SMITH'S
EPIC JOURNEY ACROSS THE WORLD

THE EARTH
BENEATH ME

edited by Jack Bennett

ANGUS & ROBERTSON PUBLISHERS

I dedicate this book to the memory of two of the world's great pioneer aviators:
"Hustling" Bert Hinkler and Charles Kingsford Smith.
They pioneered our early aviation routes and both lost their lives
flying the England to Australia route that my story covers.
I am sure both would have agreed that:
"Without a spirit of adventure a nation must
wilt and wither away."

Navigational measurements
*Imperial measures have been used in this publication
where they relate to navigation.*

Angus & Robertson Publishers
London•Sydney•Melbourne

This book is copyright. Apart from any fair dealing for the purposes of
private study, research, criticism or review, as permitted under the
Copyright Act, no part may be reproduced by any process without
written permission. Inquiries should be addressed to the publisher.

First published by Angus & Robertson Publishers, Australia, 1983

Copyright © Dick Smith, 1983

National Library of Australia
Cataloguing-in-publication data.

Smith, Dick, 1944-
 The earth beneath me.
 ISBN 0 207 14630 6.
 1. Flights around the world. 2. Helicopters.
 I. Bennett, Jack, 1934 II. Title.
629.13'092'4

Typeset in 12 pt Garth Graphic by GoodType

Printed in Hong Kong

Acknowledgements

So many people helped with the preparation for my flight and at every stop along the way that it would be impossible to thank everyone. In addition to the many people and organisations mentioned here, there are hundreds of air traffic controllers and airline crews all around the world who made a special effort to help once they knew what *Delta India Kilo* and I were trying to achieve.

In addition to the valuable financial contributions my sponsors made, I would like to thank their representatives whose unexpected help along the track was of great benefit.

I wish to thank my wife Pip, without whose continued enthusiasm, loyalty and support I could not have made the flight. Pip also spent many evenings with our encyclopaedias making notes about the places I was to fly over. Thanks also to my friend Bob Wilson of Sydney who introduced me to helicopters in the first place and has continued to help and advise me; and to the Rt Hon. Malcolm Fraser, patron of the flight and my enthusiastic supporter.

I thank also the following sponsors for their contributions, continued interest and help in hundreds of ways: the management and staff of Qantas Airways Ltd, especially Jim Leslie (Chairman), John Ward, Denis Crawford and Captain Alan Terrell; Clive Turner of Mobil Oil Australia; the management and staff of News Ltd, Australia, especially Ken Cowley, Ita Buttrose and Greg Coote; Bell Helicopter Textron staff, particularly L. M. (Jack) Horner (Executive Vice-President), Cliff Kalister, Marty Reisch, Carl Harris, Jim Brown, Ren Lee and especially Harry Miller who helped in a thousand ways throughout the flight; Bob Wilson of Hawker Pacific in Australia; Art Kelly, Peter Pain and Art Jackson of Collins Avionics; Kevin and Joe of Field Tech; Herb Waldrup of Perkins Plastics for their excellent downslides; Garry Beck and Charles Engel of Stephen L. Way International Indemnity Co. of Texas for insurance at the right price; Robert Murphy of David Clark Headsets; Charles A. Floyd of Eastern Aero Marine (safety equipment); Neil Allanach, Trevor Englis and Mike Johnson of Multifabs for my wonderful survival suit; and the Australian agents for Chinon Camera Equipment, especially John Flew.

My thanks to Sir Eric McClintock and Tony Harding of Woolworths for letting me have the time off; my secretary, Janet Richardson, who was on call at all hours; Fred Baker, the News Ltd journalist assigned to cover the flight, whose interest, enthusiasm and help far exceeded his brief; Ian Smith who did much of the original route and flight planning; Jim Heagney, my ground coordinator for the first stage, and Gerry Nolan for doing the same job on the second stage; the Australian International Pilots Association which accepted me as an honorary Qantas captain, enabling me to proudly wear their uniform — a great assistance with airport authorities in all places; Ernie Crome who gave me a piece of fabric from the *Southern Cross* to carry with me; Cliff Tait and Bill Riley whose notes and information, based on their experience of long-distance flights, were invaluable; Karl Wagner who gave me a lot of help and advice in the early stages, especially in relation to the Atlantic crossing, as he and a partner had flown a Bell Long Ranger across it earlier; Bill Whitney of Brisbane for designing the long-range fuel tank for *Delta India Kilo*; John Cameron for his assistance with the preparation of the tank, and Peter Hoyle of Air Express International for arranging delivery of the tank to Fort Worth; Ted Wixted of the Queensland Museum for helpful historical notes; Bill Storer of the Department of Communications who gave me my morse examination at the last moment thus allowing me to use amateur radio

during the flight; Jim Schofield and all his staff at the Department of Aviation for advice and assistance and the operational approval of the flight; the Department of Foreign Affairs for alerting its staff all along the track and being very helpful in many ways; Joe Moharich and his staff at Bell Helicopter in Brisbane; and Dr George Foldes of Terrey Hills.

I would also like to thank amateur radio operators everywhere and especially Harry Caldecott (VK 2DA) for organising net frequencies and coordinating contacts worldwide; Marathon Smith (VE 1MZ) of Moncton, Canada; John Wilson (G4 LOW), England; Peter Steneborg (OX 3PT), Greenland; and Bob Millgate (VK 4ADZ) of Bundaberg.

My thanks also to the following people and organisations who assisted me on my actual trip:

FORT WORTH TO LONDON Bob Bolen, the Mayor of Fort Worth, for declaring 5 August 1982 as "Dick Smith Day" in Fort Worth; Terry Parkhurst of Field Tech; Leah Chandler-Miles of the Explorers' Club; Robert Wayne Shelton for the use of his telephone when I was forced to land in Washington; John Madden and Brian James, Department of Home Affairs, at the Knoxville Energy Exposition; Qantas staff, Michael Norris in Washington and Richard Haas in New York; Ralph Alex of the FAI and Bruce Thatcher in Boston; Don McQuinn and Doug McLaughlin in Moncton for their helpful suggestions; the management and staff of the Vista Hotel in New York for putting up Jim Heagney and myself for the night at no charge; Bill Dyers, John Whisker and Bill Cameron of Cape Dyer; Yorgan Orstram, Peter Steneborg, Goran Lindmark, Carl Hannisdal, Hans Morbak and the pilots and staff of Greenlandair; Paul Elkjaer, Kulusuk; Magnus Peterson, Iceland FIS; HRH Prince Charles and his staff: Mr Collings (Personal Secretary), the Hon. Edward Adeane, Major David Bromhead (Equerry), Mr Warren Hutchins (Press Secretary); Sonia Ramos of Texas for her thoughtful card which was handed to me at Balmoral Castle; the Hon. Sir Victor Garland (Australian High Commissioner) for meeting me in London; Ray Jeppesen, Jim Rankin and Mike Hamerton of Qantas in London; Miles Wilson of Mobil UK; Neville Fish for cancelling covers; Peter Sutherst of Kodak; and my friend Arthur Cox who saw me off at Biggin Hill with my family.

LONDON TO AUSTRALIA In Rome: Vincenzo Betti of Qantas; the beautiful and capable Anamaria Pivato of the Australian embassy, and Isolina Barbiani of Mobil; and Luigi Genari who assisted me on the ground at Brindisi. In Athens: the tremendous Mobil team of Stathis Danielides, Harry Gondicas, Takis Karellis and Dimitre Vassiliades for their wonderful welcome and help with authorities; William Stefos, Col Anderson and John Gatapoulus of Qantas; Bernard McCabe from the Australian embassy; Spizos Lixtsos of HAFR TV; and the Airport Manager and Mobil representative in Crete who helped me get a fast transit. In Cairo: Taff Lark and Sue Lawrence of British Airways; Nabil Zidan and Eid Moussa of Mobil; and Roger Wilson from the Australian embassy. In Ha'il: Alan Johnston and his wife Jean; Dave Ball and John Downes; Airport Director, Mohammed Ali Alblahay, and his son, Fahed Ali Alblahay, who took me on a tour of Ha'il, and Siddiq Mageed. In Bahrain: Peter Langdon and Richard Coatsworth of Qantas; Bell representatives Richard Annis, Hal Staley and Frank Barnes; Hermant S. Naik of Bahrain Airport Services; Les Howell of British Airways in Muscat. In Karachi: Azhah Wali Mohammed of Bell; Director-General of Civil Aviation, Mr W. H. Hanafi, for the wonderful welcome; and M. Iqbal Effendi of PIA; Noshir H. Kangar of Qantas in New Delhi was tremendous; J. K. Muckherji of the Indian Oil Co. helped console me on my arrival; Robert Curtis of the Australian High Commission; Trevor Watson of the ABC; and my good friend Gyan

Jain. In Calcutta: the wonderful Mrs Neena M. Ghosh of Qantas; V. K. Rangan and all the British Airways staff; and Dinish Kelmar Sharma, the Army Security Guard. In Rangoon: Richard Gate, the Australian ambassador; Rob Jones from the embassy; and Major Mynthan of the Burmese Airforce. In Singapore: Brian and Laura Woodford and all the wonderful staff of Heli Orient, especially Ron Shambrook and Alan Abbott; Don Hook of the Australian embassy; Wayne Smith and George Kvasna of Collins Avionics for expertly fixing my aerial; and the Hilton Hotel for our wonderful accommodation — we'll be back. In Jakarta: John Lantang of Qantas; Dale Courts of Bell; Dick Brown and Timmy Tyoni of Heli Orient (Timmy assisted me in Kupang at short notice). In Bali: Peter Cario of Qantas; and Michael Mann from the Australian consulate.

The welcome I received in Darwin was tremendous and I want to thank everyone who was there to welcome me, in particular the army for sending out the Pilatus Porter to meet me; Doug Crossan and Kahl Tims of Rotor Services; the Department of Aviation staff for quickly constructing the fantastic helipad at Parap; John Haslett; Mobil's Peter Dean and Bob Glovitch; Graham Vardon and John Lawrence of Qantas; Woolworths management and staff, including Ron Strong and Ray Trewin; Tom Lackner and the school-children for a great welcome at Alexandria Station. In Longreach: Sir James and Lady Walker; Ranald Chandler; and Dr Tom Murphy. In Bundaberg: all the wonderful people in Hinkler's home town for their great welcome, including Paul Neville, Don Maddison and Thomas Quinn of the Development Board; Ald. C. J. Nielsen (Mayor); Alan Stewart (Deputy Mayor), for his assistance and the loan of a car; Captain R. Heiniger of Qantas; the manager and staff of Woolworths for their welcome; Daph Heiner who made the globe of the world that was presented to me; Ted Chapman, Jeanette Burrows and Mr M. J. McGrath of Mobil. In Surfers Paradise: Peter Dogett of Seaworld for organising my visit to see Hal Litchfield and Mrs Lores Bonney; and Sir John Egerton for coming out to meet me. In Sydney: Chris Johnson for organising everything at the Channel 10 helipad in the city; the Premier of New South Wales, Mr Neville Wran, for welcoming me; Jim Adams from the Department of Aviation for approving my Harbour Bridge "underflight"; John Oakey and 1st East Roseville Scouts for the great welcome; and Don Hartley and the Allison 250 Overhaul Section team of Hawker Pacific for the wonderful plaque they made and presented to me.

Finally, I must thank Jack Bennett who really did far more than edit this book. He was able to convert my "schoolboy English" into a greatly improved and far more readable story. Also Richard Walsh (Chief Executive of Angus & Robertson) for having the confidence to publish, and Brian Priest (editor) for his great post-production work. It was a pleasure to work with such professional people.

Dick Smith

Foreword

I was privileged to walk in the footsteps of some of the great pioneers of aviation when I had my first flying lessons from Kingsford Smith in 1933. Mascot was then frequented by such people as P. G. Taylor, Charles Ulm, Hubert Wilkins, Arthur Butler, Norman Brearley, Scotty Allen, Nigel Love, Hudson Fysh, Horry Miller and a host of others.

They discussed freely in my hearing their hopes, ambitions and bitter disappointments as I gratefully accepted transport with them to and from Mascot. They struggled to make a living out of flying as well as to promote and defend it as a means of transport.

Australia's contribution to aviation in the early days was out of all proportion to our, then, tiny population. In fact, if Harry Hawker had not failed in his courageous attempt to cross the Atlantic Ocean in 1919, Australians would have been the first to conquer every major ocean in the world by air.

Their history was little known but, fascinated by their daring exploits, Dick Smith delved into their stories and developed a tremendous respect and admiration for those early fliers. He wanted to know what inspired them, what they endured, and how they felt as they flew over vast oceans and inhospitable terrain. Now he knows!

Even though I had flown with this enthusiastic young man in the 1976 Perth to Sydney Air Race, I was still surprised to learn of his intended solo flight around the world in a helicopter. Flying alone in a single-engine aircraft with little more than the forward speed of early machines would be hard enough without the addition of filming, taking still photographs and constantly narrating, all at the same time. Much as aviation has changed, the extreme loneliness, physical and mental exhaustion, the constant harassment of bureaucratic paperwork, the occasional threat of being shot down over unfriendly airspace, are constantly with the lone flier.

It still takes an enormous amount of personal courage to head out into eternity in a single-engine aircraft to confront the ever-changing and unpredictable elements. Dick's flight focused attention on Australia throughout the world. He proved to be a magnificent ambassador for, no matter how tired and exhausted and even distressed he was when besieged by the media, he was always cooperative.

For this and his other sterling qualities I cannot hide my admiration for Dick Smith who undoubtedly joins the ranks of the pioneers he so much admires.

Nancy-Bird Walton

Contents

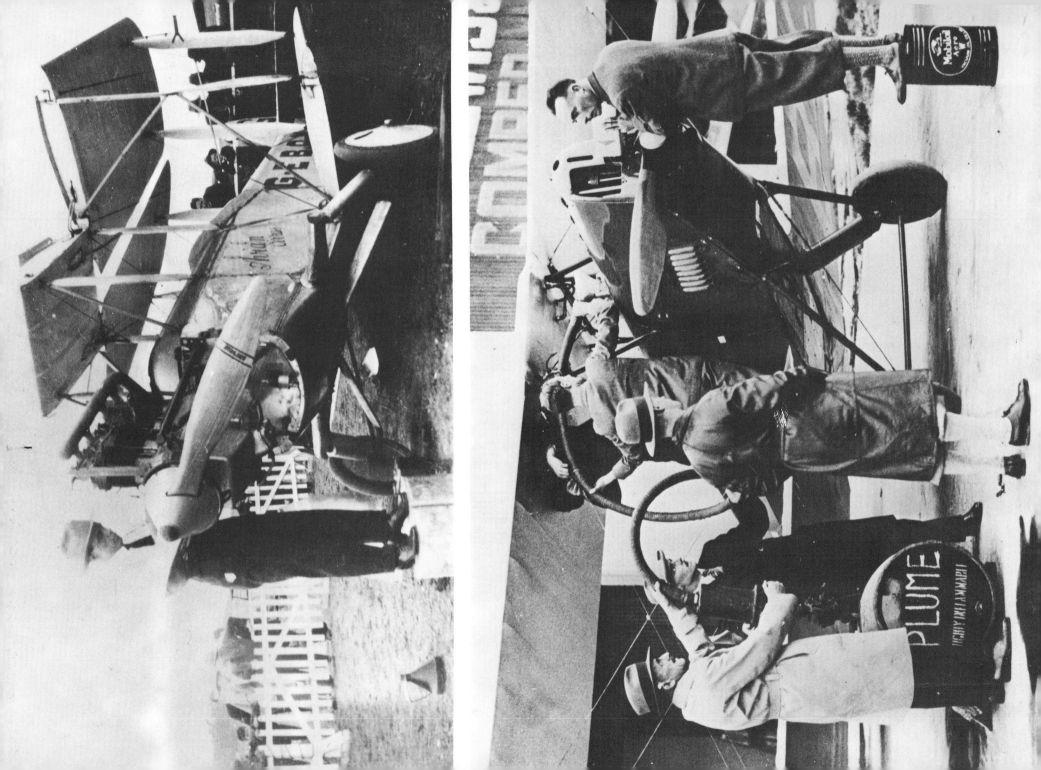

The Preparation

"Yes," people say to me, with a puzzled frown, "but why by *helicopter?*"

The "yes" is a concession that to want to fly around the world in a light aircraft may be odd, and that is understandable, but to want to do it in a helicopter is considerably odder. I suppose this attitude stems from the fact that to most people the helicopter is a short-distance machine. It is ideal for flights across cities, but could a helicopter fly around the world? Well, that is what I wanted to find out.

If the helicopter had not been invented I would have still attempted to fly around the world. I have always been a great admirer of the early aviators, the brave men and women who pioneered the air routes which we fly in comfort in jumbo jets today. I am proud to be Australian, and very proud of the significant part played in the development of aviation by Australians; a part out of all proportion to the population of the country at the time. Australia had about five million people when trailblazers like Bert Hinkler, Charles Kingsford Smith, Charles Ulm, Keith and Ross Smith, Hubert Wilkins, Raymond Parer, Mrs Bonney and others were risking their lives in primitive aeroplanes with minimal navigation equipment. I had read everything I could on their early flights but that did not compensate for the real thing. I wondered what it would be like to follow their footsteps.

I began flying about 10 years ago. After qualifying on several types of fixed-wing aircraft I finally graduated to a twin-engine Beech Baron. While I enjoyed flying a fixed-wing aircraft I did not feel there was much of a mystique about it — an aircraft was just a conveyance.

One day about five years ago, while flying back to Sydney from western New South Wales, I was forced to land and cool my heels on a country airstrip for several hours because of bad weather. While I was idling there a helicopter whizzed in — the only aircraft flying that day. I watched it enviously. Later I walked over to the pilot and asked him how he

Above left: Bert Hinkler checking the engine of his Avro Avian after his solo England-to-Australia flight in 1928. The aircraft's length was only seven metres with a wingspan of eight metres. The wings folded back so it could be garaged. (By courtesy of the National Library of Australia)

Left: Charles Kingsford Smith (centre) with the SOUTHERN CROSS JUNIOR in 1930. One thing I had in common with "Smithy" was the Mobil fuel and oil we used

Above: This is my favourite photo of Charles Kingsford Smith which I carried with me on my flight.

could fly when other aircraft were grounded.

"Easily," he said. "You can fly below the weather in a helicopter, and if it gets too bad, well, you just land until it improves. You don't need an airstrip; just plonk it down in a paddock."

Well, that set me to thinking. Some time later I was offered a flight in a helicopter owned by Channel 10, a Sydney television station. Of course I jumped at the offer. And 10 minutes after take-off, flying over an expressway with cars bumper to bumper, I was hooked on helicopters. I remember thinking, "This is wonderful, it's like a magic carpet, I must have one."

And that is how I acquired my first helicopter. It was a Bell JetRanger with the identification letters *Mike India Sierra*. I loved it from the day I took delivery of it. Since then I have logged more than 1000 hours in helicopters, from the short five-minute hop to work every day to longer journeys throughout Australia.

I have flown across the Tasman Sea to New Zealand and back in a fixed-wing aircraft. I have been dog-sledding in Antarctica, and climbed the notorious Balls Pyramid, a pinnacle of basalt rock in the Tasman Sea, 700 kilometres from Sydney. All these adventures were made possible by my business success.

Thirteen years ago I opened a small electronic-goods shop. The business succeeded beyond my wildest deams, and at the age of 33 I was able to afford *Mike India Sierra*. This machine opened a whole new world of flying for me; a multidimensional world, uninhibited by airports and airfields. It enabled me to take my wife, Pip, and daughters, Jennifer and Hayley, on camping trips to remote areas of Australia which would otherwise have been almost inaccessible.

In 1978 I found the rusted wreck of the little *Kookaburra* aircraft which forcelanded in the Central Australian Desert in 1929 on a search for the missing *Southern Cross* in which Charles Kingsford Smith and Charles Ulm were flying to England. The *Kookaburra's* crew, Keith Anderson and H. S. Hitchcock, had not taken any extra supplies of food or water for their hazardous flight over one of the harsh-

2

est terrains in the world, and died of thirst a few days after the forced landing. Finding the wreck after all those years was a moving experience. It did not put me off flying, but reinforced my great respect for those early fliers.

After flying *Mike India Sierra* around Australia for a couple of years, I decided to buy a new JetRanger. Instead of taking delivery in Australia I thought it would be a good idea to pick it up at the Bell Helicopter factory in Forth Worth, Texas, and fly it home myself. Several hours spent poring over charts convinced me that it might be possible. I could fly over the North Atlantic, across Europe, the Middle East and the Far East. But I would have to carry enough extra fuel to get me across the wide stretches of water on the way.

A friend said that if I was going to fly over halfway around the world, why not finish the job and fly *completely* around the world.

I sat down and studied the maps again, did a few more sums and reckoned it might be possible. The big problem was the huge expanse of the Northwest Pacific between Japan and Alaska. It was highly unlikely I would get permission to land on Russian soil as they had never given approval before. After thinking about it I hit on the idea of landing aboard a ship for refuelling. My JetRanger, with its extra fuel tank, would just have enough range to fly to a ship about halfway between Japan and Alaska. After refuelling I could then fly on to the Aleutian Islands.

By this time my enthusiasm was taking over. I would love to make the attempt for several reasons. It would be a grand adventure and a personal challenge. A unique way to see the earth beneath me from my own magic carpet. It would give me a greater insight into the hardships of the pioneer aviators whom I admired so much. And it would also demonstrate my belief that a "short-distance" machine is capable of flying long distances.

The decision to attempt the solo around-the-world helicopter flight instantly catapulted me into two of the busiest years of my life. Planning for the trip, from 1980 onwards, took up a great deal of time in addition to my full-time business commitments.

3

I will concede that any modern around-the-world flier these days has many advantages which the aviators of the 1920s and 1930s had never heard of. On the other hand they were not restricted at every turn by red tape, rules and regulations, and a stack of paperwork. They simply climbed into the cockpit, started up and flew away.

Before tackling the bureaucrats I had a practical problem to solve: how to carry enough fuel in the JetRanger legally and safely for the long sea crossings.

After work each night I worked on a design for a light but strong frame to hold an auxiliary fuel tank in the rear seating space of the JetRanger. I used the measurements from *Mike India Sierra* which was garaged underneath my home. When I was satisfied with my design I took it to a Brisbane aeronautical engineer who converted my ideas into finished engineering drawings, and assisted in the complex business of getting the Department of Aviation approval.

4

The tank was installed in *Mike India Sierra* for testing and I flew from Sydney to Bundaberg, Queensland, on 11 April 1982, exactly 61 years to the day after Bert Hinkler had made his record flight in his Baby Avro. The tank gravity fed its contents to the main tank, and it worked perfectly. My flight was a record too. It was the longest solo helicopter flight — more than 600 miles — ever made in Australia.

Hinkler had flown to Bundaberg because it was his home town; he was born there in 1892. I chose it as my destination because I hoped to retrace Hinkler's route from London on my world flight. The people of Bundaberg gave me such a tremendous welcome I agreed to return as a part of my around-the-world flight.

The next hurdle was to convince the Australian aviation authorities that my JetRanger should be exempted from the regulations which insisted on floats being fitted to any single-engine helicopter flying over water. The floats would cause extra wind resistance, decrease speed and increase fuel consumption, thereby reducing my range. It would make such a flight impossible. The arguments went on for months.

The navigational equipment I proposed to use caused another problem: the automatic direction finder (ADF) and the very low frequency (VLF) Omega system. The Omega is an amazing piece of navigational equipment. It picks up electronic impulses put out by earth stations in the worldwide Omega navigation network and the on-board computer analyses them. It takes a navigational "fix" on them and translates its calculations into a latitude and longitude position which flashes up on the unit's display console.

To plot a course between two points the pilot punches into the computer his present position and then the latitude and longitude of the destination. Hey presto! The computer does all the sums in a twinkling, and up on the console comes the data: what course to take and distance to destination. The computer also corrects for wind, and drift caused by wind.

The Department of Aviation officials said I must have two ADFs for such a flight as the regulations stated that Omega systems for my kind of flight were unacceptable. I protested that I had an ADF and an Omega which I thought was safer. I discovered later that the regulations were written *before* the VLF Omega existed.

At one stage it became so exasperating that I considered putting the new helicopter on the American register and flying it as an American aircraft. The American regulations are more up to date but not as stringent as those in Australia. Although this would have solved my problems it would have been a terrible pity as I am proud to be an Australian and it was important to me to make the flight as an Australian-registered aircraft.

Suddenly things began to improve. The people at the Department of Aviation must have caught some of my enthusiasm because their attitude changed and they began to actively look for ways around the problems as they arose. Several exemptions were granted and I was cleared to attempt the flight.

Cleared as far as the Australian government was concerned, I should stress. I still needed permission from the 19 governments over whose territory I would be flying. The amount of paperwork involved in planning a flight around the world was staggering. Some of the countries were helpful and replied promptly; others did not even reply at all! The Australian Department of Foreign Affairs made approaches to some countries on my behalf, but not even they could coax a response from some of the Middle East countries on my route. Despite these gaps in my pre-flight planning I was determined to go ahead. Approaches to the foreign governments, or their aviation departments, had been backed up by letters to Australian diplomats in the countries on my route, and I was sure that everything would work out in the end.

Mr Malcolm Fraser, at the time the Australian Prime Minister, agreed to be the patron of the adventure. His letter to me said in part:

". . . I agree, it must be the most exciting adventure you have attempted so

far. Thank you for giving me an opportunity to be a small part of it. I wish you all the best with this exploit, and am pleased to be associated with it."

There could be no backing out now!

The subject of money also loomed large in my planning. I could have afforded to pay for everything myself but it would have made a noticeable dent in my bank balance. A JetRanger costs more than $300 an hour to keep in the air, and I calculated that the entire around-the-world flight would involve about 300 hours actual flying — about $90,000. Then there would be hotels and landing fees, and accommodation and airfares for my ground crew. There would be a better chance of me completing the flight if someone went ahead of me to assist with the enormous amount of paperwork. It therefore seemed a good idea to find sponsors to help defray what could amount to $100,000 in costs and also take some of the organisational load off my shoulders.

Australia's international airline, Qantas, readily agreed to provide the air tickets I required in return for displaying their logo. This saved many thousands of dollars and they were to get good value for their money.

A friend of mine, Cliff Tait, a New Zealander who flew around the world solo in 1969 in a tiny single-engined AESL Airtourer 115, had advised me to wear a uniform of some sort because in the Middle East and Asia a uniform works wonders by opening doors like magic.

With some trepidation I approached Qantas for another favour: could I wear a Qantas pilot's uniform? To my delight Qantas not only agreed but they declared me an honorary jumbo captain for the duration of the flight! I hurried out to the Qantas jet base at Kingsford Smith Airport in Sydney, and was fitted out with a smart uniform. Everyone was most cooperative. The Australian International Pilots Association readily agreed to my being an honorary member of their association.

My second major sponsor, Mobil Oil Australia, was equally enthusiastic. They had supported many of the early Australian aviators with fuel and they agreed to do the same for me. It was gratifying to

find two large Australian companies enthusiastically sharing in the adventure. In the months to come, both before and during the flight, I was to be thankful for having two such willing partners. The help I received from them extended far beyond mere monetary aid. In many airports along my route their local staff assisted me in many other ways that I did not expect.

With my two major sponsors signed up I turned my attention to another cost-cutting scheme — I would attempt to make a television documentary of the flight. It would probably be the first time a flier had filmed and narrated a documentary while actually flying his aircraft. It would add to my workload, but I felt sure I could make an exciting film for television release and help cover the costs of the flight.

How would I do it? It was back to my home workshop again. Night after night I designed, made, tested and rejected camera mounts before finally perfecting a light, strong and rigid mount which would hold the camera above the left-hand passenger seat. I made many test flights over the Ku-ring-gai Chase National Park near my home, checking the camera and its mount until I was satisfied with their performance.

Fortunately, I have had plenty of experience in making documentaries. I filmed my search for the *Kookaburra*, made a documentary in Antarctica and produced a documentary which traced the footsteps of the nineteenth-century explorer Charles Sturt in western New South Wales. Therefore, I was confident I could produce an interesting documentary about my planned flight. Little did I realise what I was letting myself in for. I knew it would be hard work, but I never dreamed it would impose such a strain on me.

Some countries — especially in the Middle East — are highly security conscious. I had to take a unit which would look like a tourist's home movie camera which is allowed. Anything professional, such as my normal 16 mm camera, would arouse suspicion. I eventually chose a little 8 mm Chinon which was ideal and gave excellent picture quality. I must stress that when I was planning the

trip I was not thinking of breaking any speed records. It was decided from the very beginning that I would take my time and delay any leg of the trip if the weather turned nasty. My JetRanger would not be equipped to fly in cloud, so if I wanted maximum safety I would have to wait for good weather. Apart from the safety aspect, of course, there was the planned television documentary. The main reason for the flight was to see the world in a way that it had never been seen before.

Ironically, no sooner had I decided that I would fly at my own pace than a factor entered my calculations which would give me a very tight schedule for the first two weeks of my flight.

I decided it would be a good promotion for Australia if I could be welcomed on my arrival in Great Britain by Prince Charles. I knew that Prince Charles was an enthusiastic helicopter pilot and that he regarded his time in helicopters as the best part of his navy service.

I asked Mr Fraser if he could arrange a meeting with the Prince for me. He agreed that it was a good idea and promptly opened negotiations with Buckingham Palace.

I did not believe the Prince would agree, but he did. I suppose it appealed to his sense of adventure. The Prince's aide wrote to me setting a time and place: 10.30 a.m. on 19 August 1982 at Balmoral Castle, Scotland. I wanted to land on 19 August as this would be the 50th anniversary of the first solo fixed-wing crossing of the Atlantic, east to west, by James Mollison. If I was successful, my flight would be the first solo rotary-wing crossing.

By this time I had set my departure from Fort Worth, Texas, for 5 August. I suddenly had a schedule that I would have to stick to. I could not keep royalty waiting! Now, with everything falling into place very nicely, I had to select my "front men" who would fly ahead of me by regular passenger aircraft and help handle the airport paperwork and other administrative business.

For the first half of the flight, from Fort Worth to London, I chose Jim Heagney. Jim is a captain with Ansett Airlines of Australia, and he arranged to take his holidays at the time I would need him.

For the London to Sydney flight I recruited an old colleague of mine, Gerry Nolan. I have known Gerry for years. He is adventurous and has flown jet aircraft in the RAAF. Gerry has been with me on other projects. He coordinated my charter flights to Antarctica, and was with me on my searches for the lost *Kookaburra* aircraft.

For more than 20 years I have been an active amateur radio operator, and I planned to remain in contact with amateurs constantly during the flight. It would be comforting to know that amateurs around the world would be listening for my new call sign — VK 2DIK. It also gave me an extra safety factor.

There was a great deal of preparation for the flight but by the middle of 1982, after two years' slogging, I could see the light at the end of the bureaucratic tunnel. Suddenly, it was all over: the paperwork was done and I was ready to go.

I gave a short talkback interview over the telephone to 2GB, one of Sydney's commercial radio stations, and then heard the clattering roar of Sydney's Channel 10 helicopter (also a JetRanger) bringing in a television team to film my departure to the USA. *Mike India Sierra* and the Channel 10 helicopter flew in formation at a few hundred feet over the Hawkesbury River entrance and enough film footage for the opening shots of the documentary was taken.

From then on the day became a headlong rush, like a film which is being run too fast. I gave interviews and read piles of letters and telegrams wishing me luck. I began to have that feeling of panic that most people have when they have a plane to catch and was wondering if I had forgotten something. I flew back to my house to finish packing and set out for the airport and was surprised and touched to see so many friends there to wish me bon voyage and a safe return.

After saying goodbye to family and friends I boarded the Qantas 747 bound for San Francisco. During the flight I worried, not, as one might think, about the flight or my ability to handle the task I had set myself, but about something I could not control — the press. An entry in my diary, written at

10

Operators manning the Lowe Electronics Amateur Radio Station (G4 LOW), Matlock, England. Contacts to this station helped me during the Atlantic crossing. Seated is John (G3 PCY) with David (G8 GIY) pointing out my route, and David (G4 KFN)

30,000 feet above the Pacific says:

"My main worry now is not the flight, but the media ruining the good name I have worked so hard to keep — yes, I'm more than a little frightened of what they will do to me if I make a mistake, or if something goes wrong that is beyond my control. Will they rationalise that they have a right to destroy me? I hope not."

After staying overnight in San Francisco I boarded a flight for the twin cities of Fort Worth and Dallas. I began to worry about my new helicopter. Would it be ready and waiting? I was itching to get on with the flight.

Far from being ready, my brand new helicopter seemed to be scattered in bits and pieces all over the hangar floor. Field Tech (a company specialising in installing aviation equipment) were doing a great job, however I had not allowed them enough time to do the complex work. It was now a case of all hands to the pump, so I immediately pitched in and helped.

11

While planning the trip I had asked several Australian insurance brokers for cover. The premiums they quoted absolutely staggered me. Never having covered an around-the-world helicopter flight before, they were just plucking figures out of the air. And what figures! The cheapest quote was $75,000. By the time I left Australia to collect *Delta India Kilo* I was resigned to carrying only third party property insurance at only one-sixth of the cost.

During my busy day in the Field Tech hangar I received a telephone call from an American brokerage house, Stephen L. Way International Indemnity Company of Texas. The company's founder was so taken with the idea of my adventure that he had instructed one of his executives, Garry Beck, to call and offer me comprehensive insurance cover at a very low rate. I was very grateful. Another problem was solved.

The days wore on and the helicopter was still in pieces. I set to work installing my auxiliary fuel tank, and then worked on the wiring of the small FM marine radio which was to be fitted. It took me back to my early days in business when I ran a car radio repair shop and did all the installations myself. This was the start of a long and vicious cycle of overwork, exhaustion and little sleep which was to continue for several weeks and was potentially very dangerous. I was settling into a pattern of short nights and long days. The days were terribly hot with temperatures over 40° C.

After four days, we were getting somewhere. I had my first real meal since leaving Australia — steak and chips. I was already missing Pip's home cooking.

After making a special bracket on the control column to take my camera switches, I prepared to take *Delta India Kilo* for a test flight. It was my first flight as a pilot in American airspace, and I was pleasantly surprised at the brisk informality with which helicopters were treated. No flight plan was needed, no circuit of the field was required. I just told the tower where I was headed and away we went. Other countries have such sensible regulations, but in Australia the helicopter is still treated, for traf-

fic control purposes, like a Boeing 747, and normally made to perform dangerous circuits instead of being allowed to use its remarkable manoeuvrability to nip straight in and out of busy airports without cluttering up already crowded airspace.

Delta India Kilo flew like a dream. The autopilot worked like a charm, and the VLF Omega, although a bit complicated at first, justified itself by its remarkable accuracy.

There were only four days to go before take-off and there was still work to be done on the helicopter. I set up my movie camera controls and all the ancillary equipment. I marked on the windscreen the sighting points for the movie camera I had worked out on those flights over Ku-ring-gai Chase National Park in Sydney. I also modified my specially made aluminium map box so that it sat snugly where the co-pilot's seat would normally be. My first contact was made on the amateur radio transceiver. The next day I took *Delta India Kilo* over to the Bell factory to check out her weight and have a balance test done with the auxiliary tank installed.

With only 24 hours to go before take-off every spare minute I had was booked in advance.

I started the day with a long interview with a local business newspaper reporter from my hotel room. Then I did some interviews with Fort Worth radio stations and the American "P.M." television show.

Last-minute checks and adjustments were made on *Delta India Kilo* at the Bell plant, which included fitting a new seat, adjusting the engine idling speed and checking the VLF Omega again. I also ran a film through the camera to make sure everything was working properly.

After giving more interviews, I felt exhausted but I did my best to send everyone away satisfied. One of my last chores for the day was to pack the helicopter with charts, emergency food, films and clothing. I now felt that I was on the way at last. Before going to sleep that night I wrote in my diary:

'... the biggest and most exciting adventure of my life starts tomorrow and I'm not too sure on how it will go — but aren't I lucky to be able to attempt it?''

GREENLAND

ICELAND

BAFFIN
ISLAND

CANADA

NEWFOUNDLAND

North Atlantic Ocean

GREAT
BRITAIN

IRELAND

Portmarnock
left 6.35am Thurs

1pm Thursday

Pennfield Ridge

landed 12.45pm
Friday

MOLLISON'S FLIGHT ACROSS THE ATLANTIC

James Mollison made the first solo east-to-west crossing
of the Atlantic Ocean in a fixed-wing aircraft on 19 August 1932.
The 3000-mile journey from Portmarnock, Ireland, to Pennfield
Ridge, Canada, took 30 hours and 10 minutes to complete.

New York daylight time used

PART ONE

FORT WORTH TO LONDON

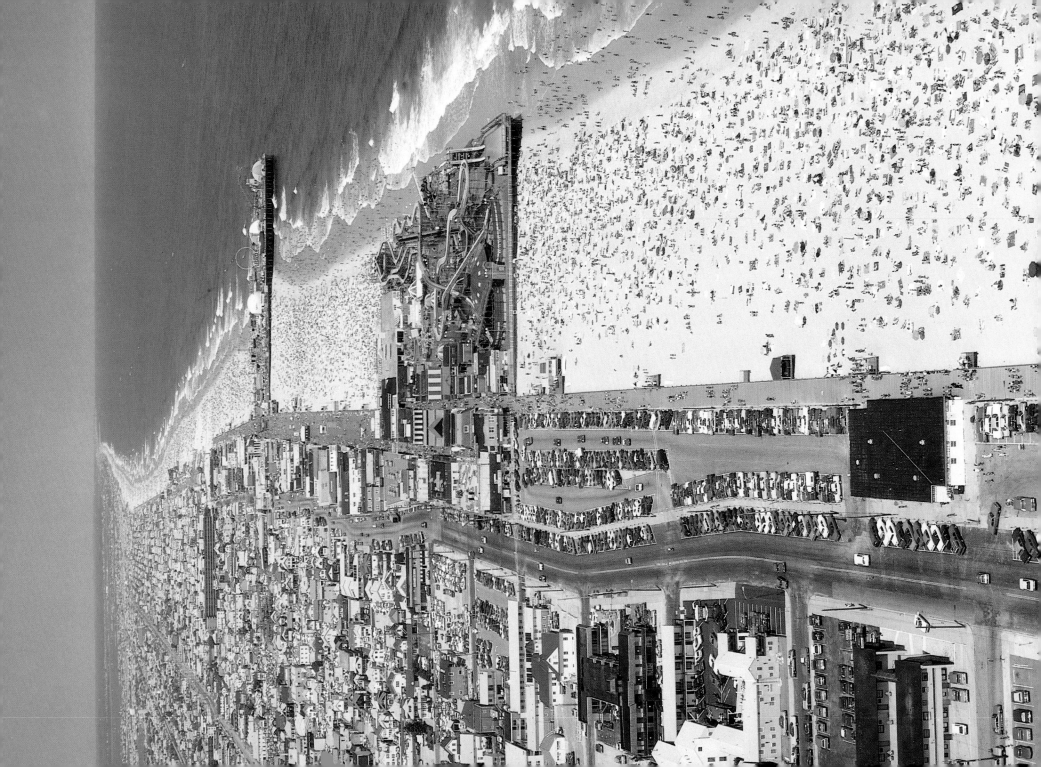

"Dick Smith Day"

TEXAS

Gulf of Mexico

<table>
<thead>
<tr><th colspan="7">AUGUST</th></tr>
<tr><th>S</th><th>M</th><th>T</th><th>W</th><th>T</th><th>F</th><th>S</th></tr>
</thead>
<tbody>
<tr><td>1</td><td>2</td><td>3</td><td>4</td><td>5</td><td>6</td><td>7</td></tr>
<tr><td>8</td><td>9</td><td>10</td><td>11</td><td>12</td><td>13</td><td>14</td></tr>
<tr><td>15</td><td>16</td><td>17</td><td>18</td><td>19</td><td>20</td><td>21</td></tr>
<tr><td>22</td><td>23</td><td>24</td><td>25</td><td>26</td><td>27</td><td>28</td></tr>
<tr><td>29</td><td>30</td><td>31</td><td></td><td></td><td></td><td></td></tr>
</tbody>
</table>

Above: How it all began. DELTA INDIA KILO on the production line at the Bell Helicopter factory in Fort Worth, Texas

Left: Holiday-makers pack the beaches on the Atlantic seaboard of the United States. Amusement piers, boardwalks and entertainment parks were a common sight on my track up to New York City

I awoke at 5 a.m. on 5 August with that exciting Christmas Day feeling I used to have when I was a boy. Today was my personal D-Day, the day it all began to happen. There was no turning back now. I turned on the television set to get a weather forecast. It did not look too bad; generally good in the Fort Worth area, with hot southerly winds, but I could be flying into thunderstorms later in the day.

After a light breakfast I drove over to Field Tech Avionics. *Delta India Kilo* looked absolutely beautiful, shimmering like a great dragonfly in the early sunlight. I had her refuelled and keyed the waypoints into the VLF Omega for the first leg of my flight. This instrument gives an actual position on the earth's surface. Waypoints are keyed into the VLF Omega prior to take-off and are used as check points during the flight. I checked everything once again and flew across to the Bell plant, which was to be my official departure point.

The morning was already very hot when I reached the Bell field at 7.50, but that had not deterred the press: there were more than 30 reporters waiting for me. Before talking to them though, I had some personal business to attend to; I called Pip in Sydney where it was midnight. After an all too brief conversation I faced the journalists yet again. I must say I got terribly tired of the same question over and over again. "Why are you doing this?" I gave them the same answer as I had given the "P.M." people, "Because it's a new way of looking at the world. It's like riding a magic carpet and I want to see it this way." I could not help wondering how many times I would have to answer this question by the time the adventure was over; hundreds probably. However, I did my best to be cooperative as I had a responsibility to give my sponsors value for money for their support.

By the time I had finished with the press quite a crowd had built up — Bell staff, civic dignitaries and just plain onlookers. At 10 a.m. I was invited to mount a little stage which had been specially erected for the occasion. Bell executive Marty Reisch then

17

made a short introductory speech before handing over to Jack Horner, Vice-President of the company, who introduced the Acting Mayor of Fort Worth, Richard Newkirk. Mr Newkirk made a warm and flattering speech about me and he announced that the Fort Worth civic authorities had declared 5 August 1982 as "Dick Smith Day". He gave me a letter of proclamation from the Mayor to take around the world with me. He ended by saying, "We wish you Godspeed and we will be here one year from now to welcome you back."

My friend Cliff Kalister of Bell gave me two more letters to carry around the world. What with the letters everyone gave me, and the souvenir covers I was already carrying, I felt like a flying postman. In addition, there were a few personal presents: a huge Texan hat (white, of course), a Texan belt and a Texan flag. Nobody could accuse the Texans of not being proud of their State.

And then it was time to go. *Delta India Kilo* lifted off at 10.31 a.m. Fort Worth time (15.31 GMT) and I took off to the south, but swung back over the field so that I could set the VLF Omega to the way-point, marking the start of the whole flight. I turned my movie camera on to film the waving crowd and headed on 347° (almost due north) at 1200 feet above ground level to get around the Dallas-Fort Worth air control zone. I had cleared the zone and was turning north-east to get on course for my first stop at Memphis, Tennessee, when I found I had company. Two television helicopters came up alongside me, each carrying a cameraman who busily filmed me as I came on to course for Memphis. I returned the compliment by filming them.

Now I was well clear of the heavily populated Dallas-Fort Worth region with the real Texas unrolling beneath me. I was surprised at just how amazingly lush and green it was. It was easy to understand why the Lone Star State is one of the richest in the United States.

I began checking the VLF Omega against the various waypoints on my Memphis route and found it to be extremely accurate. Not that its accuracy was really needed at this stage of the journey because the countryside below me was liberally dotted with VHF Omni Range stations (VOR), and so I could

have fixed my position at any time. Still, it was reassuring to be carrying a reliable piece of equipment which would certainly be used to the limit on later legs of the flight.

My route to Memphis took me over Aero Valley, Blue Ridge, Paris (named after the original Paris when it was founded in 1844), Hot Springs and then across the magnificent Red River, which really is red, a deep rich red caused, I understand, by the rich silt it carries.

The Red River, at the point I crossed it, forms the border between Texas and Oklahoma, but I was not in Oklahoma airspace for long. I flew over the Oklahoma State line into Arkansas on a track which took me over Hot Springs National Park — more beautiful green country.

Approaching Hot Springs, 48 miles away, I made my first contact with American traffic control. "Hot Springs tower. This is helicopter *Victor Hotel Delta India Kilo*. Do you copy?"

After another call the Hot Springs tower came up with a rich Deep Southern accent such as I have only heard at the movies before.

After traffic control had given me some local radio traffic instructions, I said, "I wonder if you can help me? I'm an Australian helicopter just flying for the first time in the United States. Could you tell me, if I transit over Hot Springs at 2000 feet on my way to Memphis, am I OK?"

"Affirmative," replied the rich voice. "That'll be all right. No problem." He then gave me the frequency for Little Rock and signed off after hearing that I was flying around the world: "I hope you make it, sir!"

Approaching Little Rock about 18 miles out, I discovered that I was 3.75 miles to the right of my intended track. I had underestimated the wind, which just goes to show that with even the most sophisticated equipment there is still room for human error and natural forces.

After I had contacted Little Rock tower I said, "I bet you don't get many Australian helicopters flying around here."

A rather puzzled voice replied, "*Delta India Kilo* say again?"

I repeated that I was an Australian helicopter.

19

"Australian, eh? We wuz bettin' you wuz English or sumthin'. Wasn't quite sure."

"No, I'm Australian. I'm heading around the world. It's the first around-the-world solo helicopter attempt."

"Well, good luck," said the American. "Watcha gonna do with all the big water there?" meaning the Atlantic. "Put it on a boat and sail it over?"

"No, I'm going to fly it over the North Atlantic via Greenland and Iceland. I'll keep flying it all the way, I hope. I've got a big tank in the back which gives me about 700 miles range."

"Oh, very good," said the controller. "Good luck to you."

I could imagine the headshaking in the tower over that crazy Australian.

Meanwhile, the morning had become hotter with a lot of haze developing. There was a great deal of chatter from the ground as I flew over towns and villages along my track. The traffic controllers were just fantastic but some of their accents were hard for Australian ears to decipher. All the controllers in

Finding the Energy Exposition at Knoxville was no problem — I just homed in on the great golden dome (top right). The Australian Pavilion is in the foreground on the right. I was later to begrudge the dent the Knoxville stopover had made in my schedule

Alabama and Tennessee sounded like Elvis Presley.

About 20 miles before Memphis I got a real thrill when I crossed the mighty Mississippi — Old Man River himself, writhing across the plains like an enormous fat serpent; a most impressive sight. It is no wonder the Indians called it the Father of Waters, and Mark Twain chose it as the backdrop for Huckleberry Finn's adventures.

A huge barge was labouring upstream and having a battle against the strong current. I filmed the barge and some views up and down the river, and was all set for the run into Memphis when I found to my annoyance that my radio frequency book, called the *Airport Facility Directory*, had fallen down the far side of my map box in the seat mounting.

I flew in circles above the Mississippi scrabbling vainly for the book and trying, without success, to get Memphis on the radio. Finally, I gave up and landed *Delta India Kilo* on an island in the river, jumped out, ran around the helicopter, opened the passenger door and retrieved the book.

Being down on the Mississippi, and luckily not in it, was a great thrill. It gave me another opportun-

21

ity not to be missed. I ran down to the water's edge and scooped up several cupped handfuls of Old Man River, and it tasted pretty good, probably because I was very thirsty. I managed to film myself doing this by holding the camera at arm's length. Not quite a Cecil B. De Mille technique, but it worked. I was already discovering the advantages of flying around the world by helicopter. There is no way a fixed-wing plane could land on an island in the Mississippi.

Then it was into the air again and up the river to Memphis where I touched down at 2.25 p.m. local time. The first leg of my journey had taken three hours and 54 minutes, covering 392 nautical miles – only 30,000 left to go!

Memphis was hot at 38°C. While the helicopter was being refuelled I was asked by a reporter, ''. . . and why are you doing this Mr Smith?'' After 34 minutes on the ground I was in the air again and heading for Knoxville, Tennessee. I had been asked to visit the Australian Pavilion at the 1982 World's Fair being held there.

Once clear of Memphis International Airport I ran into isolated rain showers most of the way to a small Alabama hamlet called Muscle Shoals, where I decided to use the VLF Omega to track direct to Knoxville because a heavy haze had reduced visibility to a few hundred yards. By now I was over the green and beautiful southern Appalachian Mountains. The Appalachian rural communities are among the poorest in the United States.

I was vectored into Knoxville by another pleasant traffic controller and got lost for the first time! I just could not find the helipad at the World's Fair. I flew around in circles, feeling increasingly foolish until helped by the patient controller, I finally spotted the pad in between two expressways and landed in front of a large group of Australians and Americans who had gathered to welcome me.

After greetings and courtesies had been exchanged I flew *Delta India Kilo* to the local airport, beautifully situated on an island in the Tennessee River. A helicopter owned by the Vertiflite company returned me to the fair.

I was very impressed with the Australian display. In fact, I felt terribly homesick and

AUGUST

S	M	T	W	T	F	S
1	2	3	4	5	6	7
8	9	10	11	12	13	14
15	16	17	18	19	20	21
22	23	24	25	26	27	28
29	30	31				

wondered why I had left my wonderful country on this mad adventure. It was great to hear Australian accents again, and to talk to Australians such as John Madden, Deputy Commissioner-General of the Australian Pavilion, Fiona Thompson, the protocol officer — with a *real* Aussie accent — Brian James, the pavilion manager and Helen Silk, a Qantas hostess who had been seconded to work as senior hostess at the pavilion. Altogether, a great team to represent Australia, and they made me very proud.

I had landed at the World's Fair at 6.34 p.m. after six hours and 59 minutes in the air and 775 miles into my journey. Not bad for the first day's run I thought. I spent that night in the luxury of the Knoxville Hyatt Regency, a magnificent hotel.

After a good night's sleep I awoke at 6 a.m. This was to be one of the longest lie-ins I was to have for a while. I worked on my flight plan for the day, handling all the documentation myself because Jim Heagney was already in Washington DC, making arrangements so I could fly over and film the city.

The flight plan and associated paperwork took me most of the morning. I later checked the helicopter from nose to tail, repacked everything and phoned my flight plan through to Knoxville air traffic control.

I also took the precaution of phoning Roanoke Flight Services, Virginia, a city about 200 miles north-east of Knoxville, which is on my calculated track to Washington. I had begun to regret my stopover at Knoxville. I was about to fly into rain and a ceiling of less than 1200 feet above ground level. My original plan was to fly from Memphis to Greenville, South Carolina, and then to Washington, keeping me well south of the Appalachian Mountains. By diverting to Knoxville to visit the Australian Pavilion, I had put myself in the middle of the Tennessee Valley and in the southern end of the Appalachian chain.

I left Knoxville at 11.56 a.m. turning north-east, after taking some still pictures and film footage of the area and of the World's Fair from a mandatory height of 1500 feet above sea-level.

Later, I was flying over huge dams — a part of the vast Tennessee Valley Authority irrigation and

hydro-electric power scheme. The TVA was established in 1933 and provided work for thousands of people during the Depression. I remembered reading about the dams at school, and I thought what a fantastic chance I had been given to learn more about geography. Pity every school child could not have a flying carpet like mine.

Navigational checks, using ground stations to verify my VLF Omega's figures, showed that the VLF was still very accurate. They also indicated that a tail wind was pushing my planned ground speed of 110 knots up by 10 knots.

Soon it was brought home to me in no uncertain terms that I was still in the Appalachians, skirting several high peaks. Once I climbed to 5000 feet, the highest I had ever flown in *Delta India Kilo*. I contacted Roanoke control again to get a clearance to fly over them on my track to Washington. I was asked what time I would be arriving as a large number of media people were waiting for me in the capital. All around me I could see signs of the weather closing in. I told Roanoke I would advise them later. Right now I was busily engaged in working out how I was going to get there without getting lost or being forced to land. Roanoke then suggested a southwards diversion into Washington over Lynchburg instead of via Charlottesville, further north.

"You're aware that the weather up at Charlottesville could be very bad?" Roanoke asked.

"No, I wasn't aware of that."

"They have minimums there, sir."

Minimum ceiling and minimum visibility. Surely I was not going to be grounded by bad weather on the second day of an around-the-world attempt. What a letdown!

After further conversations with the traffic controllers I consulted my map and saw that a railway line followed a river through the mountains to Lynchburg. I found the river and followed it in rapidly deteriorating weather at an altitude of 500 feet. Heavy rain cut visibility to almost zero, and by the time I had flown around several torrential showers I was temporarily disorientated. The VLF Omega would have given me my correct position instantly, but it is impossible to look up complex

Above: One of Washington DC's famous buildings — Lincoln Memorial. The tall white tower in the background is the Washington Monument

Left: Tracking through the Appalachian Mountains north of Knoxville. Minutes later the weather closed in, with mist and rain reducing visibility to almost zero

navigational coordinates when flying a helicopter at 500 feet in poor visibility. So I dialled up the Lynchburg VOR ground station and found that I was actually north-east of the city, about 12 miles out.

By now I was circling in a small — very small — reasonably clear patch without any rain over a railway bridge and thinking seriously of landing. I found the Lynchburg tower frequency marked on my chart and called them up. The response was almost instantaneous; the controller was obviously listening for me. I asked him if he knew whether the railway line went to Washington. He came back minutes later and told me to fly north-east along the line for a few miles until I intersected with a road which would take me to Washington. Suddenly, another aircraft broke in and asked whether I was in a car or a plane.

I did not comment; I then flew down the line and found the road. The next 40 miles were almost impossible. I flew down the highway at a very low altitude in appalling visibility through heavy rain showers, keeping a constant watch for high towers, electricity pylons and similar potentially lethal ob-

25

jects. At last I turned off the highway and cut across country towards the Potomac River. After a false start — I had to turn back and try a slightly more easterly approach — I finally found the river, which I crossed flying very low at 40 knots in pouring rain with the other bank just visible. This at least gave me a slight horizon in the generally bad visibility. Below me the water was smooth and pocked with raindrops but I was careful only to glance at it. It is easy to become disorientated and fly straight into water when flying low over it.

While crossing the wide river I tried without success to raise Washington control tower. The eastern shore of the Potomac — or at least the part that I had reached — was very heavily forested. I could see what looked like holiday shacks and other houses under the trees. I was still unable to raise Washington and was becoming worried by the deteriorating weather, so I decided I would have to land. I considered it would be most unwise to blunder about without any radio contact while I was in the neighbourhood of a strange and busy airport in this limited visibility.

Landing was easier said than done. The river beach was far too narrow with trees overhanging the water. Then I spotted a fair-sized paddock and made my landing approach in light rain. Just as I was about to set down I could see by the movement of crops growing in the paddock that they were about half a metre high. As I could not see the ground beneath the crops, I was unable to estimate how hard it was. A landing in boggy ground or deep mud would be unpleasant to say the least. *Delta India Kilo*'s tail rotor could be damaged, or at least chew up whatever plants were down there which would certainly upset the farmer, so I put on power again and lifted back into the rain.

To the south I saw one of the holiday shacks with an old man standing in front of it. The rain was getting heavier, so there was no alternative but to put the helicopter down on the road in front of the shack. I jumped out and ran over to the old man who had been joined by a youth of about 19. I asked them if I could use their phone, and if they minded me landing on their road. They did not mind,

26

they said with amazed looks on their faces, so I shut down the helicopter.

The nearest telephone was at the nearby house of the lad's parents, among the very green trees on the banks of the Potomac. I got through to the Washington tower controller and explained where I was. Initially he thought I was still in the air, but when I explained my around-the-world attempt and that I was phoning for a clearance from a farmer's house, he laughed and said pilots normally remained in the air and radioed for clearances. However, he was quite happy to give me mine over the telephone.

Because of the shocking weather I asked, with some trepidation, if it would be possible for me to bring the helicopter into Washington. Flying a helicopter in such conditions in Australia would not normally be allowed, especially in a control zone. No trouble said the tower. Washington National Airport was closed for all but Instrument Flight Rule aircraft. To fly under IFR the aircraft must be equipped with special instruments which I did not have. The tower saw no problems if I made my approach hugging the left bank of the river at a very low altitude.

I went out into the rain again where a crowd of very wet locals were gaping at *Delta India Kilo* with her foreign insignia, parked on their road.

I quickly took a few photographs for the record and headed up river in the rain, flying very low. I saw bright flashes through the rain. They were warning lights strung on huge power pylons straddled across the river ahead of me. I swung across the river with the powerlines, filming them, and picked up the west bank. I tried to raise Washington tower but without success. I was flying far too low to expect good radio reception. I could not get any sort of navigational signal either, so I used my chart. After a short while I entered Washington control zone, and managed to contact the Washington National tower. They were obviously busy and I received some rapid-fire, sparse instructions to keep coming but to stick to the west bank of the river. I had five miles to go by my calculations and they were confirmed by the VLF Omega.

27

It seemed unfair that at the end of a long and busy day I should suddenly be saddled with so many new anxieties. I was approaching the capital of the United States in dreadful weather, with no idea of what to do next. The murky skies, it seemed, had suddenly become full of aircraft heading for Washington National Airport. With cloud at less than 500 feet and steady rain I was suddenly surrounded by big fixed-wing aircraft, Boeing 727s mostly. One 727 passed within 500 feet of me as it came in and out of a nearby cloud.

One has to admire traffic controllers. Those at Washington that day had their hands full. Despite the weather, aircraft were taking off and landing every few minutes. The controller was talking 19 to the dozen. His messages to me were so short and rapid that I could not keep up with him, so I just kept going, hugging the left bank of the river and keeping very low as I had been instructed.

Suddenly my controller was back on the air wanting to know if I knew where the heliport was situated? Of course I did not, and quickly told him so. I was in sight of the airport now, so he asked if I could see a "green-topped plane to the north of the tower". Well, I could see several aircraft that

Right: The popular holiday resort of Little Egg Harbour, north of Atlantic City on New Jersey's coastline

Below: Forced down by heavy rain near the Potomac River. Robert Shelton, a local, let me use his telephone to call Washington airport

answered that description, and I was just about to add to his troubles by telling him so when I saw a crowd of people standing around one of them. I came in quickly, far too high, making a very bad downwind approach and landed. I was utterly physically and mentally exhausted.

Jim Heagney was there of course, shepherding the rest of the crowd, consisting mainly of media people. Jim told me that before I landed one of the cameramen had asked him to get me to go up again and make another circuit so they could get better pictures. Jim rightly told them that I would be too tired for any extra joy-rides. But I did manage a few television interviews and I think everyone went away happy.

Also there to meet me was Michael Norris, Qantas sales manager for the south-eastern United States. He handed me a Foster's and was most surprised when I did not drink it. He just could not believe that he had met an Australian who did not drink beer. It is true though, I have never been able to stand the stuff.

The welcome over, we refuelled and Jim drove me to the local Howard Johnson motel. I called Pip in Sydney while Jim had a few drinks with the Qantas people and others who had accompanied us from the airport.

Later that evening we watched the CBS television news and saw the segment on my arrival. It was a fair enough report but the newsman rather spoiled it by concluding, "Well, what else can you expect for a dull Friday?" I am sure the cynical reporter would have been far happier if he had had a few more murders or muggings to feature.

I had dinner with Jim that night and we had a long discussion about the media which was, even at this early stage of the flight, taking up far too much of our time. In future I wanted him to concentrate on the flight organisational details. Otherwise, I could see I would be handling more and more of the paperwork. With this added to the burden of flying the helicopter, filming, taking still photographs and making a running commentary for this book, it would amount to an intolerable burden. I was already having some qualms about the

AUGUST

S	M	T	W	T	F	S	
	1	2	3	4	5	6	7
8	9	10	11	12	13	14	
15	16	17	18	19	20	21	
22	23	24	25	26	27	28	
29	30	31					

workload I had set myself. A load that was to become almost more than I could handle as the days passed.

The next morning dawned dull and cloudy. I left Jim sleeping in, caught a bus out to the airport and made a thorough check of *Delta India Kilo* and the cameras. Jim arrived with the flight plan at 11 o'clock and briefed me on the next leg to New York over Delaware Bay, running up the eastern seaboard. I was delighted to find that he had also been able to arrange for me to film the famous Washington buildings from the air.

I was airborne at 11.54 a.m. and received permission from Washington tower to fly around the city at an altitude of 500 feet at 60 knots, filming the Washington Monument and other landmarks. I had to keep a respectful distance from the White House; there are very strict rules controlling the airspace near the President's residence. It was rather nerve-racking flying the helicopter while taking movie and still pictures, and at the same time avoiding restricted airspace and making sure I did not collide with any of the many jet aircraft departing over the Potomac from Washington National Airport.

Filming completed, I left Washington on a course over Chesapeake Bay, south of Baltimore, then over Delaware Bay to the famous holiday resort of Atlantic City. I discovered that the VLF Omega did not agree with my flight plan figures. I adjusted this and settled down for an easy run in sunny weather which had changed from being overcast.

Crossing the busy waterway of Delaware Bay at 1000 feet I heard the US Coast Guard on my VHF marine transceiver preparing to go to the rescue of a boat in distress, and later I saw their helicopter on its way. The wonderful visibility from the helicopter was certainly letting me see the world in a way it had never been seen before.

I sighted the Atlantic Ocean at 1.17 p.m. — a vast, shimmering blue-green shadow stretching to the horizon. It looked calm and friendly enough, belying its frightening reputation. I was going to be seeing a lot of this ocean and I hoped it would stay in its present mood.

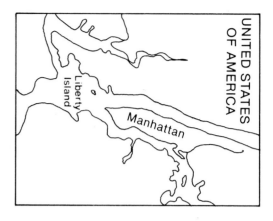

UNITED STATES
OF AMERICA

Liberty
Island

Manhattan

Circling the
Statue of Liberty

I handed over to the autopilot and cruised along at 500 feet in beautiful weather, warm and smooth. It was an absolutely ideal flying day and a welcome contrast to the frightful weather with which Washington had welcomed me.

Then the incredible sight of Manhattan towers soaring into the brilliant blue sky came into view at 1.40 p.m. I was very excited. I shall never forget it. Oh, I knew all about New York: about the pollution; the corruption; the filthy, unsafe subways; the robbers, rapists and muggers lurking in the concrete canyons below those glittering spires. I knew all that, but my first sight of Manhattan on my world flight was one I will never forget.

I grabbed my still camera for a couple of photographs as I flew in over the magnificent Verrazano Narrows Bridge, the world's longest suspension bridge. It was named after the Florentine navigator who explored the north-eastern coast of America in 1524.

In a few minutes I had achieved an ambition that I had dreamed about for two years — I had circled the Statue of Liberty on Liberty Island in my own little helicopter.

Unfortunately, my sightseeing around the lady with the torch, originally named Liberty Enlightening the World, was curtailed by the same problem I had been faced with in Washington — other aircraft. The air over New York was incredibly busy with light aircraft like bees around a honey pot. I veered away and decided to head up the East River and land at the Pan-Am heliport, officially called the Metroport, beside the East River and next to the East 60th Street Bridge. On my way I flew over the striking Brooklyn Bridge, and flew back and forth a few times alongside that famous skyline to get some still pictures and film. The towering Empire State Building was clearly visible.

After informing the Metroport of my arrival

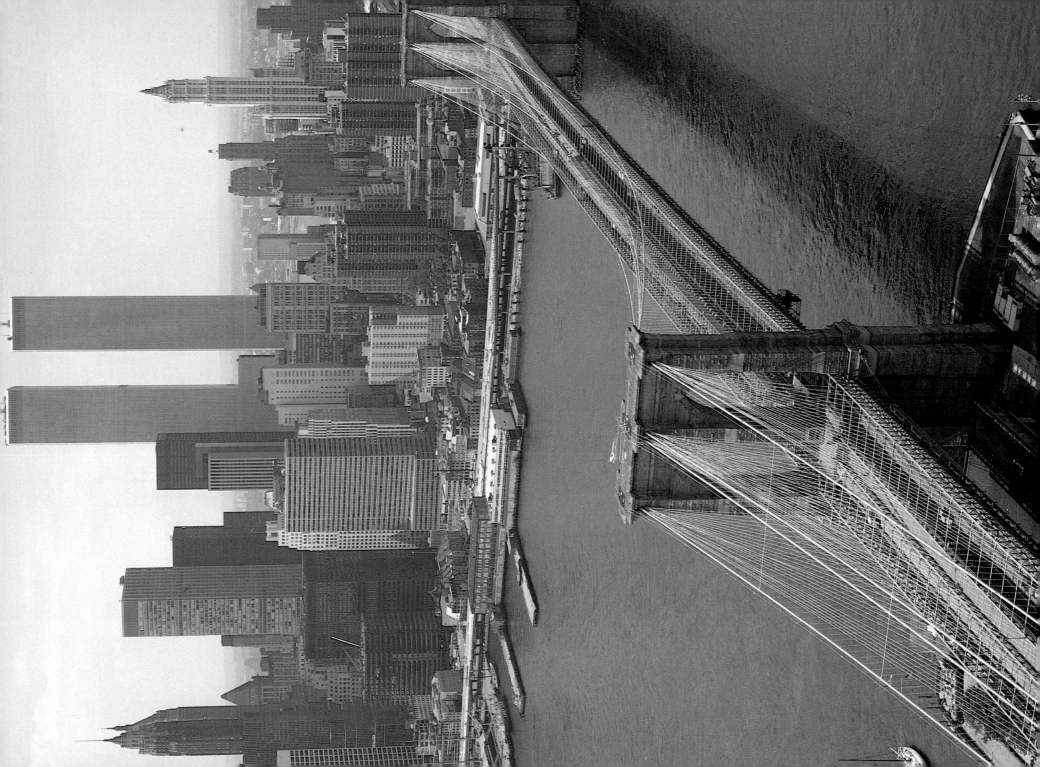

Above top: Refuelling on Manhattan's East 34th Street helipad. In air-minded New York, helipads are dotted around like service stations in an Australian city

Above: A dream comes true! For years I had dreamed about flying around the Statue of Liberty in New York's harbour

Left: Departing Manhattan I flew down the East River, over the famous Brooklyn Bridge

I came in from the north, flying into a 10-knot southerly wind, and landed beside a Bell 222 Twin helicopter in a very restricted space. The small size of the New York Metroport would never be allowed in Australia.

I should mention that even though I was within a few miles of both John F. Kennedy and La Guardia international airports, I was not in their control zones. The Americans are sensible enough to have special low-level lanes so that helicopters and float planes can operate outside the busy controlled traffic areas. I only wish we were that wise in Australia.

Waiting for me was Richard Haas, Qantas manager in New York, and, of course, a crowd of photographers, one of whom annoyed me immensely by asking me to do the most impossible things with the helicopter. After dealing with the media I was very glad to catch a taxi to my hotel, the Hilton Vista. It had been a really good day's flying. If only they could all be like that.

I had intended this to be a lay day, with no flying so that I could fix any teething troubles that may have occurred with my brand new helicopter. But as everything was going so well I decided to press on. I worked on the flight plan for the next leg, New York to Boston, Massachusetts, 170 miles away, while Jim, whom I had beaten to New York, did the calculations for the 365-mile leg after that from Boston to Moncton, Canada. If the good weather held I hoped to do both legs, a total of 535 miles, in one day.

After checking the aircraft, changing the film and keying in all the waypoints, I took off from the Pan-American Metroport at 12.10 p.m. with fuel running low. I dipped down to the East River, flying under the East 60th Street Bridge, to head downriver to find a heliport where I could refuel. New York is so aircraft-conscious that there are heliports scattered around the city the way service stations are in Australia. The heliport I wanted on East 34th Street was full. Queuing up in a car for petrol is one thing; circling in the air above a foreign city with one eye on the fuel gauge is quite another! There was nothing else I could do. I just circled and kept tuned in to the heliport's frequency until they

33

had a spare landing berth. As soon as they had room I flew in and landed between two other machines and was told not even to shut down. The attendant ran out, grabbed my American Express card and began pumping in the fuel. Within minutes I was on my way again very heavily loaded. In the hot and hazy weather I had to drop down low over the river to get the extra cushion of "ground effect" (downwash from the main rotor creating an area of high pressure) before I got enough lift to climb out. I was soon screaming along at 500 feet and up the coast past the Statue of Liberty and close by the John F. Kennedy International Airport.

Clear of New York I flew along the coast over some beautiful beaches and had a bad fright when I almost flew into a kite. Kites are the last thing you would expect at 500 feet but there were several flying at that height when I left the area and turned towards Boston. I always fly as low as I am allowed because I can see far more. Most people waved to me and this always lifted my spirits.

I soon ran into thick haze and very limited visibility. Cruising at 1000 feet on autopilot I was advised to climb to 2500 feet after calling Providence control, but found there was even less visibility. Finally I got in touch with the tower at Boston's Logan International Airport where I was cleared to fly straight in:

"Just track straight for the helipad," the traffic controller said.

"I don't even know where Logan Airport is, let alone the heliport," I replied. Help was at hand in the shape of a big British Airways Boeing 747, inward bound for Logan. I just followed the jumbo in, finally saw the helipad and landed smoothly.

At this stage I was feeling a little apprehensive as Logan was to be my official "exit port" from the United States. I would have to do all the paperwork as Jim had flown directly from New York to Moncton in Canada. I was in luck because, on landing, Bruce Thatcher, an assistant operations supervisor at the airport, met me and very kindly helped with all the paperwork. We drove around the field at breakneck speed in his official truck to arrange refuelling, flight-plan filing and presentation of

declaration forms. I was in the air again at 2.55 p.m., 45 minutes after landing. Without Bruce's help I would have spent hours walking from the customs to the flight planning and meteorological offices, which is a fair hike.

Almost before take-off I was in minor trouble. I found the controllers' New England accents almost impossible to understand. Then I had to hover downwind while waiting for take-off clearance, not easy with a heavy helicopter on a hot day. It was over 35°C. The Logan tower cleared me in a north-westerly direction when I wanted to go to the north-east, and then they seemed to forget all about me while I flew on in a direction almost at a right angle from the one in which I wanted to go.

After about 10 minutes I became worried. I was at 1000 feet and felt sure there could be high hills or even a radio tower hidden by the haze. I called the tower and was finally acknowledged after four attempts. They curtly told me that I was clear of their zone and free to fly in any direction I wanted to. I got the impression that if I had told them I was setting course for the moon they would not have cared much.

I was now at 1000 feet in a heavy smoke haze. Swinging north I was unable to raise any of the flight service frequencies. Turning towards the coast I descended to 500 feet in atrocious visibility.

My route took me out of Massachusetts into New Hampshire and then Maine, over country which would have been beautiful if it had been vis-ible through the haze which became rain and fog as I headed further north. By the time I had overflown the small town of Ellsworth I had closed in on the United States-Canadian border.

My first Canadian waypoint was Pennfield Ridge. This was particularly important for me because James Mollison had landed there after his first ever fixed-wing solo crossing of the Atlantic from east to west. Mollison had landed at Pennfield Ridge on 19 August 1932, and I planned to land in the United Kingdom on 19 August 1982, 50 years later to the day. Flying between Pennfield Ridge and St John, a biggish town on the coast, I picked up the highway. The St John control gave me clearance to

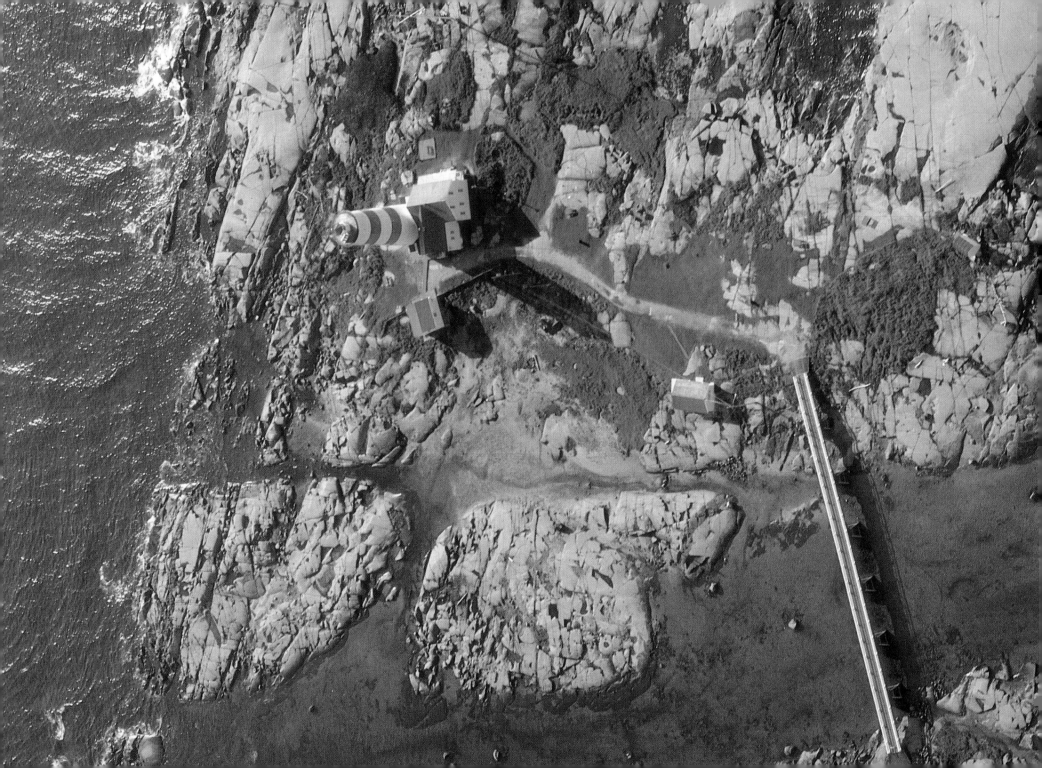

fly through their zone under Visual Flight Rules at 500 feet. (VFR allow flying operations to be conducted on a "see and be seen" basis.) They also suggested that I turn inland for a while to avoid fog which was closing in along the highway route. But after a long and trying day I just was not game enough to risk losing the highway and then have to start looking for it again while flying over strange country with rapidly deteriorating visibility. I had read about the dreaded Newfoundland fog banks and now I was experiencing them, not feeling very confident. I was freezing in the cockpit and I was still wearing the lighter clothes I had worn in New York. So I flew steadily on over the bitumen ribbon with very little forward visibility and finally landed at Moncton at 7.22 p.m. — cold, tired and tense. Of course, at these high latitudes (Moncton lies just above the 46th parallel of north latitude) the summer evenings are very long, and it was still broad daylight when I touched down.

Jim had not arrived by regular plane, so I went through the inevitable documentation formalities. I telephoned Pip in Sydney and burst into tears. "I can't go on," I said, and sobbed out to her my tale of woe. I told her the VLF Omega had stopped working and the HF radio was also giving trouble. The tail rotor chip detector (for detecting metal chips in the gearbox) was indicating "on" and for a few hours the cockpit had been full of a smell of burning. I went on to say that I was completely exhausted from flying in very bad weather and I thought the flight was not possible for me to fly solo. Pip gave me reassuring words and suggested I sleep on it and reconsider in the morning. She would support me either way.

I arrived at my hotel, the Park House Inn, unutterably depressed. I could hardly eat and went to bed early but I could not sleep. Pip rang at 11.30 p.m. She had found the telephone numbers of some Canadian amateur radio operators willing to help me check the HF in the morning. I finally fell asleep berating myself for embarking on this mad adventure, exhausted by the shattering workload I had burdened myself with and missing my family dreadfully.

37

AUGUST

S	M	T	W	T	F	S	
	1	2	3	4	5	6	7
8	9	10	11	12	13	14	
15	16	17	18	19	20	21	
22	23	24	25	26	27	28	
29	30	31					

Monday dawned with wind and drizzle and more promised for the next day. This was serious. The only way I could possibly cross the Atlantic VFR was to follow a good weather (high pressure) system, and I was now in the middle of an extensive low pressure one. I did not know it at the time but the "low" was to plague me. I was to follow it for the rest of my trip to England.

Jim worked on the flight plan for my next leg to Wabush, a mining village in south-western Labrador, 480 miles away, and then to Fort Chimo, another 320 miles across rugged central Labrador. From Moncton the country would get wilder and the weather was almost certain to get worse as I flew further north. It was a sombre thought and made me reflect more than once on the wisdom of continuing the flight. But could I just tamely ship *Delta India Kilo* back to Australia and tell everyone, "Sorry folks, I just couldn't do it"? No, of course not. Not just yet, anyway.

Most of the faults of the night before were either non-existent or not all that serious. My problem was mainly my extreme fatigue and I could not operate the complex equipment correctly. The burning smell in the cockpit was caused when I accidentally knocked the landing-light switch and the lights had overheated the plastic shield. I was greatly cheered to find the HF radio working perfectly. I called a local amateur radio operator on it and also the Collins Company, who had installed the VLF Omega. The Collins experts gave me further hints on the operation of the VLF Omega. It worked perfectly from then on, so the problems could only have been caused by myself.

I also pulled off the tail cone and cleaned a small sliver of steel out of the chip detector. This was to be expected in a brand-new machine. The whole helicopter was given a thorough going-over and I gradually felt my confidence returning.

Everyone at Moncton was extremely kind and helpful. Before flying the Atlantic in a single-engine aircraft, the Canadian authorities require that all aircraft be inspected and that the pilots be checked as to their ability to undertake such a flight. Don McQuinn, the Deputy Superintendent for Air Regulations, was in charge of my inspection and

38

seemed very impressed with the preparations I had made for the trip. A real gentleman, he was interested in everything about *Delta India Kilo* as was the Inspector for Helicopters, Austin Hayes. Austin gave me a lot of advice about flying in New Brunswick, Quebec, and Labrador, the gist of which was, "Take your time . . . it's very dangerous!" Not the most cheering advice for a man who was already beset with doubts, but it was very sensible and well meant.

Gerry McCulley, a Canadian aviation official I had written to while planning the trip and who had since returned, came out to the airport to see me, which I thought was a fine gesture. And Doug McLaughlin, the Regional Superintendent for Flight Operations, helped me find my way around the airport. I could not help comparing the attitude of the Canadians at Moncton with that of the staff at American airports who seemed to be too busy to worry about a lone helicopter flier.

Later that day I went shopping for extra survival rations: sardines, canned peaches, chocolate, nuts and sweets. This little expedition made me almost unbearably homesick again. I thought of Pip and the girls and vowed that when I got home I would go shopping with them more often. Despite my homesickness the shopping trip did me good by getting me away from the helicopter-airport-hotel environment for a while.

Back at the hotel Jim and I went over some of the navigational problems that I could be facing in the next few days, including the vital formula for calculating the ominous-sounding "Point of No Return". And threatening and potentially deadly the PNR is. Once past its PNR, the helicopter would not have enough fuel to return to its starting point, a situation which could be fatal when flying over water and unable to continue because of bad weather at the planned landing point.

That night we had one of our best meals since leaving Sydney — fresh lobster. My bedside reading matter consisted of a very complicated book about the Collins VLF Omega system, and a rather frightening publication about flight information for pilots foolhardy enough to venture north of the 60th parallel.

Following pages, left: Heading north over the mountains of the Notre Dame Peninsula, I flew over this tranquil scene on Lac Casualt

Right: Flying north across Canada's Quebec Province, into country which grew steadily wilder, I followed the iron ore railway line from Sept Iles, on the St Laurence Seaway, to the town of Wabush

39

AUGUST

S	M	T	W	T	F	S
1	2	3	4	5	6	7
8	9	**10**	11	12	13	14
15	16	17	18	19	20	21
22	23	24	25	26	27	28
29	30	31				

Despite the rather disturbing picture that was emerging of the rough, cold country I was about to fly into, I would probably have got a good night's sleep if the desk clerk had not called me at three o'clock in the morning to say he had some telex messages for me! I told him rather irritably that I would collect them in the morning and tried to get back to sleep. It was well after four o'clock when I finally fell asleep and I slept solidly until awakened four hours later by another phone call, this time from my friend Fred Baker, a Sydney journalist. He told me that my clearance to proceed to Sondrestrom, Greenland, had finally arrived. I had slept so deeply that my watch-alarm, set for 6.30 a.m., had failed to wake me; something that had never happened before.

Jim and I drove in rain and wind beneath heavy low cloud to the airport where I learned that a warm front and a low-pressure area was developing on my planned track. At Sept Iles, my first landfall after crossing the upper reaches of the St Lawrence Gulf, visibility was down to half a mile with a ceiling of 400 feet. Obviously to try to fly there on Visual Flight Rules would be highly dangerous. The country was becoming increasingly mountainous and crisscrossed with heavy high-tension power cables.

After refuelling *Delta India Kilo* in heavy rain and getting absolutely soaked in the process, I gave an interview to the Canadian Broadcasting Corporation, and then sat down with Jim and Moncton Airport officers for a very thorough weather briefing.

My planned route was from Moncton to Chatham (a little town on Miramichi Bay, an inlet of the St Lawrence Gulf), across the Gaspe Peninsula to the seaport of Matane, followed by a 30-mile leg across the wide estuary of the St Lawrence River to Point des Monts (a promontory guarding the entrance to the St Lawrence River) and from this point I would track another 73 miles north-east up the coast to Sept Iles.

Back at the hotel more telexes were waiting for me. One from Ita Buttrose, Editor-in-Chief of the *Sydney Daily Telegraph* and the *Sunday Telegraph*, was especially inspiring. There was one from my

42

staff in Sydney saying that they knew I could do it.

After a phone call to Pip in Sydney I felt much better. Talking to her always acted like a tonic on me. By now the sense of gloom and hopelessness which had descended on me the day I arrived in Moncton had lifted and I was far more confident of carrying on with the flight.

It was the combination of bad weather and the heavy workload I had set myself which had got me down. Flying an aircraft in your own country is complicated enough but it increases tenfold in a foreign country with their different procedures and regulations. In addition to this I had the chore of operating the movie camera and a still camera and putting a running commentary on to my tape-recorder for this book as I flew along.

Flying the helicopter, taking pictures, taping and navigating would have kept me busy enough, but when the weather deteriorated several new elements were added. The autopilot — which enables the helicopter to fly automatically on a set course — could not be used because I was constantly weaving around patches of fog and rain. In these conditions I had to fly low and concentrate on flying so much that I could not even read properly the maps of the terrain over which I was flying, let alone look up and communicate on important radio frequencies. It all added up to total exhaustion.

Among the friends I made in Moncton was a local amateur radio operator, Marathon (VE IM2), who telephoned me at the hotel several times and then drove over to see me for a while. A charming man, retired, he spends the winters in Florida and the summers in a trailer in Moncton. He was one of the many Canadians I met who were so friendly and helpful that they did a lot towards lifting my depression.

That afternoon, after giving another television interview, I went to see one of Moncton's much-vaunted scenic attractions, the tidal bore. Moncton lies on the Petitcodiac River which, in turn, runs into the Bay of Fundy further south. The Bay of Fundy, a wide inlet of the Atlantic between New Brunswick and Nova Scotia, has the highest tidal range in the world — up to 20 metres at some phases of the

moon. This big tidal fluctuation produces a tidal bore at high tide, a sort of miniature tidal wave that roars up the river to Moncton.

Unfortunately, I picked a bad day to view the famed bore. When I arrived at the river bank several hundred other spectators were already there, including a man playing the bagpipes for some reason I never established. We waited and waited; the bore was late. Tide and time, we are told, wait for no man, but at Moncton that day a lot of men and women waited for the tide. Finally, 40 minutes late according to the tide table, it arrived. And what a letdown! Instead of the two-metre wall of rushing water the brochures had led me to expect, what eventually came upriver was a mere ripple about 20 centimetres high! I trust it is more impressive when spring tides occur.

After my rather abortive tide watch I returned to the airport and packed the helicopter, hoping to get away later that day. While I was out there I also put a Moncton stamp on the souvenir envelopes I was carrying. After checking the weather I realised

Above: After my night among the boulders of the Meta Incognita Peninsula, Baffin Island, I was glad to see dawn bring the promise of a clear day

Top right: Clouds thicken over Greenland as I approach the mountainous coast after a 290-mile flight across the icy Davis Strait from Cape Dyer. The JetRanger's cabin temperature was minus 10°C

Bottom right: Ominous clouds swirl over the airstrip at Sondrestrom, west Greenland, grounding DELTA INDIA KILO until the weather improved for my flight around the southern tip of Greenland to Narssarssuaq

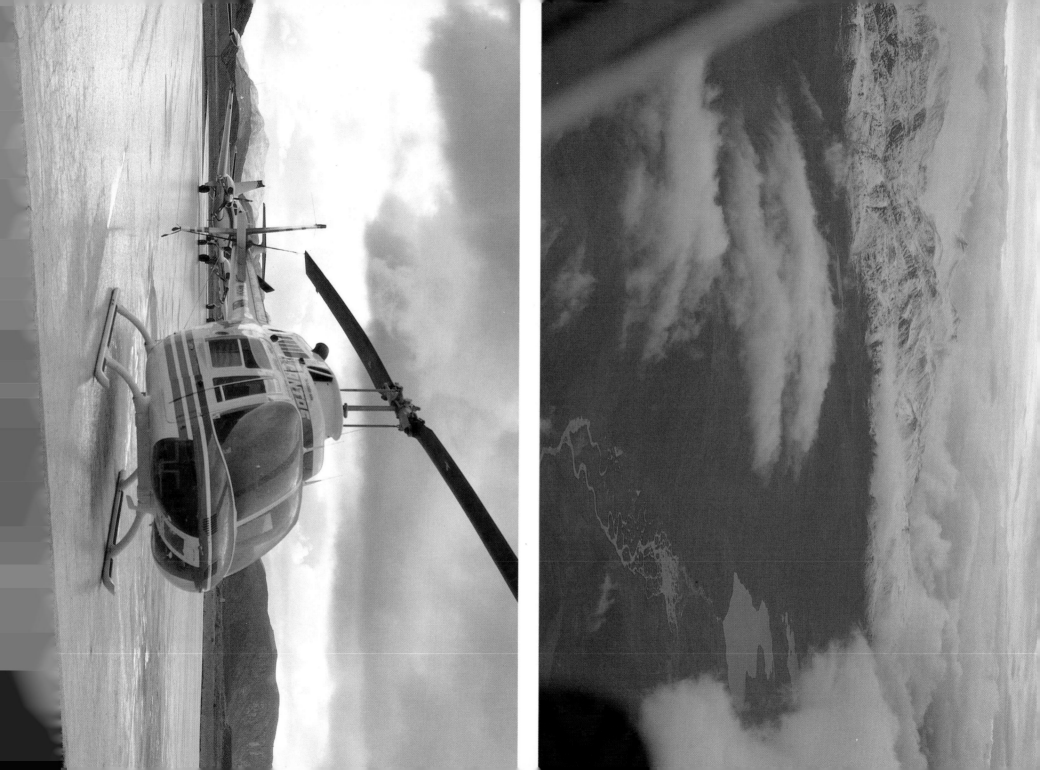

AUGUST

S	M	T	W	T	F	S	
	1	2	3	4	5	6	7
8	9	10	11	12	13	14	
15	16	17	18	19	20	21	
22	23	24	25	26	27	28	
29	30	31					

there would be no flying that day. Conditions further north were getting worse and the wind was freshening at Moncton.

I returned to the hotel and did some work on the flight plans with Jim. I was flying into inhospitable country and unpredictable weather leaving no room for error. Now, as we plotted my northwards track, I was encountering a phenomenon which would add to my workload. Because of my getting closer to the earth's magnetic pole, the variation of my magnetic compass was increasing by leaps and bounds. Even in Moncton, which is at 46° latitude north, the variation was 20°. I wondered what it would be like at Reykjavik, Iceland, more than 64° north. Normally, variation poses no major problem. It is printed on the navigational charts, and there are tables computed which show the necessary adjustment for variation. But when flying by dead reckoning and using a map it is very disconcerting as your compass always seems to be indicating a heading in the wrong direction. Pilots are always told to trust their instruments implicitly, but this is one case where trust in one's instruments has to be complemented by trust in one's arithmetic. After checking and double-checking the flight plan, Jim and I went out to the airport yet again and keyed the waypoints into the VLF Omega.

That evening Marathon Smith Leck invited me to spend the evening with him and his wife Ella in their trailer, and to use his radio equipment to talk to another Canadian ham, Brett Fader (VE IFQ) in Halifax, Nova Scotia. I accepted like a shot. The Lecks' trailer home is very large and fitted with all modern conveniences.

The talk with Brett Fader was very heartening. We discussed the frequencies on which Canadian amateurs and I would be able to raise one another. It was cheering to know that these people would be listening in for me on the long flight I had planned for the next day.

I woke at 5 a.m. to the realisation that this was the day I really set off into the remote north. The dangerous part of the trip was about to begin. Only a few hours' flying time away lay a remote, sparsely populated wilderness of snow, ice, glaciers

46

and jagged mountains. Beyond that lay the notorious North Atlantic. Pip called me from Sydney at 5.30 a.m. to make sure that I was awake and to wish me luck and 30 minutes later Jim and I were at the airport.

Moncton Flight Services thoroughly briefed me on the weather. There was good news and bad. The first part of the day's run — from Moncton to Sept Iles, some 300 miles — would be in good weather. That was the good news. I would be flying into north-westerly winds and, north of Wabush which is about 200 miles across the extremely rugged Quebec terrain from Sept Iles, the weather was described as almost impossible with rain at a ceiling of 500 feet and about one mile's visibility. Not ideal conditions for flying in hilly country. Unfortunately, the low-pressure system and the warm front were moving so slowly to the east that they seemed likely to continue affecting me.

Being a day behind schedule I was anxious to make up time if I was to keep my appointment at Balmoral Castle with Prince Charles on 19 August. So I filed a flight plan through to Fort Chimo, 800 miles from Moncton in the far north of Quebec. I hoped to press on for another 400 miles if I could.

At 6.54 a.m. I was airborne. Once clear of Moncton I was soon flying over dense, dark green forests at about 1000 feet.

Visibility was good but a 20-knot wind from the north-west cut my ground speed down to 98 knots. The VLF Omega was working perfectly, picking up all the stations I needed. After a while I turned north-west, heading straight into the wind, and flew into rough, mountainous country with heavy forests. An engine failure over this region could be fatal. Even if I survived a crash, there would be little chance of ever being found. I was grateful for the reassuring hum of the little Allison engine. I had started off by levelling out at 1000 feet, but I had to climb another 1500 feet to clear the mountains, flying around or between the higher ones.

Some time after leaving Moncton I had crossed the provincial border into Quebec Province which is fiercely French. The radio chatter I picked up was all in French.

Following page: Icebergs drifting down Davis Strait, between Baffin Island and Greenland, become shipping hazards in the North Atlantic

Two hours later I was flying across the St Lawrence River, my longest water crossing so far and it took about 15 minutes. I made sure my little life jacket was tightly strapped on and the life raft was free and easy to grab if needed. The maps indicated pack-ice on the St Lawrence crossing but as I was making the flight in summer the water was clear.

The St Lawrence is one of the great rivers of the world. It runs, officially, from the island of Anticosti in the Gulf of St Lawrence to the eastern exit of Lake Ontario, a distance of 1200 kilometres. It forms part of the great system of lakes and rivers that stretches for 4000 kilometres across North America. It is also the beginning of one of the greatest engineering feats in the world — the St Lawrence Seaway. This enormous complex of locks, dams and canals was begun in 1954 with the object of making the Great Lakes accessible to ocean-going ships, thus opening up the heartlands of Canada and the United States for development.

I called up Sept Iles as I flew across the St Lawrence but could hear nothing but voices in French. Finally, to my relief, I raised the Sept Iles traffic controller who instantly changed to excellent English. He gave me permission to track directly to Waco, high in the mountain and lake country as originally planned, instead of passing over Sept Iles. I picked up the railway line which runs from Sept Iles right through the high country to Schefferville, Newfoundland, one of the towns on my route to Frobisher Bay. I was soon flying over magnificent wild country consisting of hundreds of lakes, scoured out by the great icesheet which extended this far southwards millions of years ago. As far as the eye could see lakes were scattered among the forbidding rocks like jewels glittering in the sun. All very beautiful, but a stark reminder that, if forced to land here, things could become most uncomfortable very quickly. Everything had a wintry look even though it was midsummer. It is difficult to describe how barren, cold and forbidding the land looked below. Harsh blacks and whites of the terrain were studded with the diamond blue of the lakes.

When the controller gave me permission to

49

bypass Sept Iles, he had told me that the Waco Non-Directional Beacon (NDB) was temporarily out of service. He asked with some concern in his voice if there was going to be any problem with my navigation. I told him no, I was aware of the Notam (Notice to Airmen) from Moncton and I was using my VLF Omega which seemed to be working very well. At the same time I was calculating my position by dead reckoning as I always did. If my one battery system failed, I would lose everything except my magnetic compass and airspeed indicator. I had to be constantly prepared for such a situation.

The VLF Omega got me through with no trouble, but there was such a strong south-westerly wind blowing that I had to put on about 20° of left correction — which is considerable — to hold *Delta India Kilo* on track. Another factor I had to bear in mind when using the magnetic compass was the variation which was now 24° and was about to increase. Waco was coming up fast, almost 52° latitude north.

To give an idea of the wild and remote country beneath me, some of the waypoints did not even have proper names; they were just points along the railway designated as "Mile 163" or "Mile 224", to mention two that I used. In winter this region must be quite impassable for any sort of aircraft. Fliers have proved themselves a crazy bunch before now. One of my personal heroes, an Australian, Sir Hubert Wilkins, was one of the pioneers of Arctic aviation in the 1920s. In 1928, with a co-pilot, and American-born Scandinavian, Ben Eielson, Wilkins flew a little Lockheed Vega monoplane from Point Barrow on Alaska's most northerly point to Spitzbergen in the Norwegian-owned Svalbard Archipelago — 2500 miles literally over the top of the world. What a pity so few Australians know of his exploits.

Well, I tracked across this wild terrain and flew over Waco. My original plan had been to fly from Waco to another waypoint, Ross Bay, at Mile 224, and then follow the railway to Wabush, an iron-mining village of about 10,000 people. However, I picked up a good signal from the Wabush VOR and tracked directly across country from Mile 163.

Approaching Wabush, I sighted a Lear Jet and

followed it in to land, four hours and 34 minutes after leaving Moncton. I had covered almost 480 miles thanks to my two diversions. I shot out of *Delta India Kilo* like a rabbit and raced to the meteorological office for a weather report. There was a warm front over Schefferville, 131 miles up the track, with low rain, a 700-foot ceiling and zero visibility now and then. This was daunting, but I realised that if I wanted to make Frobisher Bay that night I had to push on. I told the rather worried meteorological men of my plans to fly on a while and then land beside the railway line to wait for the warm front to pass. The forecast for Fort Chimo was more cheerful; it was my next major stop past Schefferville, my jumping-off point across Ungava Bay to Frobisher Bay. At least the ceiling was 1200 feet.

Delta India Kilo was quickly refuelled and I was airborne again after less than an hour on the ground. I had had time to admire another Bell JetRanger on the field with me which was fitted with floats. A very wise precaution, I thought, for flying in a country with numerous lakes. Wabush, I should add in case the reader has lost track, lies 52°55′ north of the equator in south-western Labrador which is part of the Canadian Province of Newfoundland.

The country beneath me was now becoming increasingly bleak; a harsh, almost treeless region. I flew east to pick up the railway at Mile 224 before turning north for Schefferville, formerly called Knob Lake, which is the terminus of the railway line that carries iron ore down to Sept Iles and the waiting ore carriers. Schefferville has the largest iron mine in Canada, which is just as well because there are not many other ways to earn a living in this region. It has poor, shallow soil and severe winters which restrict agriculture to the summer months.

I spoke to Schefferville control several times but the weather had deteriorated so much that I did not see the little town of 6000 inhabitants until I was flying over it. At that stage I decided to push on while I could, so I continued heading north but was frequently forced off my planned track in order to fly around rain and fog. I was flying at a very low altitude at about 80 knots with very limited visibility. Fortunately, the VLF Omega was working

51

perfectly. Without the Omega system the continual changes in course would have put an impossible extra load on me. Just flying the helicopter over that frightening terrain was bad enough.

After an hour's flying beyond Schefferville it became apparent that the weather was quickly worsening and that even with the VLF Omega I stood a good chance of flying into trouble. I decided to land in the first available place and sit it out. As I was about to land, I picked up a Nordair airliner on the radio. It was one of the feeder airlines of northern Canada making its approach to Fort Chimo. I was relieved when the pilot told me that the weather had improved drastically about 70 miles south of Fort Chimo where there was no rain and plenty of holes in the cloud cover. With relief I flew

Above: Bedding down on the Meta Incognita Peninsula, Baffin Island, after being forced down. Poor visibility and approaching night had foiled my attempt to find a way through the mountains to Frobisher Bay

Right: The approach to Sondrestrom airport up the fjord can be frightening when made at night in mist and rain the way I came in. In the foreground is a United States Air Force base which is used to supply the Distant Early Warning (DEWline) radar stations in the region

52

on and at 57° latitude north broke out of the rain and fog into magnificent weather.

I touched down at the Eskimo village of Fort Chimo at 3.38 p.m., three hours and 12 minutes after leaving Wabush. *Delta India Kilo* had covered 815 miles since leaving Moncton, taking seven hours and 46 minutes. She had behaved like a little champion throughout. I was determined to make use of the long high-latitude summer twilight; it would not be dark for quite a while. Hopefully I could push on to Frobisher Bay that night, 400 miles north-north-east.

I had to cool my heels for a while to allow the airport's refuelling attendant to service the Nordair jet I had spoken to earlier, so I telephoned Pip. What a marvel modern satellite communication is. I just went into the deserted building they called a terminal, picked up the telephone handset, dialled nine and was amazed to find I was talking to an operator in Montreal, almost 1600 kilometres away. Within minutes I was through to Pip in Sydney. As always, a chat with Pip and the girls, and the thought of my home on the edge of Sydney's beautiful Ku-ring-gai Chase National Park, acted like a tonic. Even the discovery that the refueller spoke only French did not seem like an insuperable obstacle. I quickly worked out a flight plan and phoned it through to the local flight service office as *Delta India Kilo* was being refuelled.

Fort Chimo is really outback Canada. It has about 1000 people, mostly Eskimo, or Inuit as they prefer to be called, which simply means "people". It was established as a trading post by the famous Hudson Bay Company in 1830. Today, it is a Royal Canadian Mounted Police post and houses an Anglican and a Roman Catholic Mission, a health centre and a small local industry in the form of stuffed mounted birds and animals for the tourist trade. It is hard to imagine tourists flocking to Fort Chimo.

Spurred on by the knowledge that the weather was reported to be "marginal" at Frobisher Bay, across 400 miles of rugged terrain and icy water, I took off from Fort Chimo after an hour on the ground. I was wearing my special Multifabs survival suit for the first time. In these latitudes

54

"marginal" could become "impossible" very quickly. I headed north-north-west, trying to pick up my next waypoint, the Kangiqsuk NDB but could not pick up its signal. However, there was no cause for worry, the trusty VLF Omega flew me right to it. I went over the beacon at 1000 feet in good, clear weather with a 15- to 20-knot westerly wind giving me a gentle nudge to the east.

To my right I could see the waters of Ungava Bay, blue-green and clear and very, very cold. Below me was the eastern coastline of the wild Ungava Peninsula; it is rocky, indented with fjords, speckled with lakes and uninhabited except for seals, polar bears and hardy dedicated missionaries in a few widely scattered settlements.

Ahead of me were the Everett Mountains of the Meta Incognita Peninsula to the north-east which lay athwart my track to Frobisher Bay. Between me and the peninsula lay my biggest sea crossing so far: the open, icy waters of Hudson Strait, about 80 miles across.

As the glittering, frigid strait unrolled beneath me I was very glad I was wearing my survival suit. At least if *Delta India Kilo* suffered engine failure over the strait I would have a slim chance of staying alive until searching aircraft from Fort Chimo or Frobisher Bay found me, and that was only if I could get through to them on the radio in time. Chilling thoughts for a chilling country. Once again I was filled with a deep awe of those flying pioneers with only the most elementary survival gear. They had dared far bigger sea crossings than I was planning and they had never heard of such things as survival suits.

Trying to think of things other than the freezing water below me, I recalled that Hudson Strait was named after a tough-minded British explorer, Henry Hudson, who, like many other explorers of the seventeenth and eighteenth centuries, was obsessed with finding a route from Europe to Asia via the Arctic Ocean.

I cut in the autopilot and concentrated on navigating and checking the positions given by the VLF Omega. My magnetic compass seemed to be over-reading by 15° and this error, or the correction for it, had to be written into my navigational sums.

55

Forced Down in the Arctic

Cape Dyer

BAFFIN ISLAND

Frobisher Bay

forced down

The coast of Baffin Island loomed up out of the light rain which had begun falling, revealing a frightening, serrated coastline with a soaring line of mountains some distance inland; broken pack-ice and icebergs fringed the coast. Somehow I had to find a way across that inhospitable-looking peninsula to Frobisher Bay. Easier said than done. All the peaks were shrouded in icy rain. I certainly did not want to blunder blindly on and get lost in that icy wilderness when night fell; it was now almost 8 p.m. Even here at 62° north, sunset could not be more than two hours off, and I was still about 105 miles from Frobisher Bay. With a speed of about 110 knots I could still get there before dark if I could find a way to snake through those forbidding, hard-frozen mountains.

A freezing rain was falling to the west. There was no way I wanted to venture into that, so I flew east along the coast hoping to find a fjord that would lead me safely into the interior to a point from which I could hop over into Frobisher Bay. There were plenty of fjords poking their cold, glittering fingers deep into the rock-bound coast.

I took *Delta India Kilo* up several of these, flying between grim granite walls. It was like flying on the moon; not a sign of life, only rocks and huge waterfalls pouring melted snow from the plateaus into the fjords. The whole rocky landscape shone with water which would freeze in the rapidly approaching night already shadowing the deeper valleys and fjords. Many times my path was blocked by solid rock disappearing up into ice-filled clouds, so that I had to reduce speed to 40 knots and make a quick 180° turn. I considered how fortunate I was not to be in a fixed-wing aircraft.

Finally, after 40 minutes with the beginnings of fear plucking at my stomach, I gave up trying to find a way through the hills in the deepening twilight. I would be forced to set down and spend

Flying down the Greenland coast, the JetRanger was tossed about by gale-force winds sweeping down off the huge Greenland icecap. At one stage I thought the helicopter would be torn apart. There was no place below me suitable for a forced landing. One mistake and the helicopter could slip into a crevasse and be lost without trace

the night alone in the Arctic and try again the next day. It was not a pleasant prospect but there was no choice. I could not blunder about this terrible terrain at night.

I flew back to my original landfall and began looking for a suitable place to land. The map showed a hut quite nearby, possibly an old sealer's refuge. This was comforting; at least I would spend the night in shelter. Much as I loved *Delta India Kilo*, I did not fancy spending the night in her cockpit.

The hut was nowhere to be seen. I flew around, casting about for it like a dog after a scent but without success. I later discovered it did not exist. By now it was becoming quite dark, so I landed on the only reasonably level patch of ground I could find, keeping the tail rotor well clear of the boulders scattered all around like giant marbles. The country around me was harsh and inhospitable yet strangely beautiful. A check with the VLF Omega showed my position to be 62°18.0′ north and 68°43.3′ west. I had not yet crossed the Arctic Circle although Baffin Island is geographically part of the Arctic. I had been in the air for 11 hours and 13 minutes and I was extremely tired.

The island is not regarded as a Canadian province but it is administered as part of the North West Territories. It is believed to have been first sighted by Viking explorers in the eleventh century. The thought of sailing those freezing waters in a primitive longship made my bones ache. The island was officially put on the map by a British explorer, Sir Martin Frobisher, when he was searching for a north-west passage to Asia between 1576 and 1578. What brave men these explorers must have been to dare these waters with leaky, ill-equipped ships, rotten food and only the stars to guide them.

Once safely down and secure for the night I tried to call Frobisher Bay and raised a Nordair aircraft instead. The pilot readily agreed to tell Frobisher Bay that I was safe and would be camping for the night and would attempt to cross the peninsula in the morning.

I made a ground search for about a kilometre around the helicopter, trying in vain to find the hut shown on the chart. I would have to spend the night

in *Delta India Kilo* or in my little bivouac tent. After sitting in the helicopter for a while I succumbed to the rival charms of tent and sleeping bag; at least I would be able to stretch my legs. I set up the tent in a slight depression near the tail of the helicopter and unrolled my sleeping bag, made especially for the flight by a small New South Wales company, J and H Sleeping Bags. I hopped in and hoped for a good night's sleep. It was not that easy. I soon had guests: big mosquitoes, tame and hungry. Understandable, I suppose, as I was the only person within a hundred kilometres. I had to pull the sleeping bag cover right over myself to avoid being bitten to pieces. Sleep was also made difficult by the constant rush of running water from melting snow — there were waterfalls all around me — the rumble of icebergs crashing together and a lot of barking which I thought must be dogs somewhere below me. I found our later they were seals. It was no sooner dark when it began to get light again! In these high latitudes the summer nights are very short; the sun barely dips below the horizon before lifting above the rim again.

I eventually slept. The combination of tent, sleeping bag and survival suit kept me very warm despite the fall in temperature to below freezing during the night. I awoke at 5 a.m. ready to tackle the mountains between me and Frobisher Bay.

Before leaving I had a better look at my landing site. I was at a high elevation near a huge fjord about a kilometre from the coast. There was nothing but rocks and the boulders I had dodged the night before, and not a tree to be seen.

Breakfast was frugal, to say the least: a handful of nuts, some chocolate lollies and a drink of water. I gave the helicopter a thorough check and was pleased to see that the engine was using no oil at all. I took some still and movie pictures and lifted off at 6.40 a.m.

The weather had improved overnight. There was clear sky to the north in the direction I was heading. The air was also clearing over the mountains ahead of me, revealing very stark and dangerous peaks.

Above: Flying down Sondrestromfjord in glorious weather enabled me to appreciate how magnificent the Arctic scenery is. The fjord thrusts its cold blue waters inland for 112 kilometres, through mountains which soar to 2400 metres

Above (right): After leaving Sondrestrom, I found this lovely inlet called Evighedstfjord. The Greenland coast is pierced by hundreds of beautiful fjords like this. My movie camera can be seen in the left of the picture

Right: After my nightmare approach to Sondrestrom, it was a relief to fly out in clear, calm weather. The silvery building is one of the relay stations which make up the excellent Greenland telephone system

While tracking towards the mountains I contacted another Nordair jet and had my departure time and estimated time of arrival passed on to Frobisher Bay.

I flew up into the rising hills and climbed to 3000 feet to clear the central spine of the peninsula. I realised to my horror that if I had pushed on regardless in the previous night's gathering dusk and deteriorating weather, I would be lying dead on the rocks and snow this morning. All the fjord valleys I had tried ended in blind cliffs and snowdrifts which were higher than the 2000-feet cloud ceiling. If I had persisted in trying to get through, I would have slammed into either granite or snow at 110 knots. It was a sobering thought. One of the major advantages of helicopters is the ability to hastily land and sit out bad weather.

The irony was that Frobisher Bay was so close to where I had spent the night. I was in the air for only 52 minutes before touching down on the town's airfield. Small as it is, the European and

60

Eskimo population totals about 2500 and is still the largest town in the eastern Arctic.

Frobisher Bay started life as a rough whaling village in the early 1800s and was developed as a fur-trading post by the famous Hudson Bay Company in the 1920s. The Hudson Bay Company is to the Arctic what Burns, Philp and Company is to the Pacific. During World War II it was an important fuelling stop for American and Canadian aircraft being ferried to Europe. In the Cold War of the 1950s it was an American airbase and a base for some of the construction crews building the DEWline (Distant Early Warning Line), a chain of radar posts strung across the Arctic to give Washington a few minutes' warning of a Soviet missile attack. These days Frobisher Bay survives on the tourist trade and the sale of Eskimo artefacts. The climate is quite comfortable in spring and summer.

The tundra around Frobisher Bay was in bloom when I arrived. It boasts an amazing variety of small, bright flowers during the brief summer. The surrounding waters are the haunt of seals, walruses and the strange narwhal, a small species of whale which has a spiral tusk projecting from its forehead.

Frobisher Bay reminded me a little of McMurdo Sound, the American Antarctic base I visited in 1980. When I first landed I arranged for *Delta India Kilo* to be refuelled and had a most enlightening conversation with two of the locals. Aware that I was due in the night before they asked me where I had spent the night. When I told them they were obviously shocked. They explained that polar bears are common in that area and no person in their right senses would camp in the open. It had not even occurred to me that I was in any danger and I was very lucky to be bitten only by huge mosquitoes.

Jim Heagney, who had arrived by Nordair the night before, came out to the airfield and we drove into town. After living in the survival suit for a day and a night I was looking forward to a refreshing hot shower. To my annoyance I was told that the settlement's hot water system had been temporarily shut down for servicing.

Frobisher Bay would probably be an in-

teresting place to spend a few days in the summer because, according to the town's tourist literature, one can see caribou (a species of reindeer), white foxes and other wildlife in the surrounding tundra. Shopping for the household would be an interesting experience for a newcomer. One of the shops, the Amarok County Food Store, offers frozen caribou, muskox and walrus. Frobe, as the locals call it, must be very bleak in winter to put it mildly. The temperature falls to minus 40°C, and the cold is intensified by almost constant winds howling out of the North Pole.

After getting a weather report for my next leg to Cape Dyer, on the east coast of Baffin Island, I decided to leave that day. Cape Dyer is 251 miles away across daunting, wild, uninhabited country. It would be my last stop before a major water crossing between Baffin Island and Greenland — the Davis Strait. It varies from 170 to 400 miles in width. My planned crossing from Cape Dyer to Holsteinsborg would cover 181 miles. With the North Atlantic looming ever larger in my thoughts and with a considerably better understanding now of what I had undertaken, I was keen to keep going and get it over with. The low-pressure system was hovering to the south of Greenland which meant I would be travelling into bad weather again.

After refuelling and a telephone call to Pip I was airborne again after less than five hours on the ground. I circled Frobisher Bay a few times, filming and taking pictures, then headed north-east. The closeness of the magnetic pole (Frobisher Bay has a latitude of 63°44.5' north) played havoc with the magnetic compass reading as it was affected by a variation of 46°.

For a change I was flying in beautiful, crystal-clear weather. Ahead of me the mountains of the Hall Peninsula climbed gradually. I flew over snow-covered rocks, shining brilliantly in the sunshine. Later, I was crossing a huge snowcap on the crest of the peninsula when one of the most spectacular sights I have ever seen unfolded before me. The mighty Cumberland Sound lay glittering in the sunshine, dotted with white pack-ice and icebergs. The distant Cumberland Peninsula provided a stunning

backdrop to the sapphire-blue waters of the sound. It is reassuring to know that the Canadian government has declared at least part of this beautiful but dangerous wilderness a national park. It was an eerie feeling flying across that clear blue water, looking straight down through the clear perspex canopy as it unrolled beneath my feet. It was deceptively beautiful because it was, literally, as cold as ice and would kill a downed pilot in minutes. The icebergs, too, dangerous as I knew them to be to shipping, had a special beauty. The towering tops were whiter than any household-detergent maker's wildest claim, but below the surface they faded into deep jade and then emerald green. I looked at each one carefully, trying to decide if I could make a safe landing on one in case of engine failure. It did not seem possible as most of them did not have horizontal surfaces.

Mesmerised by the good weather and the stunning beauty of the sound, I made a mistake that could have been fatal. I decided to save time by using the VLF Omega to track straight across the southern tip of the Cumberland Peninsula, instead of clearing it entirely by rounding Cape Mercy and then running up the eastern coast to Cape Dyer.

I was crossing the southern tip of the peninsula at 3000 feet when suddenly the world turned upside down. *Delta India Kilo* reared and bucked as though shaken by a giant hand. I had flown into the worst clear-air turbulence I had ever encountered in all my years of flying.

The first violent impact knocked the autopilot out. I grabbed the controls and flew the helicopter manually. It was absolutely terrifying. Mountains and icy sea reeled around me as I fought for control. I actually feared the helicopter would break up. The stresses on it must have been fantastic, but the manufacturers had done a good job and she held together despite being hurled hither and thither by the wild turbulence.

In the middle of this frightening chaos I managed to raise Cape Dyer on the radio. The operator could not have been more helpful. Talk about a friend in need! Amazingly, in that remote part of the world, he knew who I was, and had been expecting me. One of my friends in England, Mike

Icy winds streaming off the Greenland icecap caused bad turbulence and gave me a nasty fright off the west coast of Greenland. There was no wind pattern on the sea beneath me, so I rapidly took DELTA INDIA KILO down and found calm air at 500 feet near Simpson's Passage. This view looks west across the Davis Strait

65

Wendon, a British Airways jumbo captain, had called the Cape Dyer frequency when he was flying from London to Vancouver a month before and told them I was on my way. I managed to fly the helicopter out of the turbulence and touched down a little later at Cape Dyer's Lower Camp, still rather shaken. The 251 miles from Frobisher Bay had taken two hours and 17 minutes and the last few minutes had given me the fright of my life.

Cape Dyer is rather a strange place. It is almost on the Arctic Circle on a latitude of 66°39' north. The Arctic Circle is 66°30' north and marks the southern limit of the area within which, for at least one day each year, the sun does not set (21 June) or rise (21 December).

Since 1957 Cape Dyer has been an important link in the DEWline chain of radar stations. This DEWline establishment consists of two camps: Dye Main Lower Camp and Dye Main Upper Camp. Its insignia is a rampant polar bear with the motto "Ever vigilant".

It must be a rather trying posting for the operators and technicians who constantly watch out for the possibility of incoming Soviet missiles. The climate is harsh; a humid 26°C in the brief summer, and minus 46° in the long, dark winter. It does not rain much because it is generally too cold but this is made up for by an annual snowfall of 5000 mm! "High winds and heavy snowfall create serious hazards to life and limb", warns an introductory brochure for visitors. There surely cannot be many visitors to this remote outpost.

I touched down at 2.42 p.m. and was met by a very friendly base officer named John Whisker who immediately organised a good lunch in the mess, even though it was out of regular mess hours. There were a few tough-looking husky dogs lying around in the sun outside. I assumed they were on guard as I was warned to lock up the helicopter carefully because a polar bear had been wandering around the camp. These huge animals, now protected, have become so used to the presence of humans that they haunt human settlements, foraging in the garbage bins the way possums do in

66

suburban Sydney. They have been known to break into buildings and vehicles in search of food. Dye Main Lower Camp is evidently on a major polar bear migration route and the camp staff are constantly aware of the danger. An angry polar bear could kill a man very easily.

The bears may have been a menacing prospect but the camp's human inhabitants could not have been friendlier. Shortly after I had lunched, a large cheery man with a big white beard appeared and introduced himself. He was Bill Dyer, the DEWline radio operator I had spoken to while fighting the turbulence. He had driven the 18 kilometres from the Upper Camp to meet me. I asked, expecting a refusal, if I could see the radar station at the Upper Camp. The visitors' brochure stressed that Cape Dyer was a high-security area, but to my surprise Bill agreed.

Before leaving I radio-telephoned the Greenland DEWline station at Red River, immediately east of Cape Dyer over the Davis Strait, and asked for a weather report. It was not good; they were experiencing snow showers. It seemed unlikely I would be flying any further that day so Bill and I drove to Dye Main Upper Camp, crossing the Arctic Circle.

The base commander readily gave his approval for me to be shown over the station. It was very impressive. Quite apart from the complex electronic equipment, which one would expect to be nursed, everything else was spotlessly clean and beautifully maintained. Covered walkways linked the various buildings — essential in a region of heavy snow and gale-force winds. I was even allowed into the station's nerve centre — the radar room. All log books had to be covered so that I could not see what the big dishes had detected.

Still hankering to try for Greenland that day, I used the excellent DEWline telephone system to call the Greenland Red River station again. The news was better. Red River, more than 3000 feet up in the coastal mountains, was experiencing snow and zero visibility; but the station's helipad, lower down the mountain, only had light snow and my

destination of Sondrestrom, at the head of the Sondrestromfjord, had 10 miles visibility down the fjord with occasional snow flurries. This was to be my approach route.

I was in better spirits than I had been for days. I had eaten, rested and washed, and I decided to try the 290-mile flight which is mostly over water. After being driven back to the Lower Camp at high speed, I checked and refuelled *Delta India Kilo* and was in the air again at 6.44 p.m., after four hours on the ground. I climbed out of the Lower Camp and flew over the Upper Camp, which is on a higher elevation, and checked my VLF Omega position. It was confirmed by the duty radar operator, Bill Cameron, whom I had met during my rather hurried tour.

Later, I was over the broad, glittering Davis Strait in fine, sunny weather. Everything was going perfectly. The sun made the deep blue icy sea below my feet sparkle with a million points of light. There was the comforting knowledge that I had enough fuel aboard to go all the way to Sondrestrom and back to Cape Dyer, if necessary. A pessimist might have pointed out that if the weather at Sondrestrom and Cape Dyer went bad simultaneously, which is quite possible in these latitudes, I would be in the soup, or strait. But pessimists do not choose to fly helicopters solo around the world.

I backed up my electronic navigation with dead reckoning calculations using the magnetic compass and charts as I had done ever since leaving Fort Worth. Was it really only seven days ago? The magnetic variation across Davis Strait was now a gigantic 51°!

I climbed to 3000 feet in clear, still air. Below my feet icebergs dotted the indigo waters of the strait. I was cruising over scattered cloud when Bill Cameron came on the air again to tell me that Red River had already picked me up on their radar, which I thought was pretty amazing considering I was still more than 100 miles from them. At their request, passed on by Bill, I switched on *Delta India Kilo*'s transponder, sending out a signal which would help Red River track me. I then called up Red River and asked for a weather report. It was still snowing.

Tracking up a fjord in
Greenland, I suddenly came
upon this town. A few
minutes earlier I was unable to
locate it on my map, and for a
moment I thought I was lost

69

This called for some thought. I called Sondrestrom and got them immediately, loud and clear. The VHF communications in this part of the world are excellent. I asked Sondrestrom if I should try to track straight across country to them once I had crossed the coast, or turn south and pick up the entrance to the fjord which would put an extra 60 miles on the leg? Before Sondrestrom could advise me the pilot of a Greenlandair Sikorsky S61 helicopter came on the air. He had just left Sondrestrom where there was some cloud but he had managed to find several openings. He suggested I climb to 6000 feet and come in over the cloud, then descend through one of the gaps I would be sure to find. I decided to follow his advice. The little helicopter did not mind the high altitude, but I did. It was minus 10°C outside the aircraft and, although I was wearing my survival suit over several layers of clothing, I felt bitterly cold. My hands and feet ached.

At 8.27 p.m. it was still broad daylight. I made my Greenland landfall, flying over the little town of Holsteinsborg, 181 miles across the Davis Strait from Cape Dyer. The town was visible through a large break in the clouds and it was reassuring to know that if I could not get into Sondrestrom I could track back to it and spend the approaching night there.

I was becoming very worried by the increasing cloud and depressed by the biting cold. Sondrestrom kept calling to find out if I could come in by using the signal from their Non-Directional Beacon. I tried but was unable to get any sensible bearing from it. At last I saw an opening in the clouds some miles to the south of my track, and below, a dark stretch of water enclosed by cliffs. I quickly realised it must be Sondrestromfjord, and turned towards it. It was the fjord right enough, but my hopes of a pleasant, easy flight up it to Sondrestrom were quickly dashed. Rain and swirling light snow combined to reduce visibility to a few yards. I came down to 500 feet above the water with the sickening realisation that if the weather got much worse I would probably fly right into it. The situation was becoming alarming when the Sondrestrom controller, God bless him, turned on the

Two handsome Inuit (Eskimo) children play on an abandoned mine dredge at Kulusuk, Greenland. They were very friendly and insisted on borrowing my camera and taking photographs of me, too

AUGUST						
S	M	T	W	T	F	S
1	2	3	4	5	6	7
8	9	10	11	12	13	14
15	16	17	18	19	20	21
22	23	24	25	26	27	28
29	30	31				

airport's brilliant strobe lights which suddenly appeared two miles ahead as a glow in the rain and snow. To my immense relief I touched down, exhausted, frightened and almost frozen to death. To put it mildly it had been a trying flight.

The flight from Cape Dyer had been cold but my reception at Sondrestrom was certainly not. I was met by a party of Greenlandair people who gave me a warm welcome. They bustled me inside, gave me a meal and did their best to make me feel at home. I was given accommodation in the Greenlandair crews' quarters, and I met a party of Americans ferrying a Beech Baron aircraft to Australia.

It had been a long day. Since getting out of my sleeping bag in the wilds above Hudson Strait 19 hours before, I had spent five hours and 32 minutes in the air, working absolutely non-stop every minute flying, navigating and taking films and photographs. I had a few terrifying minutes in the turbulence over the Hall Peninsula and travelled more than 600 miles, the last few hours of it in temperatures that would try an Eskimo. I was now north of the Arctic Circle. Small wonder that I slept like the proverbial log that night!

I awoke early and refreshed after a good night's sleep and went to the airport weather office. I suppose I was becoming a bit obsessive about the

71

weather; flying in the Arctic can do that. But the Sondrestrom weather people were very reassuring, as well as being very thorough and knowledgeable.

I had hoped to fly on that day to Kulusuk, 345 miles away on Greenland's east coast, and my jumping-off place for Iceland. My friends in the meteorological office quickly dashed my hopes with some, literally, cold facts. The low-pressure system that had plagued me since Moncton had now moved to the east of Greenland. The east coast was snowed in with a 200-foot ceiling. My route to Kulusuk was across the Greenland icecap which is largely uninhabited terrain with mountains up to 2400 metres high. My chances of a safe landing were minimal if the weather deteriorated any further, so I resigned myself to spending the day in Sondrestrom.

The little town at the head of Sondrestromfjord, a beautiful fjord almost 200 kilometres long, was an American Air Force base in World War II, and still has American personnel. It is used as a staging point to supply the DEWline stations in Greenland.

Greenland is administered as part of Denmark, although it has a certain amount of "home rule". The largest island in the world, it first became known to Europeans in the tenth century when the Viking, Eric the Red landed there. A few Viking settlements were established but soon dwindled to nothing. The English seaman-explorer, John Davis, visited the island in 1585. Davis Strait is named after him. Not much interest was taken in the country until a Danish mission was established in 1721 on the site of what is now Godthab, the capital.

Most of Greenland must still be as Eric the Red saw it 1000 years ago. The total population is only about 50,000, which is not a lot of people for such a large territory.

Most of the population is of Eskimo (Inuit) stock inured to the harsh climate, which keeps about 80 per cent of the country covered in ice throughout the year. Snow can fall in any month of the year, and even in midsummer the temperature on the central icecap averages minus 12°C. The general chilliness is easily understood. The southern-

AUGUST

S	M	T	W	T	F	S
1	2	3	4	5	6	7
8	9	10	11	12	13	**14**
15	16	17	18	19	20	21
22	23	24	25	26	27	28
29	30	31				

most tip of Greenland barely nudges the 60th north parallel while the northern coast is lapped by the Arctic Ocean. Not exactly the spot for a holiday, yet there is a thriving tourist trade in the summer. In good weather the mountains and fjords are beautiful, without industrial pollution of any kind.

As I wanted to do a thorough check of my HF radio, I asked the Sondrestrom airport people if they knew of any amateur radio operators in the area. They suggested Peter Steneborg (OX 3PT), who flew Sikorsky S61 helicopters for Greenlandair. I contacted Peter and explained the trouble with the HF. He told me to fly the helicopter down to his home — a trailer parked about half a mile away beside the main runway. The control tower was not too happy about a strange helicopter landing halfway down the runway but they finally agreed to let me go. In occasional snow, we took out the HF tuning unit and checked every connection thoroughly but could not find anything wrong with it. When we put it back it worked perfectly, so perhaps the main connection had not been seated properly before.

Peter is a very experienced Arctic pilot, and he disapproved of my proposed plan of a direct flight across the high icecap to Kulusuk.

"Too dangerous," he said firmly. "Go down the west coast to Narssarssuaq, cross the southern end of the island and fly up the east coast to Kulusuk. Much safer."

When flying in strange places, especially the Arctic, it is wise to take local advice. I redrew my flight plan as Peter suggested, even though it would involve a much longer flight. Better a few extra hours in the air than coming to grief on the Greenland icecap.

After helping me with the HF and his good advice, Peter compounded my debt to him by inviting me to dinner at the Sondrestrom Club with him and his wife, Lotte, and his parents, who were holidaying with them. I gladly accepted and had my first dinner since leaving Moncton.

I awoke early the next day, impatient to be away.

The helpful and efficient meteorological staff gave me a thorough weather briefing. That terrible

73

low-pressure area was still hugging the east coast making flying there impossible, but I decided to press on down the west coast to Narssarssuaq anyway as I knew the town had an airport and fuel for a stopover if necessary.

I left Sondrestrom in fine, clear weather and flew back down the glorious Sondrestromfjord. It was so beautiful that I became quite camera-happy and took far too many pictures. Clear of the fjord, I turned south and tracked down the coast at 2000 feet above patchy sea-fog. On my left unfolded a continuous magnificent panorama of mountains, fjords and glaciers, against the shimmering white backdrop of the eternal snowcap.

Peter Steneborg came on the air and he put me in touch with another radio amateur, Eric (OX 3EN) in Godthab. Then, thanks to the wonderful flexibility of amateur radio, Peter was able to arrange a truly wonderful link-up. He telephoned my journalist friend, Fred Baker, in Sydney and patched him through to me in *Delta India Kilo*, as I flew down the west coast of Greenland, a whole world away. I gave Fred a running commentary on the scenery. The warmth and friendliness of the amateur radio clan worldwide is a great comfort when sitting alone in a small aircraft with only your own thoughts for company.

My radio was certainly kept busy that morning. As well as talking to Peter and Fred and other Greenland radio amateurs, I had to report "operations normal" at 10, 30 and 50 minutes past every hour to the flight controllers in the small towns I flew over along my route. Greenland is very aircraft-conscious, and in that fierce climate and wild terrain the safety procedures are stringent. I was also pleased to talk directly to Harry Caldecott (VK 2DA) in Sydney.

Soon after passing the Greenland capital of Godthab I missed one of these mandatory "operations normal" calls because of extreme turbulence. It was the very worst I have ever experienced, even worse than the bad jolting I had received on the Cumberland Peninsula. I found later it was caused by a 50-knot gale of icy air streaming off the icecap from the north-east. In a way I had asked for trou-

The small American-built wharf on the island at Kulusuk. I spent a day and a night here after realising I was too tired to risk flying across the wide Denmark Strait to Iceland

ble by turning away from the course I had plotted on Peter's advice in an attempt to cut directly across the southern edge of the icecap to Narssarssuaq. I had a terrible fright in return for my impatience. Looking down on the icecap from the shaking, reeling helicopter I could see ice and snow split by gaping crevasses; not an ideal place to be forced down on. I tried to escape the turbulence by climbing and reducing speed to 80 knots but it did not work. The disturbed air was worrying the little helicopter the way a terrier worries a rat.

At this point I was east of an inlet called Simpson's Passage and glancing down I noticed that there

AUGUST							
S	M	T	W	T	F	S	
	1	2	3	4	5	6	7
8	9	10	11	12	13	14	
15	16	17	18	19	20	21	
22	23	24	25	26	27	28	
29	30	31					

was no windpattern on the water. I quickly went down to 500 feet and, to my immense relief, found still air. Minutes later I was flying to Narssarssuaq up a fjord dotted with icebergs and some fishing boats. The Narssarssuaq traffic controller kept telling me something but I could not understand him. I managed to land without mishap on the correct airfield which had such a slope on it that I was amazed to discover that DC8 jet airliners used it.

Officials of Greenlandair and the Ice Patrol met me at the airport. They saw me booked safely into the Arctic Hotel and were generally most friendly and helpful. The spotlessly clean hotel was full of Danish tourists who were unnaturally quiet.

After seeing *Delta India Kilo* safe for the night I strolled about the little town. I was shown over the Ice Patrol hangar which is a magnificent centrally heated installation costing millions of dollars. There was an Ice Patrol helicopter undergoing repairs at the time. The pilot, Goran Lindmark, had just had a hair-raising experience. He was out on patrol when the helicoper's engine failed. Fortunately, it was fitted with floats and he managed to auto-rotate safely on to the water and wait to be rescued. If he had been flying a fixed-wing aircraft I doubt very much if he would have survived to tell the tale.

Later I strolled down to the wharf to look at the fishing boats and the icebergs. The great towering masses of ice are most impressive with only about one-tenth of the berg showing above the water. Despite their beauty they can be deadly to shipping — remember the *Titanic?* The Ice Patrol's job is to watch the drift of icebergs and keep shipping informed of their whereabouts.

After a good night's sleep I awoke to a gorgeous day. The icebergs glittered in the brilliant sunshine, the surrounding peaks soaring into a cloudless pale blue sky. I telephoned Sondrestrom from the weather office to get a detailed weather report on Kulusuk. The news was disappointing; the weather at Kulusuk was still too bad for flying, and the low-pressure system was moving eastwards very slowly. I wondered if I would ever get to meet Prince Charles.

I spent the rest of the day talking to the Ice

AUGUST

S	M	T	W	T	F	S
1	2	3	4	5	6	7
8	9	10	11	12	13	14
15	16	17	18	19	20	21
22	23	24	25	26	27	28
29	30	31				

Patrol fliers and other people at the airport, and studying the icebergs to see if it would be possible to make a forced landing on one. It seemed unlikely though because they were all irregular on top.

I also gave *Delta India Kilo* a thorough going-over and entered the waypoints into the VFL Omega for my next leg after working out my flight plan. I had not had Jim Heagney's assistance since leaving him at Frobisher Bay three days before and had to handle all the paperwork myself.

Goran Lindmark and another Ice Patrol pilot, Carl Hannisdal, helped me with my planned east coast route to Kulusuk. They carefully went over the whole route and were particularly careful to point out where various caches of food had been left on small islands along my track. A wise precaution because there is no settlement anywhere on the wild shoreline between Narssarssuaq and Kulusuk, almost 650 kilometres north.

When I awoke at six o'clock the next morning I rushed eagerly to the window to look at the weather and almost wept with frustration. Narssarssuaq was blanketed by fog. Later, at the airport, the efficient meteorological officer, Gorm Buber, gave me better news; the local fog would lift in a few hours, and the weather at Kulusuk was perfect.

For three frustrating hours I had to cool my impatient heels at the airport, getting a crick in my neck from constantly scanning the murk overhead for little patches of clear sky. Finally Goran Lindmark came to my rescue by showing me a route out of Narssarssuaq along a small river and up several waterfalls. Although Goran's route headed north and I wanted to go east, he assured me that I would get clear of the local fog and over the icecap. From there I could get back on course, so I decided to try it.

I took off at 9.45 a.m. with the heaviest load of fuel that *Delta India Kilo* had ever lifted, but still the little helicopter climbed beautifully. The river Goran had told me to follow climbed steeply in a series of waterfalls up through the mountains. I followed the trail he had marked and emerged into brilliant sunshine with Narssarssuaq still hidden in thick white fog below.

77

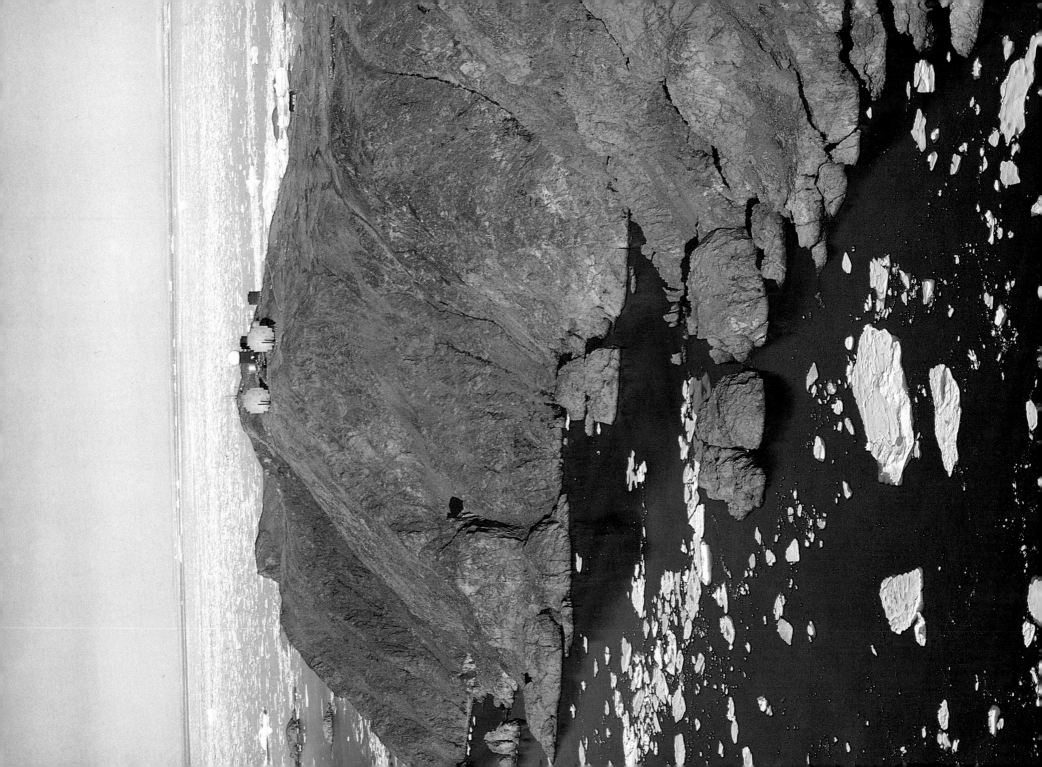

GREENLAND

Narssarssuaq

High Over the Greenland Icecap

I climbed steadily eastwards over spectacular country of endless ice and snow. There were enormous glaciers seamed by deep crevasses which would have made forced landing very dangerous in the event of an engine failure.

In smooth air and bright sunshine I climbed to 9000 feet above sea-level — 2000 feet above the icecap — and cruised at 80 knots. Although the outside temperature was below zero, the bright sunlight kept the cabin pleasantly warm. Flying conditions were absolutely perfect: calm and warm with great visibility: the kind of weather I had dreamed about. It made some of the nasty experiences of the past few days seem like a bad dream. From my height I could see about 100 miles up the jagged coast while to my right the sea, covered with pack-ice, seemed to stretch to infinity.

Clearing the high mountains north-east of Narssarssuaq, comprising enormous peaks with glaciers sliding between them to the sea, I came down to 2000 feet and headed eastwards up the coast. The great glaciers covering Greenland must be one of the world's biggest iceberg factories. After centuries of edging down the valleys from the icecap, the glaciers break up into icebergs on reaching the sea where they gradually drift away into the North Atlantic.

As I flew over this remote coastline I checked off the small huts containing the food caches that Goran and Carl had shown me, and my confidence was greatly boosted to find them correctly located. I also raised a boat on my VHF-FM marine radio; it was ferrying jet fuel to the food caches for Greenlandair. It was very comforting to know that there were some men down there on the frigid and otherwise uninhabited coast. If something did go wrong, it would not take long for the alarm to be given, thanks to the mandatory "operations normal" reports. Being on the east coast of Greenland I had

Overlooking a sheet of shimmering pack-ice, DEWline radar station Big Gun scans the Arctic skies for incoming missiles from this rocky promontory, 300 metres above sea-level near Kulusuk. Big Gun would be able to give Canada and the United States 10 or 15 minutes 'warning of an attack

to call in at different times than on the west coast. As these were required at 15, 25 and 55 minutes past the hour an aircraft would only be missing for about 20 minutes before the authorities became alarmed.

Flying conditions were so perfect I decided to shorten my journey by flying directly across the sea from Cape Mosting to Kulusuk instead of hugging the coast. This meant a long flight over water covered with icebergs and large clumps of pack-ice. I hoped I would be able to find a place to land in a hurry if I had to. I used the VLF Omega to navigate with on this leg because the Greenland NDBs were so weak at my altitude of 500 feet that I could barely receive them.

The sea crossing to Kulusuk was made without trouble and I sighted the DEWline radar station, named Big Gun, on the rocky heights of the island. When I asked the radar operator at Big Gun if he could pick me up on his radar 50 miles out, he curtly told me that he was not allowed to give me that information. I suppose their radar range is an American military secret. I flew around the station taking lots of film and still photographs, and found the small Kulusuk airstrip after some difficulty. I was guided in by a most cooperative and friendly Danish civilian radio operator, Paul Elkjaer.

There is a wild, primitive beauty about Kulusuk, surrounded by mountains, glaciers, small rocky islands, icebergs and pack-ice. The airstrip, originally built with American aid to service the DEWline station, is now mainly used for Greenland civilian traffic and aircraft from Iceland, 400 miles to the east.

After refuelling I telephoned my ever-obliging friends in the Sondrestrom meteorological office and asked them about the weather in Reykjavik. It was not very encouraging. The Sondrestrom people suggested I spend the night at Kulusuk and try for Reykjavik the following day. Their opinion was supported by a long telex from Jim who had already been in Reykjavik for a few days, having flown there from Frobisher Bay.

It took me only seconds to make up my mind to go. I was desperate to get back on schedule and

Jim's telex said, in part:

WINDS EN ROUTE KULUSUK–REYKJAVIK FROM THE SURFACE UP TO 2000 FEET AT 20 TO 40 KNOTS. CLOUD BASE EN ROUTE 2000 FEET WITH PATCHES AT 1000 FEET AND LOWER. RAIN, SLEET AND SNOW CAN REDUCE VISIBILITY TO 400 METRES.

WEATHER AT KULUSUK IS MUCH BETTER THAN THAT ON WEST COAST OF ICELAND. REYKJAVIK METEOROLOGICAL OFFICE SUGGESTS YOU STAY IN KULUSUK AND TRY AGAIN TOMORROW. THEY SAY DO NOT BE FOOLED BY GOOD WEATHER AT KULUSUK.

MY SUGGESTION IS THAT YOU TRACK DIRECT FROM KULUSUK TO KEFLAVIK AS PLANNED. PROCEED TO EQUI-TIME POINT AND MAKE DECISION THEN. IF YOU ENCOUNTER ANY ICING, RETURN TO KULUSUK AT LOW ALTITUDE. PIP IS IN LONDON. GOOD LUCK.

the ground staff at Kulusuk had worked like demons to refuel the aircraft. I must go through to Reykjavik that day otherwise it would be almost impossible for me to get back on schedule for my meeting with Prince Charles. I jumped back into *Delta India Kilo* and several things happened to warn me of how mentally and physically exhausted I was. First, I opened the back of my 35 mm still camera without rewinding the film and fogged some of my photographs of the Greenland east coast. Then I began making too many mistakes when keying the waypoints into the VFL Omega for the Kulusuk–Reykjavik flight. Nevertheless, I stubbornly did my pre-flight checks and started up the Allison.

Then commonsense belatedly overcame stubbornness and pride. I switched off the Allison and told the startled ground staff that I was in no condition to make a long sea crossing in marginal weather. It was disappointing, but I know now it was a wise decision. It was the only decision. If I had not been so tired I probably would not have hesitated in making it. It was a sort of Catch 22 situation where I was too tired to fly but so tired that I was almost incapable of making the decision *not* to fly. In retrospect, it was a potentially lethal set of circumstances.

Once I had decided not to fly that day I used the time already gained to give the helicopter a full check. During my flight from Narsarssuaq I had been able to smell fuel vapour, but a thorough check of the fuel lines showed everything to be normal. I reloaded film in all my cameras.

Then, who should I meet but a Greenlandair pilot who turned out to be Eric (OX 3EN), the amateur radio operator I had spoken to when passing Godthab. Eric showed me over his aircraft, a Dash 7, and we had a long talk about amateur radio.

Also at Kulusuk that day was a party of Americans from Memphis, Tennessee, who were about to mount a search for several United States Air Force planes lost on the Greenland icecap during World War II. The searchers reckoned there were at least six P38 fighters and two B17 bombers "somewhere up there", probably under three metres of ice. They were going to crisscross the icecap and

try to locate the buried aircraft by using an ice-penetrating radar beam emitted from a set towed on a sled. Many people have searched for these missing aircraft before, I might add. I recalled my own arduous search in 1978 for the wreck of the *Kookaburra*, the monoplane that carried Keith Anderson and Bobby Hitchcock to their deaths in central Australia in 1929. I had found the *Kookaburra* after a long search, but it was not covered by three metres of ice. I could only wish the Memphis team the best of luck.

After securing *Delta India Kilo* for the night I was taken around to my quarters in an old building known locally as the Kulusuk Hilton. It has very little in common with those well-known hotels, being built in a style described as "early GI". However, a bed is a bed when you are tired. The Kulusuk Hilton's cook, a very friendly Dane, cheerfully whipped up a quick snack for me. He loved Australia and Australians after spending several years working on a ship based in Cairns, north Queensland. The contrast between Cairns and Kulusuk must have been startling to him, but he seemed quite happy.

Before turning in for the night I took a stroll around the little settlement. Despite its ruggedness

Kulusuk's friendly flight-service officer Paul Elkjaer was not too impressed with my flight plan for the Greenland to Iceland leg, so he drew me a new one, making all the calculations himself

The debris of modern civilisation litters the streets and waterside of the Inuit village at Kulusuk. The rubbish of the village is simply dumped outside. I found Kulusuk a most depressing place and questioned whether our materialistic lifestyle had brought any advantages to these simple people

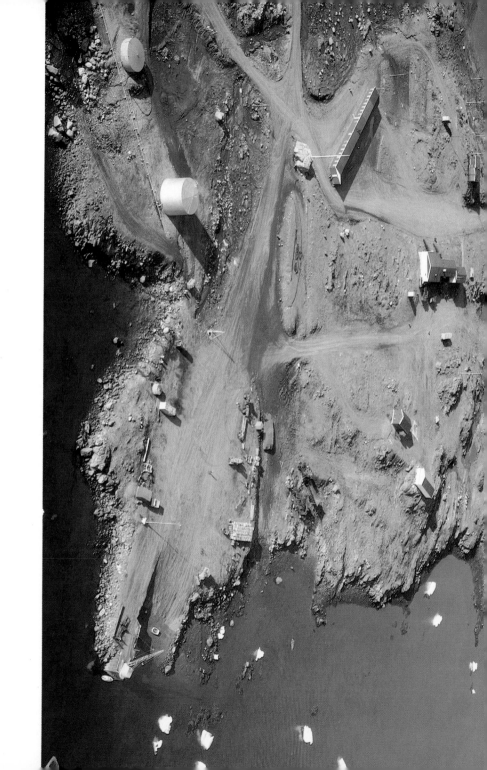

A last look at Kulusuk at the start of my flight to Reykjavik, Iceland. The water sparkled sapphire and indigo; huge glittering icebergs and an enormous glacier provided an impressive backdrop.

It was still four hours to sunset so I managed to take some pictures of the wonderful scenery. The weather was perfect with a cloudless sky.

The Kulusuk airstrip was a little surprising. The runway seemed very short with a decided slope to it. It did not seem to deter the pilot of an Icelandair Fokker F28 which landed smoothly with a charter party aboard. Watching it land, I was thankful I was flying a helicopter.

The flight service officer at Kulusuk, Paul Elkjaer, was another friendly Dane. When I hastily put in my flight plan to Reykjavik earlier that day before deciding to abort the flight, Paul, obviously unimpressed with my calculations, had redone it for me. He suggested that a stroll to the nearby Eskimo village would be interesting.

The track to the village was marked by rusting 200-litre fuel drums and the remains of abandoned snowmobiles, so I found the place easily enough. It was a terrible disappointment. The village has

A last look at Kulusuk at the start of my flight to Reykjavik, Iceland. The long, low building on the left is the "Kulusuk Hilton," where I spent the night. The white shapes on the water are icebergs

83

about 500 inhabitants and was absolutely filthy. The houses seemed neat and clean but the occupants had thrown most of their domestic rubbish straight out of the front door. The village centre looked like a great garbage dump. It seemed to me that the Eskimos — in that village at least — just cannot cope with the rubbish generated by modern materialistic society. The Eskimos would have generated very little garbage before the white man came.

The village children seemed happy and healthy enough, but I saw several very drunk Eskimo men, some of whom asked me for money. It was all very depressing. The squalid village was such a staggering contrast to the crisp beauty of its surroundings. Sadly, it seems the arrival of the European man in the Arctic has had a similar effect on the Eskimos as his arrival in Australia has had on our Aborigines.

Before going to bed I was given another example of Danish kindness. As a rule the Kulusuk airfield opened at 8.30 a.m. but Paul Elkjaer offered to open it two hours earlier so that I could make an early start to Reykjavik. I slept well in the Kulusuk Hilton that night.

I woke at five o'clock with a tingle of apprehension. In two days' time I had an appointment with Prince Charles at Balmoral Castle in Scotland on the other side of the Atlantic. I had doubts whether I would make it. It would be most embarrassing for me and Australia if I did not. After all the Prime Minister himself had arranged the meeting. I was also missing Pip and the girls terribly and feeling homesick.

I walked briskly to the runway, about a kilometre away from where I had slept the night, checked the helicopter again, and keyed in the VFL Omega waypoints, this time without any trouble. Then it was back to the Kulusuk Hilton for a quick breakfast, specially prepared for me the night before by the friendly Danish cook from Cairns, and then I was ready to go.

I called Sondrestrom about the weather and read another telex from Jim in Reykjavik. The weather there was still not wonderful. There were winds of 20 to 25 knots from the north, low cloud and rain. But this time I was determined to go. The

84

AUGUST

S	M	T	W	T	F	S	
	1	2	3	4	5	6	7
8	9	10	11	12	13	14	
15	16	17	18	19	20	21	
22	23	24	25	26	27	28	
29	30	31					

weather was so good at Kulusuk and I could always return if the weather prevented me getting into Reykjavik. *Delta India Kilo* was carrying a full load of fuel, enough for seven hours and 20 minutes in the air. I calculated that the 402-mile flight — my longest water crossing to date — would take about four hours, so I had plenty of fuel in reserve.

I checked my compass against the known heading of the runway and found it was now under-reading by 10°. I lifted off at 6.44 a.m. and flew around the Big Gun DEWline radar station, taking photographs to make up for at least some of those my tiredness had caused me to fog the day before. Then, in perfect weather with a cloudless blue sky from horizon to horizon, I headed out over the Denmark Strait. The air was so clear the shining white top of the Greenland icecap was visible 100 miles to the west. The sea unrolled ahead, smooth as glass and dotted with icebergs. About 30 miles out I spotted what appeared to be a large island just north of my track. My detailed map did not show it, but as I flew closer it turned out to be the largest iceberg I had ever seen.

For the first 50 miles I kept in touch with Sondrestrom and then contacted Iceland radio on the HF set. All was going well. Perhaps I would be meeting Prince Charles on time after all.

Alas, it was too good to last. After one and a half hours of beautiful, peaceful flying at 2000 feet, the weather turned sour. Ominous dark clouds loomed ahead and forced me down to 500 feet. The wind increased to over 40 knots from the north and as I was heading due east the wind kept pushing the helicopter sideways. I compensated by heading slightly to the north and consequently my ground speed dropped to between 95 and 100 knots and I soon flew into shocking weather. Visibility decreased as mist, snow and rain fell around me like a curtain, but there remained enough visibility to allow me to see the ocean, whipped into angry foam by the wind. It was a frightening sight, and a reminder of what fate awaited me if the little Allison failed.

To make matters worse my HF radio contact with Iceland was lost. I called generally, trying to raise anyone, and was answered by a British Airways pilot flying a Boeing 747 to London. He

agreed to pass my position on to Reykjavik and to telephone a message to Pip when he reached London.

I was left alone again over the turbulent, icy sea. Hour after hour I flew on, hunting for breaks in the weather. Several times, just as I was on the point of turning back to Kulusuk, I found a way through the murk at the last minute.

The signals from the low-power NDBs at Kulusuk and Reykjavik were too weak to be of any assistance, but I picked up a Reykjavik radio station with a good strong signal which I used all the way across the strait. I enjoyed some music instead of the morse code usually transmitted by NDBs.

I was greatly cheered during this worrying and tiring flight by amateur radio contacts. Jerry (E1 3BK) came through from Cork in Ireland and a station (G4 LOW) set up by friends of mine at Lowe Electronics in England. They had both been listening out for me. It was always comforting to know that friendly ears all around the world were listening to my progress. It helped to dispel the loneliness which sometimes crept over me like a black fog. Looking back now I realise I must have been under

A glacier slides towards the sea like a petrified river near Hornafjordur, on the south-east coast of Iceland. Dark patches on the glacier are pumice from the many volcanoes inland. This glacier has its origins on the slopes of Vatnajokull, a mountain over 1800 metres high which spreads out to contain about 8550 square kilometres of snow and icefields

great tension on this leg of the flight. At one stage I was asking myself the famous question "Why am I doing this?" I was very frightened most of the time; not a very enjoyable experience.

The weather slowly began to improve about 120 miles out from Keflavik and I was soon flying through patches of sunlight. Reykjavik came through on VHF and told me that Jim was in the tower and he had suggested I track directly to Reykjavik instead of coming in via Keflavik. I agreed, and shortly afterwards I landed at Reykjavik after three hours and 55 minutes in the air.

By now, I was all fired up to go on despite my unpleasant flight. The Balmoral appointment was looming ever larger in my mind. I could not afford to lose another day. Hastily wolfing a bag of sandwiches Jim had brought to the airport for me, I hurried with him to the weather briefing office for a meteorological report. The weather on my planned route looked reasonable even though the low-pressure system was moving towards the east coast of Iceland, so we filed a flight plan for Hornafjordur, 210 miles away on the east coast of Iceland, and then on to Vagar in the Faeroe Islands, another 260 miles.

After two hours on the ground I was in the air again. The weather was lovely with brilliant sunshine warming the cabin. It was a deceptively pleasant beginning to what was to be yet another trying flight. I had problems soon after clearing Reykjavik to turn south-east to Hornafjordur. The mountain range ahead had several high peaks which were obscured by cloud and rain. Blundering around unknown mountain ranges in that sort of weather is definitely unsafe, so I decided to swing south of my planned course. Finally, I managed to creep over a rocky ridge below the cloud with only 50 feet between me and the rocks below, and picked up the coast south of Reykjavik.

By now it was raining heavily as I headed southwards at 500 feet. Despite bad visibility I could see the beach below me so I was not particularly worried because I could always land quickly if the weather became worse. What I could see of the scenery through breaks in the rain was spectacular. Great lava flows from Iceland's many volcanoes (the island has about 200) ran down from the hills, and I could see several glaciers. It really is a land of fire and ice, as the tourist brochures say.

Iceland was under total Danish sovereignty from 1380 until 1903, when it won complete domestic autonomy. In 1918 a special Act of Union gave it the status of a sovereign kingdom under the Danish crown and it became an independent republic in 1944. During World War II it was an important American air and naval base. The republic has the distinction of having the oldest legislative body in the world, the Althing (parliament), founded in 930.

Although very bleak and cold by Australian standards, Iceland is an easier place to live in than Greenland. It has a much milder climate because, although it is as far north as Greenland, its southern shores are washed by the warm Gulf Stream current. Reykjavik, for example, has an average annual temperature of 5°C, which is tropical compared with Sondrestrom, shivering in temperatures well below freezing for nine months of the year.

There is much more vegetation in the form of grass and heather and some rather stunted birch

AUGUST

S	M	T	W	T	F	S
1	2	3	4	5	6	7
8	9	10	11	12	13	14
15	16	17	18	19	20	21
22	23	24	25	26	27	28
29	30	31				

and beech trees. The population of about 300,000 is scattered around the coastline, leaving most of the interior thinly inhabited, like Australia. It is a very clean, organised society which has made the best of living in a tough country. An example of this adaptability is the extensive use the Icelanders have made of the country's underground hot springs and geysers which are harnessed to heat homes and factories.

Still, spectacular scenery or not, it was an unpleasant flight, brightened by several chats with amateur radio operators in England. I was very glad to set down at Hornafjordur after two hours and three minutes in the air. A very friendly traffic controller, Magnus Peterson, guided me into the town; he quickly refuelled the helicopter himself.

A steady rain was falling and the prospects for the 260-mile flight across the North Atlantic to Vagar in the Faeroes that day did not seem too bright. A phone call to the weather people at Reykjavik confirmed my doubts; it was also raining in Vagar, with a 700-foot ceiling.

I scrapped any plans to fly further that day. The Faeroes, which belong to Denmark, are a group of 17 small islands slap in the middle of the North Atlantic. If the weather worsened and I could not land there I would be in big trouble. Regretfully I resigned myself to spending the night in Hornafjordur. Magnus Peterson took me to a hotel after I had arranged with him for an 8 a.m. departure. Magnus showed me where to find him in the morning in the partly completed new terminal where he lived.

I was back at the airport by seven o'clock the next morning. A smart bang or two on the wall of his room quickly woke Magnus, who opened the small temporary flight service office, took my flight plan and gave me a weather forecast. At 8.03 a.m. I was airborne and heading out over the North Atlantic for the Faeroes.

I climbed away from Hornafjordur in good weather with a 4000-foot ceiling but it did not last long. Later, I was dodging rain squalls and remembering all the terrible things I had read and heard about the North Atlantic. Staying between 500 and 1000 feet I settled down to a firing game of hide-

and-seek with the scattered rain squalls. I flew below the cloud and evaded most of the showers.

I avoided looking at the cold sea below me. If my engine failed at 500 feet I would have 15 or 20 seconds in which to give a May Day call before hitting the water. I had already worked out what to do in an emergency. The JetRanger would only float for less than a minute, so the first priority was to get out quickly. I was wearing my Multifabs survival suit and life jacket of course, so I would stay afloat and the suit would, I hoped, protect me from the cold until I could climb into my tiny life raft and wait till help arrived.

The little self-inflating life raft was in the cabin with me. My disaster drill was: get the May Day call out, try to rotate the helicopter to land on its left side in the sea (JetRangers are flown from the right-hand seat), grab the life raft, scramble out of the right-hand door, inflate the raft and climb into it as the helicopter sunk beneath me. It would have to be done extremely fast; a slight delay would send me down with the JetRanger.

Flying across the Atlantic alone is a profoundly disturbing experience, even today with the most advanced communications and navigational systems money can buy. There is a great feeling of loneliness over such an immense wilderness of water. Many times on my flight I thought of James Mollison and his solo flight that I was commemorating. Gosh, if he could do it when it was so much harder, I could do it too. The very thought of his achievements was a morale booster. Imagine winging across the Atlantic alone for 30½ hours as he did in 1932, with no friendly voices on the radio to comfort him, no effective weather forecasts and with such primitive navigational equipment that at the end of his trip he had to look for an opening in the fog to land at Pennfield Ridge in Canada. See map on page 14. In only two days' time it would be the 50th anniversary of his famous flight. Yes, those early fliers were heroes, every one of them.

Despite the poor weather, I was having a fine day I suppose, by North Atlantic standards. Two hours after leaving Hornafjordur I sighted the rugged coastline of the Faeroes with a jagged peninsula jutting into the sea towards me.

After tracking across the North Atlantic from Iceland, I came in to the Faroes airstrip by the back door. I was on the wrong side of the mountains and could not find the inlet which would have led me to the airstrip

I had trouble finding the airport at Vagar. After receiving instructions from the Vagar controller I made a 90° turn and headed north, clearing the peninsula and running along a very rugged coastline featuring a huge waterfall. It soon became obvious that it was not the way to the airport. The Faeroes, like Greenland and Iceland, are of volcanic origin and certainly look it with jagged lumps of windswept rock with a few hardy trees, all introduced, I believe, sheltering in valleys and lee slopes from the almost constant gales. Fortunately, there was no gale blowing that day.

The Vagar controller agreed I could come in over the mountains, so I followed the waterfall up into the hills and overshot the little airport. The startled controller pointed out my error and told me to look down to my right where I would be able to see the airport. After a quick 180° turn I landed at Vagar two hours and 39 minutes after leaving Hornafjordur.

I would have liked to look around the Faeroes but time was running out. My appointment with

Prince Charles was now uppermost in my mind. The timetable arranged by Buckingham Palace called for me to land on the Queen's Golf Course at Balmoral at 10.30 a.m. local time. Thanks to the stop at Knoxville to visit the World's Fair, and the enforced stops due to weather in Moncton, on the Meta Incognita Peninsula, at Kulusuk and at Hornafjordur, I had used up all my credit balance of spare time. My meeting with Prince Charles was less than 24 hours away, and I still had about 500 miles to go. In that 24 hours I still had a great deal of work to do.

I was impatient to get away again as quickly as possible. A picture kept recurring in my mind of Prince Charles and his aides on the golf course at Balmoral, scanning the sky for *Delta India Kilo*, while I sat out a storm somewhere. I could imagine how embarrassing it would be for Pip and the girls, Jim Heagney and the people from the Australian High Commission. The only people who would not be disappointed, I thought rather bitterly, would be the press, especially the Australian press. I could see the headlines:

"Dick Smith stands Prince up."

"Red faces as Dick Smith misses Balmoral date."

It was unthinkable. So I leaped out of *Delta India Kilo*, ready to refuel and take off on my next leg to Sumburgh in the British-owned Shetland Islands. It was a 218-mile leg and the quicker I got it behind me the happier I would feel. The weather changes so rapidly in the North Atlantic that I would have to take advantage of the good weather when it occurs.

If I got through to the Shetlands that day nothing short of total disaster could stop me from making that 10.30 a.m. meeting!

Imagine my disappointment when I was told that the weather at Sumburgh was "very marginal" and that it was unlikely to get in there. I was shattered. Not only were my plans of meeting Prince Charles in considerable jeopardy at this, the eleventh hour, but representatives from British Airways and Qantas were waiting to welcome me in Sumburgh. It was maddening that I just could not get away

92

from the bad weather which had plagued me for the last week.

A decision had to be made, and quickly. It would be very disappointing for the people who had flown to the Shetlands especially to meet me. But I just could not hang about in Vagar until the weather improved; it might take days. On my present, extremely tight schedule, which seemed to be tightening like a noose every hour, I could not afford any delay at all. Hastily, I consulted my maps again. A few calculations told me that I should be able to fly to Stornoway in the Outer Hebrides off the west coast of Scotland, and bypass the Shetlands and their bad weather altogether. I would save more than 100 miles on that Faeroes – Britain leg.

However, you cannot fly into a country at just any point; there are rules and regulations to be observed. I asked the Vagar traffic control office if I could enter Britain through Stornoway. They said I could but there was one snag; Stornoway Airport closed at 4 p.m. local time which was really 3 p.m. GMT as Britain was currently on daylight-saving time. The Faeroes, although about seven degrees west of the Greenwich Meridian, are in the Greenwich Time Zone. So, as the time in Vagar was by now 11 a.m. GMT, I had only four hours in which to redraw my flight plan, refuel and fly across 241 miles of empty, dangerous ocean.

There was nothing for it but to work like mad. I sat with my maps, pencil and protractor at a desk in the Vagar control tower and drew up another flight plan. It took 10 minutes, including calculating all the waypoints for the VLF Omega. I handed it in to the flight controller, feeling pretty pleased with myself, and then ran into trouble from a totally unexpected quarter. Would I please come and see the Faeroes customs officer? Of course, I had to go and minutes later I was being carpeted by an angry customs man who had expected me the previous evening. He had spent "many hours", he said, cooling his heels at the airport waiting for a transatlantic flier who never arrived. I calmed him down finally by getting through to him that it was not my fault. Reykjavik control had been told through Hornafjordur that I was spending the night at Hornafjordur,

and Reykjavik should have advised Vagar. It turned out that Reykjavik had told the Vagar tower but they had not thought to pass on the message to the unfortunate customs man. Anyway, we parted amicably enough.

After refuelling I finally got away one hour and 22 minutes after landing. Considering that in that time I had drawn a completely new flight plan, refuelled, and soothed an irate customs man, I felt I had done very well. In fact, I felt pretty good generally now that I no longer feared bungling the royal appointment and making myself and Australia a laughing stock.

The flight from Stornoway to Balmoral would take little more than an hour unless the most incredible bad luck intervened. "I've got it in the bag," I thought, and the depression which had never been far away during the past two weeks seemed to slip from my shoulders. I was still mentally and physically exhausted. The monstrous workload had drained me, but I was happy.

Stornoway is a little town on the Isle of Lewis, the northernmost island in the Outer Hebrides group. The weather forecast showed slight headwinds and rain showers on my track, but nothing serious.

My course from Vagar was almost due south at 500 feet. About 80 miles out I flew over a large fishing fleet spread across about 20 miles of shimmering sea. They must have had a good catch because they were surrounded by tens of thousands of wheeling, diving seabirds. I dropped down and circled some of the boats, taking pictures of them and noting their position on the VLF Omega so that I could get back to them if I got into trouble.

Up to the halfway point I kept in touch with Vagar control, then switched to Stornoway. I also had some very good amateur radio contacts with my friends at Matlock, England.

After little more than two hours in the air I felt like shouting "land ho!" There it was — the coast of the Isle of Lewis.

In a few minutes I would have done it! The first person to fly a helicopter solo across the Atlantic! It was a great feeling.

First Across the Atlantic

A small village and a lighthouse drifted into view, and a courteous Stornoway controller came on the air. Minutes later I touched down in the United Kingdom at 3.25 p.m. local time (14.25 GMT), 18 August 1982.

The little airport still had 35 minutes to closing time, so I had nothing to worry about. What would they have done if I had arrived after closing time? Nothing I suppose. They could hardly have stopped me landing, or insisted that I circle the airfield all night until it opened the next morning. I was tired after spending five hours in the air in marginal weather conditions, but I was happy.

After I had complied with the customs requirements and done the other paperwork, I refuelled *Delta India Kilo* and gave her a good wash.

Then I set about smartening myself up. I brushed the creases out of my survival suit, cleaned

Above: The mysterious bullet holes. The bullet through the downslide would have passed only 30 centimetres in front of my chest. Another bullet went through the rear window and punctured the auxiliary fuel tank — luckily, above the fuel level

Right: Brooding Loch Ness, Scotland, and not a monster in sight. Alas! Nessie proved as elusive as ever. Even the siren call of DELTA INDIA KILO's engine could not lure her to the surface

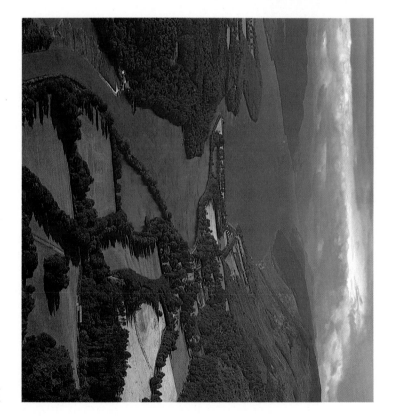

95

my jumbo captain's hat and managed to borrow some shoe polish from an airport fireman to put a gleam on my shoes. After all, I could not meet royalty in grubby shoes!

Afterwards I posed beside the helicopter for a fireman who wanted to take some photographs — and made a frightening discovery. There was a small hole in the perspex of the pilot's window. We studied it and decided that it must have been made by some object which had chipped the perspex while it had been parked somewhere. Then we found another hole through the rear window perspex and into the fuel tank. This was obviously a bullet hole. I examined the other side of the aircraft to see if the bullet had gone right through the tank, but it had not. There was a bump where it had hit the riveted main top seam of the tank. Obviously it was still inside. Perhaps some hooligan had taken pot shots at the helicopter while it was parked on the ground somewhere. In that case, as I had always put a cloth cover over the cabin section at night for security against pilferers, the cover would have bullet holes, too. I got the cover out of the luggage compartment and had a look. No holes. I had to face up to the frightening knowledge that there were people around who would deliberately fire on a passing helicopter with intent to kill. The bullet through the pilot's window had passed a few centimetres in front of me. It could have hit me in the stomach or lower chest, depending on its angle of entry. In either case I would have been killed or so badly wounded that I would have lost control of the helicopter and crashed.

The bullet through the fuel tank was less dangerous because *Delta India Kilo*'s Allison jet turbine uses aviation kerosene which is relatively less volatile. If the helicopter had been powered by a piston engine using high-octane aviation fuel, there is every chance that either a spark from the bullet striking the outer casing of the fuel tank and ricocheting inside or the heat generated by its impact would have ignited the fumes in the tank and caused a violent explosion.

Looking at the damaged tank I remembered that while flying along the coast of Greenland I had

96

thought I smelled fuel vapour. While doing my routine post-landing check of the helicopter at Kulusuk, I had gone over the fuel lines carefully, looking for a leak, but had found nothing wrong. I had not noticed the hole in the tank itself because it was so high up. Why had I not noticed the bullet holes in the windows? I do not know. Maybe they were hidden by the rain and mist which always left some sort of residue on the perspex. The fact that I did not notice them shows how tired and inefficient I was becoming with my ground checks. Those bullet holes will remain a mystery. The Bell agents in England later cut a hole in the top of the tank and removed the bullet. It was a .303 calibre, or larger, all-lead projectile of the type normally used by sealers.

My first thought was to go straight to the police and tell them what the fireman and I had found, if only for the sake of having the incident officially logged somewhere as soon as possible. Then I had second thoughts. If I told the police there would be investigations, photographs, questions, statements to be made; they would probably impound the helicopter for a while! That decided me. "By crikey," I said to myself, "I've flown for two weeks and this is the hardest thing I've ever done in my life, and nothing, *nothing*, is going to stop me from getting to Balmoral Castle to see Prince Charles tomorrow morning!" So I decided to leave the police out of it, at least for the time being. I explained the situation to the fireman and he agreed to keep quiet about the bullet holes.

With helicopter and shoes shining, I hired a car and drove into Stornoway, a small fishing town of about 5000 people, and booked into a hotel for the night. I went out and bought a road map at a service station. With all my sophisticated navigational gear and complex, large-scale charts, I was not at all sure where Balmoral Castle was! The big Operational Navigational Chart I had for the area simply showed a large restricted airspace area around the area where I thought Balmoral Castle would be. The map showed the location of the castle and all the roads leading to it, as well as the nearby town of Braemar, home of the famous

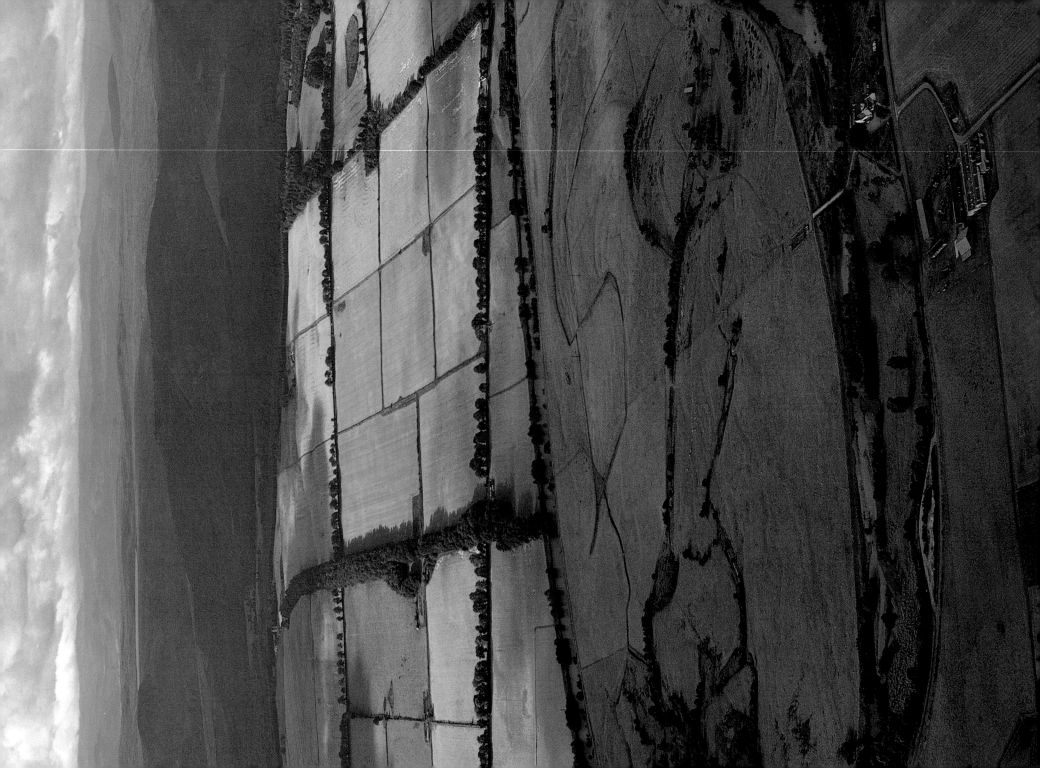

| AUGUST | | | | | | |
S	M	T	W	T	F	S
1	2	3	4	5	6	7
8	9	10	11	12	13	14
15	16	17	18	19	20	21
22	23	24	25	26	27	28
29	30	31				

Above: The little Scottish town of Braemar, home of the Highland Games. I used up a few minutes circling the town so that I could get to Balmoral Castle, a few miles away, dead on time for my meeting with Prince Charles

Left: The sunlight falling on this chequerboard of Scottish fields near Inverness gave me the chance to do some low-level photography. Clouds building up over the Grampian Mountains caused me to worry about keeping my appointment with Prince Charles at Balmoral Castle, which lay beyond the mountains

Highland Games, where Pip and the girls were staying the night awaiting my arrival. Qantas had flown them from Australia to share one of the most exciting days of my life. Jim Heagney and a party of media people were also staying in Braemar, so there was going to be quite a reception committee.

I almost made an error at this late stage which could have delayed my meeting with Prince Charles after all. Throughout the flight I had kept my watch on GMT. I had naturally assumed that Britain would be on GMT, an ill-informed assumption because, as I had found when plotting my course from Vagar to Stornoway, Britain was on daylight saving which meant that my watch was an hour slow. I would have arrived at Balmoral at 11.30 a.m. instead of the 10.30 a.m. indicated by my watch.

Fortunately, I was alerted to my error when I listened to a radio news bulletin that evening. In Braemar, Jim Heagney had had the same thought and telephoned me to point it out. It fairly made my blood run cold to think there could have been an error in timing, however slim the chances were.

After catching up on my never-ending paperwork I finally got to bed at midnight, feeling very tired. I had flown for five hours that day, which is not a very long time, but it had virtually all been over water which imposes more nervous strain.

I did not get to see much of the Outer Hebrides or Stornoway, but I was given a practical demonstration of the Scots' attitude to money. At Washington National Airport I was charged less than one Australian dollar to land *Delta India Kilo*. For the privilege of putting down in Stornoway's tiny field I had to pay £15 sterling (A$25) plus £1.70 (A$3) for parking, making Stornoway one of the most expensive touchdowns on the whole journey in terms of landing fees.

The day I had been looking forward to for almost two years dawned fine and clear. I was up before 6 a.m., ready in record time, and at the airport at 7 a.m. It was exciting to think about the people waiting for me only a few hundred miles away. I was as jumpy as a cat on a hot tin roof. The weather report was generally good except for the

low cloud and rain showers predicted for the rugged Grampian Mountains, which lay slap-bang across my final approach to Braemar and Balmoral Castle. The forecast would have had to be very bad indeed to delay my flight at that stage. I filed my flight plan and sat impatiently at the airport for another half hour. I had to kill that time on the ground rather than in the air because I had calculated my fuel for the Stornoway–Balmoral leg, then on to the Glasgow leg as I did not think Prince Charles would have a spare drum of jet fuel lying around. I wanted to arrive at exactly the agreed time. I did not want to get there early and sit around, which would have been an anticlimax; and if I did get there too early and filled in the time by flying around until it was time to land, I would probably not have enough fuel to fly the 116 miles from Balmoral Castle to Glasgow, my next refuelling stop.

Finally, after putting on my survival suit and life jacket, I started up *Delta India Kilo* and at 7.59 a.m. lifted off Stornoway field for my last over-water section of the Atlantic crossing — the channel between the Isle of Lewis and the Scottish mainland called the Minch. The Minch is very deep and swept by fast currents and has an average width of 35 miles, but as my course angled across it from Stornoway south-eastwards to Greenstone Point, I would be flying over water for 40 miles.

Except for my first view of an ocean oil-drilling rig, the flight was uneventful. I used my new road map to find my way around the glens and lochs. Just over an hour after leaving Stornoway I sighted the city of Inverness, and to my right was the legendary Loch Ness! This was too good an opportunity to be missed; what a coup if I spotted the famous monster! With the still and cine cameras I was carrying I should be able to get enough good pictures to have the beast identified once and for all. Filled with the thrill of the hunt, I took *Delta India Kilo* down to 80 feet and skimmed over the peat-darkened water.

Loch Ness is the largest body of water in Britain and, thanks to the monster, the best known.

Flying across its rather forbidding surface, with the lowering hills on either side, it is not dif-

ficult to imagine that some strange creature lurks there; perhaps some leftover from an earlier age.

The monster, be it a plesiosaur or plain red herring, as I am more inclined to believe, failed to make an appearance, so I swung back on course for Braemar and Balmoral Castle. Ahead of me were the Grampians, wreathed in cloud. "Crikey," I muttered, "don't tell me I'm going to miss out getting through at the last moment!" There was nothing for it but to keep going. I still had plenty of time in reserve, and by following the roads shown on the road map I gradually worked my way up and over the mountains without any trouble, flying over lovely heather-clad country etched by beautiful little rivers. The only snag was the Scottish air traffic controllers; I just could not understand their broad accents. In fact, I had more difficulty with the Scots controllers than I had since leaving the United States. I found the American accent hard to understand; they compounded the difficulty by speaking terribly fast because they were all so busy, poor devils. Here I was having the same trouble in Scotland, part of the United Kingdom and home of the English language! It seemed even stranger when I remember the perfectly intelligible English spoken by the Danish and Icelandic traffic controllers who used English as a second, but foreign, language.

I was still running well ahead of time, despite my brief search for the monster. I was determined not to be seen at Balmoral Castle before the appointed time, so I steered by compass course across the hills, well out of sight of the castle, and sighted the little village of Braemar at 9.59 a.m. local time. I was not going to be caught out thinking in GMT again until the day was safely over.

I circled the village a few times, thinking of the excitement Pip and the girls must be feeling on hearing the familiar beat of the JetRanger and realising that I had really done it.

To kill time I flew up and down the valleys around Braemar, keeping one eye on my watch and getting very excited about my meeting with Prince Charles. In a few minutes he would be driving down from the castle to the Queen's Golf Course to welcome me.

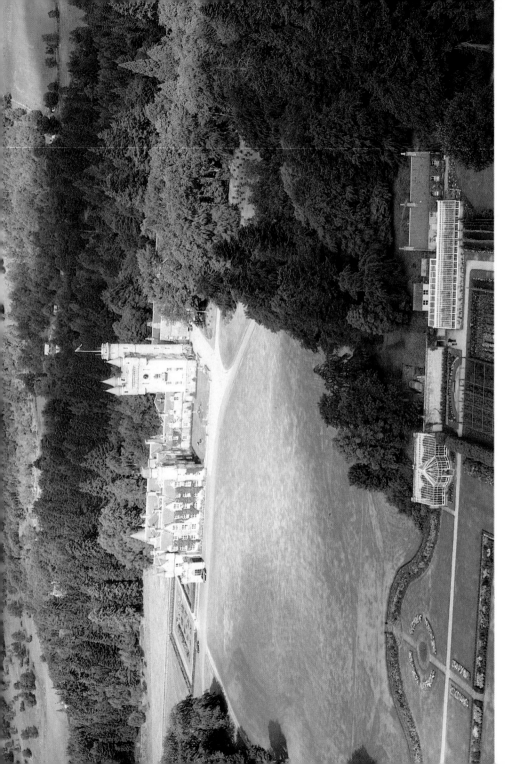

Meeting with Prince Charles

With five minutes to go I had no fears of being late. Jim Heagney wanted to know where I was and was already on the golf course with a portable two-way aircraft radio. "I'm flying around Braemar," I told him, "and I only hope I'm in the right location."

A few minutes later Jim was back on the air, "Prince Charles has arrived two minutes early," he said. "He wanted to make sure he was here when you arrived!"

"No problems, Jim, I'm coming now," I said and turned away from Braemar and roared off down the valley of the River Dee at 500 feet. Then I got an unpleasant shock. I swept around a bend in the Dee expecting to see an enormous great castle towering over the river from a craggy height along the bank. Surely Balmoral Castle would be similar to Windsor Castle I thought. But there was no castle in sight.

For a few seconds I hit the panic button. "Crikey," I thought, feeling sick, "it's the wrong valley and I'm going to be late, I've mucked it up!" And then, to my immense relief, I saw the castle — it was only small — nestling among the trees. I was in the right place at the right time after all.

I descended rapidly and flicked on the movie camera. I came in a few hundred feet above the castle when I saw the welcoming party on the golf course, a few hundred metres below the castle. And what a party! There were at least 40 or 50 people in one group, most of them from the media, and a smaller party near Prince Charles's green Range Rover. I could see Pip, my daughters Hayley and Jenny, Prince Charles, Jim Heagney, and the chief London executive from Qantas, Ray Jeppesen.

I orbited the golf course once to check wind direction and came back on a south-westerly direction, heading towards the castle. A large **H** had been laid out on the golf course as a landing marker.

It was very exciting and I was so nervous that

Above (left): Balmoral Castle is usually prohibited to non-official aircraft but the then Australian Prime Minister, Mr Malcolm Fraser, patron of my flight, had arranged special permission for me to enter the forbidden zone

Left: After eagerly awaiting my arrival at Balmoral Castle, Pip and our daughter Jenny, aged eight, take a look inside DELTA INDIA KILO. Prince Charles has his arm around our eldest daughter, Hayley, who is ten

Far left: A stirring sight after 6300 miles! The mighty Thames unrolls beneath me with Tower Bridge ahead. Two bridges beyond it, on the right, may be seen the floating helipad I was making for

I almost fumbled the landing which I had wanted to be my best ever. I came in far too high, and to get into the glide slope required to put me on to the landing-site marker I had to reduce power drastically and almost auto-rotate down. Many people think that a helicopter always drops in vertically. Well, of course it can, but it is not the safest or most professional way to land, especially in front of royalty and media people.

I got back on my glide slope and landed acceptably, turning the helicopter while it was hovering, putting Prince Charles on my side of the aircraft.

There he was, wearing a kilt! I hastily switched on the movie camera and began filming and talking into the microphone in a voice trembling with excitement. Looking at the Prince's kilt I had a crazy thought: perhaps I should have worn the Smith tartan. It would have gone well with my Qantas captain's cap.

Why, the reader might ask, having flown all this way to meet Prince Charles, did I sit in my helicopter filming him instead of leaping out as soon as I landed?

The answer lies in the one quirk of the Bell JetRanger which I find both irritating and time-wasting. After landing, the Allison engine has to be left idling for two minutes while the turbine outlet temperature stabilises. So the Prince and I just had to stare at each other for two minutes until I could shut down the engine and climb out. Touchdown had been at 10.29 a.m. on 19 August 1982, one minute ahead of schedule. Not bad timing I thought after more than 50 hours of flying and 5000 miles. A fitting commemoration to James Mollison, exactly 50 years after his historic solo Atlantic flight.

At last I was shaking hands with Prince Charles and, although I was dreadfully tired, it all seemed so worthwhile. Then I was hugging Pip and the girls, it was all absolutely wonderful. Seeing them there so far from home was as exciting as meeting the Prince. Jim Heagney was grinning widely in the background. He had been talking to Prince Charles before I arrived, telling him about the flight from Fort Worth.

Prince Charles was extremely friendly and most interested in the JetRanger. He asked many

104

questions about the flight and seemed amazed by the smallness of the helicopter.

Thank goodness the protocol surrounding royalty in Britain kept the media people in the background while I chatted with the Prince and my family.

Prince Charles examined the mysterious bullet holes and speculated about who could have shot at me and why. "Perhaps the Trans-Globe Expedition took a few pot shots at you," said the Prince jokingly. The Prince is patron of the Trans-Globe Expedition, led by a friend of mine, English adventurer Sir Ranulph Twistleton-Wykeham-Fiennes. (It is a better name than Dick Smith!) The expedition has recently circumnavigated the world via both poles.

While talking with Prince Charles I suddenly remembered I had something that I had brought all the way from Australia for this occasion. It was a little wooden helicopter which Pip had bought in Sydney. My mother had painstakingly painted a small blue kangaroo on the fuselage so that it looked like *Delta India Kilo*. I gave it to Prince Charles, who received it with, I think, genuine delight, and said it would be ideal for his son.

"Don't let him eat it," I cautioned.

The Prince smiled. "Don't worry, he probably will."

I then told the Prince I had diverted over Loch Ness. "But I couldn't find any monsters," I added.

The Prince glanced at the horde of waiting photographers. "Don't worry," he said. "There are plenty here."

Prince Charles spent about half an hour with us and obviously enjoyed himself. He then drove back to the castle in the Range Rover and I spoke with the media. Most of them were far more interested in what Prince Charles had said to me than in the fact that I had just completed the first solo helicopter crossing of the Atlantic.

I was delighted to see a television team which had interviewed me in Fort Worth. They had come all the way to Scotland to record my arrival at Balmoral Castle. Was it really only two weeks ago that I had left there? For the sake of transatlantic relations I popped back into the helicopter and re-emerged wearing the Texan hat I had been given in

Fort Worth just before my departure.

While I was talking to the press Jim worked on the flight plan for the Balmoral Castle–London leg. Fifty-three minutes after landing I took off and flew to Glasgow where it was raining heavily. However, I managed to refuel and get airborne again in 35 minutes. The weather was rapidly deteriorating and as I reached Solway Firth, that big arm of the Irish Sea south of Dumfries, it became so bad that I had to turn back and orbit for a while. Finally, I took the helicopter down to 500 feet, tracked around the head of the firth, and found better weather as I crossed the border between Scotland and England, which bisects the head of the firth and runs just south of the famous little Scottish village of Gretna Green. The village was made famous as the goal of English couples wanting to make hasty marriages without the approval of their parents. Scottish law was more lax where marriage was concerned and they were usually performed by the village blacksmith until they were banned in 1940.

Ahead of me, as I crossed into England, lay the Cumbrian Mountains and the legendary beautiful Lake District which I knew well as I had climbed and walked in this area a number of times. The weather was turning nasty again. I could see the dark blur of heavy rain and savage thunderstorms lashing the hills and mountains ahead of me. I certainly was not game enough, or silly enough, to tackle that sort of country in bad weather. To avoid it I swung away to the west after talking to a Scottish flight service officer who warned me about straying into the restricted airspace above the atomic power station near Whitehaven. On the track again near Morecambe Bay in Lancashire, I flew on in low cloud and rain to the famous town of Sheffield.

South-west of the town, and only slightly off my track to London, was the little Derbyshire town of Matlock, home of Lowe Electronics. The Lowe team, who had never let me down in my cold, lonely and worrying flights across the North Atlantic, had been talking to me by amateur radio ever since I left Balmoral Castle. They had asked me to drop in on my way to London and meet the staff. I could hardly refuse. The Lowe people had been wonderful to

me throughout the trip; a constant link with the outside world, and a great electronic safety-net if anything went wrong.

The weather had worsened by now, and in the crowded Midlands there are literally dozens of small towns all looking very similar. How on earth would I find Matlock in the murk surrounding me? Then I remembered the trusty VLF Omega. I keyed in Matlock's latitude and longitude, and simply let the helicopter fly me there. It was not long before the amber alert light flashed on the Omega, indicating that my "target" was one mile away. By now the Lowe amateur radio operator, David (G8 GIY), was becoming very excited. "I can see the helicopter, yes, I can see the helicopter."

That was all very well, after all *Delta India Kilo* was the only helicopter in the sky above Matlock at that moment; but where on earth were my friends? David came on the air again; "Turn 180 degrees and look at the centre of the town. You'll see a group of people in the middle of the park."

I turned the helicopter and found the park. Fortunately, Matlock is not big; it has fewer than 30,000 people. "I can see a park," I said, "and some schoolchildren."

"No, no, they're not schoolchildren," he answered excitedly. "That's all the staff of Lowe's."

Lowe Electronics had got permission for me to land in the middle of the town, so I came screaming in and plonked the helicopter down slapbang in the middle of the park. I knew I did not have much time as I wanted to make London by 4.30 p.m., so I jumped out and was soon busy shaking hands with all the enthusiastic, excited Lowe staff. It was all so hurried that I can only remember a blur of faces, but everyone seemed delighted to see me; to meet in the flesh the man who had just been a voice on the ether. I bet I was the first Atlantic flier to land in Matlock. Cameras clicked like mad as I waved goodbye and jumped back into the helicopter to lift off again. I had been on the ground for only a few minutes but I knew it was worth it. It made me feel good to be able to thank them in person for all the help, encouragement and confidence they had given me.

107

Following page: A dirigible soars over DELTA INDIA KILO in her pen at the Farnborough Air Show. The little JetRanger was on show for a week and attracted a great deal of interest

A 4.30 p.m. appointment in London with the Australian High Commissioner, Sir Victor Garland, and, of course, the media was the reason for my haste. I certainly did not want to muck up my arrival in London by being late.

The weather to Oxford was marginal. I asked the London control for advice and they said the helicopter routes into London generally followed the major motorways. When I told them I did not know anything about the area, they agreed to vector me in by radar. They brought me in from the northwest, across Oxfordshire and Buckinghamshire, and soon I picked up the River Thames.

I flew up the Thames looking for a helipad and not London's Heathrow Airport. It was too exciting for words. Hundreds of years of history unrolled beneath my feet: there was St Paul's Cathedral, the Houses of Parliament, Westminster Abbey and Tower Bridge. It was like a flying history lesson. I was almost choked with emotion to realise that here I was, living out the fulfilment of a dream. I had seen New York and flown around the Statue of Liberty in little *Delta India Kilo,* and now this! I filmed and rattled a commentary into my tape-recorder, feeling as excited as when my first crystal set worked when I was eight years old.

The helipad, which is on a barge in the Thames near Blackfriars Bridge, close to St Paul's Cathedral, came into view. I then had to give all my attention to the job of making a good approach and landing. Just as I was going in another helicopter carrying a group of German media photographers radioed me and said they wanted some pictures of me flying over London. I climbed over the Thames again and obliged the flying photographers by doing an orbit.

Meanwhile, I could see the crowd waiting for me on the helipad. I was horrified to see that they, and a parked helicopter, were on the eastern side of the pad, the side on which I had intended to approach because there was a strong westerly wind blowing. There was no way I could tell them to move, so I compromised and came in from the north over the walkway which linked the pad to the Embankment. It was not one of my ideal

approaches but the best I could manage in the circumstances.

After sitting tight for the Allison's required two minutes (what a fool one feels!) I got out and was met by Sir Victor and a large group of newspaper, radio and television people. There must have been at least 40 of them.

By this time I was absolutely physically, mentally and emotionally exhausted. I was in no state to meet the media, but of course it had to be done. I think I was a little bit high with the realisation that I had crossed the Atlantic alone in a helicopter, met the Prince of Wales and was now here slap-bang on a helipad on the historic Thames in the heart of London. I did not know whether to laugh or cry; I felt like doing both.

But tired as I was I spent half an hour with the media, giving interviews, describing the flight and having picture after picture taken and many metres of film used on me and *Delta India Kilo*. Smile Mr Smith. Look this way Mr Smith. Can we have one of you in the helicopter Mr Smith? Lean against the helicopter Mr Smith. Smile please. Look this way. Look that way. Tell me this Mr Smith. Tell me that Mr Smith. What about this, that and the other Mr Smith? And for the hundredth time, why are you doing this Mr Smith?

At last it was over. But not quite. I could not leave *Delta India Kilo* on the small floating helipad all night, so, after 25 minutes on the ground, I was in the air again flying across the river to a large heliport operated by the Westland Helicopter Company in Battersea. When I landed I had flown six hours and 30 minutes that day, once again in very marginal weather. It was with enormous relief that, after tucking up *Delta India Kilo* for the night, I tumbled into a Qantas car to be driven to the flat Pip had rented in Sloane Square in the West End.

It was one of those blocks of flats with a security lock on the common front door. I shall never forget my feelings as I pressed the doorbell and waited for Pip to let me in. The door was opened and there she was with the girls! Gosh, it was exciting to be back with them. My memory is a bit fuzzy after that. I remember following Pip upstairs and plonking myself down on a couch and saying, "Well,

never again. That's it. I'm not going on."

Looking back on it now, it is hard to recall how I could have been so depressed as I walked into that flat. I cannot, today, see how I could ever have felt that way, to even consider packing up the whole adventure, after having got this far. But that is how I felt. At the time I was just so mentally and physically exhausted that there was absolutely no way I was going on with that flight — and to hell with what people thought. I think I was affected mentally by the enormous tension of flying my tiny single-engine helicopter over a long ocean crossing in bad weather, knowing what would happen if the engine failed.

I actually sat down and worked out how I would get *Delta India Kilo* back to Australia. I seriously considered having it dismantled and sent home in a container, which would certainly have been an ignominious end to a great adventure. Mental and physical exhaustion does strange things to people.

After a good night's rest and some of Pip's cooking I felt a bit better. Free of the constant nagging knowledge that the day ahead held nothing but a horrid grind of planning, flying, navigation, filming, commentary and airport paperwork. I had allowed myself a three-week break with my family in London, and I felt like a schoolboy waking up on the first day of the holidays. Three whole weeks to spend as I liked. The prospect was fantastic after what I had been through.

Yes, that London stopover was one of the best ideas I have ever had. Gradually all the tension ebbed out of me. Pip, Hayley, Jenny and I had lots of fun. We hired a boat and spent three days on the Thames. It was glorious just to lie back and relax as we cruised up the beautiful river, between lush, cultivated green banks and pretty little villages, through the locks past Windsor Castle, and as far as Henley-on-Thames, venue of the famous annual Henley Royal Regatta. We spent one night moored in front of Rolf Harris's house at Maidenhead where the eucalypts he had grown made us feel homesick.

We wandered along London's history-soaked streets and marvelled at the places we had only read about before. Since I was a boy I had always wanted

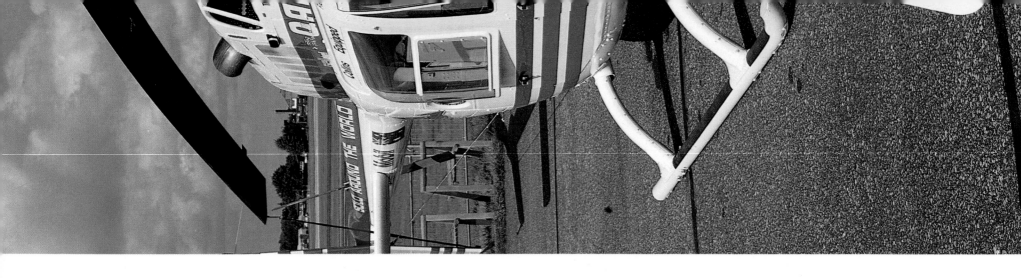

to fly a kite on Hampstead Heath. I had decided during the flight that if I ever reached England that is what I would do. We went to the heath with our kite but it was not as I had imagined: an empty stretch of land. It was covered with trees. Anyhow, we managed to get our kite airborne and it turned out to be one of the highlights of the holiday.

In between all this relaxed fun, there was some work to be done. One day, for example, I had to fly the JetRanger up to Oxford for a full service by Bell dealer, CSE Aviation Limited. Then, on 8 September, Gerry Nolan arrived from Australia to take over from Jim Heagney as advance man for the rest of the flight home. Jim, very glad to be relieved of his arduous duties, was going to Sydney.

Bert Hinkler and the other early aviators may not have had the efficient aircraft and spot-on navigational systems we have today, but they did not have as much red tape to cope with. The only "foreign" countries Hinkler landed in on his 1928 solo flight from Croydon — Britain's major airport in those days — to Australia were Italy, Libya (then an Italian colony) and the Dutch East Indies (now Indonesia). The Italians detained Hinkler for several hours because he had landed on a military airfield near Rome instead of a civil one; they eventually allowed him to continue. The Dutch in Batavia (now Jakarta) were extremely helpful. His other stops along the way were either in British colonies or in protectorates or other treaty territories. He probably did not fill out more than six forms on the whole trip.

By 1982 the great empires have dwindled to a few isolated enclaves here and there, and none of them on my route. Between Fort Worth, Texas, and Sydney, New South Wales, I had to fly over 20 independent countries, each one wanting me to fill in numerous forms, statements, declarations, disclaimers, waivers, receipts, chits and dockets. Which prompts me to offer Smith's Theorem:

"The size and importance of a country is in inverse proportion to the amount of paperwork required to enter or leave it."

It is no exaggeration to say that the paperwork

112

FIRST SOLO TRANS-ATLANTIC
HELICOPTER FLIGHT
BY DICK SMITH (Australia)
FIRST STAGE OF SMITH'S SOLO
AROUND-THE-WORLD FLIGHT

BELL MODEL 206B
JETRANGER III

SPECIFICATIONS

GR. WT. 3200 LBS.
EMPTY WT. 1641 LBS.
MAX. SPEED 115 KTS.
CEILING 13,500 FT.

- STD. FUEL 93 U.S. GALS.
- AUX. FUEL 84 U.S. GALS.
- RANGE WITH
 AUX. TANK) 787 N.M.

SMITH'S OPTIONAL EQUIPMENT

INSTR. GROUP
AVIONICS
AUTOPILOT

- VLF OMEGA NAVIG. SYS.
- AUX. FUEL TANK (SMITH)
- KING RADAR ALTIMETER
- PARTICLE SEPARATOR

involved on the first two stages of my planned around-the-world trip would fill a decent-sized packing case.

My pleasant break in London was not without its irritations. On 3 September I went up to Oxford to collect the JetRanger from CSE Aviation, so that I could take it down to the Farnborough Air Show where it was going on display for a week. Firstly, I was annoyed to see that *Delta India Kilo's* usually spotless perspex was speckled with paint-spray mist. Obviously someone had been using a spray-gun in the hangar and had not bothered to cover the JetRanger. Then, within 20 minutes of taking off I received not one but two chip detector warning signals. When I removed the detectors I found them covered with a fine layer of metal dust, which was acceptable if they had not been cleaned in the past 50 hours, but unacceptable if they had been cleaned during the service, as I was assured they had. I spent three frustrating days checking the engine, first replacing the oil, running the engine on high power and then inspecting the chip detectors. I did this many times and as nothing extra appeared on the chip detectors it became apparent that the engine was in perfect condition. I must admit I was very annoyed at the time I had wasted on this matter.

My annoyance did not last long enough to spoil my pleasure at having *Delta India Kilo* on display at Farnborough, the world's most prestigious air show. Hundreds of thousands of people attend this large exhibition of aircraft every year, so it is a fair bet to say that many thousands must have seen *Delta India Kilo* sitting there in her Australian colours. I had especially called her "Australian Explorer" so that my flight could promote our wonderful country to the rest of the world.

I had a little innocent fun at the air show too, when two American helicopter pilots turned up on the Bell stand. They had set out from Dallas with the avowed aim to beat me around the world. It appears that the younger of the pilots, Ross Perot Junior, the son of a very wealthy Texan, was reading the Dallas newspaper on 6 August which reported my departure the previous day on my world flight attempt. Perot was quoted in a later paper as say-

113

ing: "Since America has been the world leader in aviation I thought America ought to have this record, I think this is something we can be proud of and the American people can be proud of."

Perot quickly purchased a demonstrator Bell Long Ranger fitted with emergency pop-out floats and desperately set to work to do my two years of work in only three weeks. He need not have hurried though as I had planned to take a year to make my flight, and even if 300 Americans had copied my idea and set off to beat me, I would not have changed my plans.

As Ross Perot had only very limited helicopter experience he chose an experienced ex-Vietnam pilot to accompany him. (The Long Ranger helicopter is a lot bigger than my little JetRanger and this meant they had room for two.)

The Bell company had been told not to tell me that I had a competitor because it was feared I would keep going and be first around the world. But past friendships are a great thing and one of my close friends at Bell telephoned me and told me the full story. As I was over two weeks ahead at the time he urged me to keep going and be first as he did not like someone copying my idea, even if it was a fellow American, after the enormous amount of work I had put into it. I quickly explained that my intention with the flight was to see the world in a way that it had never been seen before, which meant that I would be flying visually and this would take longer. Also my flight was solo and nothing was going to make me change my plan for a 12-month tour around the world.

However, Ross Perot's flight was different from mine in a number of other ways. Firstly, and most importantly, his aircraft was equipped for instrument flight so it could fly in cloud. I looked back to my Atlantic crossing and thought just how much easier it would have been if I could have flown in cloud; then again, it would be nowhere as satisfying, as IFR helicopters had made numerous crossings of the Atlantic before.

It should be remembered that I was attempting to show that a helicopter was not just a short-distance machine, that it was just as good as a fixed-wing plane and that it could fly around the world.

114

Ross Perot obviously thought that his helicopter required the assistance of a fixed-wing aircraft, chartered at staggering cost to ensure the success of the flight. The *Dallas Times Herald* stated:

"The transport plane, an L-100 Hercules nicknamed *Mother Hen*, was chartered and filled with spare engines and parts and food, plus a 50-day supply of bottled water. *Mother Hen* also carried her four-man crew, the trip coordinator and an EDS representative, a mechanic for the L-100, two mechanics to work on the Long Ranger and two trained rescue workers who could parachute out of the plane over desert or sea or mountains if the Long Ranger went down."

So as you can see my solo attempt was not in the same class as the American team. They also had the advantage of being able to use my published flight-plan route (which they followed closely), including my original idea of a shipboard landing north of Japan. I believe the main reason no one had attempted an around-the-world helicopter flight before me was because they had not thought of that idea.

They seemed very nice blokes and we got on fine. Of course they did fly around the world. Even though for their own reasons they only touched the equator and mainly circumnavigated the northern hemisphere. I explained to them my flight would take about 12 months as I wanted to see the world as I flew, and take a lot of movie film and photographs. I also told them I had a lot of sponsors to whom I had certain obligations.

Then I gave them a bit of a start.

"When are you leaving on the next leg?" I asked casually.

"At noon," they replied.

"Oh, half an hour after I leave," I said. "I'm off at 11.30!"

Their jaws dropped. I really think they believed I was going to jump into the helicopter and race off to beat them around the world. They looked relieved when I said I was joking.

Anyway, meeting the Americans certainly did not detract from my enjoyment of the Farnborough Air Show at all. I thoroughly enjoyed myself. London was a wonderful shared experience

with my family. As the days passed I could feel my high spirits and optimism flowing back into me. The terrible strain and gloom, the self-doubt and fatigue of the last month just ebbed away in the mild English sunlight.

One day I drew up a balance sheet of my progress so far. I thought it was pretty impressive. From Fort Worth to London I had been in the air without accident – although not without a few scares – for 60 hours and 52 minutes, covering 6346 nautical miles. And in doing so became the first person to fly the Atlantic solo in a rotary-wing aircraft.

My average speed had been 104 knots (192 km/h) instead of my planned 110 (203 km/h) because of the bad weather and headwinds I had encountered. The JetRanger had been superb. All it had needed in London was an oil change and a wash and polish. The piece of manmade machinery had worked perfectly and was still in absolutely A 1 condition.

Unfortunately, the man who had flown it all those miles was not in quite the same shape. I certainly wished I was in as good a condition as the helicopter. However, at the end of those three happy weeks in London I had made up my mind to continue the great adventure.

My departure for the last long leg was set for tomorrow, Monday 13 September from the famous World War II Fighter Command base, Biggin Hill, in Kent. I said goodbye to our pleasant flat in Sloane Square and drove down to Farnborough.

We reached the air show at about 10.30 a.m. to find a huge crowd already gathered around *Delta India Kilo*. I was amazed to find three Australian television crews: Channel 2 (the Australian Broadcasting Commission) and Channels 9 and 10. I spent almost an hour talking to the television people, and then gave the helicopter a thorough check.

Lifting off at noon exactly I was excited and moved that I was being farewelled by the huge crowd of perhaps 50,000 or 60,000 people. Even on the short run to Biggin Hill, about 30 miles away, I was given another example of the helicopter's advantage over fixed-wing aircraft. It was a sunny day, but an extraordinary ground haze kept most other aircraft on the tarmac. Not the helicopter, though.

116

I just dialled the Biggin Hill VOR (VHF Omni Range) and minutes later I was happily tracking in at 500 feet. The Farnborough–Biggin Hill hop took 20 minutes, and a pleasant Biggin Hill controller let me land right on the historic fighter airstrip.

Biggin Hill is a lot quieter these days, although still listed as a Royal Air Force station. It must have been very different 40 years ago when it was one of the RAF Fighter Command's main stations. The Spitfires and Hurricanes which scrambled from this airfield to intercept the German aircraft of the Luftwaffe played a major part in saving Britain from invasion and possible defeat.

So I was extremely proud to land *Delta India Kilo* at Biggin Hill, more so because many Australians had flown with the RAF and many of them probably from Biggin Hill.

Jim Heagney and his relief, Gerry Nolan, were already waiting for me. We began to prepare for my departure the next day, scheduled for 6.50 a.m. I particularly wanted to leave then because Bert Hinkler had left at that time on 7 February 1928 from Croydon, less than 16 kilometres away. I was thinking more about Hinkler as my time for departure drew near as he was the first person to fly a fixed-wing aircraft solo from England to Australia. He had planned what was for those times a huge jump for the first day of his 11,500-mile flight to Australia: London to Rome, almost 900 miles by the shortest route. Hinkler was flying in mid-winter in his tiny Avro Avian with an open cockpit. The fabric-winged biplane had wings which folded for storage in a garage, and a four-cylinder engine which could propel at 105 miles an hour (170 km/h) in good weather.

Modern bureaucracy prevented me from leaving at the same time as Hinkler, 54 years before. Biggin Hill airport does not open until seven o'clock, and the customs officers, who have to clear any international flight, are not on duty until 7.30 a.m. However, one cooperative customs officer, when he heard of my eagerness to be away early, offered to come in at 7.20 a.m. I accepted this with the best grace possible.

The helicopter was given another thorough going-over, and I discovered that the aircraft-

mounted camera was not working. It was the one I had used to film my departure from the Farnborough Air Show, so I had lost my record of that huge cheering crowd, which was annoying. A quick check showed that the cyclic-mounted switch was faulty, so I replaced it with a spare and hoped it would not fail. I would be flying over some beautiful, exotic lands and it would be heartbreaking to get home without any pictures.

Having done all the pre-flight chores I drove to a nearby village where I had an appointment with Eric Webb, a man whom I can only call a piece of living history. He was born almost a century ago. At 94 he is, not surprisingly, the only survivor of Douglas Mawson's 1911-14 Antarctic expedition. Eric is a truly wonderful man. I first met him when I brought him to Australia in 1978 to be a guest on a Qantas Boeing 747 I had chartered for a sightseeing flight to Antarctica. I figured that as Eric had done the journey himself the hard way more than half a century before, he deserved to have a look at the magnetic South Pole in comfort as he neared the end of his long and adventurous life.

Eric was delighted to see me again. He embarrassed me by treating me as a hero. I found this admiration from a man who had spent months in the frozen wastes of the Antarctic extremely moving and humbling. He actually *pulled* a sled several hundred kilometres across the snow while making observations about the magnetic South Pole during the Mawson expedition at Commonwealth Bay.

After my visit to Eric Webb, Jim and Gerry drove me around to Pip and the girls near Reigate, Surrey, where they were staying with Pip's grandmother. I wanted Pip to see me off from Biggin Hill. After all, Bert Hinkler's wife saw him off from Croydon in 1928. I now felt I was following in the footsteps, or should I say exhaust trails, of the early Australian fliers. In *Delta India Kilo* I had two very special mementoes. One was a small piece of fabric from the *Southern Cross*, the Fokker tri-motor which Charles Kingsford Smith and Charles Ulm purchased and used to fly the Pacific in 1928. This was given to me by Ernie Crome, an old friend of Smithy. The other memento was a photograph of Kingsford Smith sitting in the cockpit of the *Southern*

118

Cross Junior. You would have to realise the admiration and depth of feeling I have about those early aviators to understand what those two simple souvenirs mean to me.

I spent a beautiful evening with Pip and the girls. Although it was September the evenings were still long; twilight seemed to go on forever. We walked along the lovely Surrey lanes picking blackberries and marvelling at the beautiful soft green English countryside. I felt it was very important that I spend that last night with my family. Certainly, I would not have to face the icy gales of the North Atlantic again, but my track lay over deserts and jungles and included several sea crossings. I was heading into areas frequently devastated by torrential monsoon rains and typhoons with winds in excess of 150 kilometres an hour. I was not pessimistic but simply aware that in the air almost anything can happen.

Later that night, in the lovely thatched cottage in which we were staying with Pip's grandmother, I did some last-minute flight planning and rang the meteorological office and received some depressing weather forecasts. The good weather we had been enjoying was ending, and my flight to Paris the next day would have the same dreary weather I had experienced over the North Atlantic.

It was an unhappy prospect to go to bed with, but I tried not to think about it too much. Instead, I read the limited notes Bert Hinkler made about his flight. I had decided to follow Hinkler's route as closely as I could, and see if I could get to Darwin in the time he did — 15½ days. (See map over the page for Hinkler's London to Darwin route.)

I marked up my flight diary with Hinkler's arrival and departure times at the stops along the way, because I wanted to see if I could keep up with the pace he set which was a tough one. In fact, his whole flight was almost unbelievable. I remember thinking before I went to bed that night how I wanted to find out what it was like to do a long trip alone in a small aircraft. I found the Atlantic flight extremely hard, maybe I would find this one even harder, in which case I would not go on. I would simply ship the aircraft to Australia and fly home by Qantas.

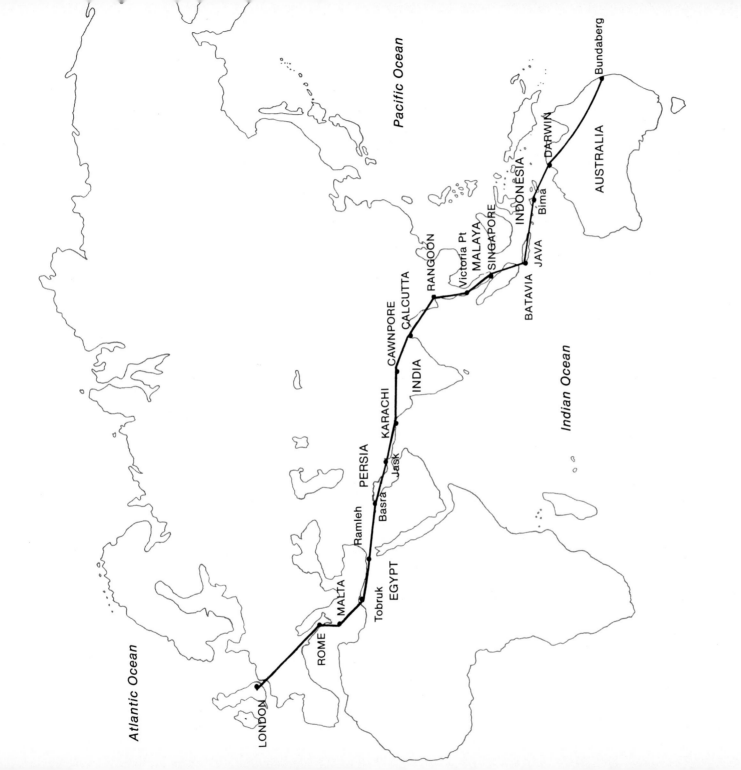

HINKLER'S FLIGHT FROM ENGLAND TO AUSTRALIA

Bert Hinkler flew from London to Darwin in 15 and a half days.
He then flew on to a hero's welcome in his home
town of Bundaberg, Queensland.

Atlantic Ocean

Pacific Ocean

Indian Ocean

LONDON

ROME

MALTA

Tobruk

EGYPT

Ramleh

Basra

PERSIA

Jask

KARACHI

CAWNPORE

CALCUTTA

INDIA

RANGOON

Victoria Pt

MALAYA

SINGAPORE

BATAVIA

JAVA

Bima

INDONESIA

DARWIN

AUSTRALIA

Bundaberg

PART TWO

LONDON TO SYDNEY

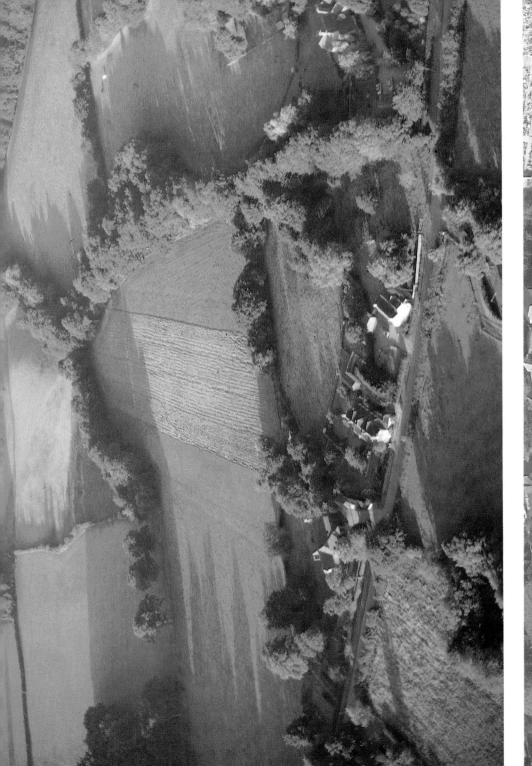
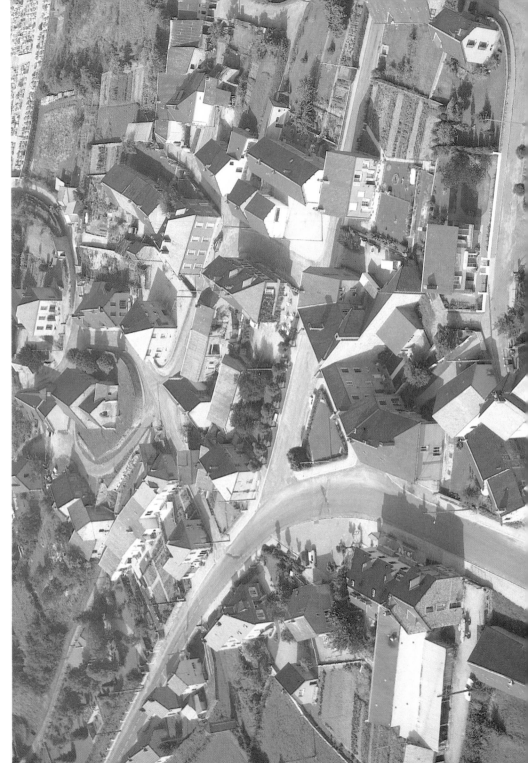

In the Footsteps of Bert Hinkler

After a quick, light breakfast we drove through heavy fog to Biggin Hill, arriving at the airfield at 7 a.m. On the way I bought two London newspapers to deliver at Alexandria Station in the Northern Territory, just as Hinkler had done. The airfield was wreathed in mist when we got there; a thick ground mist coiling everywhere. Bert Hinkler had taken off from Croydon in mist in February when it would have been a raw, damp, bone-aching kind of mist. He was wearing only an ordinary lounge suit and a woollen pullover under a thick greatcoat. No Multifabs survival suits in those days. I was lucky. I had the best, most up-to-date air navigation charts available, a magnetic compass, a gyro compass and the highly sophisticated VLF Omega navigation system with an on-board computer to do all the complex calculations for me. Hinkler only had a magnetic compass and a copy of *The Times Atlas*. Then again, I had only one engine like Hinkler, and if it failed I would have the same problems.

After another check of the helicopter and the customs formalities were over with, it was time to go. I was so glad that Pip and the girls and a few friends were there to see me off. I did a little filming, and even at this most emotional moment I could not forget my obligations as I kissed Pip and the girls goodbye.

Pip hugged me and said: "I hope you have good weather and safety, I'll be thinking of you." Fifty-four years before, on another misty English airfield only a few kilometres from where we were, Bert Hinkler's wife had said those same words to him. I had always remembered them, and it meant a lot to have Pip say farewell to me in exactly the same way. It seemed a link across the years. Hinkler had made it safely home on that trip. So, I felt, would I.

Above: It was a cool, misty English dawn when I left the famous World War II fighter base at Biggin Hill. Pip, Hayley and Jenny were there to see me off on my flight to France

Above (left): Long, early-morning shadows lean across the green English countryside as I leave Biggin Hill

Left: Munching Vegemite and lettuce sandwiches, I flew over this neat and orderly French village on my approach to Lyon

SEPTEMBER

S	M	T	W	T	F	S
			1	2	3	4
5	6	7	8	9	10	11
12	13	14	15	16	17	18
19	20	21	22	23	24	25
26	27	28	29	30		

English Channel

Bexhill-on-Sea

FRANCE

•PARIS

I started the Allison and lifted off at 7.38 a.m. — eight minutes behind my planned departure time and 48 minutes behind Hinkler's. The mist was so heavy that the runway lights showed as faint blobs in the murk. The mist thinned as soon as I began to climb, giving way to quite reasonable visibility as I cleared the vicinity of Biggin Hill.

I flew south-east across southern England, crossing the coast near the Sussex seaside town of Bexhill. From there I headed out over the English Channel, after a friendly "goodbye and good luck" from Biggin Hill control, for a 65-mile leg over smooth water to Dieppe on the French coast. I flew over several oil-rigs and some ships and fishing boats but the Channel was not as busy as I had expected it to be.

Regulations required me to contact Paris Approach control when I was halfway across the English Channel, but I could not raise them. I kept on going, anyway. Flying above heavy Channel mist I sighted the French coast, north of Dieppe, which had high white chalk cliffs like those at Dover.

I finally managed to raise Paris. The woman radio operator had trouble understanding me, perhaps because of my accent. I was worried the operator would answer in French. However, she spoke in English which is, after all, the accepted international air traffic language.

I had planned to fly up the River Seine and around the Eiffel Tower but the fog had reached France ahead of me. Paris was even closed to aircraft flying on Instrument Flight Rules, let alone a helicopter on Visual Flight Rules. Paris Approach suggested that I track around the north of Paris via Beauvais. I managed to find it on my map and called up Beauvais control tower who picked me up and took me right over the city at 3000 feet above thick mist. I flew for about 90 minutes with only occasional glimpses of the ground through rents in the white vapour which seemed to be blanketing the whole of France. At least I was in brilliant sunshine.

After Beauvais I got through to a radio controller at Charles de Gaulle Airport in Paris.

124

"My call sign is *Helicopter Victor Hotel Delta India Kilo* . . . I'm a VFR helicopter flying around the world and I'm about 11 miles east of Beauvais at the moment . . . can you give me some radar vectors to get me around the Paris control zone so I can head to Lyon? . . . I'm flying VFR at 2500 feet above seven-eighths cloud . . . there aren't enough holes for me to get down through the cloud . . ."

The Charles de Gaulle operator was wonderful. Instead of just rattling off a string of French place names which I would have had difficulty in understanding, he gave me specific radar headings and then tracked me well to the north and north-east of Paris, and then brought me back on to the Lyon track. The mist and cloud had given me a lot to worry about, and I was only three hours out of Biggin Hill and in trouble already.

On the bright side, I was making very good time.

My commentary tape records: "Well, it's 9.09 a.m. and I'm really screaming along — I'm doing 124 knots . . ." And a little later, when the cloud had thinned and I had descended to 1000 feet, "It's now 9.30 and I've only got 22 miles to Autun, and I'm absolutely screaming along, doing 130 knots over beautiful little villages."

Bert Hinkler took 12¾ hours to fly from Croydon to Rome in his Avro Avian. It seemed as though I would have no trouble in matching that time in the JetRanger. Not that I was out to beat Hinkler's times; I wanted to match his course and times as closely as possible, to fly where he flew, and to try to feel how he felt.

While belting along towards Lyon I was given a practical demonstration of another advantage I had over the early aviators. I recorded it on tape:

"Oh. I've just dropped my map down the front (of the cabin) . . . I had to release myself from the seat belt to go down and get it and luckily the autopilot flew perfectly . . . but you wouldn't be able to do that without an autopilot . . . I've also lost my pen for about the 400th time, and had a nice peach."

The air traffic controller at Pisa allowed me to fly close to the famous leaning tower and take photographs. My only fear was that the JetRanger's noise and rotor-wash might send the tower toppling

Hinkler would certainly not have been able to leave the controls of the Avian while he scrabbled around on the floor of the cockpit looking for a map or pencil he had dropped.

There was another factor which Hinkler and many of the other pioneers must have found exhausting — noise, especially in open-cockpit planes. Early aero-engines were conventional piston engines and they were extremely noisy. The silencing provided by short exhaust pipes was minimal, and there was no such thing as fuselage anti-noise insulation. In that kind of plane there was also the ceaseless

126

roar and buffeting of the slipstream. No wonder he frequently landed after a long flight partly deaf and with a splitting headache.

The cabin of *Delta India Kilo* was, by comparison, as quiet as a cathedral, thanks to the low noise level of the little Allison, and to my David Clark headsets which I could wear for up to 11 hours without discomfort.

Shortly before landing at Lyon to refuel, I felt rather peckish. Pip had sent me off with a packet of sandwiches, and now, at about 1000 feet over the Monts du Maconnais, I had a real Australian lunch — Vegemite and lettuce sandwiches. That would have to be a first, I reckon. They reminded me of home.

I landed at Lyon three hours and 43 minutes after leaving Biggin Hill with a run of 409 miles. This was pretty good going, considering the big detour I was forced to make around Paris. But Hinkler went to Rome non-stop on his first day; however, my shorter range meant I had to refuel at about the halfway point.

I had learned a few things on the way, the most important being that once away from France's international airports, the traffic controllers speak only French with maybe a bit of English thrown in. Once I was clear of Paris I found the French controllers very hard to understand. I just repeated what they told me and kept heading the way I wanted to go and never had any problems. Ever since leaving Fort Worth I had encountered a way of handling helicopter traffic which I think should be introduced to Australia. Overseas, I was never asked to get into a circuit pattern. It was always: "Just fly straight into the airport on the heading that you are on", which is the most sensible way to handle a helicopter. Fixed-wing aircraft and helicopters flying in the same circuit pattern, as is often the case in Australia, is very dangerous.

I was eager to refuel and push on to Rome almost immediately, but it was not that easy. Lyon is not Paris, and every airport official I met spoke only French. As I speak only English, this slowed things down a bit. My interview with the

127

meteorological officer was especially farcical, like a scene from *Fawlty Towers*. However, I managed to grasp something of what he told me. The weather over the southern section of the Maritime Alps was good, so I could track directly from Lyon to Nice (236 miles) which would save me almost an hour.

Then I refuelled and hit another snag.

"Sorry m'sieur, but French francs, please." I had a wad of United States dollars which I had been told would be acceptable anywhere. They probably are but not at the Lyon airfield. Feeling frustrated I had to find someone to change the greenbacks into French francs.

I managed to get airborne again after one hour and 13 minutes on the ground, and flew south towards Nice at about 1000 feet above the magnificent Rhone River. Twelve miles south of Lyon I passed over the old town of Vienne, founded by the Romans in 122 BC, and decided, as the weather was good, to track directly to the mountain town of Gap in the Alps de Haute Provence.

Gap was founded by the Romans in 14 BC. It has a population of 24,000. In 1815 it distinguished itself by being the first French town to give Napoleon a warm reception on his march to Paris from his exile in Elba to reclaim the emperorship of France.

As I approached the country became more mountainous. The scenery was absolutely spectacular with high peaks rearing all around me. The updraft over the mountains generated large masses of cumulus cloud which towered over me, so I was forced to make constant diversions to the right or left.

Around Grenoble, north-west of Gap, the mountains are mainly limestone, pitted and holed with enormous caves and sinkholes which I could see quite clearly. I itched to land and do a bit of exploring.

As the little town of Gap came into view out of the encircling mountains I did not give a thought to the Romans or Napoleon, as I remembered my earlier visit. In 1966 I had driven through Gap on

my way to a scout climbing course. I was 22 then, and a Rover scout. If anybody then had prophesied that 16 years later I would be flying over the town in my own helicopter I would not have believed them.

To clear the mountains around Gap for my run down to Nice and the Mediterranean I had to climb to 7500 feet. The JetRanger soared like an eagle, taking the mountains easily at 110 knots. The view was stunning. I picked up a nice tail wind, the first since leaving England earlier that day, and fairly buzzed along. I had the rest of the lunch Pip had made for me and recorded my excitement on tape:

"That munching noise you can hear . . . I'm sitting over the Maritime Alps eating Vegemite and lettuce sandwiches! Below me is a magnificent vista . . . there's the railway line running from Gap to Nice. I'm right on the Maritime Alps and it's absolutely incredible, the scenery is beautiful . . . huge limestone mountains with little villages perched among them . . . only another 34 miles to go to Nice and everything seems to be working well. Fantastic!"

I got my first sight of the Mediterranean, sparkling in the morning sun but a bit obscured by haze. I ran down to the coast to the famous resort town of Nice, on the Cote d'Azur, playground of Europe's millionaires, and a few minutes later I was over the principality of Monaco. The harbour was packed with expensive-looking cruisers and yachts. The sun was shining and the water was a beautiful blue. Monte Carlo, the capital of the little state, looked very orderly, civilised and wealthy. I circled at 500 feet over the crowded beaches, gay with awnings, beach umbrellas and paddle-boats, and took a lot of pictures. As Monaco is small in area my sightseeing did not take long, and I was soon heading almost due east across the Ligurian Sea towards the Italian coast and another historic town I was really looking forward to seeing — Pisa with its famous leaning tower.

I had taken my life jacket off at Lyon because I was getting rather warm and it seemed a bit silly to wear a life jacket while flying over central France. With a 100-mile flight across water facing me, I put

129

it on again. The water below me was calm and considerably warmer, about 24 °C, than the North Atlantic or the English Channel, but I was still taking no chances.

I was flying through heavy sea haze at a very low altitude when suddenly a huge shape loomed out of the murk to my right. It was a big destroyer heading north at about 30 knots and putting up a big white bow wave. I guess I must have given the crew as much of a surprise as their ship gave me. I do not know what navy it belonged to. I circled it, took some pictures and got back on course for Pisa.

Surprisingly for that crowded part of the world, it was a lonely crossing because I had difficulty in raising anyone on the radio. I eventually raised Pisa Airport tower but it did not help much. The controller was friendly enough but we had trouble understanding one another. Then, when I was at my wits' end trying to penetrate a gabble of Italian voices all talking at once, I heard an English voice calling me. It was the pilot of an American aircraft offering his help. I told him I was trying to get permission to fly over and around the Leaning Tower of Pisa, and asked him if he could get the message across to the Pisa Airport tower. He said he would.

Minutes later I was talking to an English-speaking Italian controller who took some time to grasp that I was flying across the Ligurian Sea in a helicopter.

"*Delta India Kilo, Delta India Kilo*, please say again your point of departure, your airport of destination and your type of helicopter," he said, rather puzzled.

We finally got it all sorted out and, after requesting the controller to talk more slowly, I was cleared to fly around the Leaning Tower and track down the coast before turning inland to Rome's Ciampino Airport. Later, I could see the historic Leaning Tower. The tower is actually a campanile, or bell tower, and has a lean of more than four and a half metres from the vertical, which is quite a lean. Building began in 1173 but it was stopped because

the foundations were not deep enough. Despite the instability it was begun again in the 14th century. It began leaning soon after it was finished, and will probably go on leaning until it finally topples over; a tragedy for such a beautiful piece of work.

My photographic orbits at Monaco and Pisa had cost me about 30 minutes. I left Pisa and reached the coast, picking up a good northerly wind on my tail which added 15 knots to my speed and quickly wiped out the time I had lost. I came down low along the west coast of Italy, over crowded beaches, more mud than sand, with no surf. What a surprise Australian beaches must be to our Italian migrants!

Even flying down that sunny coast in good weather I was reminded of the hazards early aviators faced. To my left the River Arno wound up through the beautiful province of Tuscany to the old city of Florence, in which Bert Hinkler lies buried. "Hustling Hinkler", as many called him, was given a hero's funeral with full military honours by the Italian government in 1933, four months after he had crashed his Puss Moth in the Italian Alps while trying to break the England to Australia record of eight days and 20 hours. In his eagerness Hinkler pushed himself harder than usual and must have cut corners closer than ever before. He hit the mountains north of Florence during a snowstorm. His frozen body lay near the snow-covered wreckage high up in the mountains until a party of Italian charcoal burners found it months later, when the spring thaw had made the mountain tracks passable.

Because I was thinking of Hinkler and his tragic death in those Italian mountains I was very unhappy when the weather suddenly deteriorated with a bang.

Rain came down in thick grey sheets and thunder rolled and muttered overhead. The lightning, which kept its distance at first, had moved ominously closer, and one huge, crackling bolt of blue-white fire suddenly jumped the gap between heaven and earth, striking the earth close by and giving me a tremendous fright.

To Rome in a Day

I was very glad when I raised Ciampino Airport control. Rome has two major airports: Ciampino and Leonardo da Vinci Airport about 24 kilometres south-west of Rome. I was cleared to track into Ciampino Airport, which is much closer to the ancient city.

Although the weather was still terrible with moderate rain I was given a radar heading which would have brought me right across Rome into Ciampino. Some distance out the Ciampino controller came back and said it was forbidden to fly over the city. He gave me a new heading which would take me around the city to Ciampino. Then I was handed over to another controller who told me to track directly over the city to Ciampino! I did not argue but kept flying straight in. Suddenly, the Vatican appeared below me. I had overshot it, and I simply had to get a picture of the Holy See. I did a quick right turn over the Tiber — the river that flows through Rome — and took a picture. There was an instant squawk of protest in my earphones. The Ciampino controller was really keeping tabs on me, "Hey, have you turned right?" he asked.

Anyway, no harm was done. I landed at Rome after four hours and 35 minutes from Lyon, and eight hours and 18 minutes flying time since leaving Biggin Hill. It had been a long time in the air and I was extremely tired because of the bad weather in the past few hours, but I was also very happy. I was in Rome, the same city Hinkler had made his first stop on his record-setting flight from England in 1928. It gave me a great thrill.

After more than eight hours at the controls all I wanted to do was sleep. That, unfortunately, was impossible for the moment. There was a huge crowd waiting to welcome me. My new forward man, Gerry Nolan, a busload of newspaper, radio and television people, and the delightful Anamaria Pivato from the Australian embassy and several officials from Qantas and Mobil Oil.

The media interviews, which I had always

132

SEPTEMBER

S	M	T	W	T	F	S
			1	2	3	4
5	6	7	8	9	10	11
12	13	14	15	16	17	18
19	20	21	22	23	24	25
26	27	28	29	30		

found tiring, were made more tedious by the language barrier. Everything had to be translated. We got through the interviews eventually and with the help of the people from the embassy, Mobil and Qantas Gerry and I got through all the paperwork much more quickly than usual.

Then, to my enormous relief, I was free to go to the hotel where Gerry presented me with an Explorers' Club flag. It was especially flown across from the club in New York for me to carry on the rest of my journey and return to New York for display in the club when I completed my around-the-world flight.

I must add that some of the pleasure I got from keeping up with Hinkler, at least as far as Rome, and the loan of the Explorers' Club flag was considerably diluted by the hotel Gerry had booked us into. It must have been one of the cheapest in Rome. It certainly was the noisiest. Trucks and buses roared and rumbled past all night. To reduce the noise enough to even attempt sleep, I closed the window and the room became so hot and airless that sleep became impossible.

As if the heat and the noise were not enough, I discovered in the early hours of the morning that my room was right opposite the hotel bar! I discovered this unpleasant fact when the bar was suddenly filled with a noisy party of drinkers who seemed to have settled in for a long session. It was just too much. I telephoned the hotel manager and complained bitterly, even threatening to move out to the Sheraton. That got action. The noisy revellers were persuaded to go home and I sunk into an exhausted sleep.

I was up at 4.50 the next morning, after one of those nights of restless, shallow sleep which left me as drained and depressed as if I had had no sleep at all. I had slept a little over an hour. Not a very good preparation for a flight from Rome to Athens, a 704-mile jump, and a water crossing of more than 60 miles. I would also be flying over the southern end of the Appennino range — the mountains further north in this range had claimed the life of Bert Hinkler.

133

Modern freighters lie stern-on to the quay in the port of Gaeta, south of Rome. They are overlooked by the ruins of ancient Roman buildings, whose owners probably moored their sail and oar-driven boats in the same berths some 2000 years ago

There was no time to waste on morbid forebodings if I wanted to depart at 7 a.m. as planned. In fact, Gerry and I moved so briskly that morning that we were at Ciampino by 5.40 a.m., and with all the formalities complied with I was airborne before dawn, three minutes ahead of schedule. Vincenzo Betti of Qantas helped us with the paperwork which speeded things up enormously.

I climbed above Rome before the sun had risen in absolutely perfect weather, except for a bit of ground haze. Turning west I flew to the coast and followed it until I reached the legendary Isle of Capri in the magnificent Bay of Naples, shimmering in the sun beneath the menacing but beautiful cone of Mount Vesuvius. A lovely sight against the blue sky. It is hard to believe that when it erupted in the year AD 79 it completely destroyed the Roman town of Pompeii, killing thousands of people.

South of Naples I began looking eastwards for a pass which would take me over the Appennino Lucano mountains to Brindisi. Tracking inland over vineyard and fruit country I flew over the town of Battipaglia and followed a road and a railway line winding up over the mountains in the direction of Brindisi. Visibility was good despite a ground haze, but a headwind cut my speed down to 87 knots. To clear the mountains I had to climb to 5000 feet. Once, two Italian Air Force jet fighters flew past me at exactly my height. They were so close I could see the pilots' faces.

The headwind which had reduced my ground speed played havoc with my fuel calculations for the 276-mile Rome–Brindisi leg. I had hoped to fly to Athens in one hop, but now I would have to land at Brindisi to refuel before crossing the Adriatic Sea to Greece.

I reached Brindisi two hours and 51 minutes after leaving Rome. My eyes almost popped out of my head when I landed on Brindisi's military airfield. There were little foxholes dug along the runway with soldiers manning anti-aircraft guns! It looked as though they were expecting an attack. I spent a chaotic one hour and 20 minutes on the ground, and refuelling was no problem despite the

language barrier. Filing my general declarations could have been difficult, but one very helpful member of the ground staff did everything for me.

Then, when I was ready to go with the Allison running, I hit a major bureaucratic snag. The tower told me I would have to file a new flight plan. Patiently, I explained that I had already filed a Rome–Athens flight plan in Rome. "I've got to get into Athens before last light," I explained over the radio. Too bad, said the tower. They were sympathetic but a new one was required because I had departed from my original flight plan by landing at Brindisi.

By now I was desperate to depart. There was almost 400 miles and a sea crossing ahead of me. I was already very tired; the sleepless night in that awful hotel was beginning to take its toll. Trying to be helpful, the tower allowed me to dictate the new plan over the radio. From then on the situation degenerated into pure farce. The controller and I knew very little of each other's languages. By the time I had finished I realised ruefully that it would have been much quicker to shut down the helicopter, walk over to the tower and file the plan in the conventional way. We live and learn.

I took off at last and was soon heading out in haze over a glassy sea. Later, the sun streaming through the canopy was so hot I had to drape a towel over my head to prevent a bad sunburn. I recollected that Bert Hinkler had worn a British solar topee — the famous pith helmet of the Raj — for part of his flight across India. It may have prevented sunstroke but it had left his ears unprotected as he was not wearing his flying helmet. As a result, the constant roar of the Avian's Cirrus engine had left him completely deaf for several hours after landing. The towel worked fine, anyway. I did not get sunburn and, unlike Hinkler, I had no noise problem. The outside temperature as I crossed the Adriatic was 36°C. Was it only a month ago that I had made that hellish flight across the Davis Strait from Cape Dyer to Sondrestrom, with the outside air a blood-chilling minus 10°C? It seemed an age ago.

One of the factors which had made that flight

136

A VOR navigation station squats like some alien spaceship on a rocky cape thrusting into the Tyrrhenian Sea near Sorrento, Italy. In the background is the fabled Isle of Capri

so unpleasant was still with me — fatigue. I could feel it overwhelming me like a dark rising tide. I had not counted on this when planning the trip. I just did not realise what an enormous strain I was going to be subjecting my mind and body to. Flying alone was a bit wearing, but the triple burden of flying, filming and narrating was crushing.

I had other things besides tiredness to worry about.

Slap-bang down the middle of my chart of the Adriatic Sea ran a blue line showing where the Brindisi air traffic control zone ended and where the Zagreb-Belgrade zone began. And printed in very

137

large bold type on the Zagreb-Belgrade side of the line was this notice:

WARNING: AIRCRAFT INFRINGING UPON
NON-FREE FLYING TERRITORY MAY BE
FIRED UPON WITHOUT WARNING.

There was nothing I could do except grit my teeth and keep going, and hope that I did not deviate from my route and suddenly get an air-to-air missile in the seat of my pants. Then there was another unpleasant surprise. I was sailing along very nicely over the sea, running down the Strait of Otranto towards my first Greek landfall, the island of Kerkira (better known as Corfu) when the Kerkira tower suddenly announced that I was not allowed to land at Athens Airport. Then I was ordered to land at Kerkira.

After that, things became as chaotic as they had been at Brindisi. The airways fairly crackled. I was furious. There would be a crowd awaiting me at Athens: the media, Qantas and Mobil personnel and Gerry Nolan who was flying ahead of me.

I argued vehemently but to no avail. I was to land at Kerkira and sort it out from there. It was maddening. Months ago, back in Sydney, I had received official clearances to land at Athens. At this stage an American voice joined the conversation, the pilot of a civilian airliner.

"There's some reason I can't go to Athens International Airport," I told him. "Do you know why?"

He, too, could not understand why I could not go through to Athens. He very helpfully got on to Kerkira control himself. I could hear him talking to them. Finally he came back with some really absurd news: *"Delta India Kilo, he's just said Athens won't accept you in their airspace."*

"I'm not going to land at Kerkira," I said firmly. "That's 200 miles short of Athens. I'm just not going to do that."

I heard my unkown American friend talking to Kerkira again, and then he came back. *"Delta India Kilo, Athens won't accept you until 1800 Zulu."*

"Crikey!" I said stunned. "1800 Zulu!" I

138

grappled with the conversion in my head for a few seconds, and then said, rather lamely, "That's pretty late, isn't it?"

"Yeah," said the American. "Another eight hours from now."

Eight hours. What a dent in my schedule that would make! Desperate to talk to someone else, to get a second opinion, so to speak, I set my radio to the universal talk frequency, an unofficial radio frequency (123.45 MHz) which most international aircraft monitor so they can chat with passing aircraft. I jabbed the button, and said, "This is helicopter *Victor Hotel Delta India Kilo* on 12345. Does anyone copy?"

The next second I almost jumped out of my skin as Gerry's voice replied, "Yes, what do you want, Dick? It's Gerry here."

I was absolutely staggered; so staggered, in fact, I forgot to ask where he was. (He was, in fact, about 80 miles away on the flight deck of the Alitalia plane flying him to Athens to await my arrival.) All I could say was, "Are you on the air there, Gerry?"

"Affirmative, I can read you, Dick."

When I had got over my surprise, I said, "Gerry, there's a big problem. They won't let me go into Athens until after 1800 Zulu, which is eight hours from now. It's absolutely crazy considering we got all the approvals and everything . . . Gerry, you're in the air somewhere are you?"

"Yeah, we're south of you."

"Look, ask the pilot if there's any chance of him calling Athens and asking them to call Qantas and tell them that they won't let me in to Athens . . . You should have the approval telex there with you. It just seems incredible to me that they won't let me in."

After a few minutes Gerry came back to me.

"You're still supposed to land at Kerkira and straighten it out from there," he said. He also promised that as soon as he landed at Athens (the Alitalia plane was about an hour out) he would get everything straightened out.

I was too tired to argue any more. Reluctantly I tracked to Kerkira, a beautiful, mountainous

139

island about 60 kilometres long with sandy beaches lapped by the clear blue waters of the Ionian Sea. I came in over olive, orange and lemon trees, vineyards and small plots of what looked like maize.

Despite my irritation and weariness I could not fault my reception at the island's small airport. Everyone was absolutely charming. I went straight up to the tower, armed with all the brochures about my whole trip and my other documents.

"Everyone is waiting for me at Athens," I protested. "I requested permission to go there six months ago!"

Well, they quickly trumped that by producing a Notam (Notice to Airmen) dated two months previously which warned that from that date all private aircraft were banned from Athens International Airport.

"Why don't you fly to Marathon?" suggested one of the friendly men in the tower. "It's only 30 kilometres from Athens."

Reluctantly I agreed. But I decided to make one last attempt to alter the new rules. I asked one of the Kerkira officials if he would telephone Athens and explain why I particularly wanted to land there.

He was back in 10 minutes with great news. Athens control had relented: I could land there! But, of course, I would need to file a new flight plan. My heart sunk. I was so tired that the last thing I wanted to do was a complicated flight plan.

The friendly traffic controller grabbed a flight plan form and wrote out the plan for me. Downstairs again for more form-filling, and a kind person in the operations office did my general declaration for me, stamped my passport and bustled me out on to the tarmac, where *Delta India Kilo* was being goggled at by the hundreds of British tourists milling about the airport. I cranked up the Allison and was airborne again 42 minutes after landing.

To make up for the rotten day I had had so far, the rest of the flight to Athens was fantastic. The weather was magnificent. Beneath me the sea unfolded like smooth blue glass, the sky was a hard

140

Tracking up from the Greek town of Levkas towards Athens, I discovered several beautiful quiet bays sheltering little flotillas of mothballed Greek freighters

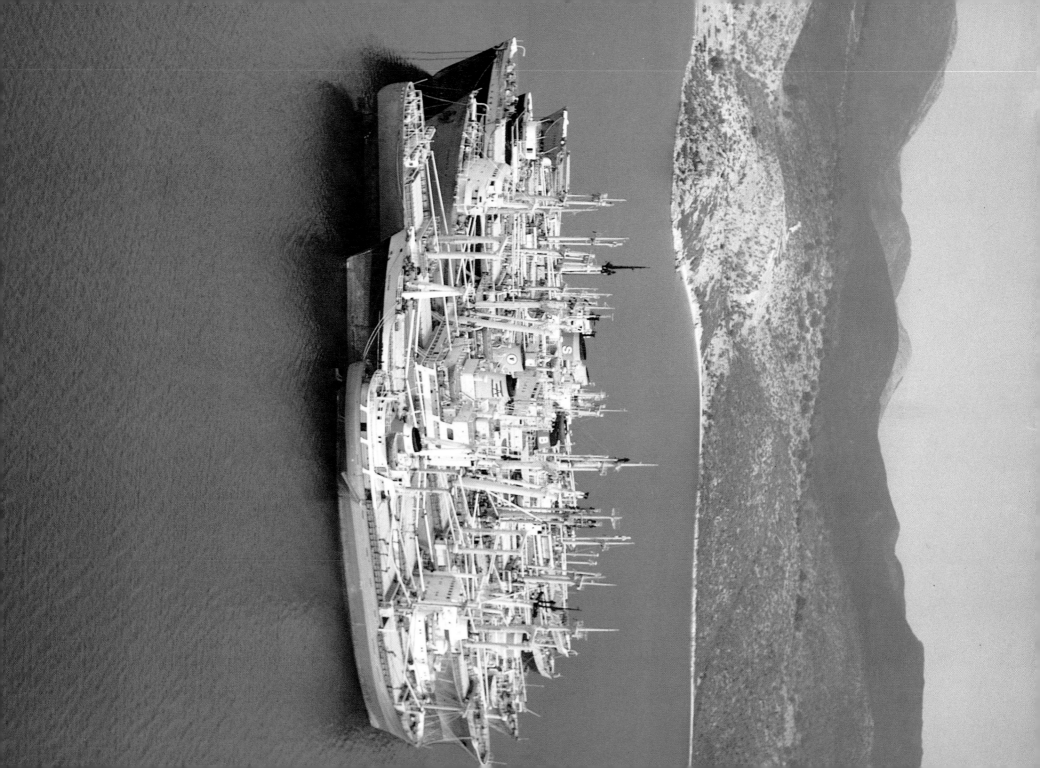

brilliant blue and on my left the mountains of Greece soared into the heavens.

From Kerkira I tracked across the Ionian Sea and made my mainland landfall at a place called Levkas, and then ran along the northern coast of the Peloponnesus, past Araxos and Patrai, until I picked up the wonderful Gulf of Corinth, sparkling in the sunshine. It was exhilarating. I flew over quiet little beaches, crescents of white sand tucked away behind cliffs, and over huge bays where big merchant ships lay at anchor — some of the Onassis fleet lying idle, I supposed. There was no other air traffic; what a change from the crowded airspace over America and Canada! Obviously there are not many privately owned light aircraft in Greece. I did see one amphibian, but that was all. Everything passing beneath me was so beautiful that I reduced speed to 40 knots and came down to 500 feet, taking time out to film and photograph some of the beautiful land and seascape.

From Patrai onwards I ran into a bit of a headwind but it did not bother me much. In the way of a bonus, I accidentally came across the famous Corinth Canal, an impressive piece of engineering which slices through the Isthmus of Corinth and cuts 320 kilometres off the journey from the Ionian Sea to Piraeus, the port of Athens. The canal was begun by the ferocious Emperor Nero in AD 67, but the project was abandoned and it was not until 1882 that it was opened to shipping.

When I had taken enough pictures of the canal I called Athens control and asked them to radar vector me in. After all the worry they had given me earlier in the day they were as nice as could be. At first, they began to vector me straight in over the Gulf of Saronikos to Athens. Well, I was not too keen on that as I wanted to see some more of the fabulous scenery. So I explained to them that I was flying a single-engined helicopter and was not too keen on flying over water. They quite understood, and agreed that I could fly up the coast. Naturally, I did not have the heart to tell them that I had already flown the Atlantic. So I finally picked up Athens and the Acropolis towering above it —

142

magnificent! I understood all at once the meaning of the phrase: "The glory that was Greece". It was awe-inspiring to see the Acropolis and its classically beautiful buildings standing there in the brilliant sunlight, dominating the sprawling modern city below.

I landed at Athens to a great welcome. As well as Gerry and the Qantas and Mobil people, the Australian embassy had even sent a representative. It was extremely hot and Gerry, realising how trying my flight had been, came out to the helicopter with a most welcome surprise: a glass of ice-cold Coca-Cola. I drank it before getting out of the helicopter, glad of the refreshment.

Then I had to pose for pictures from every angle. The Mobil people were very keen on a picture of me advertising their name. Well, I could not disappoint my sponsors, so I obliged them by wearing a jacket carrying the Mobil legend. It was designed for my Atlantic crossing and it was very uncomfortable as the temperature on the tarmac was 37°C.

This time Mobil had chosen the hotel. They had booked us into the Glyfada Astra, one of the most magnificent hotels I have ever stayed at. Our rooms were right on the shore of the Mediterranean.

After a shave and a rest I felt ready to face the ordeal of yet another press conference. This had been arranged by Mobil and was extremely well done. There were at least 40 newspaper, magazine, radio and television people, many of them from such prestigious journals as *The Times* of London, *Life* and *Time* magazines, the Melbourne *Age* and other big-name publications. Everyone was extremely pleasant, and the Greek food provided was excellent. It gave me a great lift after my tiring and trying day.

In fact, the friendliness of everyone I met that day in Athens was heart-warming and quite inspiring. Stathis Danielides, the Mobil company's top public relations man in Greece, for example, was a marvel of efficiency and understanding, as was the driver he supplied for us, Dimitri. For the first time on my trip I seemed to be surrounded by people who realised how exhausted I was, and were

prepared to rearrange their plans so I could get some rest. The local Greek news people, unlike many other journalists I had met, were very considerate and understanding. But Athens was a good scene generally.

Another example of helpfulness was shown after I had parked the helicopter and was on my way down to the VIP lounge to meet some members of the welcoming party I had not met. I saw a person tying the helicopter's rotor blade down and putting the cover on the aircraft. He turned out to be a Qantas engineer, Col Anderson, stationed in Athens. Later, he helped us in other ways. I found

Above: The Corinth Canal came as a surprise. I knew it was in the area as I tracked up towards Athens, but I had not planned to visit it. Suddenly, there it was — a magnificent engineering feat, conceived by the Romans 2000 years ago

Left: Idyllic flying conditions along the southern coast of Greece. The translucent water in the foreground is the Gulf of Corinth

Right: A spectacular open-cut limestone mine scars the cliffs on the island of Kea, south-east of Athens

Below: The ground service at Iraklion in Crete was impressive. The Mobil fuel tanker chased the JetRanger before it had touched down

144

this sort of unsolicited kindness really fantastic.

Later that day Gerry explained to me how he had managed to come up so quickly on the radio when I was over Kerkira. Shortly after boarding his Alitalia flight from Rome to Athens he had sent one of our standard printed cards up to the aircraft's captain. These cards contain a brief outline of my around-the-world attempt and Gerry had written a short request on this one asking the captain if he could contact *Victor Hotel Delta India Kilo*.

The Italian captain was wonderful. He invited Gerry up to the flight deck and the flight engineer gave up his seat so that Gerry could contact me himself. He had just put out his first call when I suddenly popped up with my desperate call, and there we were.

I was thankful to get into bed that night. I had been in the air for six hours and 24 minutes. On Bert Hinkler's second day's flight in 1928 he had flown from Rome to Valletta, Malta, in five hours and 53 minutes. I had flown for 31 minutes longer than he had. After today I could imagine what he and the other pioneers must have gone through. If there was one thing this flight was teaching me, it was that those early aviators were not only as good as I had always thought them to be — they were a darn sight better.

After a good night's sleep in that great hotel I was just itching to get going the next morning. Africa was just across the Mediterranean, then the Middle East and I would soon be more than halfway home!

My planned route for the day was quite a long one to Cairo — over 700 miles — with most of it over the Mediterranean. By 7.30 a.m. I was airborne and heading south-east on the first leg, to the island of Milos, where the famous statue the Venus de Milo was unearthed in 1820. Shortly after leaving Athens in beautiful weather and a lovely tail wind I flew past the impressive Temple of Sounion which I had seen on my visit to Europe in 1966. Unfortunately, it was too hazy to take any photographs.

The tail wind gave my speed a tremendous boost. I was soon scooting along at 500 feet and

146

SEPTEMBER

S	M	T	W	T	F	S	
				1	2	3	4
5	6	7	8	9	10	11	
12	13	14	15	16	17	18	
19	20	21	22	23	24	25	
26	27	28	29	30			

making a good 135 knots. I passed rugged little Milos and tracked in towards Iraklion in Crete. Crete has great significance for Australians. During World War II hundreds of Australian soldiers were killed or wounded defending it from the Germans, and more than 3000 prisoners were taken. The Allied forces — Australians, New Zealanders, Britons and Greeks — were defeated on Crete, but not before giving the German paratroopers a terrible mauling.

As I had planned only a very brief refuelling stop in Iraklion, Gerry had not flown ahead to arrange things for me. Before leaving Athens I had spoken to the Mobil people and asked them if their Crete branch could give me any assistance. Could they ever! Before I had even touched down a Mobil refuelling truck was chasing me around the field like an eager puppy. By the time I had got out of the helicopter, with its blades still turning, the Mobil man had his fuel hose out and was preparing to plug it into *Delta India Kilo*.

The Airport Manager came running up, all smiles, to meet me and introduce me to his son. Apparently my Athens television interview had been seen in Iraklion too. So of course I had to have my photograph taken with the Manager and other people; then the Manager, seeing I was in a hurry, took me over to the meteorological office, bustled me through flight control, took my landing fee which was nominal, and got me back in the helicopter, all in 59 minutes.

I was sorry I could not spend more time in Crete. It looked like a wonderful island. I would like to have visited the Australian war graves on the island and paid my small tribute to those men who died there more than 40 years ago. I was very proud to see the esteem in which Australians and New Zealanders are held in Crete. People were constantly coming up to me during my very brief stay there and asking eagerly, "You Australian?"

But soon it was time to go. The Iraklion tower cleared me out on a south-easterly course with a 25-knot wind behind me. Minutes later I was clear of the island and heading across the Aegean Sea towards Egypt and Cairo, 480 miles away.

Above: For a long time I had wanted to take DELTA INDIA KILO around the pyramids at Giza, near Cairo, Egypt — and I did. I wonder what the Sphinx, who had brooded in the shadow of these great monuments for more than 2000 years, made of the JetRanger

Right: After sneaking a look at the pyramids, I was directed to Cairo airport, tracking at 1000 feet across the teeming suburbs of the ancient city. I have never found out why so many houses seemed to be roofless — were they still being built? Or did it rain so seldom in this desert metropolis that roofs were unnecessary most of the year? Another unsolved mystery of the East

Once clear of Crete I settled down at 2500 feet with that nice tail wind giving me a brisk 120 knots, put the autopilot on and tried to raise Cairo air traffic control. I was feeling a bit apprehensive because the chart carried another of those ominous warnings about prohibited zones and control areas and the risk of being shot down without warning by deviating from the planned track.

My taped commentary records my worries that day:

"Well, I'm on another long ocean crossing . . . I didn't realise the Mediterranean was so big. I've got nearly three hours over water ahead . . . I'm just heading towards the Cairo flight information region boundary, and I can't raise Cairo . . . I only hope they don't come and shoot me."

I had heard several tales about how jumpy the Egyptians were, so I was feeling really nervous. I had even dismounted the movie camera and put it in the luggage boot so that I could not be accused of being a spy, taking aerial photographs of military installations.

So we droned on into the bright morning. Below me the Mediterranean was blue and slightly ruffled by the wind. I reflected that the water would be considerably warmer than the North Atlantic if I had to ditch in it. Those things cross your mind when you are aware of having only one engine behind you and hundreds of miles of sea ahead.

About 200 miles from the Egyptian coast I saw the first ship of the crossing; a big container ship heading, I guess, towards the Suez Canal. It was probably on its way to Australia.

As I drew closer to the Egyptian coast I became increasingly worried by the radio silence from Cairo. I was due to cross the coast at a little village (it turned out to be a collection of mud huts) called El Daba. Frantically I tried Cairo control again. Silence. I flew over El Daba and by now I was really worried. I just hoped that some controller did not suddenly spot me on his radar and scramble a fighter to shoot me down. I had been climbing steadily while still a long way out over the sea and crossed El Daba at 6000 feet. To add to my worries,

150

I could get no response from any of the Egyptian ground navigational beacons. Later I learned that they were all out of order. Finally, to my relief, I managed to contact a high-flying Egyptian airliner and asked the pilot to call Cairo for me, which he did.

Even then, with *Delta India Kilo* well into Egyptian airspace, the controller did not seem very interested in me.

"Your nationality?" he asked.

"I am Australian."

"Would you confirm Australian?"

"Yes. Australian. From Down Under."

"Would you confirm that you are VFR?"

"Roger, Cairo. It is a VFR flight and I am flying VFR at the moment. I am doing a solo helicopter flight around the world."

"*Delta India Kilo* you may maintain any altitude you wish."

Now that was truly amazing. When planning the flight I had read all sorts of alarming things about flying in Egypt; about the danger of flying into Egyptian airspace without formal clearance, and about how it was illegal to fly below 6000 feet. I suppose they figure that there would not be much of military interest to see from that height. And yet here was a controller saying I could fly at any height I wished. Fortunately, I called him back.

"Roger, Cairo. I will go to 2000 where the visibility will be better. Thank you. This is *Delta India Kilo* leaving 6000 on descent to 2000."

I should have known it was too good to be true. Seconds later the controller called me back. I think he said I could fly at any altitude as long as it was 6000 feet! As he did not seem too sure about it himself, I compromised and cruised on at 5000 feet. Perhaps the controller was too busy to worry about a lone little helicopter.

I could hear the airport radio traffic now, and it seemed like a complete shemozzle, with planes coming and going in every direction. It was obvious that the poor controller did not even have radar to assist him. A few years ago, I remembered, the International Airline Pilots Association had severely

151

criticised the way Cairo Airport was run, listing it as one of the most potentially dangerous in the world. It would appear that things had not changed in recent years.

After leaving El Daba I flew over the desert, endless sand with no habitation in sight, towards my next VOR checkpoint at the town of El Faiyum, about 136 miles away across a sea of hot sand. El Faiyum lies between the River Nile and a lake called Birkat Qarun, so there is enough water for small farms and gardens. Its pleasant patch of green is a sharp contrast to the huge, drab ochre expanse of the Western Desert.

Clear of El Faiyum I headed for the mighty Nile itself. Then huge shapes loomed out of the desert haze ahead. They were the pyramids! What a great thrill. And such a pity I was so damn high! I called up the harassed Cairo controller again.

"It's very rough up where I am," I told him.

"The helicopter is bobbing around. May I fly lower?"

Wonder of wonders, he agreed to let me come down. First to 4000 feet and then to 1500! It was magnificent. The pyramids are a truly impressive and humbling sight. To see those huge towering masses of stone which have sat there for more than 3000 years watching empires come and go and the Nile rise and fall is a moving and stunning experience. The Sphinx too, brooding over the desert with its damaged, inscrutable face, what must it have seen during its long life? And now it was seeing another strange sight: a lone Australian flier in a helicopter. As I flew around these mighty monuments to men whose very bones have been dust for thousands of years, I remembered that two years ago, while planning this trip, I had written saying I would fly around the pyramids, and now I had done it. It was a great thrill, and a fitting climax to a wonderful day's flying in superb weather.

Then I had to turn my attention back to my friend the Cairo controller, who seemed busier than ever. The radio traffic was so busy I had difficulty in realising when he was talking to me. Still, he got me into that busy airport safely. I was very glad to be safely parked away from the roar and jet blast

of the big planes.

A Mobil tanker was waiting for me, and also the local Manager for British Airways, Taff Lark. There was also a television crew; this time from NBC of America.

Within half an hour of landing I had satisfied the media people, refuelled and checked the helicopter for an early start the next morning. Gerry was supposed to meet me at Cairo but arrived two hours after I did because his plane had been delayed in Athens. I was rather pleased to think that *Delta India Kilo* was more reliable than a jumbo.

That night we had dinner with Taff Lark, and then decided to go back to the airport to get the clearance for my stop the next day at Luxor, several hundred miles down the Nile. We took this precaution because of what we had heard about Egyptian bureaucracy, and it was just as well that we did because a frightful shemozzle developed at the airport. When my original application was made to fly from Cairo to my next foreign stop — Ha'il in Saudi Arabia — it had not been mentioned that I also wanted to call at Luxor for refuelling. Thank heavens Nabil Zidan from Mobil had come out to the airport with us. He evidently knew the local ropes pretty well and managed to talk our particular bureaucrat into accepting a special request for a revised clearance which I wrote on a scrap of paper. If Nabil had not been with us I am sure we would have been in a pretty pickle.

That night, as I entered in my diary the day's work: six hours and 11 minutes in the air, 681 miles covered, I felt pretty pleased with myself. It had been the sort of day I had visualised when planning the trip two years before, but, unfortunately, there had been too few of so far.

As I fell asleep in my comfortable bed in the Heliopolis Hotel, my thoughts turned to Bert Hinkler again. There was no bed waiting for him at the end of his third day's flight from England. He had spent the night in the Libyan desert near Tobruk, sleeping under the wing of his Avro Avian and using his inflatable rubber boat as a mattress. This was about 800 kilometres west of where I was right now, snuggling between cool sheets in an air-conditioned room.

Down the Nile

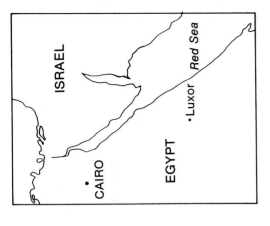

SEPTEMBER							
S	M	T	W	T	F	S	
				1	2	3	4
5	6	7	8	9	10	11	
12	13	14	15	16	17	18	
19	20	21	22	23	24	25	
26	27	28	29	30			

Limestone bedrock thrusting through wind-drifted sand, south of Cairo, gives the desert the appearance of a frozen, ochre ocean. Most of the desert regions over which I flew are staggeringly beautiful

I was up well before dawn after less than three hours' sleep and despite more clashes with the Egyptian bureaucracy, I was airborne at 6.36 a.m. only 21 minutes behind schedule. I had to sit and sweat in the helicopter for a quarter of an hour after I had started up while some type of clearance or other was obtained. It was an upsetting start to the trip because I was already worrying about having to do my own clearance at Luxor, and having some doubts about that handwritten clearance application I had filed the night before. Gerry was flying ahead to arrange things at Bahrain.

The tower eventually gave me permission to go. It was still dark. The dawn was glowing red and pink in the east with low cloud over the airport. Everything was dim and mistily mysterious. It was blissfully quiet and peaceful after the heavy air traffic of the previous day. I took off and climbed rapidly to 3000 feet and then repeated yesterday's haggle over heights.

"What altitude do you want?" asked the tower, which had already told me that 7500 feet was the minimum acceptable altitude for my flight down to Luxor.

I took a punt. "Four thousand feet," I replied, mentally crossing my fingers. I always like to fly low so I can see as much as possible.

"Roger," said the tower, and yet another rule was mysteriously changed.

Below me the city and desert were still shrouded in purple shadow, and a few minutes later the sun lifted itself over the mountains to the east. The countryside uncovered by the growing light was spectacular. I had expected to be flying over flat sandy desert. Instead, there were ancient wind and sand-eroded mountains stretching out to the horizon. Some of the peaks were quite high. The whole terrain was seamed with dry river beds giving the landscape a seamed, wrinkled look, rather like the Queensland Gulf country.

154

South of Cairo the Nile bends westwards. It would have been interesting to follow the river all the way to Luxor but I decided to fly straight across the desert and pick up the river when it swung back again a few miles below Luxor. Once again I had a handy tail wind pushing me along at about 120 knots which really eats up the mileage.

The countryside beneath me reminded me of central and northern Australia. Seared by the sun, scoured by the wind. Suddenly, I came across a very strange sight. It was a modern bitumen road across the desert with parts of it covered by the constantly shifting sands. It marched across the desert and into the mountains, appearing as a smooth black stripe and then sliding beneath the sand again. It was like a great black serpent showing its long back now and again between the sand billows.

About 77 miles out of Luxor the high mountains of the Al Hijaz range of Saudi Arabia reared upwards on the eastern horizon across the Red Sea. They marched along the edge of the earth, a towering rampart which I would have to cross later in the day.

About 40 miles out I realised that I was not going to be able to hold out long enough to make use of Luxor Airport's probably dubious toilet facilities. In a fixed-wing aircraft I would have had an uncomfortable problem. But not in a helicopter. I just plonked *Delta India Kilo* down on a handy piece of mountain, a rocky spit sticking out into a barren valley, shimmering and trembling in the heat haze, and obeyed nature's call. I wandered around the area and took several photographs of the little helicopter sitting there in the middle of nowhere. Yes, a helicopter certainly has some great advantages over its fixed-wing counterparts. Then I was airborne again within 10 minutes. I could see no reason for upsetting Luxor control by telling them of my landing. They would probably have demanded another flight plan!

Soon afterwards I picked up the Nile again. It looked like a great muddy-green snake winding through the desert, with the only vegetation for kilometres around growing in a narrow watered strip along either bank. The Nile is life itself to

Egypt, and has been ever since humans first walked the desert along its banks. There were established villages and farming communities along the Nile long before there was any sort of settlement or civilisation in Europe. Out of them grew the 30 great Egyptian dynasties. They built the pyramids, the Sphinx, the great temples at Thebes and the tombs of the Valley of the Kings. Looking down on the Nile as it slid through the surrounding desert it was awesome to think that it started as a minor stream in the highlands of equatorial Africa to the south, and drained into the Mediterranean 1600 kilometres to the north, after winding its way through jungles, deserts, swamps and mountains for 6650 kilometres. The longest river in the world is a most impressive piece of water and I felt privileged to have seen it.

The leg down the Nile to Luxor was taking me away from Hinkler's 1928 route. He had flown due east after his night stop in Libya to the Royal Air Force base at Ramleh, near Jaffa (now the Israeli city of Tel Aviv). After an overnight stop he flew on over the Syrian Desert to the Iraqi city of Basra at the head of the Persian Gulf. The kingdom of Iraq had signed a treaty with the British after the expulsion of the Turks in 1917, so once again Hinkler found willing British hands to help him refuel and service the Avian. His next leg took him down the Persian gulf to the dusty Persian seaport of Jask where the British had a special concession there as Jask was on the Indo-European Overland Telegraph Line.

Hinkler's route and mine, which had diverged after Rome, were now converging again to link up at Karachi, Hinkler's next stop after Jask. I would have liked to follow Hinkler's track across the Middle East but the Iranians (who had called themselves Persians in Hinkler's time) and the Iraqis were engaged in a major war. Hence my southward diversion via Luxor.

I landed at Luxor with a few butterflies in my stomach at the prospect of doing a complete departure clearance by myself. The sight of an official with a sub-machine gun did nothing to calm my fears either! However, everyone was friendly enough. *Delta India Kilo* was soon refuelled and

157

I was constantly awed by the harsh beauty of the Middle East terrain. This tortured landscape was photographed after crossing the Red Sea from Egypt to Saudi Arabia. It is the edge of a huge fault in the earth's crust, tilted by some titanic upheaval millions of years ago

ready to go. With only the paperwork remaining I accompanied an official into the airport terminal, feeling that perhaps things were not going to be so difficult after all. I was very quickly disillusioned. The air of inefficiency, futility and bumbling bureaucracy, which was evident in Cairo, really got into its stride in Luxor. The official wanted a general declaration.

"Certainly", I said, and handed it to him.

"So sorry", he said, "but we want three."

So, with a sigh, I wrote out two more on some dirty pieces of paper he had supplied and they were duly signed and stamped. I was sent on to immigration and then to customs and cleared these two hurdles in fine style.

Oh, I had sadly underestimated the powers of the Egyptian bureaucracy. My next stop was the control tower, where I explained to a flight-planning officer that I had already filed a flight plan in Cairo. He replied that he knew nothing about it and I would have to do it again. Luckily, I had an ace up my sleeve; Gerry Nolan had made me a copy of the plan so I hastily handed it over, solving that little problem.

However, Egypt was not quite ready to let me go. There was the little matter of Luxor Airport fees of $30 which had to be paid in American currency. The strength of the Australian dollar is not yet evident in Luxor. No problem. I pulled out all the United States currency I had — a 50-dollar note.

Predictably, they had no change, but they told me I could change it at the bank downstairs in the terminal building. The bank, of course, was closed — for tea, siesta, prayers, lunch or for whatever reason. I even tried to pay the fees with my remaining Egyptian currency. The Egyptians desperately need hard currency and decline to accept their own money whenever possible.

In exasperation, I said "Look, take the $50. Keep it. Don't worry about change, I'm in a hurry!" More apologetic refusals. Eventually, a very senior officer agreed to accept payment in Egyptian currency if I acknowledged, on the relevant form, that I had in fact paid in local currency and not the foreign variety.

Surely I could now get into the JetRanger and shake the dust of Egypt from my feet? Talking of dust, there was certainly enough of it. Everything was drab, dreary and dusty. There were dusty officers sitting in dusty offices, looking as though they had sat there for 50 years, shuffling dusty files on dusty shelves.

With the airport fees paid I felt I had cleared the last hurdle. Armed with my receipt, I went back to the customs man who was holding my passport in case I raced to *Delta India Kilo* and took off without paying for the privilege of landing at Luxor. On showing him the receipt, he clutched my passport tighter and muttered something about yet another fee. I explained that I had paid my airport fee. More mutterings about a fee. With a growing feeling that I was being done, I produced an Egyptian 20-pound note (about $16) and plonked it on his desk. "Is that enough?" I asked, my irritation growing. The customs man was still unhappy, but I had had enough. I grabbed my passport and stalked out, not knowing whether I had paid a genuine fee or was the victim of a little freelance extortion. Probably the latter.

Minutes later I was in the air and very glad to be leaving Egypt. Climbing steeply out of Luxor I saw something I had not noticed on my approach; a huge military installation with numerous aircraft hidden in camouflaged bunkers alongside the air-

160

port. Egypt is a poor country with a very low standard of living, and the equipment must have represented millions of dollars. That was just one base! The amount of money Egypt must be putting into arms is mind-boggling.

Although little *Delta India Kilo* had a full tank of fuel aboard, she climbed to 7500 feet in about 10 minutes. Once again a tail wind gave me a helpful push and minutes later I saw the Red Sea ahead, a 120-mile-wide slash of water between two arid lands. I had put on my life jacket before leaving Luxor; 120 miles is a long way across water. I had a spectacular view of both coasts of the Red Sea. I wondered just where the sea had parted to let Moses and the fleeing Israelites through. The Red Sea is lukewarm with beautiful coral reefs and an awful lot of sharks. Across the blue water I could see the first obstacle awaiting me on the Saudi Arabian side — the high Al Hijaz mountains.

The Red Sea is a busy waterway. I flew over several ships heading north towards the Suez Canal, and once I passed, and photographed, a large white liner with yellow funnels. It looked like one of the P & O liners which I have often seen tied up in Sydney Harbour.

Now that the bustle of getting airborne and attaining the required cruising height was over, I had more time to think about my documentation for Saudi Arabia, which I knew was insufficient. In fact, I had no general declaration forms for Saudi Arabia at all. I had been told how difficult the Saudis could be, and I became rather worried.

Meanwhile the combination of the Allison and the tail wind were pushing me across the Red Sea at a cracking pace. Because of my altitude and weight I was only running the engine at 70 per cent power. But despite this I was getting an extra 25 to 30 knots.

My map stated that I should call Jeddah, the major Saudi Arabian Red Sea port, about two-thirds of the way across the Red Sea, and get permission to enter Saudi airspace. I called and called but the airways remained silent. Finally, I tried to call the coastal city of Al Wajh on HF and drew another

Above: After leaving the "liberated" Muslim state of Bahrain in the Arabian Gulf, I was soon over Doha, Qatar, an Arab Emirate

Left: A Bedouin camp appears as three black bars in the vastness of the Saudi Arabian desert. The white specks, like grains of rice, are utility trucks. The grey splodges are where the goats are held; their droppings have discoloured the sand

blank. In no time at all I was across the Red Sea, undocumented and completely ignored, in Saudi Arabian airspace. The charts warn that Saudi Arabia, including territorial waters to 12 nautical miles, is a prohibited area. Flying outside the permitted corridors without permission would mean that I would be forced to land by the authorities. Then to my relief I contacted a high-flying Scandinavian civil aircraft which passed on my message to Jeddah. I heard Jeddah reply and they did not seem at all interested in me. Jeddah is the main point of entry for Muslims making the pilgrimage to Mecca which is forbidden to infidels or non-Muslims.

I had crossed the Saudi coast near Al Wajh, a fair-sized town with a very modern airport. The warm shallow sea beside it is a blue and green mosaic of coral reefs and small islands. The Al Hijaz range provides a spectacular backdrop of jagged peaks and high valleys, painted in vivid purples, reds, oranges, browns and ochres. They reminded me of the Flinders Ranges in South Australia, but these were far more brilliantly coloured.

Beauty apart, it looked terribly inhospitable and as dry as a bone. I was heading for my next stop, Ha'il, a town slap-bang in the middle of this wilderness, when things started to get bumpy. The tail wind which had assisted my rapid passage across the Red Sea was naturally deflected upwards when it hit the mountains. I got into some huge downdrafts and updrafts and the going became extremely rough. Despite the turbulence I managed to get some magnificent photographs and film of the forbidding terrain below.

Occasionally I saw some signs of habitation in the sun-scarred empty desert unrolling endlessly below me, unrelieved by the smallest touch of green. The airwaves were equally barren. Nobody in Saudi Arabia seemed to know, or care, where I was. It was quite an eerie feeling.

Approaching the tiny desert hamlet of Halaifa, one of my checkpoints, I got my first real glimpse of Saudi Arabian life: a Bedouin camp with square black tents arranged very neatly in twos. They were set down in the middle of the desert, miles from

anywhere. The Bedouin must live a terribly hard life, constantly on the move to find food for their animals. As primitive and unbelievably harsh as the life of the Bedouin must be by Western standards, I did see some signs of civilised amenities. A modern utility truck was parked near each group of tents. The Bedouin must be getting some benefit from the country's huge oil revenues.

Saudi Arabia is strongly religious, some would say fanatically so. It has Islam's two most sacred cities, Mecca and Medina, within its borders. Women who commit adultery can be stoned to death, drunkenness is punished by flogging and thieves are likely to have a hand chopped off. More serious offences are punished by beheading. If it were not for its oil, Saudi Arabia would probably be nothing more than a vast desert kingdom with its eight million people scratching a living from the desert.

A course change at Halaifa put me on track to Ha'il. Lunch consisted of a peach and an apple pie which I had been given at my Athens hotel. An odd meal to be having thousands of feet over the desert!

At Halaifa I saw more signs of life. Cars were moving north and south along the narrow strip of bitumen road linking that lonely outpost with places hidden in the desert haze, hundreds of kilometres away. I saw more small Bedouin camps and caught sight of some greenery, a plant which looked rather like our Australian spinifex. Occasionally I saw spiral dust storms swirling high above the desert. They were similar to the Australian willy-willy, and looked most spectacular. They were no doubt very dangerous to light aircraft and I gave them a wide berth.

All the way across Saudi Arabia I had found the ground navigational aids to be excellent. Then I became very worried. My recording on tape recalls:

"Oh! I only hope there hasn't been a terrible misunderstanding. I don't seem able to find Ha'il. I'm only 12.2 miles out by the DME (Distance Measuring Equipment) but I can't see anything! I can just see lots of sand and a few little rivulets, dried river banks with a few trees on them, but I certainly can't see the city of Ha'il . . . there is a big

164

shadow from a cloud on the desert ahead, so maybe it is hidden in shadow . . .''

After cruising around for a while and becoming increasingly alarmed at the prospect of landing in the desert in the hope that a friendly Bedouin would help me, I spotted Ha'il to the west of where I had expected it to be. Meanwhile I had been trying to raise the airport on the radio but my existence was not acknowledged. Having spotted the town I ran straight in on it. I discovered later that the VOR towards which I had been tracking is shown on the map as being 10 miles west of Ha'il, whereas the VOR is in fact at the airport.

Ha'il Airport, slap-bang out there in the middle of the desert, was staggering. Very modern and obviously designed to international airport standards, except that it appeared to be deserted! On approach I called up the airport several times and was met by dead silence. Eventually, I landed at this magnificent airport with no clearance of any sort, and no communication with any member of Saudi Arabia's air navigation authorities at all. So much for all the dire warnings on the charts.

My landing did provoke a mild flurry of activity. Two people wandered across the sizzling tarmac towards me — a Saudi Arabian, wearing a holstered revolver, and a European. The armed man stood in the background while the European introduced himself as Alan Johnston, an Englishman working for the Ha'il Airport fire brigade. He took down a few details and then directed me to the Airport Director's office.

Luxor air terminal had been small, old and shabby whereas Ha'il terminal was enormous and sparklingly new with air-conditioning to boot. The Airport Director's office was huge, measuring about 10 metres long and 6 metres wide. It must have cost a fortune to decorate. It was fitted with a beautiful oriental carpet and expensive wall hangings, vying for space with large portraits of Saudi kings and princes. In the midst of this opulence sat the Airport Director at an enormous desk, in traditional Arabian headdress.

There was another difference between Luxor

Above (top): This impressive sports stadium rears up out of the barren desert outside Abu Dhabi in the United Arab Emirates. Obviously all those oil dollars are being put to good use

Above: A new housing estate laid out in neat squares in the desert between Abu Dhabi and Muscat

Right: Wind carves wave-like patterns in the sand near Abu Dhabi. Oil dollars have changed many Arab mud-brick villages into modern air-conditioned towns but the desert is as it always was — vast, empty and potentially deadly

and Ha'il. The officials at Luxor may have been inefficient but at least they were friendly. The man glaring at me across the huge desk was not only unfriendly, he was furious. In fact, he was hopping-mad. He could not understand much English, but he made up for this deficiency by shouting, stamping and waving his hands. I produced the official clearance I had been given in Australia in the form of a telex message from the Saudi Arabian embassy, but it was waved aside.

The Director made six phone calls, shouting at people on the other end, while I sat there with my stomach churning. One of the phone calls produced results. A charming young man called Braheem came to the office and acted as interpreter between me and the Director. He explained that the notification of my clearance approval in the Saudi language should have arrived. Gradually the Director calmed down enough to ring Jeddah. He must have been swiftly put in the picture because seconds later he was shouting again, not at me this time, but to one of his staff to bring him a file. The Director impatiently riffled through a large file of what appeared to be landing clearances and pounced on what seemed to be the Arabic translation of the telex I had shown him. I gathered it had been filed away three months previously and then forgotten.

The Director was as pleasant as could be after this and offered to find accommodation for me near the airport. Later, I learned that his name was Mohammed Ali Alblahay, a close relative of the Prince of Ha'il, and, I suppose, related to the Saudi royal family. So at least I had been berated by royalty.

I was very disappointed when the Director said I would not be allowed to visit the town. By this time I was very tired. I had had a long day and the combination of Egyptian and Saudi Arabian bureaucracy at the beginning and end of it had really stretched my endurance to the limit.

"The Saudi Arabian embassy in London told me that I would be regarded as air crew and could leave the airport," I told him as politely as I could. Of course I could

166

see the town. In fact, he would get his son to drive me around at five o'clock. I was not sure what to expect. Some little desert settlement probably, but it would kill time and I could take a few pictures.

The quarters I was shown to were excellent. Like everything else at the airport they were new and air-conditioned with all the facilities. Afterwards I walked across to the airport fire station to find the Englishman whom I had met on arrival. On the way I gaped at the sparkling new airport facilities around me. The whole project must have cost hundreds of millions of dollars. And yet there were some surprising omissions. For example, the tower did not appear to have a VHF radio or air traffic control personnel!

The fire station was also new and expensive. Nothing had been spared in the way of equipment. It was manned by Alan Johnston and two of his countrymen, Dave Ball and John Downes. I expressed surprise at finding three Englishmen running a Saudi Arabian airport fire brigade. Alan Johnston explained that the King was impressed by English firemen and had perhaps seen them in action on a visit to England. Whatever the reason, he had decreed that firemen at *every* Saudi Arabian airport should be English. The big American company that had won the gigantic airport-construction contract had been obliged to recruit scores of English firemen.

Dave Ball spends his spare time keeping fit and, like Alan Johnston, collects stamps. When I arrived, I was asked if I would "like a nice cuppa". Who would have believed that after such a harassing day I would be sitting drinking tea with three Englishmen in the middle of Saudi Arabia? We had a very pleasant chat. John Downes produced some crisp cold watermelon, and Alan's wife, Jean, came over from their house with some freshly baked cakes. It was all very homely and a welcome break from flying.

At five o'clock the Airport Director's son, Fahed Ali, arrived. We were about to start off for town when he discovered he had run out of petrol! This, in Saudi Arabia, which produces billions of litres of

oil a year. I could not help laughing. Luckily, one of the airport staff, Siddiq Mageed, came to the rescue and took us to town in his car.

I found Ha'il fascinating; it was an incredible mixture of an ancient mud town and a modern city with buildings going up everywhere and six-lane highways snaking between them. The traffic was very light, and the cars were all big and new. The population (about 100,000) appeared to be prosperous. Shops were crammed with colour television sets, tape-recorders, watches, jewellery and cameras.

There were hardly any women to be seen. I saw only two and they were completely swathed in black cloth so that only their eyes showed. Despite all their new and modern technology the Saudis still retain their traditional social customs. Expatriates have lived in the country for years without ever meeting a Saudi woman socially. Women who break this strict social code are severely punished.

Another thing which struck me about Ha'il was its cleanliness. The town is surrounded by a sandy desert, the temperature is usually about 38°C and a wind generally blows from one quarter or another. And yet the streets are absolutely spotless. A huge force is employed to sweep the streets at least three times a day.

Back at the fire station Alan Johnston invited me to his house for a meal. I could not get over the fact that I was in the middle of Saudi Arabia, downing a superb meal of steak, chips and tomatoes — the kind of meal Pip gives me — and talking to friendly English-speaking people. What with the homely atmosphere and children running around, I could have been back home in Sydney.

As Alan Johnston was a keen stamp collector, I asked him if he could arrange to have the envelopes I was carrying stamped with the Ha'il postmark, and he readily agreed. Later that evening I went to the Airport Director's office to ask how to file my flight plan for my departure to Bahrain the next morning. I was surprised to find the Director stamping my envelopes himself, with his own official stamp! Photographers were summoned and he insisted that I sit beside him at his great desk while several photographs were taken.

It was much easier now that the Director and I were on friendly terms. A Saudi Arabian Airlines official had told me that I could not file my Bahrain flight plan until the next morning, which would have meant a delay. The Director telephoned Jeddah himself and put me on to a European who took down the details. All went well until I was asked for a flight clearance number. I did not have one, and with sinking heart I handed the telephone to the Director. After another shouting session into the receiver I got the telephone back and was told that my flight plan to Bahrain had been accepted. It pays to have friends in high places.

I went to bed that night tired but feeling pretty pleased with myself. Before I fell asleep my thoughts turned to Bert Hinkler again. On the fourth day of his 1928 flight he was in Palestine; I was in Ha'il, south and east of Palestine, which put me a bit ahead of him. He had flown for eight hours and 15 minutes, and I had put in seven hours and 10 minutes.

Flying down the Pakistani coast towards Karachi, I sighted many small villages like this — poised between a harsh, arid hinterland and the Arabian Gulf

How is this for a little weekender? It is probably the property of a very rich sheikh. It boasts a four-car garage, and its own swimming pool. It squats on a rocky peninsula, lapped by the jade-green warm waters of the Arabian Sea near Muscat

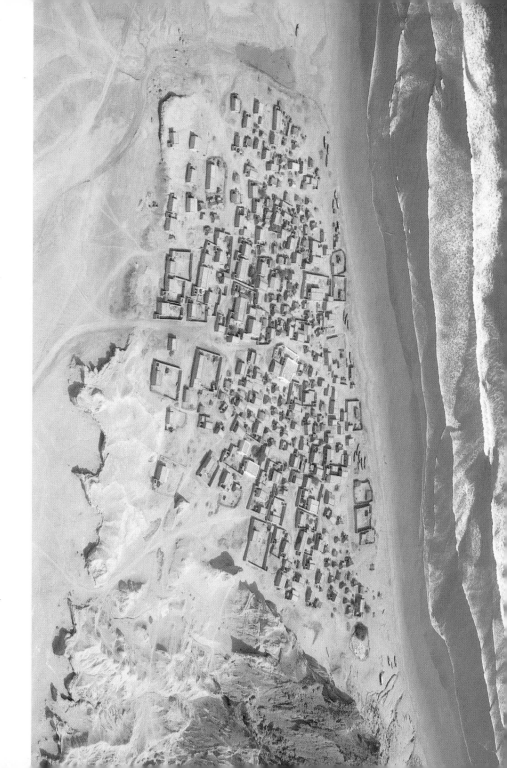

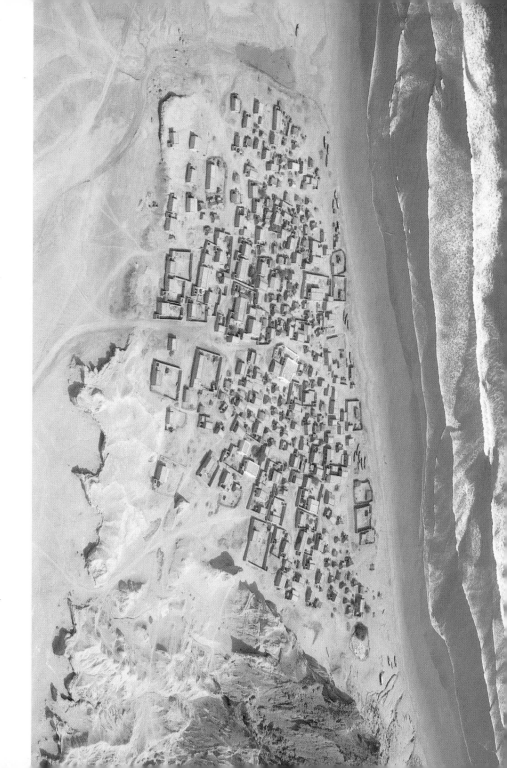

I was up before dawn the next morning, which was just as well because I could not find the keys to the back compartment of the helicopter. I was quite upset over the incident, and hoped it was not a bad omen for the day. I later found them in my flight bag when I reached Bahrain. Only 30 minutes behind schedule, I managed to get away at 6.30 a.m. after saying goodbye to my English firemen friends. I was carrying lunch that Jean Johnston had thoughtfully made me. It was greatly appreciated because I was in such a hurry to depart that I had skipped breakfast, and I had a long flight ahead of me.

I departed Ha'il as I had arrived — in complete radio silence! There was no one to listen to my departure call. My taped commentary records:

"I've departed from Ha'il at 6.30 a.m. and I'm heading east across the desert . . . Below me I can see Bedouin camps . . . they all seem to have small long-haired goats around them . . . I don't know what they eat, there doesn't seem to be any food at all but obviously they get something from the desert. It's very hot, even at 5000 feet . . . it's 32°C outside

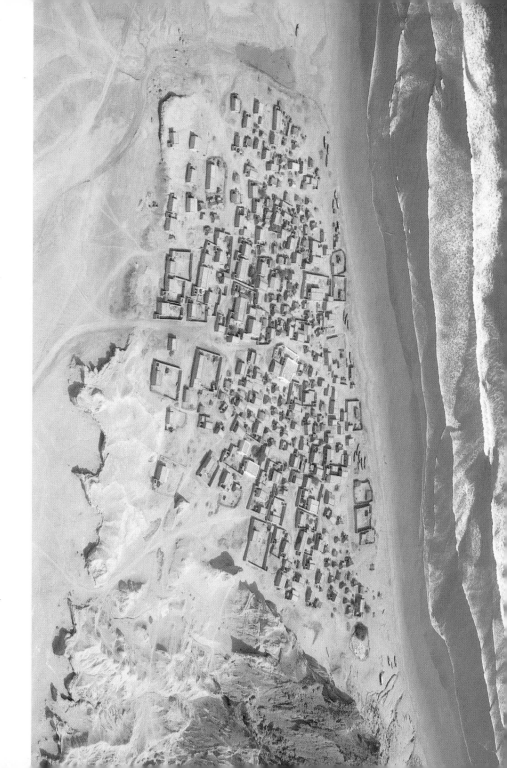

SEPTEMBER

S	M	T	W	T	F	S
			1	2	3	4
5	6	7	8	9	10	11
12	13	14	15	16	17	18
19	20	21	22	23	24	25
26	27	28	29	30		

171

at the moment . . . and the sun has only just risen."

I also flew over a number of what looked like irrigation schemes. Bores had been sunk but it looked like a tough proposition to grow anything in all that sand.

For the third day running I picked up a great tail wind which fairly scooted me along at 110 knots and 7500 feet up. It was obvious I was going to be in Bahrain earlier than I had stated on my flight plan. I tried to raise Bahrain on the radio without any success. I saw another Bedouin camp and decided to take some movie film. I came down very low and many of the Bedouin waved at me. I was nervous about the Bedouin because of their fearsome reputation, but none of them took a shot at me. I had a closer look at their goats which looked like a cross between a yak and a goat, and at their camels' hair tents. I then saw a spectacular sight past the encampment — a group of 50 or 60 camels charging through the desert.

The desert now was more like Australia's Simpson Desert, with great sand dunes running from east to west, sculptured by the winds.

When I could not raise Bahrain I put out a general call to ask any aircraft if they could relay for me. I got almost instant results. I was answered by the pilot of an aircraft a long way above and ahead of me who passed my position and height to Bahrain control.

"*Delta India Kilo*, are you really going around the world?" he asked.

"Roger. I started in Fort Worth and I'm heading back to Sydney, where I live, and then I'm going back up via Japan."

I thanked the unknown pilot for his help, and he wished me a good flight. Then I was in touch with Bahrain myself, and was answered by an American who was very efficient.

On my run into Bahrain I had a magnificent contact with a Swedish amateur radio operator, Roland (SM 1CXE). I spoke to him for a couple of minutes and asked him if he could call Pip and reverse the charges, but he said he did not have a phone handy. This made me all the keener to get to Bahrain and call her from there.

172

More examples of Saudi Arabia's wealth were evident during the last 200 miles to Bahrain. I flew across a huge pipeline consisting of about 12 large-diameter pipes, and a new bitumen expressway under construction. It had a median strip with flyovers. Huge sections of it were covered with sand making it impassable. Perhaps they have sand ploughs that sweep the highway clear.

Just before leaving Saudi Arabia to fly across the narrow strip of water to the neighbouring sheikdom of Bahrain, I flew over Dhahran, near the site where oil was first discovered in Saudi Arabia in 1938. Shortly after I recorded:

"Well, I've got across Saudi Arabia! I can see the gulf of Bahrain on my right. It's beautifully sunny . . . brilliant blue water. I'm across all that terribly hot desert . . ."

I was very glad to be clear of the desert and heading for the sparkling sapphire waters to the island of Bahrain. I had often landed there on business trips to Europe, but had never seen anything of the place, because my flights stopped there at night. The island looked spectacular as I approached it. After the deserts of Saudi Arabia it looked like a green gem set in a brilliant blue sea.

I was guided into Bahrain by very polite controllers who were as courteous and efficient as any I have met in the world. At 10.52 a.m. I put *Delta India Kilo* on the ground. I was met by two officials of Arabian Aviation, Richard Annis and Frank Barnes. Arabian Aviation is the Bell Helicopter agent in Bahrain, and I suppose they were interested to see how the JetRanger was performing in the extreme temperatures. Just before leaving Saudi Arabia my cockpit thermometer had shown 38°C.

Gerry arrived with some Qantas officials soon after I landed. After checking and refuelling the helicopter I went into the airport's beautiful terminal and was whisked through customs and immigration with great speed and courtesy. It took about five minutes. What a contrast to Egypt.

Bahrain is an Arab monarchy with Islam as its official religion. It has benefited enormously from the oil boom of the late 1970s, and its wealth is spread over a small area and a small population.

173

That afternoon I went for a short boat trip and at the marina some of the powerboats which came roaring up were very impressive. One of them, driven by a handsome Arab, also carried eight very attractive European girls in scanty bikinis. A stunning contrast with the religious austerity of neighbouring Saudi Arabia.

I gave a few press and television interviews and packed for a 4 a.m. departure. It was now 12.41 a.m. and I was dead tired. I had a long day's flying ahead of me and it was obvious I was not going to get much sleep. I could only hope, as I hit the pillow, that I would have good weather, and that the bureaucrats at Karachi, would not be like those in Cairo or Luxor.

Gerry and I were at the airport shortly after 4 a.m. My Qantas honorary captain's uniform worked wonders: Gerry and I just walked unchallenged through every official door and on to the runway. An English meteorological officer gave me an excellent weather briefing, and before the sun came up at 5.10 a.m. I lifted off the runway and turned north to get the lift provided by the prevailing wind before turning south down the Persian Gulf towards Abu Dhabi. The blue waters of the gulf below me were

SEPTEMBER

S	M	T	W	T	F	S
			1	2	3	4
5	6	7	8	9	10	11
12	13	14	15	16	17	18
19	20	21	22	23	24	25
26	27	28	29	30		

Left: Bert Hinkler and Amy Johnson were staggered by this spectacular, agonised landscape on the Pakistani coast. The dramatic formations are carved from the ancient sedimentary clay lake beds by wind and infrequent rain

Above: I took a closer look at this strange landscape as I approached the Pakistani fishing village of Jiwani, near the Iran-Pakistan border

patchy with little puffballs of mist as the sun rose. I climbed to 2000 feet making a handy 110 knots.

In the briefing office just before leaving Bahrain I had met the crew of Qantas QF 8 who were about to fly to Sydney via Kuala Lumpur. Halfway to Abu Dhabi a voice crackled in my ear:

"Hello, Dick, this is Qantas Eight on one two three four five."

How fantastic to hear a friendly Australian voice 2000 feet above the Persian Gulf!

"What's the weather like up there?" I asked — after all, QF 8 was at 30,000 feet, over five miles above me.

"It's quite splendid up here," said QF 8's captain. "We've got a great view of Abu Dhabi, it's all quite smooth and clear, a little bit hazy on the horizon, that's all."

After a bit more chitchat I asked QF 8 when he would be in Kuala Lumpur.

"About six and a quarter hours to go," he said.

"I've got about six and a quarter days," I said, "so you might beat me." "I hope we can do that, Dick," said QF 8.

The captain agreed to pass on a message to Qantas in Sydney telling them that I was well and

he continued on his way. I could not help thinking of those hundreds of people so high above me, all being waited on and having magnificent meals. Here was I roasting (it was 40°C in the cabin) in my little helicopter alone.

I was not alone for long. Warned by Abu Dhabi control, I kept a sharp look-out and soon spotted another helicopter on a parallel course but below me. It was used for ferrying men and equipment to the oil-rigs that were dotting the gulf. One of them was burning off oil or gas and trailing a huge plume of smoke. About an hour after leaving Bahrain I was flying over Abu Dhabi, one of the United Arab Emirates which used to be called the Trucial States. Looking down on Abu Dhabi I could see the incredible wealth oil has brought to the region. A few years ago Abu Dhabi was a dusty Arab sheikdom with mud buildings and a medieval way of life. Now there are modern skyscrapers, a huge international airport and a very impressive sports stadium. At the request of Abu Dhabi control I climbed to 3000 feet to keep out of the way of other helicopter traffic. I was quite happy to comply, because I hoped it might be cooler. A spectacular mountain range, the Al Jabal Al Akhdar, lay across my track to Muscat, so I had to climb to well over 5000 feet. Muscat was my scheduled refuelling point on the eastern shore of the United Arab Emirate peninsula.

I turned on the camera to capture the scenery beneath me which was harsh and spectacular: great sunburned red, yellow and purple mountains rearing up under a cloudless sky. In some of the valleys I spotted small villages. Any existence the people eked out in these little hamlets must have been meagre indeed, because I could see no sign of water and only a few patches of scrub-like plants.

Another Qantas plane, Boeing 747 QF 2, bound for Singapore, came on the air. The captain also gave me details of the weather ahead since he had a visibility of over 100 miles. Then QF 2 was gone and I was alone again. It had been a wonderful flying day. Talking to those Qantas planes made me feel good.

I had been rather worried about landing in Muscat, another Arab sultanate. Gerry would not be

176

there, or in Karachi, as the regular airlines could not get him there in time, so for the next two days I was going to be on my own again.

As soon as I touched down I was met by Les Howell, Muscat station officer for British Airways.

The airport terminal was very modern. The air-conditioning kept the desert air at bay; outside the temperature was about 45°!

The topping-up at Muscat had taken the helicopter to her full fuel load, and I was worried about the effect of the high temperature on her lifting ability. When I started up the engine it did not seem to be in any distress. The turbine outlet temperature gauge, which I had expected to be sliding off its scale, was still in the "green" or safe area.

Just over an hour after landing at Muscat I was in the air again. Despite the heat and the load *Delta India Kilo* was carrying, I climbed smoothly and effortlessly, helped by a 15-knot headwind. I flew along the coast for a few miles to take some film of Muscat which is the capital of the sultanate of Oman. Like other countries in this part of the world the bulk of its income comes from oil.

Leaving Muscat I headed out across the Gulf of Oman, a leg of about 220 miles. I would soon be picking up Bert Hinkler's 1928 track. Hinkler left Basra, at the head of the Persian Gulf, on his sixth day out of England. He piloted his Avro Avian to the Iranian town of Jask, 160 miles north-east across the gulf from Muscat. I was not allowed to fly to Jask, so I planned to cross the Pakistan coast near the village of Jiwani.

Hinkler landed at Jask in 1928 and got a nasty fright. While inspecting the Avian before taking off for Karachi he noticed that his petrol tank was leaking. With no facilities to repair it it looked as though Hinkler's flight was over, at least until a new tank could be flown to him. Then he had an idea; he counted the drips as the petrol leaked out of the tank, worked out how much petrol he would lose and use during the flight to Karachi, and calculated that he could make it before the tank was empty. It must have been a nerve-racking flight but he made it.

177

Pakistan's Coastal Wilderness

I sighted the Pakistan coast after two hours and 10 minutes. My tape records my excitement:

"Well, I'm down now to 3500 feet, cruising along at 100 knots with a 10-knot headwind and I can see wind on the water below . . . the cloud has disappeared now . . . I've got to be careful because I'm very close to the border of Iran and I've heard they'll shoot you down. I can see the coast. Fantastic! I can see mountains and everything. It's just tremendous! I've just flown over Jiwani and I've seen a big sailing dhow!"

I had always wanted to see this coast after reading Amy Johnson's book which recounted how impressed she was by the spectacular cliffs. Looking at them now I was equally impressed:

"I'm cruising along the coast at 1000 feet beside spectacular mountains and beautiful beaches. I wouldn't care if this trip along here took two years — this is what I came for. It's absolutely fabulous. There are these incredible mountain formations . . . that I'm sure very few people have ever seen. I thought I was going to see the world in a way it had never been seen before — and I am!"

Suddenly, in all that wilderness, I saw a lone Pakistani motorcyclist roaring along a 25-kilometre stretch of empty beach. At one stage, so lonely and deserted was the country beneath me, I landed on the beach and did some filming. I walked along the beach stretching my legs and taking in the spectacular scenery.

Meanwhile I had contacted Karachi, who wanted to know my expected time of arrival because a big reception party was waiting for me. Reluctantly I cut short my sightseeing and gave *Delta India Kilo* her head. Despite a rising headwind I landed at Karachi at 6 p.m. after five hours and 24 minutes in the air. It had been a good day's flying, and I was back on Hinkler's course.

The stark, eerie beauty of the Pakistani coastline. I flew over these tortured mountains at about 1000 feet and could not see a trace of vegetation anywhere. The sun-cracked, crumbling clay is ancient lake-bed sediment forced upwards as the earth's plates move. Erosion has also created a photographic oddity — this picture looks almost the same if turned upside down

178

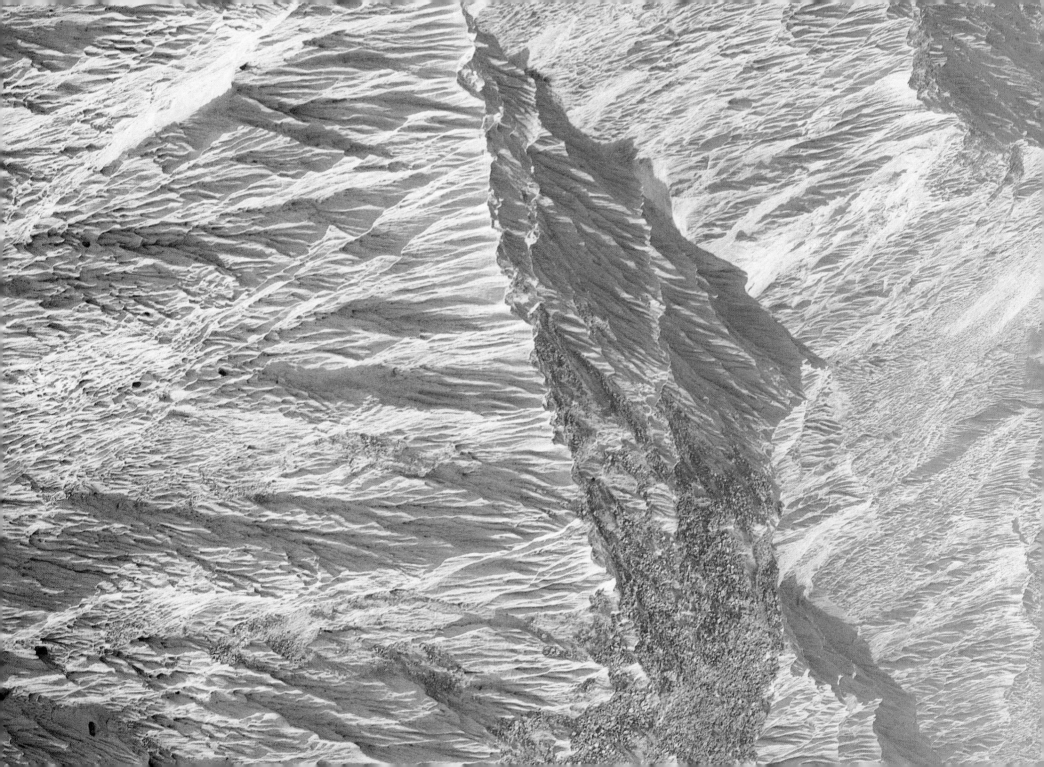

There was a wonderful reception. Not only was there a crowd of press and television journalists, but I was officially greeted by the Director-General of Civil Aviation for Pakistan, Mr W. Hanafi. It was the most official reception I had yet received. Mr Hanafi, a charming, friendly man, took me into the air-conditioned VIP lounge for a press conference. He quickly realised how exhausted I was and closed the conference after 20 minutes, after presenting me with a letter from the President of Pakistan to the people of Australia.

Also there to greet me was a senior official of Pakistan International Airlines, Captain Akbar, who informed me that PIA would do everything they could to make my brief stay in Karachi a pleasant one. They put me up at the historic Midway House Hotel and paid my airport handling charges.

In short, my treatment in Karachi was quite unbelievable. I had been expecting all sorts of trouble, and to be treated like this was staggering. Everything was done for me. I was whisked into — and later out of — Pakistan without doing any paperwork myself. I had been placed in the hands of an enthusiastic bunch of people who were trying to create a good impression of their nation. And they certainly succeeded.

I was absolutely dead beat and dying to go to bed, but as always there were things that had to be done; people that could not be disappointed. A beautiful woman journalist from Pakistan's leading magazine was most interested in Pip and my daughters, so I suppose she was doing the story from my family's angle.

I dined with the Bell dealer for Pakistan, Wali Mohammed, whom I knew from a previous meeting in London. Wali knew I was exhausted and did not keep me up late, but my hopes of an early night were dashed by the arrival of two more local reporters who spent hours in my room talking to me. They just would not go away.

Finally, at midnight, with my alarm set for 4 a.m., I got into bed. I had been up for 16 hours and spent nine hours and 39 minutes of them in the air. I was back on Hinkler's route and in the city he had reached on 14 February 1928, his

180

seventh day out of England. I was in Karachi a day ahead of him. Hinkler had been in the air for a total of 62 hours and 17 minutes by the time he reached Karachi. It had taken me 42 hours and four minutes flying time.

The day began well enough. I was up at four o'clock as planned and noticed that I had more grey hairs than when I left Sydney!

Still, I had no time to agonise over my appearance. The ever-helpful Pakistan International Airline people were waiting to take me to the airport, making my departure immeasurably easier than it would have been. They even gave me 50 copies of a specially printed General Declaration for *Delta India Kilo*.

The original flight plan, worked out by Jim Heagney several weeks before, had me flying from Karachi to Delhi almost directly, and I could not understand why this was not acceptable to the Indians. Their regulations required that I go via Ahmadabad, far to the south of my planned track. I had been pleased with the way I had handled sticky bureaucrats at Luxor and Ha'il, and disarmed by my wonderful reception at Karachi. Was my luck going to turn bad now that I was almost on the last leg home?

With foreboding I worked out my new flight plan. I discovered that my chart for the area did not go as far south as Ahmadabad, but stopped about 60 miles north of the city. So about 80 miles of my flight that day would be done without the aid of a chart, which was not a happy thought to start the day with. How I envied Gerry, safely in Delhi awaiting my arrival.

Finally, at 5.30 a.m., I was ready to leave. I had mentioned to one of the PIA officials that I would not mind a sandwich and a soft drink to take with me. As I got into *Delta India Kilo* my request was granted with embarrassing generosity. Not one sandwich but over a hundred were proudly carried out on a huge tray, and a full crate of Coca-Cola. It was a kind and touching gesture, but I had to explain that I was operating a tiny helicopter and not a jumbo jet. I compromised by taking two cokes and a handful of sandwiches.

181

Following page: A lonely beach on the rugged, beautiful Pakistani coast where I landed for a few minutes to stretch my legs. The strange mounds are cast up by some burrowing animal — perhaps a crab

It was still dark when I lifted off at 5.40 a.m. and turned south-east over the lights of Karachi. The helpful controller vectored me around a high radio mast. As the sun rose I could see a weird landscape, consisting of nothing but desolate swamps and lakes, linked by small winding streams sparkling in the early morning sun. I was flying over the delta of the mighty Indus River which winds through Pakistan and Kashmir from its source in the Himalayas about 2900 kilometres to the north. The sight of all that water gave me a fright as I had not expected to be flying over water between Karachi and Delhi. My life jacket was in the helicopter's luggage compartment, but I still had the life raft.

The Indus delta seemed to go on and on. As I flew south-east I crossed the great tidal mudflats lapped by the Arabian Sea. The tide was out and the mud gleamed a beautiful purple in the sunlight. Here and there were long white stripes of what I realised was salt deposited by evaporation. In a strange way it was very beautiful.

By now the sun was rising, making the cabin very hot. I was flying almost due east as I approached Ahmadabad. The heat and glare with only my three hours sleep the night before (even less the night before that) were a very dangerous combination. I had to force myself to stay alert by taking an interest in the countryside unrolling beneath me. I was surprised by its greenness as I had imagined most of the interior of India to be virtually desert. There were farms, crops of what looked like maize, and goats and sheep in little stone corrals.

I came down to 2000 feet as I approached Ahmadabad with the little helicopter screaming along at 118 knots. It was beautiful flying weather with no wind at all and excellent visibility except for a slight ground haze; the outside temperature was 27 °C.

I was struck by the emptiness of the countryside. India has a population of over 700 million people, and it was obvious not many of them lived in the area I was flying over.

Things got livelier about 50 miles out of

Ahmadabad. A bus scooted down a road amidst cultivated paddocks of rich, dark brown soil.

I later contacted Ahmadabad air traffic control. To my relief the controller sounded very friendly. Thank goodness, I thought. Perhaps it will not be as bad as I have been expecting it to be. It was not. It was considerably worse.

I landed at Ahmadabad in searing heat — 46 °C. A fair warning of the bureaucratic hell I was about to enter. I was taken first to the customs officer in a hot, dusty office where the steamy air was swirled by a languid fan. Stacks of mildewing files vied for space with office equipment which the British must have installed 60 years ago. This official put me through an ordeal I shall never forget.

Forms flowed across the scarred wooden counter towards me in a seemingly endless stream of paper. I had to declare *everything* that I had brought into India, including my watch, the exact amount of money I had on me, and the fuel in the JetRanger's tanks. There was no carbon paper so every form had to be in duplicate, triplicate, or quintuplicate. Everything had to be stated and signed again and again. I must have written my address at least 15 times.

When I had finished with the customs man, about an hour after landing, I set about refuelling *Delta India Kilo* which took about 15 minutes. I had to make a trip to another office to fill in a few dozen forms, then I had to pay for the fuel. Only foreign currency was acceptable so there was no problem. The fuel bill was $US180 and I only had even money of $US200 on me. Alas, the man in the fuel office had no change and said he could not accept my $200 for the $180 worth of fuel. Exhausted and streaming with perspiration I had a ghastly vision of the fuel I had bought being drained out of the JetRanger again while I wandered about Ahmadabad trying to find someone with change for my $200.

The fuel man must have realised that I was at the end of my tether because he relented and promised to mail the change to me in Australia — I am still waiting for it.

That little ordeal lasted 40 minutes. I had now been on the ground for almost two hours and still had several more bureaucratic hurdles to clear. To make it worse, it was getting hotter and hotter.

Even now I was not finished. I had to talk to the communications officer who questioned me about my radio equipment and several other points which had already been clarified. Then *he* signed the flight plan. It was back to the customs man again for a few more forms, and he had to sign my flight plan for the second time. By now I felt I was trapped in a bureaucratic quicksand from which I would never escape. Every signature on my flight plan seemed to breed the need for yet another signature.

Then I had to go to the meteorological office for a briefing and have my flight plan signed. I was sent to another desk to get a "defence" flight number and my flight plan signed again. (I suppose the "defence" number was to enable Indian military authorities to keep track of me.) Then I had to see another officer who briefed me about the navigational aids available on my route, and he too had to sign my flight plan.

Despite the very thorough meteorological briefing, it was depressing because according to the data I was given the JetRanger would be fighting headwinds all the way.

My next stop was the control tower. I had planned to track directly from Ahmadabad to Delhi along the airway marked on the map. Unfortunately the tower did not see it that way. They insisted I track almost 100 miles due east, at right angles to the direction I wanted to go, before turning towards Delhi. There was no logical explanation for this, so I had to accept it. I had refuelled the helicopter with enough fuel to take me to Delhi by the direct route. After some quick mental arithmetic I realised I possibly had insufficient fuel to do the additional 100 miles. I could not bear the prospect of another refuelling operation in that searing heat, and then going through another 40-minute performance to pay for it. There was no way I was going to stay in this frustrating place a moment longer, so I decided to

184

leave in the hope of picking up a tail wind.

I will not forget Ahmadabad in a hurry. Events of that dreadful day keep flashing into my mind: like paying my landing fee at the counter, soggy with sweat, while the clerk carefully examined each dollar and wrote the serial number on the receipt after handing each note to his assistant for further checking.

At long last it was over and I was airborne again, almost crying with relief after spending hours on the ground in the appalling heat, filling out reams of forms. I wondered if anyone would ever read them.

I could still appreciate the beauty of the country below me despite the heat and my tiredness. It looked rich and well watered with many large rivers and dams. I passed several towns each dominated by a large fort or castle on a hill — relics of India's feudal days.

I had climbed to 5000 feet where there was very little wind, but thermals (rising columns of air heated by the temperature on the plains below) made the going pretty rough.

After my experience of Indian bureaucracy in Ahmadabad I felt ill at the thought of what awaited me in Delhi. Gerry Nolan would be there to help me, but even so the prospect was not a pleasant one.

Depression and exhaustion flowed over me in black waves. I was also worrying about the extra fuel consumption caused by the 100-mile deviation. I was convinced there would not be enough fuel to get to Delhi. I craned my neck to look over my shoulder at the reserve fuel tank. To my horror I could see nothing in the visual fuel indicator! I tried to tell myself that it was impossible to have used so much fuel in such a short time. But I was so tired that I could not think coherently. It would mean having to land somewhere south of Delhi. More bureaucratic clashes would upset my plans and I would not be able to match Bert Hinkler's flight.

Over Jaipur I tried to calm down and forced myself to think rationally. I had made up a bit of time and the JetRanger was now barrelling along at 120 knots.

185

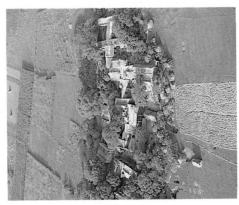

I was puzzled by the missing fuel. I looked hard at the reserve tank and realised that the fuel level was far higher than I had thought because it had dropped behind a fitting which obscured part of the visual fuel gauge. Normally, I would have realised this, but I had been so exhausted after the Ahmadabad experience and my lack of sleep. The relief was so great I burst into tears. For the first time on the flight I wished I had someone flying with me.

I approached Delhi Airport at long last. After some confusion over which of the two runways I should use the tower ordered me to land in a direction which would put the JetRanger's tail into the wind, making it very difficult to land.

Using all my reserves of concentration I managed to get down without making a fool of myself. It was a great relief to see Gerry Nolan, accompanied by two Indians, running up to me. I told Gerry I was utterly exhausted and that I could not continue the flight the next day. Secretly, I told myself that there was no way I would go on at all. I felt as depressed as I had in Moncton, Canada, at the start of the flight, and wished I had never undertaken it.

As I climbed out of the helicopter I was confronted by a barrage of questions from the media. It was unbearably hot and my mind went blank. Gerry had been trying to telephone Pip for me but it was hopeless as communications in and out of India are appalling. That was the last straw. I just broke down and sobbed. It was most embarrassing but I could not help it. One of the Indians with Gerry put his arm around my shoulder and told me not to worry. It was very kind of him, but I just could not stop. I recall the story of a well-known aviator at one stage of his solo flight who burst into tears. I did not understand at the time how a fully-grown man could cry, but I understood now.

One of the television cameras recording this event was from the Australian Broadcasting Commission, so my problems were shown all over Australia the next night. I must say the media

SEPTEMBER

S	M	T	W	T	F	S
			1	2	3	4
5	6	7	8	9	10	11
12	13	14	15	16	17	18
19	20	21	22	23	24	25
26	27	28	29	30		

were most understanding, but they did not help alleviate my anxieties at the time.

The Delhi officials could not have been more helpful. They could see the state of nervous exhaustion I was in and did their very best not to delay me.

The first thing I did when reaching my hotel was to try to ring Pip to warn her of the ABC's coverage of me. I tried for an hour without success which depressed me even more. I lay on the bed sunk in the blackest gloom berating myself for having embarked on this mad adventure. I should be back home enjoying myself with my family instead of having to put up with all this fatigue and loneliness.

The Australian Broadcasting Commission's correspondent in Delhi, Trevor Watson, agreed to help me get through to Sydney by telephone. In the meantime I had fallen asleep. It was 7 p.m., the earliest I had been to bed for a week. Twenty minutes later the phone rang — it was Pip! Tired and dejected as I was it was an enormous tonic to hear her voice. We spoke for 40 minutes. "Keep on coming," said Pip, "and I'll meet you in Singapore in four days' time."

My original planned route was to have taken me to Katmandu in the mountain kingdom of Nepal, and then south to Calcutta. However, I decided that I definitely needed a good rest. A tired pilot is a dangerous pilot. I redrew my schedule to take me directly from Delhi to Calcutta via Lucknow. Cutting out Nepal would make up for the day I would lose by resting in Delhi, and put me back on schedule. I was still ahead of Bert Hinkler who had reached Karachi on his eighth day. Feeling as I did after eight days in the relative comfort of the JetRanger, I could only shudder at the thought of what Hinkler must have gone through in his noisy, open cockpit Avian.

I passed the day quietly, resting and catching up on my diary notes while Gerry kindly went out and organised my departure for the next day.

Across the hotel grounds from my room an extension to the main building was going up. I watched, fascinated, men and women swarming

188

SEPTEMBER
S	M	T	W	T	F	S
			1	2	3	4
5	6	7	8	9	10	11
12	13	14	15	16	17	18
19	20	21	22	23	24	25
26	27	28	29	30		

over the site like ants. They worked entirely by hand in the blistering heat. There was no machinery to be seen. Men with picks and shovels would break the soil and shovel it into baskets where waiting lines of women would carry them on their heads, dump their loads and then return for more.

Gerry came back from his day's duelling with Indian officialdom with some good news: I could track directly from Delhi to Calcutta and refuel at Lucknow with no silly diversions; and the weather forecast was good! I felt happier than I had for days.

At 5.30 a.m. I was at the airport after another good night's sleep. I collected the weather forecast Gerry had ordered the night before and was quite staggered by it. It was a detailed four-page document, describing every condition I would meet on my planned route, including colour drawings of the types of clouds along my flight path. Dangerous clouds, those containing ice, were drawn in red. And it predicted tail winds all the way.

Gerry and I must have set a record for Indian paper shuffling that day. It took us a mere 50 minutes to handle all the formalities of departure. Not bad, considering that our documents had to be signed by just about every official in the airport.

I took off from Delhi in a very optimistic mood at 6.20 a.m. Climbing to 5500 feet I soon picked up the tail wind as forecast. It was a magnificent flight and I dropped down to take pictures of farmers tilling the soil of their fields with oxen. I landed at Lucknow two hours and 10 minutes later.

Again I was confronted with the same petty officialdom that I had found so maddening in Ahmadabad. I had been told many times that in India fuel may only be bought with US dollars. My experience in Ahmadabad had borne this out. However, in Lucknow they wanted rupees only.

"I have no rupees," I said, trying to stay calm. "Only US dollars."

"You will have to change them, sahib."

189

Above (top): A typical mud-walled Indian village near Lucknow. It was the scene of one of the most famous sieges of the Indian mutiny in 1857

Above (centre): A jade chequerboard of well-irrigated fields hugs the banks of the Hooghly River near Calcutta

Above: Brickworks on my approach to Calcutta's Dum Dum airport

"Where may I change them?"

"There is a bank in town."

"Well, can I get into town and change the money very quickly?"

"No hurry, sahib. The bank doesn't open until 10.30 a.m."

This meant having to stew in the dreadul heat for two whole hours. I told the official very firmly that I had been assured in New Delhi that Lucknow would accept US dollars. That caused a flutter. There were hurried consultations and eventually it was agreed I could pay in US dollars. With that settled, I went up to the tower and paid my landing fees of $3. It took 20 minutes for the paperwork to be processed. When I was ready to go I asked the traffic controller if I could take off from where I had been refuelled.

"Impossible," he said, giving no explanation.

It was a ridiculous situation. Here I was on this huge airstrip with enormous taxiing areas everywhere and not another aircraft in sight. And yet to comply with some silly regulations I was being forced to use a runway and take off with the wind behind me.

Suddenly I had an idea. I gave the controller one of my "JetRanger around the World" badges and it worked like a charm. The controller decided that because I was an adventurer and not your common or garden variety pilot, the rules could be changed.

Graciously I was told to take off from where I was and into the wind. This may sound like a very minor victory, but it was a very important one. In that very high temperature I would have been hard pressed to get the heavily laden JetRanger airborne at all if I had not been able to use the extra lift obtained by taking off into the wind.

I finally got away after only an hour and 13 minutes on the ground — an incredibly short time, given the slow pace at which everything is done in India. My departure was watched by a number of Indian soldiers scattered all over the airport, armed with World War II .303 Lee-Enfields.

Later I was flying over the India of the travel

190

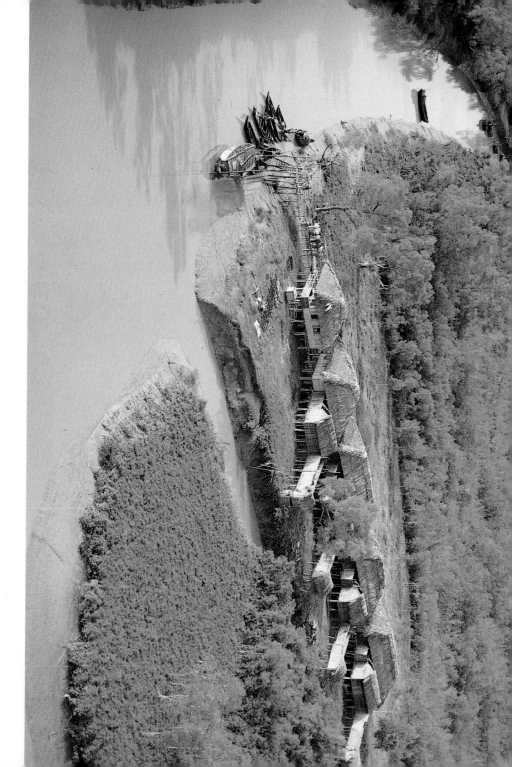

brochures. There were vivid green fields and not a sign of a tractor or any modern equipment. Patient oxen pulled ploughs, helped by men pushing from behind. This was farming the way it had been done for thousands of years.

I flew low over several of these hard-working people to take photographs. I wondered what the dark upturned faces made of *Delta India Kilo*. Probably some of them had never seen a helicopter before.

Not many people have seen India the way I saw it that day. I was so impressed and so enthusiastic that I fairly burbled into my tape recorder:

"Straight between my feet now I can see a big canal going past a little village and people in the fields with their ploughs. I can see roads, railway tracks . . . everything!

"With these vertical downslides for windows, I can look straight out of the aircraft. Nothing is in the way . . . it's as if you're on the edge of a big platform . . . I'm now looking down

Above (top): Thatched houses amidst a mixed wilderness of swamp, estuary and thick forest in the Sundarbans, southern Bangladesh, home of the fierce Bengal tiger. The outside lavatories extend to overhang a convenient creek

Above: The Bangladesh side of the winding Ganges delta with the Bay of Bengal beyond

191

on a beautiful sandbar in a muddy river.

"Below me to the left is this enormous temple . . . unbelievable!"

Flying low across India I could appreciate the country's enormous problems with so many people to feed.

The landscape alternates between droughts and floods. Australia has similar regions where there is one family for every several hundred square kilometres, compared to India where there are many thousand. It would make relief work in time of floods, for example, almost impossible, causing a high death toll. Looking down on poor, crowded India made me deeply appreciate my homeland.

Down below me I saw a huge river snaking across the lush green land ahead of me — the mighty Ganges, India's sacred river.

The country levelled out as I tracked towards Calcutta. It had evidently been flooded recently and I was flying at the tail end of the monsoon season. Everything was a beautiful, vivid green.

Approaching Calcutta I had to descend to 2000 feet to miss some clouds — the first I had seen since leaving Delhi. They were piling into rather ominous looking thunderheads at 4000 feet, and I slipped into the city beneath them without any trouble.

I soon had Dum Dum (Calcutta's airport) on the radio. It was the first time I had spoken to anyone since leaving Lucknow, by the way. I seem to have spent most of my flight in silence or talking to myself and enjoying my magic carpet ride since leaving Fort Worth.

Dum Dum Airport is built near where the British had an ammunition factory in the colonial days. It was where the infamous dum-dum expanding bullet was made.

For a reason which was never clear to me I was made to fly well to the north of Dum Dum Airport and then ordered to turn south again. At the very last minute, as I was approaching the airport, the controller's voice crackled in my ear:

"Helicopter *Delta India Kilo*, turn hard left, you are flying into a restricted area." I thought this was quite extraordinary since the controller had been directing me.

I finally came into the apron and saw a crowd of at least 40 photographers and other media people waiting for me. As I hovered over the parking position the crowd ran towards the helicopter. Naturally, not wishing to land on top of someone, I slowed my descent and forward motion.

"Keep going," barked the controller.

"What about the people?" I asked.

"Don't worry about them, they are only reporters," said the controller. "They'll get out of the way."

To my relief they did. They were so keen that as soon as the JetRanger's skids touched the tarmac they clustered around and peered at me through the canopy.

After a successful press conference, organised very efficiently by a Calcutta Qantas officer, Neena Ghosh, I checked in to my hotel. I was staggered by the numerous people in Calcutta's streets, and the poverty all around was both appalling and depressing. Calcutta has about four million people most of whom live in conditions beyond the imagination of an Australian. Many thousands of them have no homes at all. They are born in the streets and live and die there.

Communications into and out of India are generally difficult, so I was delighted to get a phone call from Pip soon after arriving at my hotel. She had some good news for me, too. As I mentioned earlier, some of the countries I approached when planning the trip did not even acknowledge my requests for permission to enter their airspace. Burma — my next stop after India — was one of these countries. I had been feeling rather apprehensive about arriving unannounced, as I had heard a lot about their tough regulations. Fortunately, Pip had been working on the problem. She had spoken to the Australian embassy in Rangoon, the Burmese capital, where they gave

SEPTEMBER						
S	M	T	W	T	F	S
			1	2	3	4
5	6	7	8	9	10	11
12	13	14	15	16	17	18
19	20	21	22	23	24	25
26	27	28	29	30		

Two fishing boats moored side by side in the silt-rich waters of the Ganges delta. They are in a network of wilderness in the Sundarbans which stretch for several hundred kilometres across the southern Ganges border of India and Bangladesh

her my special clearance number and assured her that everything was in order. That was a great burden off my mind and helped me to get a good night's sleep.

The following morning Gerry Nolan and I walked out of the hotel into Calcutta's steamy pre-dawn darkness and there was the ever-helpful Neena Ghosh waiting for us in a Qantas chauffeur-driven car. Talk about service!

Even at that early hour thousands of people were sleeping on the pavements. Sanitary conditions in India's largest city would turn an Australian sanitary inspector white overnight.

After my experiences elsewhere in India I was not looking forward to the paperwork my departure was certain to involve, but I need not have worried. Gerry had kindly spent two hours fighting bureaucracy and had filed the flight plan to Rangoon the night before. The Indian officials turned out to be friendly, and with the help of a British Airways official and Neena Ghosh, everything was over in half an hour.

My pre-departure weather briefing was like the one I had been given in Delhi — meticulous, immensely detailed, and accompanied by another of those beautifully drawn and coloured diagrams of the clouds I would meet en route. These weather briefings were the best I have had anywhere in the world. Everything is explained so clearly that it would be hard to get into trouble.

The Indian briefings are extremely accurate and much easier to understand than those issued in other countries where the briefing usually consists of a computer printout with line after line of abbreviations and weather and cloud codes. They are not nearly as effective as an actual drawing of the cloud with red cross-hatching indicating ice. The Indian meteorological people are to be congratulated.

At 6.03 a.m. I took off into the misty dawn, heavily laden with seven hours of fuel aboard. I expected to cover the 520 miles to Rangoon in five hours and 20 minutes, so I had plenty of spare fuel if I ran into trouble.

194

I was now a day ahead of Bert Hinkler. He had landed his Avro Avian at Dum Dum Airport on 17 February 1928 — his tenth day out of England. On my tenth day out I would be, I hoped, in Rangoon. I had found the heat and the Indian bureaucracy exhausting. I wondered how Hinkler had felt at that stage of his flight home. At least he did not have to contend with bureaucracy in those days.

I was soon clear of teeming Calcutta, which straddles the Hooghly River, and heading across the incredible Ganges delta. The Ganges fans out into many mouths with the main part of it entering the sea more than 150 kilometres east of Calcutta. The country was a wet and wild jungle, the home of the Bengal tiger. I would not like to have to spend the night down there in my little tent if the Allison stopped suddenly.

Every now and again I flew over small riverside huts where I did a lot of filming. As I approached the coast and prepared for the run to Burma across the Bay of Bengal I had to remove the movie camera and stow it in my map box as I was not sure if the Burmese would allow filming. I was getting a little nervous about approaching Burma, as I was not able to raise Akyab, my first Burmese checkpoint.

So, zooming along, high above the mirror-smooth Bay of Bengal, sparkling in the sunlight and dotted with fishing boats, I recalled the warnings I had been given about Burma. I was told that the authorities would shoot down aircraft if they did not get approval to come in. I kept trying but the ether remained silent. By the time I was less than 90 miles from the Burmese coast I was really worried.

My calls finally got a response, not from the Burmese, but from a Thai International Airways jetliner 30,000 feet above me. To my relief the friendly captain agreed to contact Rangoon and tell them I was on my way.

I was able to relax and enjoy the flight over the huge bay now that I did not have to worry about being shot down. The leg from Calcutta to

my first landfall on the Burmese coast kept me over the sea for more than 200 miles. Although I was no longer as wary of long sea crossings as I had been earlier in the trip I took no chances. I had put on my life jacket before leaving Calcutta, and the life raft was in the cabin with me.

It was a beautiful day and, up where I was at 5000 feet, pleasantly cool after India although I could still feel the sun through the canopy.

I would be flying through the monsoon and already I could see a great towering mass of cloud ahead of me. I did not want to lose height so I flew around them instead of beneath them, and took some marvellous still photographs with the 35 mm camera — great canyons and valleys of dazzling white and sombre purple in the sky. By a coincidence, Bert Hinkler had met clouds at almost exactly the same place on 17 February 1928! Bravely he weaved the Avian between their lowering ramparts. Hinkler loved clouds and their variety of shapes and colours fascinated him. He later recalled his encounter with the clouds of the Bay of Bengal as one of the most enjoyable experiences of his whole flight.

Beyond the clouds the coast of Burma came into view. It was a magnificent sight with high massive mountains covered in jungle. They ran down to beautiful sandy beaches, deserted except for the occasional small village. Small fishing boats could be seen and what looked like canoes working all along the coast. A truly beautiful country.

I crossed the coast and headed inland and began the long climb over the Arakan Yoma mountains which lay between me and Rangoon.

Suddenly I got the very devil of a fright. A sudden rattling roar like machine-gun fire filled the helicopter. Fortunately for my blood pressure, I realised what had happened. In England CSE Aviation had put special strips of tape on the leading edges of the main rotor blades to protect the aluminium from the corrosive action of water and sand. A section of the tape had come unstuck and was cracking like a whip as the blades turned.

Above: The coastline running down from Burma to Thailand is beautiful with unspoilt, sandy beaches flanked by graceful coconut palms. This village is near the southern Thailand tourist resort of Phuket

Above: By coincidence, Bert Hinkler, who loved clouds, had come across a similar cloud formation in almost the same part of the Bay of Bengal when approaching the Burmese coast more than 50 years ago

It made a frightening noise but did not seem to be causing much vibration. If heavy vibrations did occur I would have had to land very quickly. This would have caused a problem because the jungle beneath me was a solid green mat with no sign of a clearing anywhere.

Gritting my teeth and trying to ignore the noise I flew steadily on, climbing all the time, and when I finally cleared the mountains I managed to raise Rangoon on the radio. I explained my problem, but there was not much they could do except send out a search party for me if I was forced to come down in the jungle.

The final run down to Rangoon's Mingaladon Airport was over beautifully lush country where some of the world's best teak comes from. I crossed the big Irrawaddy River and could see teak logs being floated down towards Rangoon. I even saw a couple of elephants doing the work of tractors.

The mountains became hills and then ended as I flew over level flood-plain country, patchworked with brilliant green rice paddies. I ran into more clouds and was constantly on the radio to

Rangoon asking for approval to fly lower and lower.

Unlike the Indian controllers, who made me take all sorts of roundabout routes, the Mingaladon controllers vectored me straight in to land. Tracking in towards the airport I could see the huge shining golden dome of the Shwe Dagon Pagoda — the biggest Buddhist shrine in the world. I landed at Rangoon shortly after noon, having been in the air for five hours and 12 minutes, which meant that I had almost two hours of fuel left.

Unlike many of my stops in other major cities there was no reception committee awaiting me at Mingaladon. I was certainly not ignored once I had landed though. The people manning the control tower, the refuelling technician, and the customs and immigration people, all came out onto the tarmac and congratulated me on getting to Rangoon.

I was anxious to track down the source of the frightening noise which had so startled me over the mountains. As I had suspected, it was merely a piece of blade tape which had come unstuck. I solved the problem by peeling off all of the tape.

I had just finished refuelling when a member of the Australian embassy staff, Rob Jones, arrived and we went through the arrival formalities together. Like India there was a lot of paperwork, but everyone was so friendly and helpful that there were none of the maddening delays I had experienced in India. I was staggered though when the customs officer asked for 17 copies of my general declaration form.

Before going into the city with Rob Jones, I called at the flight briefing office to file my flight plan for an early departure the next morning. I had been told by several people before arriving in Rangoon that I would only be allowed to depart from Burmese airspace by the established air routes. The Burmese are extremely security-minded as a result of fighting a long and drawn out campaign against Communist terrorists in the north-east mountains.

Smithy's Jungle "Graveyard"

RANGOON

BURMA

forced down

The regular routes were of no use to me as I wanted to fly down the coast to the island of Aye, about 100 miles south of Rangoon, where it is believed Charles Kingsford Smith and Tommy Pethybridge crashed in the *Lady Southern Cross* in 1935. Luckily, the flight briefing officer agreed to my proposed flight track down the Burmese coast to the Thai holiday resort town of Phuket, on the Isthmus of Kra. I was very pleased. Kingsford Smith has always been a hero of mine, and by flying over the area in which he disappeared I would be paying tribute to one of the world's greatest aviators. Often during the lonely hours on my flight I had looked at his photograph and speculated about how he had felt and had handled all the problems a solo pilot faces. And of course I had that piece of fabric from his earlier aircraft, the Fokker tri-motor *Southern Cross*, tacked to the instrument panel just near my left knee.

It would have been a bitter disappointment if the Burmese bureaucracy had dug in their heels and prevented me from flying down the coast. Instead they were charming and cooperative all the way.

With the formalities over, Rob Jones drove me into the city which was still full of gracious old buildings built by the British.

After lunch I was taken for a tour of Rangoon in an embassy car. We visited the Shwe Dagon Pagoda, and the old race course where Kingsford Smith, Hinkler and others, who flew to Rangoon before World War II, had landed. There was no proper airport in those days and early aviators planning a stop in Rangoon had to remember that they could not arrive on a Saturday because that was race day.

I found the Burmese very friendly people and very interested in foreigners. They are a good-looking race, and speak some of the best English

Above: Burma's Aye Island may hold the key to Smithy's disappearance in 1935. A wheel from his aircraft was found in an inlet (upper right of picture)

Above (left): A stark village hacked out of the Malaysian jungle

Left: Western-style houses among the coconut palms on this Malaysian plantation

SEPTEMBER

S	M	T	W	T	F	S	
				1	2	3	4
5	6	7	8	9	10	11	
12	13	14	15	16	17	18	
19	20	21	22	23	24	25	
26	27	28	29	30			

in Asia. Tourists are discouraged and one week is the longest a casual visitor may stay.

Burma was ruled as a British possession and was regarded as a province of India from 1862 until 1948. It then became a republic, the Union of Burma, outside the British Commonwealth.

After my tour of the city I was taken to the residence of the Australian ambassador, Mr Richard Gate. It is a beautiful place set in several hectares of ground which the Australian government has purchased. Mr Gate kindly invited me to stay the night as Rangoon is noticeably short of hotel accommodation.

The ambassador's kindness could have caused me some embarrassment. On the evening of the day of my arrival, the ambassador was giving a dinner in the grounds for about 80 people. I was invited, and naturally accepted. I decided to finish my flight log and my next day's flight plan in my room before strolling down to the poolside dinner, about 200 metres from the residence.

Easier said than done. My work finished, I tried to let myself out of the front door of the residence only to find it was locked! Every servant on the ambassador's staff was down at the pool helping with the dinner, and the residence had been locked up tight as a drum. I walked from room to room looking for a way out, but every window was barred and every door locked. Half-an-hour later I found a small, unbarred window, forced it, and climbed out through it into the garden. I hate to think what would have happened if a passing Rangoon policeman had seen me breaking *out* through a window of the ambassador's residence. After all that, I relaxed and had a good dinner.

The flight from Calcutta to Rangoon had been great and I awoke bubbling with enthusiasm about the coming day's flight which would be a pleasant run down the beautiful, unspoiled Burmese coast to Phuket, flying over the same waters traversed by Kingsford Smith, Hinkler, and other great aviators. I was looking forward to a memorable day.

As events will show, it was just that. Perhaps the most memorable in my life and certainly the most frightening.

It began well enough. Rob Jones collected me at the ambassador's residence at 4.30 a.m., and by 5 a.m. we were at Mingaladon Airport, waking up all the officials who appeared to spend their nights sleeping at their desks. The paperwork for my departure was as heavy as it had been for my arrival, but once again everyone was very courteous and helpful. So helpful, in fact, that when I asked for a bucket of water with which to clean the JetRanger's windscreen, a huge water truck was produced.

By 6.15 a.m. I was ready to go, feeling on top of the world. The weather forecast looked good right through to Phuket, about 586 miles to the south.

Out of Rangoon I weaved in and out of scattered rain squalls at 500 feet without any trouble and picked up the coast of Burma as it turned south. After an hour's flying I came across Kalegauk Island, and near it I could recognise the outline of Aye Island.

It was strange and extremely moving to think that I might have been flying over the remains of the *Lady Southern Cross*, somewhere down there, in those dark muddy waters. One day I would like to launch an expedition to search for that historic wreck.

I made a low run over Aye on the course Kingsford Smith would have been flying. The island is rocky and covered with jungle with cliffs on one side. It would certainly be a dangerous place to fly too close to at night in bad weather and poor visibility. One of the theories about Kingsford Smith's death is that engine trouble forced him down and he clipped the top of the unmarked island while searching in the darkness for a place to make a forced landing.

It was an uncanny feeling to circle the little island, photographing it from every angle. I located and photographed the small beach where the only remains of the *Lady Southern Cross* were found — an undercarriage leg and tyre.

I spent 15 minutes looking at Aye, and then swung south again, to get back on course for Phuket. Unfortunately, the weather along my track had deteriorated dramatically. I ran into a torrential tropical downpour — a solid sheet of water which drummed on the canopy and lashed the smooth sea beneath me. Visibility had dropped to the absolute minimum. I hastily changed course, moving from

my planned track which would have kept me out over the sea, and flew in to pick up the coast. I certainly did not want to get lost somewhere out in the Gulf of Martaban with zero visibility, heavy rain and dwindling fuel.

Once I had picked up the coast I dropped down and skimmed southwards over beaches and headlands, and little fishing villages with boats pulled up on the sand. People ran out and waved at the helicopter.

I kept this up for another half-an-hour and then the weather, which had been appalling, degenerated even further and became thoroughly dangerous. The rain became so heavy and thick that I could see virtually nothing ahead of me. I had never seen rain like it. My visibility was limited to a small patch immediately below the helicopter. The noise was horrendous and deafening.

I've got to get out of this, and very quickly, I thought. I reduced speed to 40 knots and headed through the rain at 100 feet. Luckily there was no wind. Below me I could see waves crashing on a sandy beach, so I dropped the helicopter, moved in sideways and put it down on the beach as quickly as I could, breathing a sigh of relief.

Crikey, I thought, I'm alive! I had been given a terrible fright. When the rain lifted slightly and I looked along the beach ahead of the helicopter, I got a bigger one. There, looming dimly through the murk was a huge dark headland. If I had not landed I could have flown straight into it. Even at 40 knots that would have been the end of me and the JetRanger.

I sat in the helicopter for a few minutes after landing, stunned by the narrowness of my escape, and rather expecting to be surrounded by gaping villagers from a nearby fishing village. I got out, getting drenched in the process, and dragged my wet weather gear out of the luggage compartment.

Back in the cockpit, sopping wet and tired, I was just about to sit back and take it easy until the rain stopped when I noticed something extremely alarming. The helicopter was slowly tilting to one side! The right-hand skid was being forced down by the huge weight of fuel still in the tanks, driven deep

into the wet sand at the water's edge.

I got out of that helicopter as though it was on fire. Already the JetRanger had developed a dangerous list. It was several degrees out of the vertical and still sinking. *Delta India Kilo* cannot lift off with a list of more than 10°. I dug frantically at the sand for a few minutes to bring the JetRanger back on an even keel and I realised I was not getting anywhere. The skid was just sinking deeper and deeper.

I jumped in the helicopter and started the Allison. By now the helicopter had developed a fore-and-after list as well as a sideways list and the tail rotor was only a few centimetres above the sand. At 100 per cent power the JetRanger would still not move, so I increased power to 110 per cent for the maximum five seconds allowed and it finally hauled itself clear of the clinging sand. Another few seconds and either the tail rotor would have touched the beach or the list would have increased beyond the maximum take-off angle. Either way, I would have been stuck on that lonely Burmese beach.

Once clear of the sand, I hovered the helicopter up the beach until I could see the dark gloom of the jungle. I dropped down and hoped the sand would stay firm for a while.

I sat and wondered what on earth I should do. There were not many options. It was raining so hard that flying was out of the question. Visibility was for all practical purposes absolute zero. The rain was so heavy that I doubted if a small helicopter could have stayed airborne in it.

I checked my coordinates on the VLF Omega, 13° 48.0' N 098°05.0' E, and related them to my chart which was by now decidedly soggy thanks to the rain. The chart showed that I was about 30 kilometres south-west of the town of Tavoy and about seven kilometres from a road. Unfortunately, between me and the road lay thick jungle and a high mountain range. So walking to the road and hitching a ride back to civilisation was out of the question.

At last the rain began to ease off. I walked up and down the beach, thinking. I also noticed the tide was coming in and the waves were dashing higher and higher up the beach with each surge. The jungle ran down to the beach and I could hear monkeys

chattering and the screech of parrots. It was an incredible situation. Here I was, trapped on a jungle beach and my mind went back to Kingsford Smith's story of his solo Australia to England flight in the *Southern Cross Minor*. To the south of where I was now he had very similar problems. His autobiography says:

"The rain was coming down in sheets . . . I could see nothing except the lighter colour of the sandy beach below me, and, if I went on blind flying like this at such a low altitude, I might crash into a hill at 70 miles an hour. There was only one thing to do — to come down on that beach and wait until the weather cleared.

"Fortunately for me that beach was all right! I taxied the plane up near high water mark, right up almost against the jungle which came right down to the beach. . . .

"The rain was coming down in sheets, making a horrible drumming noise on the wing above me; in front of me was the black gloom of the jungle; behind me was the raging sea and the tide was coming in!

"I sat there in the cockpit after having stuffed up the exhausts to keep the rain out. Nothing happened except more and more rain. I was tired, hungry, wet, cold and depressed."

Luckily for me the rain continued to ease. After one hour and 18 minutes on the ground I lifted off in what for those parts was a light shower, but it was still heavy enough. I could at least see for a few hundred metres.

I tracked out to sea for a few miles — I did not want any more scares with headlands — and switched on the autopilot so I could concentrate on navigating. Instantly, the helicopter began swinging violently from right to left. Now what was happening? I had had just about all the frights I could take in one day. I grabbed the controls and flew manually a few hundred feet above the sea in the driving rain, forcing myself to think calmly. I had been taught to always believe my instruments, but now, when I looked at my gyro attitude indicator, it told me that the helicopter was in a tight right-hand turn. I thought, that cannot be right. I could see the water below me between my feet, whereas if I had been

206

Following page: The smoke haze in the background of these riverside houses in Sumatra, Indonesia, is from the wasteful "slash-and-burn" method of agriculture practised widely in this region

in a tight right-hand turn it would have been below my right shoulder.

I glanced desperately around the bucking cabin, trying to get a clue to the helicopter's potentially lethal behaviour. Immediately, I saw what the trouble was. The on-off flags for the attitude and horizontal situation indicators were in the off position. I hastily looked up to the switches in the roof panel and saw that I had forgotten to turn on the switch which operates both of these instruments.

The autopilot had been wildly chasing heading information from a switched off instrument. With all the flying I had done in helicopters this was the first time I had failed to do the proper start checks. I can only surmise that the fatigue I was suffering was responsible.

I turned on the switch, took control of the helicopter again and turned south. I shall never forget my flight down the Burmese coast.

Flying through steadily increasing rain, I looked at my soggy chart and decided to keep out to sea and head straight across the water to an island called Malikyun. I chose Malikyun because the chart showed clear water to it from my present position. There were no other islands to fly into if the visibility got worse, as it seemed very likely to do. The rain was now unbelievable with solid water glancing off the windscreen.

Back on autopilot, I bored south through the deluge, feeling increasingly unhappy because although I could see the sea between my feet, I had virtually no visibility ahead. Despite the weight of rain smashing into it, *Delta India Kilo* was making good speed. The chart showed Malikyun to have some high mountains and I wanted to keep it well to the east by heading out into the gulf.

By now I was feeling sick with worry. It was a most unpleasant experience, flying a few hundred feet over the sea, cocooned in a tiny cabin and unable to see anything at all except the monotonous pouring, thundering rain.

As I came abeam of Malikyun Island the rain must have eased slightly, because I could see its high rugged green shape loom out of the falling torrents like a passing liner. So at least I was on course. The next minute my hair almost stood on end because

207

off to the right, and almost on my track, was a cluster of islands which were not on the map at all! They stuck up out of the sea, five or six hundred feet high — hazards which had obviously not made the charts yet.

If the rain had not eased off just then, or if I had made a slight westerly change of course, I would have flown slap bang into one of them and become a statistic in the book of aviation mysteries, joining Kingsford Smith and Pethybridge on the bottom of the Gulf of Matarban.

It was a terrifying thought. For the lone aviator in a small aircraft, death is sometimes not far away. One slip, a little miscalculation, one factor taken for granted

Happily for my morale, which by now was at an extremely low ebb indeed, the weather began to improve, and I turned in towards the coast again. I approached the coast near the village of Mergui, which I was told had an airstrip and a radio. I called Mergui repeatedly on the frequency I had been given in Rangoon, but there was dead silence.

There was nothing for it but to press on, fighting my feelings of mounting depression. The weather was worsening again and I could not get a response from any Navigation Directional Beacon on the entire Burmese coast, although I had been assured in Rangoon that they would all be turned on for me. Fortunately the VLF Omega appeared to be working perfectly.

In fact, I was beginning to feel a little bitter about my friends at Mingaladon Airport. After all, the weather forecast I had been given there had promised me a clear run all the way to Phuket, instead of which, I had been flying through a watery hell since shortly after leaving Rangoon.

As I could not raise anyone on the radio, there was nothing for it but to keep heading south. I hugged the coastline at a very low altitude. Most of the land below me seemed pretty swampy — not a good type of terrain to set down in.

The weather began to change from bad to really dreadful again at one of my last Burmese reference points, Sir Robert Campbell Island, on Forest Strait. Tracking almost due south to my next

208

waypoint, Victoria Point, I began to get extremely worried again. The weather had now deteriorated to absolutely marginal conditions. If it got any worse I would have no choice, I would have to land. Desperately I scanned the jungle-covered hills, interspersed with swampy inlets, which passed beneath me.

Victoria Point's NDB, like all the others on that long coast, was not working, so I tracked into Victoria Point with the VLF Omega, with the discomforting knowledge that as I had not started this flight leg with an accurate fix on the beach even the usually accurate Omega could be a few miles out.

I was now flying down the west coast of the Isthmus of Kra, the narrow strip of land on the Malay Peninsula where Burma runs into Thailand. The coast was greatly indented, with scores of bays and headlands, and the green of mangrove swamps right at the sea's edge.

The rain had increased and before long I had no forward visibility. I knew that there must be a landing strip at Victoria Point because I had read about the early aviators landing there on flights to Australia. Even "Hustling" Hinkler had landed there on his twelfth day out of England in 1928.

The books I had read about Hinkler said he landed "on an airfield in the jungle". Well, I could see signs of habitation through the rain. There were many houses and two very old-fashioned looking radio masts which confirmed I was over Victoria Point — but not a trace of an airstrip.

I came in very low on a landing approach over the town, but there was nowhere to land. At one stage I began my descent to what I thought was a clearing, but realised just in time that it was a rice paddy.

By now I was very tired and frightened. It was still raining heavily, and the unpleasant events of the day had shaken my nerves pretty badly. And here I was, going round and round Victoria Point in a tropical downpour. I spotted another clearing which looked like a sports field, but it was surrounded by buildings and palm trees and would have been impossible to approach safely in the present conditions of almost zero visibility. Ahead of me through the

rain-smeared windscreen, I could see nothing but more rain. It was only directly below my feet that I could see anything at all.

I began to seriously consider ditching the helicopter in the shallow water in front of the town. Then I thought I saw a glimmer of light through the murk, and what seemed to be a boat. Perhaps the visibility was better in that direction I thought, and flew towards it. No such luck. The shape I had taken for a boat turned out to be a small low coral atoll. But there was a lighter patch in the gloom to the south. It looked as though the rain might be lifting. Gritting my teeth, I flew on down the coast.

The day, which had started so happily in Rangoon, had turned into a nightmare. The rain still fell in solid grey curtains. I kept low and flew very slowly. My eyes ached with the effort of trying to penetrate the almost solid wall of water ahead. The thunder of rain on the JetRanger's metal skin added immensely to my fatigue and nervous strain.

I hung on grimly, alternating from manual to autopilot. Flying was terribly dangerous. Every few minutes a great dark blur would loom up out of the rain and I would have to take evasive action to avoid colliding with an island or a headland. I began to feel quite sick with tension and I thought I would never get out of this weather.

When I was just about at the end of my tether the fates or furies who order the weather must have decided that I had been tested enough, because about 20 miles south of Victoria Point the rain became patchy and at last I could see the sunshine, glorious sunshine, on the sea beneath me. At Ban Khao Ba, a little Thai village, I flew out into clear skies and visibility of 20 miles.

The rest of the flight, down to the Thai village and holiday resort of Phuket, was like a lovely dream after a bad nightmare. The change in the weather had come none too soon. I was sopping wet, thanks to my excursion on the beach near Aye Island, and dead tired and hungry, as I had eaten nothing since attending the ambassador's dinner in Rangoon the night before.

I began calling Phuket Airport when I was about 20 miles out. No reply. Oh my God, I thought,

Following page: Friendly villagers wave from a fishing village on the low, swampy coast of Sumatra. The black scar behind the buildings is the aftermath of a fire lit to clear the ground

don't tell me there is no airfield at Phuket. I was prepared to believe it at this stage because everything else I had been told to expect on my trip down the Burmese coast had been wrong.

I called again. And again silence. And then, suddenly, unbelievably, the Phuket tower answered and told me to fly right in. It was Gerry Nolan's voice! I learned later that he had been in the tower for some time, getting increasingly worried about me. He had my time of departure from Rangoon, and simple arithmetic told him that I must have either run out of fuel or landed somewhere. I could hear the relief in his voice.

I landed at Phuket (pronounced Foo-ket) at 1.45 p.m. local time, five hours and 48 minutes flying time after leaving Rangoon. I do not know how Hinkler felt after his seven hours and 30 minutes in the Avian to Victoria Point, but I felt absolutely done in.

I was greatly cheered by the sight of Gerry waiting for me on the tarmac with, as usual, a cold drink. Once I had got that down I felt much better.

I had planned to refuel at once and fly on to Butterworth, Malaysia, where the Royal Australian Air Force has a big base, but I was tired. Phuket looked a pretty place, and the weather forecast for Butterworth did not look too good, so I decided to spend the night there. Phuket is on an island in the Andaman Sea, about 350 kilometres north of Butterworth and the very popular Malaysian resort of Penang.

Unfortunately, Phuket, like Penang, has recently developed a bad reputation as a place to which young European tourists come in search of drugs. I was not offered any drugs — I suppose I look too square — but at about midnight that night I was awakened from a deep sleep by someone knocking on the door of my hotel room. I snapped awake and thought it was Gerald. I must have overslept! Five o'clock already, time to go!

I rushed to the door and hurled it open and there was a lovely little Thai girl, sent up by the thoughtful hotel management to entertain me. At least I gathered that was what she was there for. I was still in such a sleep-fogged stupor that I could

211

not make out what services she was offering. As politely as I could I asked her to go away and fell into bed again.

Lightning flickered over the sea as Gerry and I climbed the stairs to Phuket Airport control tower just before dawn. Thunderstorms were developing to the west, and as the meteorological office was not yet open, I could not get a weather forecast unless I waited until official opening time which was several hours away.

As the weather looked reasonably clear to the south I decided to go without a detailed weather forecast. At 6.24 a.m. I lifted off and turned on course for Singapore, 551 miles away. I hoped the weather would stay fine for a clear run down the Thai and Malaysian coasts. Pip was in Singapore, so I was determined to get there as soon as possible.

The JetRanger climbed out of Phuket just as it was getting light. The Straits of Malacca gleamed like pearly jade ahead of me in the slanting early sunlight. The water was flat as a plate and beautifully clear, dotted with strange steep islands which reminded me of the Balls Pyramid monolith near Lord Howe Island off the New South Wales coast. Fishing boats and small coastal trading vessels trailed wakes across the smooth sea.

I had not been out of Phuket for very long when I spotted a large isolated thunderstorm ahead — a strange island of rain and turbulence in an otherwise calm sky. I had to make a detour of several miles to avoid it. As it was, I flew through some of the rain on its fringes. In the centre of the storm I could see that it was raining very heavily.

I was pushing into a 10-knot headwind at about 500 feet when I heard a familiar accent in my earphones. It was an Australian air traffic controller at RAAF Butterworth. It made me quite homesick.

"Do you want to call in?" he asked.

"Yes, I'd like to pop in and have a cup of coffee."

"I'll see what I can do," he said.

He called me back a few minutes later. Officialdom had come between me and my coffee.

"The RAAF would love to have you," said the controller, "but a diplomatic clearance would be required."

I hastily decided to forgo the cup of coffee. The thought of all the paperwork involved in landing a private foreign helicopter on an Australian base in Malaysian territory was daunting.

Butterworth is on the Malaysian mainland, separated from the beautiful island of Penang by two kilometres of water. From my helicopter I could look down on the Mirage fighters on the airbase tarmac and, by turning my head, I could see the beautiful hills and beaches of Penang.

Hugging the Malaysian coast I was soon flying over rich plantations of rubber, coconut, and palm oil. The shoreline was dotted with little fishing villages and the shallow straits were busy with small craft. It was glorious scenery with scores of small islands lying like jewels scattered in the calm clear sea. If I had not been in such a hurry to get to Singapore I would have landed. Instead, I flew low and filmed the very interesting countryside.

About 80 miles south of Butterworth, I suddenly found myself flying through a thick ground haze. It was caused, I learned later, by peasants burning off areas of jungle to clear it for cultivation, and also by smoke from a big Indonesian volcano, hundreds of kilometres to the south.

I came down as low as I safely could to avoid the haze, doubtless thrilling a lot of little Malaysian children who waved at me as I flew over their villages. The haze persisted right down to the end of the Malay Peninsula. The visibility got very bad, making navigation very difficult.

At one stage I seriously thought of landing if the haze got any worse. I spoke to Johor Baharu traffic control — Johor Baharu is the Malaysian town on the southern end of the Malaysian Peninsula — and a few minutes later I was landing at Seletar airfield on the north coast of Singapore Island.

Well, the elements and my own human error had tried to kill me on the run down the Burmese coast and failed. Here I was in Singapore, the Lion City, a day ahead of Bert Hinkler! It was a good feeling to know that I had completed about three-quarters of my trip.

Hinkler ran into trouble in Singapore. He landed on the official airfield and was told to take off again and land on the racecourse instead. The

213

racecourse was very soggy after a heavy rainstorm and the Avro Avian, heavy with fuel, sank up to the axles. The crowd which had gathered to watch him depart was recruited to push the Avian until the engine could drag it clear of the mud.

When I landed at Seletar the Bell agents, Heli-Orient, gave me a great welcome and rolled out a red carpet as I stepped out of *Delta India Kilo*. Also waiting was a large group of media people. When the press conference was over I handed *Delta India Kilo* to Heli-Orient for servicing, and joined Pip at the luxurious Singapore Hilton. My plans for the next 24 hours were mainly to relax and catch up on my sleep.

I have visited Singapore many times and it never fails to impress me. Founded by the British East India Company's Sir Stamford Raffles in 1819, it remained a typical colonial Asian seaport until given its independence from Britain in 1959. Since then, it has become one of the mercantile phenomena of the world. Its three million people have one of the highest standards of living in Asia, and they inhabit the region's cleanest, greenest city.

It is not surprising then, that in this city in which hard work and enterprise are highly prized, *Delta India Kilo* should have received the best servicing since leaving the Bell plant at Forth Worth. Heli-Orient had gone over the JetRanger with a fine-tooth comb. They had given it the regular 100-hour service and also washed and polished it so that it shone like a new pin. It looked absolutely beautiful and did not look as if it had just flown many thousands of miles through a wide range of temperatures. The Heli-Orient maintenance men had even noticed a small aluminium fitting beneath one of the seats was broken. I had accidentally broken it during pre-flight work on the helicopter in Fort Worth. They not only spotted the broken fitting but they repaired it without being asked to. I think it is that sort of initiative that has made Singapore boom.

Brian Woodford, Chief Executive of Heli-Orient, knowing I would be facing time-consuming bureaucracy in Indonesia, had thoughtfully arranged to have printed 100 copies of the general declaration forms I would need. Chief Pilot Ron Shambrook

SEPTEMBER

S M T W T F S
 1 2 3 4
5 6 7 8 9 10 11
12 13 14 15 16 17 18
19 20 21 22 23 24 25
26 27 28 29 30

briefed me on my Indonesian legs and gave me large-scale maps of the area.

I treated myself to a bit of a lie-in in Singapore and did not get up until 6.30 a.m., which was very late compared with the pre-dawn risings of the earlier part of the trip. I lifted off at 8.59 a.m., a minute ahead of schedule, and flew almost due south across green and crowded Singapore Island, catching a glimpse of the old Raffles Hotel completely surrounded by tall modern buildings. The crowded harbour was packed with shipping from every corner of the globe.

I had intended to put in a leg to Palembang, on the Indonesian island of Sumatra, but despite the bad smoke haze the weather was so good that I decided to make the most of it and track direct to the Indonesian capital of Jakarta. I checked with Singapore air traffic control and they were quite happy with this change of flight plan, and with my descending to 1000 feet.

Just under an hour after leaving Singapore I crossed the equator. This called for a little ceremony, so I grabbed my water bottle and splashed water all over myself. It was a poor substitute for the ceremony on passenger liners. Anyway, it was great fun and I was excited to know I was in the southern hemisphere. Below me rolled the rich patchwork of a tropic sea dotted with small islands, fishing villages, canoes, fishing boats, tramp steamers. It was beautiful.

I came across heavy haze again, similar to the sort that gave me so much trouble on my last leg into Singapore. I managed to get below the worst of it over the water. When I crossed the southern tip of Sumatra I could not escape the smoke. Tropical rainforest covers much of the country and as I flew over it I could see many clearing fires, all adding their separate columns of smoke to the general pall. It worried me to see this as we have little rainforest left. I had to veer away eastwards to the coast away from the worst of it and track along the shoreline for about 15 miles before getting back on course for Jakarta.

In clear weather I crossed the northern end of the Sunda Strait, which separates Sumatra from Java,

and managed to get some good film of Indonesian fishing boats with brightly coloured sails, darting about on the blue sea like butterflies. Radio Australia came in loud and clear on my HF radio on frequency 17870 kHz. I did not feel so lonely then.

I was not looking forward to landing at Jakarta because I had been told the Indonesian bureaucracy could give the Arabs and Indians lessons in the art of paper-shuffling and form-filling. My fears were proved groundless when I contacted Jakarta air traffic control and found they were expecting me, and seemed to be taking a friendly interest in my flight. This was such a contrast to the indifference so many other air navigation authorities had shown.

After I had spent four and a half hours in the air, a very efficient controller guided me in to Jakarta's Kemayoran Airport and there was Gerry Nolan waiting for me with an ice-cold Coke. I landed to another enthusiastic welcome from the media and people from Bell Helicopters, Heli-Orient and Qantas. I was whisked through customs and immigration in no time at all.

There was one little snag and it could have

Above: Red-carpet treatment from Heli-Orient, the highly efficient Bell Helicopter dealers in Singapore

Below: A VOR navigation station on an Indonesian island north of Jakarta, which I tracked in on before landing at the Indonesian capital's smaller airport, Kemayoran. The strange structures dotting the sea are fish traps

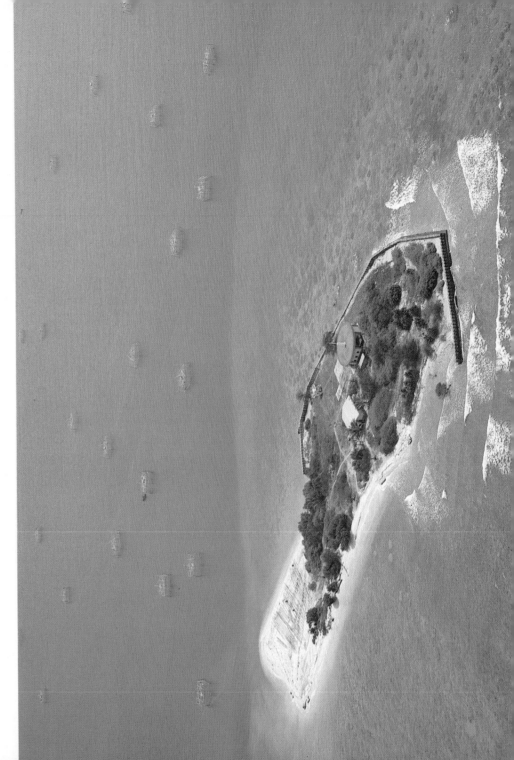

been a big one. Before leaving the airport for our hotel, Gerry, knowing that it would be very difficult for me to take off in the high temperature of 35°C with a tail wind, had arranged for the helicopter to be parked in a position where it could stay the night for a cool early morning take off the next day. Scarcely had the helicopter been refuelled when an airport official asked me to move it. We quickly explained that it would be very difficult to move with the heavy fuel load in that temperature; we would have to unload the fuel. One of the Qantas men intervened and after about half-an-hour of argument it was agreed that I could leave *Delta India Kilo* where it was. The official spoiled my peace of mind when he said that one of the big passenger jets would probably blow it over with its jet blast!

At the hotel I checked my last flight plan for the next day which was to be my last day's flight outside Australian airspace. I had originally intended to fly from Jakarta to Denpasar, on the island of Bali, and to Kupang on the island of Timor, in one day; and then across the Timor Sea to Darwin the next

217

SEPTEMBER

S	M	T	W	T	F	S
			1	2	3	4
5	6	7	8	9	10	11
12	13	14	15	16	17	18
19	20	21	22	23	24	25
26	27	28	29	30		

day. After doing my sums it seemed unlikely I could get through to Kupang in one day. It would have meant flying about 1075 miles which would have pushed me to the very limit.

I held a conference with Gerry, Dick Brown of Heli-Orient and Dale Courts of Bell, and we decided it would be better if I flew to Bali on the first day and then a double hop to Darwin on the following day. To avoid a delay at Kupang Dick Brown agreed to send a Heli-Orient employee, Timmy Tyoni, to Kupang to assist me. It is 448 miles from Kupang to Darwin and I wanted to be sure of getting through the Kupang departure formalities quickly so that I could leave early enough to get to Darwin before nightfall. Gerry, meanwhile, would fly ahead of me to Bali and fix things up there. With all that settled I managed to get another good night's sleep. I was thrilled to be so near to Australia, and home.

I slept for nine hours and awoke feeling "fantastic" according to my diary. I was driven out to the airport where a Qantas officer helped me through the departure formalities in a record 10 minutes. Dale Courts in the meantime was date-stamping all the souvenir envelopes I had carried with me from England.

Everyone was so enthusiastic and so cooperative that I was able to depart at 8.57 a.m., three minutes ahead of schedule. Even the air traffic controller contributed to my speedy departure by allowing me to leave directly from where the helicopter was parked.

I climbed rapidly to 1500 feet through smoky haze which reduced visibility to about a mile, and then turned due east. Jakarta sprawled beneath me, a crowded, bustling city of five million people. Looking down on it from the air I was reminded of Australia — almost every building had a red-tiled roof.

Once I was out in the country, I was surprised at the brown drabness of the landscape. I had expected Java to be green and lush, but the parts I flew over were experiencing a severe drought. I wondered if this could be attributed to the rampant destruction of the forests as some scientists believe.

I went up to 3000 feet and tracked along Java's

"I'm flying over what looks like rice paddy fields, I can see where they're burning them off. Little villages in a very low area with beautiful canals for irrigation . . . The water in the irrigation canals is very muddy and I can see gangs with huge bulldozers and very modern equipment building the canals . . . I've just flown over Cirebon and just to the east were these magnificent sailing craft out fishing; a great group of them; you'd swear they were out on a sailing regatta, with their beautiful coloured sails."

I then pushed on towards my next flyover checkpoint of Surabaya, Indonesia's second largest city. The Surabaya controller was very keen because he got on to me when I was about 30 miles out and from then on until I had left the area he asked me for my altitude and position every minute or so. The poor fellow was obviously handling a lot of air traffic and he had no radar to help him.

After clearing Surabaya I rounded a large cape and turned south towards the narrow Bali Strait and the fabled island of Bali itself, beloved of young Australian holidaymakers. Looking south I could see several of Java's smoking volcanoes, and even smell their acrid fumes.

I hit a lot of turbulence over Java because of fierce air currents set up by the sun blazing down on the rather arid land. Off the eastern tip of Java I dropped down into smooth air above the water and flew over several small coral atolls.

Approaching Bali low from the north-west I flew over a beautiful little island with a canoe pulled up on a white beach and a couple of sheds. I was about to land and take some photographs when I saw a group of people standing around. It looked as though they were waiting for a party of tourists to arrive, so I decided not to disturb them. They waved as I circled and flew on.

On my run in to Denpasar International Airport I flew over some beautiful beaches, with vivid green terraced rice paddies right beside them. The land soon curved out in front of me again and I had to climb to more than 1000 feet to cross over a high

saddle between two even higher mountains.

After a short cross-country flight over a region much greener and lusher than Java I was guided into Denpasar by a very efficient traffic controller. In fact, all the Indonesian controllers I dealt with were very good, and the country's navigational aids seemed to work perfectly, making nonsense of the scare stories I had been told about Indonesia.

Touching down after five hours and 21 minutes in the air I saw a ground marshalling officer waving from the middle of the apron, so I swung towards him. It turned out to be Gerry Nolan! He showed me where to park and, when I got out of the helicopter, opened his shoulder bag and produced the inevitable but very welcome cold Coca-Cola.

Gerry and I got the refuelling and the paper-work over in a very short time and headed for our hotel, a luxurious place on the beach. That night Gerry and I discussed the tough job which faced me the next day which was flying from Bali to Kupang and on to Darwin in one day — a total distance of 1084 miles. It was the longest leg of the whole flight and the last long leg over water. I reckoned I could do it even though time was the crucial factor: I must leave Denpasar very early, no later than 5 a.m., and spend no longer than an hour on the ground in Kupang if I was to arrive in Darwin before nightfall and match Bert Hinkler's time of 15½ days.

Gerry dashed back to the airport to make sure all the necessary officials would be there when I wanted to leave. Even though Denpasar Airport of-ficially opens at 6 a.m., the air traffic controllers had very kindly promised to come in at 5 a.m. Unfor-tunately, we had overlooked the vitally important customs people, so Gerry returned to the airport to make absolutely certain there would be no hidden snag to delay my departure.

I desperately wanted to get to Darwin the next day. Hinkler had spent his last night before reaching Australia in a place called Bima, a small Dutch port on the island of Sumbawa, about 200 miles east of Bali and about 150 miles closer to Darwin than I was. Gerry came back from the airport with good news: everyone was cooperating and there would be no delays.

220

Nothing would have made me oversleep that night. I was awake at 3.45 a.m. At 4.10 a.m. Peter Cario of Qantas drove us to the airport through the heavy tropical darkness, full of strange scents and sounds.

True to their promise the air controllers were in the tower. Gerry, during his hurried visit to the airport the night before, had persuaded the customs officer to sign all the relevant documents in advance. It saved the officer from getting up early.

By 4.43 a.m. I was all ready to go. It was still dark with a faint hint of dawn in the east. I called the tower and asked if I could be cleared to go, hoping it would not strain my friendship with the controllers. To my surprise they said yes! I hastily waved farewell to Gerry and Peter Cario, dim figures in the shadowy dawn, and lifted off.

Almost immediately I was over the sea which was flat and shining in the growing light. Gradually the lovely islands of the long Indonesian archipelago emerged from the darkness below me — Bali, then Lombok, and then Sumbawa where Hinkler spent his last night.

The sun appeared over the horizon in a blaze of red and gold and climbed into wispy cloud. The long lonely beaches unravelling beneath me were magnificent and quite unspoiled. It was a great flight that morning and I took roll after roll of film.

About 70 miles out of Bali, cruising at 1000 feet in superb weather, I heard an Australian voice!

It was Perth! Then Darwin radio came through.

I was on my way home at last.

Looking down at the sea I was reminded that everything was far from perfect. My taped commentary says:

"I saw a great thrashing in the water. I thought it was a reef but when I reached it there was a large group of fish churning the water . . . They looked like large fish, maybe sharks eating smaller fish. Not a very nice thought if you come down."

A little later I had another surprise. I picked up a RAAF Lockheed Hercules transport aircraft flying from Darwin to Butterworth — Aussie 768 of 37

		SEPTEMBER				
S	M	T	W	T	F	S
			1	2	3	4
5	6	7	8	9	10	11
12	13	14	15	16	17	18
19	20	21	22	23	24	25
26	27	28	29	30		

Squadron. We had a long chat and the pilot was very helpful in giving me an actual weather forecast for the trip.

"It's rather beaut," he said, in his great-sounding Aussie voice, "a very, very small amount of cloud, some smoke haze, but the weather at Kupang is clear, so you won't have any problems. And the weather from Kupang to Darwin is also very fine and beaut, mate."

After that little interlude I felt really great. I was going home, the helicopter was buzzing along beautifully, and the weather was perfect. I flew over the island of Sumba which was also brown and dry. There were grass-roofed villages on the hills which reminded me of New Guinea.

To make my day, the Australian amateur radio operators began coming in. My first call was from Lionel (VK 6LA), using a portable set north of Broome, Western Australia, followed by calls from dozens of amateurs all over Australia. It was all very good for the morale.

Four hours and 55 minutes out of Denpasar I landed at Kupang, hoping desperately that I would not be held up by some over-zealous official so close to home, but I need not have worried. Before the helicopter's rotor had stopped turning the refuelling tanker was driving up to me. I feared he would drive into the rotor. The customs and immigration men came out with a man wearing a big pistol, and Heli-Orient's Timmy Tyoni. Everyone was smiling and friendly and very eager to get me airborne again as quickly as possible. They were so cooperative I wondered what on earth Timmy could have done. I learned later he had shown the Kupang officials the Jakarta newspaper stories about my flight, and that had done the trick. Everyone had fallen over themselves to be helpful, fearing, probably, that anything they did to delay me would be reported in the newspapers. I completed the formalities required to leave Indonesia, refuelled the helicopter, and had it inspected by a customs official for the first time on the flight.

I was airborne again 52 minutes after touching down! It must surely have been a record. Then I turned east and headed towards Australia. It was a

222

wonderful feeling. I climbed over the mountain to the east of Kupang and was shortly over a beautiful blue sea at 500 feet and receiving Darwin Flight Service loud and clear. I switched on the autopilot and sat back and enjoyed myself. I was still getting calls from amateur radio operators all over Australia and this helped me forget the 448-mile sea crossing ahead of me. I was unable to receive the Darwin NDB, so I tracked in on the strong signal of radio station 8DN.

Listening to this station I discovered that a large group of people were coming out to meet me. My excitement rose above the tension of the long sea crossing. About 60 miles out of Darwin aircraft came out to meet me. A Pilatus Porter appeared and took up station ahead of me, followed by a helicopter which was piloted by an old friend, Doug Crossan, who I had flown with in the Kimberleys when making a film on Kingsford Smith's "Coffee Royal Affair".

Another helicopter joined us and soon we had quite a little aerial cavalcade approaching Darwin. At last the low coastline of the Northern Territory came into view as a low dark line on the horizon. My excitement mounted as I finally sighted Darwin. I could imagine how Bert Hinkler, Smithy and all the other early aviators felt.

I swung across the city, completely rebuilt after being devastated by Cyclone Tracy in 1974, and saw a big **H** laid out on the ground in front of the old hangar at Darwin's original airport. The early fliers to Darwin landed at this site at Parap, now a Darwin suburb. I had asked the Department of Aviation if I could land in the vicinity of this historic site as I wanted to recreate as faithfully as possible Bert Hinkler's flight. They complied with enthusiasm by constructing a beautiful helipad on the exact location of Hinkler's landing.

There was a huge crowd down there, and I was worried to see how close they were standing around the four sides of the marked-out area, not leaving a clear approach for me. I have never liked flying low over people. However, I could hardly circle and expect them to disperse, so in I went. A sense of immense relief and an enormous feeling of accomplishment came over me. The crowd was even larger than I had thought — over 2000 people.

Above (top): DELTA INDIA KILO *whips up a storm of red dust as I bring her into Parap, Darwin. (Photo courtesy of Allan Adams)*

Above: Bert Hinkler stopped for a cold drink here at Ranklin's Store on his flight home to Bundaberg in 1928. It has since fallen into disrepair

Left: These wonderful children from Alexandria Station school met me with this charming surprise — a special Dick Smith cake with DELTA INDIA KILO *traced out in lollies*

224

On Australian Soil at Last

AUSTRALIA

DARWIN

I touched down at 5.31 p.m. local time. I had managed to match Bert Hinkler's time — fantastic! Pip was there in the front ranks and they were all thickly dusted by the miniature whirlwind created by the helicopter's rotors. Impulsively, I leaped out of the JetRanger and, kneeling down, pressed my lips against that good red Australian soil. Oh, was I glad to be back!

Right: This landscape south of Katherine, NT, may seem harsh and barren but to me it is the real Australia

Far right: Lying here at the lonely Delta 4 Bore, south of Creswell Downs, NT, I felt closer to Bert Hinkler than I ever felt before

Right: Too late for breakfast, but I did deliver a London newspaper to the manager of Alexandria Station, John Olson, just as Bert Hinkler had done more than 50 years before

Far right: Following Hinkler's historic trail from Longreach to Bundaberg, I tracked along the railway line, passing many small, lonely stations like this one

225

SEPTEMBER

S	M	T	W	T	F	S
			1	2	3	4
5	6	7	8	9	10	11
12	13	14	15	16	17	18
19	20	21	22	23	24	25
26	27	28	**29**	30		

SEPTEMBER

S	M	T	W	T	F	S
			1	2	3	4
5	6	7	8	9	10	11
12	13	14	15	16	17	18
19	20	21	22	23	24	25
26	27	28	29	**30**		

After a tumultuous reception from the crowd and several television interviews I climbed back into the helicopter and flew over to Darwin Airport and went through the usual arrival formalities. I was pleased that my own country only wanted *two* copies of my general declaration.

That evening the City of Darwin held a reception for me where I was presented with a commemorative plaque. It was a kind gesture and I appreciated it. One of the highlights was my opportunity to meet a number of early Northern Territory aviators. But after nine hours and 26 minutes in the air I felt just the way Bert Hinkler had felt at his Darwin reception 55 years earlier; I just wanted to go to bed and have a long, long sleep.

Despite my rest day in Darwin I was not allowed to sleep late the next morning. From 8 a.m. the telephone never stopped ringing, with calls from radio stations and newspapers all around Australia. I also received dozens of telegrams including one from the Prime Minister.

Later that day, walking around Darwin with Pip, I was touched and flattered by the friendly interest people showed in me. Complete strangers came up and asked for my autograph.

I was in such a good mood and feeling so great that I was not even worried when the Darwin Airport weatherman told me that I could expect strong headwinds on my flight to Alexandria, 534 miles south of Darwin, the next day. Why should strong headwinds worry me now? I was in Australia after 91 hours and 14 minutes in the air and 10,037 nautical miles from London.

I lifted off the tarmac at 8.45 a.m. and was then asked by the controller to "hold" over the NDB for several minutes while an RAAF Hercules took off! I found this archaic procedure quite incredible. It was the first holding I had to do since leaving Fort Worth, and I had landed at much busier airports than Darwin. Still, that is Australia. A great country but with some maddening quirks.

Finally I was off, following the railway line down to Pine Creek at 500 feet across harsh but beautiful country, with that overwhelming sense of space which seems to be unique to the Territory.

I refuelled at Katherine, south of Darwin, where another friendly crowd was waiting to welcome me, and then carried on down the track to Malapunya Springs Station — a huge, isolated cattle station. As well as flying, navigating and filming I was on the air almost constantly talking to amateurs all over Australia. The Darwin weatherman had not been wrong about the headwinds. Soon after leaving Darwin I found myself flying into a very strong south-easterly wind. My speed was reduced because of the heavy load of fuel but I did not care as I was flying over the lovely Australian landscape again. I flew low over some large bushfires and the tangy smoke brought memories flooding back. I was enjoying myself so much that I found myself reciting Dorothea Mackellar's famous poem, "I love a sunburnt country, a land of sweeping plains, of rugged mountain ranges and droughts and flooding rains".

On the way down to Malapunya Springs Station I was really back in my own country. I flew over several kangaroos and I could smell the eucalypts of the Australian bush. A part of my taped commentary captures my feeling:

"I'm just going over a beautiful little billabong in the river — first bit of water I've seen for an hour. A beaut place down there; lovely reeds and water lilies floating on the water. There are birds flying away and a few cattle shooting through. They must think I'm the local mustering helicopter."

Suddenly, Tennant Creek Flight Service called me. They were worried about a helicopter being used by a geological survey company as it was supposed to call in and give an "operations normal" report on the hour and at 30 minutes past the hour. It was now 10 minutes late and they asked me to contact it. I was unable to raise it so I suggested dropping in on the mining camp to see what the trouble was. Naturally the Tennant Creek operator doubted my chances of finding a few tents in the vastness of Central Australia as he was not aware that I had a VLF Omega on board.

"Just give me the coordinates," I said.

"Seventeen degrees nine minutes south, one hundred and thirty five degrees, forty seven minutes east," he replied.

227

Above (top): Bert Hinkler's home town of Bundaberg nestles amid the rich canefields of northern Queensland, on the banks of the Burnett River

Above: Well-wishers in the foreground resemble a huge serpent as they await my arrival in Hinkler Park, Bundaberg. I touched down at exactly the same spot that Hinkler had landed on in 1928

Above (left): These cattle in western Queensland are regularly mustered by "flying cowboys," in helicopters, so when they heard the JetRanger they obediently began moving off

Left: This rugged outcrop broods over the vast Queensland emptiness between Mt Isa and Longreach

Above (right): I skimmed over the famous beaches and skyscrapers of the Gold Coast

Right: Flying south towards Sydney on the home run, over Maitland Bay

I punched the figures into the VLF Omega and in effect gave the helicopter its head and said "fly me there".

My friends the D'Arcy family lived nearby at Malapunya Springs Station, so I dropped in to see them before flying on to the camp. After a refreshing cup of tea I went down to the creek where hundreds of flying foxes were hanging in the trees like folded umbrellas. It was a happy place to be in with many children playing about. I later watched the Aboriginal stockmen shoeing the horses at the stockyard. This was the real Australia and I loved it.

I left the station and flew on to the camp which consisted of a few tents, a truck — and the missing helicopter parked nearby. I came in, raising a cloud of dust, and the survey crew came running out to welcome me. They might have been living in the middle of a very remote area, but they seemed pretty comfortably established. There were sleeping tents, a separate mess tent where they had their meals, a generator to provide power for lighting, and down at the nearby creek they had set up a shower operated by an electric pump!

The pilot explained that he had, in fact, called in to Tennant Creek as he was supposed to, but somehow the call had not been logged. I lunched with the survey crew and prepared to leave on my next leg to Alexandria via Brunette Downs Station. I was planning to go on to Mount Isa, the big mining city in northern Queensland, and was a little worried because the persistent headwind was affecting my fuel consumption. "No worries", said my new friends when I mentioned this. "Take some of our fuel." I topped up the JetRanger with 135 litres from one of their drums and headed off.

After leaving the survey camp I flew low over the beautiful blacksoil plains of Brunette Downs Station. Several times I flew over large herds of cattle and as soon as they spotted me they would all start trooping back towards the station yards. They were obviously used to being mustered by helicopter.

Eventually, as the shadows lengthened on the ground below me, I realised I was not going to make Alexandria that night, so I would have to look for a place to land and camp. After crossing a creek I saw

230

OCTOBER

S	M	T	W	T	F	S
					1	2
3	4	5	6	7	8	9
10	11	12	13	14	15	16
17	18	19	20	21	22	23
24	25	26	27	28	29	30
31						

a bore in the distance, with a tall big-bladed windmill and a "turkey's nest" dam. I landed just as the sun was setting over the perfectly flat plain. It was completely silent except for the slight creaking of the windmill as it turned in the gentle breeze.

I had called Tennant Creek and told them where I was. Imagine the newspaper headlines if I had mistakenly been declared missing this late in the flight! I sat in the helicopter and called up several amateur radio operators in New South Wales, Victoria and Western Australia.

It was incredibly quiet and beautiful around me. The stars came out and the Southern Cross sparkled above me in the ink-black sky. The moon rose, full and golden. Banjo Paterson's evocative poetry drifted into my mind, '. . . and he sees the vision splendid of the sunlit plains extended . . . and at night the wondrous glory of the everlasting stars . . .' What wonderful words, and how true a description of outback Australia.

Lying there on my sleeping bag I thought of Bert Hinkler who did the same thing 55 years before me and I knew now why he did it. Exhausted on his arrival in Darwin and wearied even more by the civic receptions, the speeches, and the crowds who followed him everywhere, he obviously wanted to be by himself. He had spent a night at a lonely bore in the bush, probably similar to the one I was camped beside. Sitting there and watching the moon and the stars and feeling Australia all around me, I felt closer to Bert Hinkler that night than I had ever felt before.

My evening meal consisted of some dates and chocolate which I had bought in Moncton for use as emergency rations. I thought it would be all right to eat some of them as I could not imagine disappearing for too long in Australia. I slept very well that night in my sleeping bag beside *Delta India Kilo*.

At dawn I climbed the windmill tower and stood on the platform, making sure I was not in the way of the great blades as they chewed into the breeze, and just absorbed the immensity of the landscape. I attached to the tower the Explorers' Club flag that Gerry had presented me in Rome. It was a moving experience as I took pictures of it. The flag has flown on Mount Everest and on the moon, and so

it was quite an honour to have it loaned to me during my flight. Here it was flying on a windmill tower in the middle of Australia! The actual location of the bore, called Delta 4, is south of Cresswell Creek in a clear area of grass on the black soil plains at 18°09.5' south and 136°14.8' east, according to the VLF Omega.

I had intended to take off very early that morning so that I could have breakfast with the manager of Alexandria Station, and also deliver the newspaper I had brought from London, as Hinkler had done in 1928, only 17 days out from London. But the beauty of the outback entranced me and I just wandered about enjoying the beauty of it all until almost 9 a.m. which was a very late start for me.

Forty-eight minutes after leaving my lovely, lonely bore I was landing at the huge cattle station of Alexandria. It looked like a small country town with its many buildings. It also has an Aboriginal community settlement, a post office and a school.

I was given a wonderful welcome. Waiting for me was Tom Lackner, an American who teaches in Central Australia. I had met him on a visit to Brunette Downs where I opened the school sports day the previous year, and he had asked me to call in on my flight.

Tom drove me around the school and the children were wonderful. They lined up at the school entrance as I arrived and cheered wildly. The children had made a huge banner saying "Welcome Dick Smith". They then produced a beautiful cake with a helicopter marked out on it in chocolate lollies. It was a moving experience and a great honour. The school had a very good atmosphere and was very well disciplined. This gave me a lot of hope for the Aboriginal people, as I have always thought a lot about them. The answer to their future seems to lie in children like those I saw at Alexandria.

Although it was too late for breakfast I did present my London newspaper to John Olsen, the station manager. It was about 9.40 a.m. when I arrived at the homestead, which is about lunchtime to a country person. I departed to the cheering of the entire school after one of the most enjoyable stops of the trip.

232

My next stop was to be Rankin's Store. I particularly wanted to see it because Bert Hinkler had stopped there for a cold drink after his breakfast at Alexandria. John Olsen had told me I would have no problems in finding it about 50 kilometres down the road to the south. He also warned me not to expect too much because the store was deserted and falling into disrepair. On the way I passed a number of road trains transporting cattle and I dropped down to film and photograph them.

I found the old store about 17 minutes after leaving Alexandria. John had been right, it was not in good condition; just a small tin shack sitting at the junction of two roads. I landed in front of the store and took photographs. A vehicle pulled up with one of the Alexandria managers and he seemed quite amazed when I explained why I had landed there.

I flew on over Camooweal, near the Queensland border, and then on to the big smoking mining city of Mount Isa in the middle of nowhere. After refuelling I dashed into the terminal for a genuine Australian milkshake and a mince pastie. I filed my flight plan to Longreach and had a chat with some local newspaper reporters.

An hour later I was airborne again and heading towards Longreach where Qantas, my major sponsor, began operations in 1920. I was flying over some of the most magnificent country I have ever seen. It was harsh and very dry with rugged mountains slashed with reds, yellows and purples. Colours that could be seen in the paintings of the great Aboriginal painter, Albert Namatjira. I could see small mines and railway lines and occasionally I would have to dodge bushfires. All the time I was pushing into a persistent 20-knot south-easter which had not faltered since I left Darwin.

I landed at Longreach after six hours and 27 minutes in the air since leaving the Delta 4 Bore. I was looking pretty rough. I had not shaved, and my shirt and slacks were wrinkled. But my appearance certainly did not affect the wonderfully warm welcome I received at Longreach with Sir James Walker leading a large crowd. There was a simple ceremony and several speeches which made me feel very welcome.

I was delighted when it was pointed out that *Delta India Kilo* was parked outside the historic hangar in which the fledgling Qantas company had commenced operations and had assembled its own aircraft. Queensland and Northern Territory Aerial Services started off with single-engined biplanes. Today, Qantas has one of the world's biggest fleet of Boeing 747s. I was delighted to find that Qantas had flown their manager up from Brisbane for my arrival. Bert Hinkler had received exactly the same sort of welcome when he arrived in Longreach on 26 February 1928. You cannot beat Australian country towns for their warm-hearted, no-nonsense friendliness and hospitality.

I visited the site of the Stockman's Hall of Fame which I have a great interest in. A tremendous amount of our country's wealth has come from stockmen and the pioneers who worked the huge properties in the west. I also saw the Visitor's Centre made out of cut stone and built by R. M. Williams. It was a good start to a great project.

That evening while dining with Sir James and Lady Walker I was called to the telephone. It was from the Prime Minister's private secretary who told me the Prime Minister had been trying to contact me since leaving Darwin and that he would phone me the following night at Bundaberg.

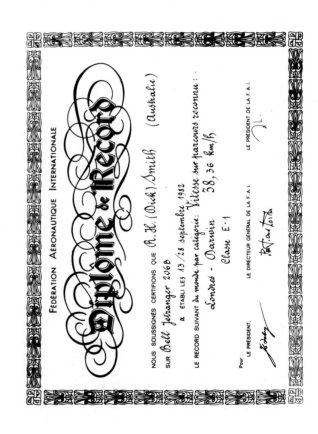

A record certificate issued for DELTA INDIA KILO by the Federation Aeronautique Internationale for the London to Darwin record

In Hinkler's Tracks to Bundaberg

After a shave and a light breakfast I hurried out to Longreach Airport. A crowd was waiting to see me go as early as 7 a.m. There was even a party in a chartered bus on their way to a wedding, and they had made a detour to see me depart.

I was airborne at 7.44 a.m. and beating into a headwind at 500 feet as I followed the exact route Bert Hinkler had followed to his hometown of Bundaberg. I could imagine how excited he must have felt, knowing that he was so close to home after that long, lonely and exhausting flight. I flew in Hinkler's tracks along the railway line over country towns dotted like islands in the vastness of western Queensland. When Hinkler passed Alpha, the postmaster there telegraphed Bundaberg with the news. As I flew over Alpha I spoke directly to Bob (VK 4ADZ), an amateur from Bundaberg, so telegrams were not necessary. Bob then moved his station to Hinkler Park, my planned landing place and constantly monitored my progress. As the crowds grew he connected his transceiver to the public address system so they could hear me directly.

As I approached Emerald, locusts began splatting against my windscreen. I was constantly filming through it and I wanted to get it cleaned. Below me was Emerald Airport, so I went roaring straight in and landed in front of the small terminal building. I quickly jumped out, armed with my drinking water flask and a chamois, and washed the windscreen. After giving the startled onlookers in the terminal a cheery wave I jumped in and took off again after 45 seconds on the ground. Try doing that in a fixed-wing aircraft.

I kept very low as the headwind would probably have been stronger at a higher altitude. I left the railway line I had been following and headed out over the bush towards the settlement of Thangool, again following Hinkler's historic route. Turbulent air

235

Bundaberg went wild over Bert Hinkler when he landed here in 1928 after his record flight from England to Australia. This park was named after him as a tribute.

gave me a buffetting and there were bushfires all around me so I had to constantly change course to avoid the dense acrid clouds of smoke swirling up into the sky.

As I approached the Great Dividing Range I had to climb to 3000 feet to clear the high ridges. I crested the mountains and was able to see the glint of the Pacific Ocean to the east. Meanwhile, I was giving a running commentary to Bob in Hinkler Park and he gave me exciting news of the expectant crowd waiting for me.

Thirty minutes later I began my approach to Bundaberg. The sight was amazing. Thousands of people stretched out like an enormous snake, with more arriving all the time. I flew in over the town, over the bridges, and not under them as Hinkler had done, and made three orbits so everyone would know that I had arrived. I flicked on the movie camera as I approached the park and filmed my descent right to the ground.

The crowd was unbelievable. Bundaberg has always had a proprietary interest in Bert Hinkler ever since he put its name on the aviation map. Its people were obviously delighted that my flight was commemorating their famous son. There was a loud thunder of applause, cheers, clapping and whistling as I got out of *Delta India Kilo* and walked over to a small dais which had been set up in the park. Banners of welcome strained in the breeze. The Deputy Major, Alderman Alan Stewart, escorted me to the stand and introduced me to Mrs Queenie Palm, Bert Hinkler's sister. She was the youngest in the family and she still remembers Bert very well. Later on I spoke to several people in the crowd who had actually seen Bert Hinkler land there in 1928. They told me that I had put *Delta India Kilo* down exactly where his *Avro Avian* had come to rest! What an incredible coincidence!

Bundaberg had gone wild over Hinkler in 1928; in fact, the welcome laid on for him is reported to have been the biggest celebration the city has ever seen. After a number of speeches and presentations I signed autographs and met most of the city's amateur radio community.

I had arrived on Harvest Festival Day, and was

236

The cheers were deafening as I rode through the streets of Bundaberg as guest of honour on Harvest Festival Day

OCTOBER

S	M	T	W	T	F	S
				1	2	
3	4	5	6	7	8	9
10	11	12	13	14	15	16
17	18	19	20	21	22	23
24	25	26	27	28	29	30
31						

declared the guest of honour. I was asked to ride through the streets of the city on a float which Mobil had organised. It carried an enormous photograph of Bert Hinkler on one side, and on the other side there was another large photograph of me getting out of *Delta India Kilo* on the Thames helipad in London. The pavements were thronged with well-wishers — over 10,000 of them. Their cheers were deafening and they kept rushing up to the float and seizing my hand. It really was the most incredible occasion.

The float stopped outside the Council Chambers and I was escorted with Pip and the girls to a small stage where the Mayor gave a very flattering speech and presented me with a cane-knife mounted on a special plaque to commemorate my arrival in his city. And so the day went on with more presentations and speeches, and a wonderful rendition of "Those Magnificent Men in Their Flying Machines" by the Bundaberg Municipal Band. Pip was presented with flowers by a lovely little girl, and a dinner was given by the Bundaberg Development Board.

Despite the tight schedule, I managed to get back to the motel (called the Bert Hinkler Motel, of course) to take my call from the Prime Minister. He seemed genuinely delighted to be able to talk to me. We chatted for 10 minutes about the flight and he congratulated me for getting to Australia. I have always appreciated his interest in the flight from the time he agreed to be my patron, and I appreciated the effort he and his staff had made in keeping track of me by sending cables and telegrams.

I spent most of that last night in the Bert Hinkler Motel lying awake with my mind churning over the day's events. Within hours I would be home! For weeks I had been dreaming of swooping in over the beautiful Ku-ring-gai Chase National Park, and seeing Wally, my pet kangaroo, and Penny, the sheep, scamper away as *Delta India Kilo* came down.

I left Bundaberg at 8.22 a.m. and flew across the canefields. Bundaberg is a very important cane-growing area. For the first time since arriving in Australia I picked up a tail wind which pushed the little helicopter along at a good pace. I had flown over this country before when I flew to Bundaberg

237

A cherished meeting with a famous aviator. Mrs Lores Bonney had flown from Australia to England and South Africa in the 1930s

to test the reserve tank before the big adventure. It was wonderful to see the familiar landscape unrolling beneath me. It was the first time I had flown over country I knew since leaving Fort Worth.

Once again the ether fairly crackled with amateur radio operators calling me. In fact, ever since arriving in Australia they had never stopped. And very welcome they were too. I was approaching the Glasshouse Mountains, between Bundaberg and Brisbane, when one of the amateur operators I was in contact with remarked that he lived there.

"I'm just to the north of the mountains," I replied.

"I can see a helicopter out of the window of my radio shack," he said excitedly. "Yes, it is *Delta India Kilo*."

So I quickly turned towards him and by following his directions I managed to track down his house. His wife came running out and waved a towel to identify herself. I made a low pass over the house and I think we all shared the thrill.

I was escorted over Brisbane at 1000 feet by the Channel 7 helicopter. As a special concession to me, the air traffic authorities allowed me to deviate from the usual visual flight rules route, which would have taken me east of the city, and allowed me to track right over the city, across the Story Bridge over the Brisbane River, and near the Queen Elizabeth II Stadium, packed with people watching the Commonwealth Games.

I landed at Seaworld, Coolangatta's large oceanarium and marine sports complex, at 10.30 a.m. I had arranged to meet two famous aviators whom I admired tremendously. They were Harold Litchfield and Lores Bonney. Harold Litchfield had been Kingsford Smith's navigator on several early flights. Mrs Bonney had flown from Australia to England and South Africa in the 1930s.

I told her of my forced landing on the Burmese beach and she related a similar experience on her first flight to England when she had flown into a tremendous tropical downpour off the west coast of Malaya. The deluge was so heavy Mrs Bonney had been forced to land her tiny plane on the beach until the storm lifted. Unfortunately, the air-

craft flipped over on landing, probably because the wheels had sunk into the wet sand, and the aircraft was extensively damaged. That, one would think, would be the end of the trip. It certainly would have cooled my flying ardour. But it did not stop Mrs Bonney. She dismantled the aircraft, hired a barge, and had the plane towed to Calcutta, where she supervised the repair work. Then she flew on to England.

Is it any wonder that I have such unbounded admiration for those early aviators? It meant a lot to me to be able to meet someone who had flown a single-engine plane in the early days when navigational aids and the reliability of equipment was nothing like it is today.

The tower controller at Coolangatta sent me a message of congratulations and from then on it was downhill all the way. This was all familiar territory, the high-rises of the Gold Coast, and then the lovely, rolling green coast of northern New South Wales.

The things you can do with a combination of amateur radio and a helicopter! As I approached Port Macquarie I asked one of the amateurs I was talking to if he would call a friend of mine, Denis Culliton, who has a small farm near "Port", as the locals call it, and tell him I was on my way. My parents live nearby and I had arranged to drop in and see my father. My mother was in Sydney at the time. At 1.03 p.m. I landed at the farm and jumped out to shake Dad's hand. He was very happy. We went into Denis's house for refreshments and 29 minutes later I was in the air again heading for Sydney.

At 500 feet I fairly screamed along over the beaches, getting waves from the people swimming, fishing and boating along this beautiful coast. I heard a familiar voice as I passed the seaside village of Old Bar. It was Paul Brownlow, a friend of mine for many years. He was up in his own light aircraft looking for me! Minutes later he zoomed up out of the west and flew alongside, clicking his camera like mad, and offering his congratulations. He veered away and disappeared as rapidly as he had arrived. I thought it was a great gesture.

Just outside Newcastle another amateur radio operator called me. He was talking from his car,

Flying under Sydney's famous harbour bridge was an exciting finish to my flight. Even though I thought the 55-metre clearance would be adequate, I had to dodge around a number of masts from sailing craft

parked on a headland jutting out into my track. I soon found the right headland and the car. I dropped down and shot past him, waving. I don't know who was more excited, him or me.

And that's the way it was all the way to Sydney. At The Entrance, a holiday resort about 130 kilometres north of Sydney, two helicopters rose to meet me. The Sydney commercial television channels, Ten and Nine, had sent their flying camera crews to film and escort me on the last few miles home. We flew down the coast in formation.

After crossing the mouth of the Hawkesbury River, Sydney traffic control gave me my clearance for landing at the mid-city helipad on Darling Harbour and I realised I was going to get there a few minutes early. The Premier of New South Wales, Mr Neville Wran, was due to meet me there at 3 p.m. I called the helipad and discovered that Mr Wran had not yet arrived. It seemed a bit rude to arrive before the Premier, so I asked traffic control if I could orbit Sydney Heads for a while. They agreed. I had just done one orbit of the Heads, those great sandstone cliffs which guard the entrance to Sydney Harbour, when the helipad called up to tell me Mr Wran had arrived. I made a swift turn, dropped to 500 feet, and roared up the Harbour. It was a beautiful spring Sunday afternoon. The sky was cloudless and the brilliant blue water of the Harbour was dotted with hundreds of boats.

The sparkling white Sydney Opera House suddenly came into view, with the huge grey coathanger of the Harbour Bridge behind it. I quickly had a panicky thought! Was I really allowed to fly under the Harbour Bridge? To fly under the bridge without permission, which is rarely granted anyway, would be to risk losing my flying licence.

With the bridge approaching at an alarming pace I called Sydney air traffic control to confirm whether I was cleared to pass *under* the bridge.

"Affirmative", said the controller. "Affirmative."

The two escorting helicopters soared away overhead, and I dropped *Delta India Kilo* down to 80 feet and zoomed under the bridge which was laden with cheering spectators, and over a fleet of boats and ferries sounding their hooters.

240

The bridge has 55-metre clearance over the water and it did not seem much when flying under it, especially when there are tall-masted boats sharing the space with you.

I swung left and headed in to the Sydney heliport, climbing to 500 feet to get a good approach angle over the old Pyrmont Bridge. As I got closer I could see the welcome awaiting me. There were banners saying "Welcome home Dick", and a large crowd of well-wishers. And then I was down on the ground, back in my hometown of Sydney after all those exhausting and worrying weeks in the air. I had flown a total of 18,815 nautical miles (35,844 kilometres) and it had taken 174 hours and 12 minutes.

I cannot describe the feeling. It was overwhelming. I sat in the helicopter with the slowing rotor swishing above me and, of course, who should appear but Gerry Nolan clutching a can of soft drink. Gerry had been a great help, and a welcome no-nonsense, innovative Australian presence in so many strange places. I was delighted to see him.

Yes, it was good to be home. I hugged Pip and the girls and shook hands with Premier Wran. I

241

stood on a small stage while speeches were made and the Premier toasted me with champagne.

"Dick Smith is a real Australian adventurer and pioneer who has done something no other person has done. Australia would be an even better place if there were more people who had Dick's get up and go," he said.

I thanked the Premier for his warm speech. The official welcome over, a sea of friendly faces flocked around the helicopter. People from my own company were there, smiling, cheering, shaking my hand. The Earlybirds, an organisation of early Australian aviators, had come to welcome me. There was Bob Bolton, one of Smithy's offsiders, Captain Scottie Allen, who had flown regularly with Smithy up and down the Burmese coast, Nancy-Bird Walton and many other early aviators. It was quite a day after seeing Harold Litchfield and Lores Bonney in Coolangatta and then meeting all the others down at the city helipad.

One lady came up and threw her arms about me and burst into tears and said she had been praying for me. My mother was there and I must admit she had a few tears when she gave me a hug.

At 4.20 p.m. Sydney time I started *Delta India Kilo* and lifted off from the helipad on the very last leg of my trip: one I had been looking forward to for so long. I climbed across the magnificent harbour, across the bridge and the red roofs and turquoise swimming pools of the northern suburbs of Sydney, to my house nestled into the flanks of Ku-ring-gai Chase National Park. I patted the dashboard top of *Delta India Kilo*. "You little beauty," I said. It was so much a part of me that it felt like an extension of my body; as if I had wings.

Coming home was a feeling I find hard to describe. As I brought the JetRanger in, the browsing kangaroo lolloped away, the geese waddled to safety, and our big pet sheep shuffled aside. On the balcony a large poster said, "Welcome Home Dad."

I landed and switched off the Allison.

Ahead was the next leg of the trip — back to Fort Worth — a dangerous crossing across the North Pacific. But that was months away. For now, I was home.

A "Welcome Home Dad" banner greeted me from the balcony of my home as I landed and switched off the engine — I was home

242

Itinerary

Stage 1 Fort Worth to London

6346 nautical miles (11,752 km). 60 hours and 52 minutes.
Average speed 104 knots (192 km/h).

DATE	FROM	TO	DISTANCE MILES	DISTANCE KILOMETRES	TIME
Day 1 Thursday 5 August	Meecham	Fort Worth	15	28	.12
	Fort Worth	Memphis	392	726	3.54
	Memphis	Knoxville	363	672	2.49
	Knoxville	World Fair	5	9	.04
Day 2 Friday 6 August	World Fair	Washington	775	1435	6.59
Day 3 Saturday 7 August	Washington	New York	345	639	3.27
Day 4 Sunday 8 August	New York	Boston	236	437	2.24
	Boston	Moncton	210	389	2.00
			362	670	3.27
			572	1059	5.27
Day 5 Monday 9 August	(lay day)				
Day 6 Tuesday 10 August	(lay day)				
Day 7 Wednesday 11 August	Moncton	Wabush	480	889	4.34
	Wabush	Fort Chimo	335	620	3.12
	Fort Chimo	Baffin Island (forced landing)	349	646	3.27
Day 8 Thursday 12 August	Baffin Island	Frobisher Bay	1164	2155	11.13
	Frobisher Bay	Cape Dyer	95	176	.52
	Cape Dyer	Sondrestrom	251	465	2.17
			262	485	2.23
Day 9 Friday 13 August	Sondrestrom	Narssarssuaq	608	1126	5.32
	(lay day)		475	880	4.45
Day 10 Saturday 14 August					
Day 11 Sunday 15 August	Narssarssuaq	Kulusuk	345	639	3.37
Day 12 Monday 16 August	Kulusuk	Reykjavik	402	745	3.55
Day 13 Tuesday 17 August	Reykjavik	Hofn	226	418	2.03
	Hofn	Vagar	628	1163	5.58
	Vagar	Stornoway	252	467	2.39
			241	446	2.21
Day 14 Wednesday 18 August	Stornoway	Vagar	493	913	5.00
	Vagar	Stornoway	210	389	2.00
Day 15 Thursday 19 August	Stornoway	Balmoral	116	215	1.03
	Balmoral	Glasgow	361	669	3.17
	Glasgow	London	18	33	.10
	London	Battersea helipad	705	1306	6.30

Itinerary

Stage 2 London to Sydney

12,469 nautical miles (23,092 km). 113 hours and 20 minutes. Average speed 110 knots (203 km/h).

DATE	FROM	TO	DISTANCE MILES	DISTANCE KILOMETRES	TIME
Day 1 Monday 13 September	Biggin Hill	Lyon	409	757	3.43
	Lyon	Rome	504	933	4.35
			913	1690	8.18
Day 2 Tuesday 14 September	Rome	Brindisi	314	581	2.51
	Brindisi	Kerkira	119	220	1.05
	Kerkira	Athens	271	502	2.28
			704	1303	6.24
Day 3 Wednesday 15 September	Athens	Crete	160	296	1.27
	Crete	Cairo	521	965	4.44
			681	1261	6.11
Day 4 Thursday 16 September	Cairo	Luxor	275	509	2.30
	Luxor	Ha'il	513	950	4.40
			788	1459	7.10
Day 5 Friday 17 September	Ha'il	Bahrain	480	890	4.22
Day 6 Saturday 18 September	Bahrain	Muscat	468	867	4.15
	Muscat	Karachi	594	1100	5.24
			1062	1967	9.39
Day 7 Sunday 19 September	Karachi	Ahmadabad	341	631	3.06
	Ahmadabad	New Delhi	427	791	3.53
			768	1422	6.59
Day 8 Monday 20 September	*(lay day)*				
Day 9 Tuesday 21 September	New Delhi	Lucknow	238	441	2.10
	Lucknow	Calcutta	444	822	4.02
			682	1263	6.12
Day 10 Wednesday 22 September	Calcutta	Rangoon	572	1059	5.12
Day 11 Thursday 23 September	Rangoon	Beach in Burma (forced landing)	266	493	2.25
	Beach in Burma	Phuket	372	689	3.23
			638	1182	5.48
Day 12 Friday 24 September	Phuket	Singapore	576	1067	5.14
Day 13 Saturday 25 September	*(lay day)*				
Day 14 Sunday 26 September	Singapore	Jakarta	545	1009	4.57
Day 15 Monday 27 September	Jakarta	Bali	590	1093	5.22
Day 16 Tuesday 28 September	Bali	Kupang	541	1002	4.55
	Kupang	Darwin	497	920	4.31
			1038	1922	9.26
Day 17 Wednesday 29 September	*(lay day)*				
Day 18 Thursday 30 September	Darwin	Delta 4 Bore	587	1087	5.20
Day 19 Friday 1 October	Delta 4 Bore	Longreach	710	1315	6.27
Day 20 Saturday 2 October	Longreach	Bundaberg	537	995	4.53
Day 21 Sunday 3 October	Bundaberg	Sydney	598	1108	5.26

SUMMARY					
	Fort Worth	London	6346	11,752	60.52
	London	Darwin	10,037	18,588	91.14
	Darwin	Sydney	2432	4504	22.06
			18,815	35,844	174.12

244

How the Helicopter Flies

The most important part of the helicopter is the main rotor which works exactly the same way as a large propeller. By rotating, it lifts the helicopter off the ground. When the main rotor turns, the body of the helicopter would tend to turn in the opposite direction (Newton's laws of motion). This of course would make the passengers awfully giddy, so the problem is solved by adding a small tail rotor which counteracts the turning force.

Motive force for both the rotors in the JetRanger is provided by an Allison jet turbine engine. Jet engines are simplicity in themselves. They consist of a blowlamp (similar to the ones that strip paint) with a turbine wheel in the stream of hot gases. Of course in practice it's a little more complicated than that but it works on exactly the same principle. In the Allison engine the blowlamp spins one two-stage turbine wheel connected by a short shaft to a compressor which provides compressed air to the flame. Immediately after this two-stage turbine is another two-stage turbine which drives the main and tail rotors. The compressor turbine spins at an amazing 53,000 revolutions per minute.

The engine is activated by pushing the starter button and a starter motor runs the turbine up to about 7000 rpm. The throttle is then opened, introducing fuel into the combustion chamber where a spark plug ignites the fuel. The resultant flame increases the turbine speed until, at about 25,000 rpm, the starter button can be released.

In a helicopter the rotors always operate at the same speed. In the case of the JetRanger the main rotor goes at 394 rpm and the tail rotor at about 2500 rpm. Now if both rotors run at the same speed controls are necessary to vary the speed of the helicopter. In between the pilot's legs is a control called the "cyclic", similar to the normal joy stick or control column in a fixed-wing aeroplane. To the left-hand side of the pilot is a lever called the "collective". This lever also has a twist throttle control. However, in the JetRanger the throttle is only used to start the aircraft and is left full on and not touched at all during normal flight. The other main controls are the foot pedals.

The Collective As you lift this lever it operates two "pitch rods" which increase the angle of pitch on the two blades of the main rotor. This pitch increase takes place during the complete rotation of the main rotor. If the helicopter is sitting level on the ground or in a hover position and the collective lever is pulled up, the helicopter will rise vertically because the extra pitch provides extra lift. The pitch is the same all the way around as the rotor goes through the 360° turn.

The Cyclic To go forwards, backwards or sideways some other method of controlling the helicopter is necessary. This is done by the

245

cyclic control. This control operates the pitch in a cyclic fashion. If the cyclic is pushed forward the pitch on the main rotor increases at the back and decreases at the front as the rotor rotates. (Because of more complex rotational forces the actual pitch is changed 90° before this point; however, for simplicity of explanation the result is the same.) When this happens the rotor tilts up at the back and down at the front causing the helicopter to move forward. If the cyclic control is tilted to the left this gives extra pitch on the rotor on the right-hand side and less pitch on the left-hand side. The helicopter then moves towards the left as the whole plane of rotation of the rotor actually tilts and the helicopter follows the way that it is tilting. This operation of the cyclic control means that the pitch is changing during every rotation, that is 394 times per minute, or over six times a second.

The Pedals The main reason for the pedals is quite fascinating. If the collective control is pulled and more pitch is put on the main rotor then naturally the fuselage of the aircraft wants to turn more in the opposite direction. (For every action there is an equal and opposite reaction.) This fuselage turn is arrested by increasing the pitch on the tail rotor blades and the pitch increase is controlled by the pedals. If the left pedal is pushed the tail rotor pitch is increased, pushing the right pedal decreases the pitch. Flying a helicopter is a constant interaction of the three major controls described above. In a hover it is almost impossible to move one control without having to move the other two.

The helicopter has been described as "so unstable and so hard to fly that it's like riding a one-wheeled bike on top of a billiard ball, balanced on a greasy billiard table". Well it's not quite that difficult and once you've got the knack of it, after about 50 hours of training, it becomes like second nature. In fact if you have to stop and think what you have to do with a control it is too late. The only way to fly well is to practise so much that your body "automatically" flies the machine without having to consciously think about what you are doing.

I found my helicopter was extremely difficult to learn to fly but after I had flown about 200 hours it became easier to fly than a fixed-wing plane and just as easy as driving a car.

Auto-Rotation The common belief is that if the engine fails the helicopter will plummet down like a brick because of the small size of the blades. Fortunately, this is not true. Helicopters actually glide beautifully, slower than the gliding speed of most fixed-wing aircraft. This is called auto-rotation. There is also the advantage that a pilot can arrest the glide near the ground and land quite softly at near-zero speed. If the engine stops the pilot simply enters auto-rotation by pushing the left-hand lever (the collective) down to the bottom of its travel. This puts the main rotor blades to minimum pitch and the air coming up through the blades as the helicopter descends keeps them turning. One section of the blade keeps the rotor turning and

another section of the blade actually provides lift, so in the case of the JetRanger it will descend at a slow 55 knots and glide for about 4000 feet horizontally for every 1000 feet of descent. When the helicopter is within 30 or 40 feet of the ground the collective lever is raised and the inertia in the rotor system keeps the blades turning with their extra pitch long enough to provide sufficient additional lift to arrest the descent. The pilot can pull the aircraft up completely and then just sit it down on the ground quite smoothly. Of course, this is what should happen in theory; in practice it is a lot harder to do. It should be mentioned that the tail rotor is connected by a drive shaft through to the main rotor and if the engine fails there is a clutch which disconnects the engine from the shaft in auto-rotation. When entering auto-rotation there is really very little difference in the operation of the controls except the helicopter only descends. About 30 per cent of training time is spent on auto-rotation practice when obtaining a helicopter licence.

Forced Landing Over Water If I was flying over water my only chance of getting out of the helicopter safely in the event of engine failure would be to immediately push the left-hand lever down, enter auto-rotation, glide around into wind and, on reaching about 30 or 40 feet above the waves, pull on the left-hand lever to give pitch and slow down my descent, letting the helicopter gradually drop into the water. As it settled into the water I would tilt the cyclic to the left so the helicopter would roll over, instantly destroying the blades as they hit the water. The gear box would probably be pulled out of the top of the helicopter at the same time. I would then grab my life raft and jump out of the right-hand pilot's door. Of course this is all theoretical as there is a very good chance the helicopter's fuselage would rotate as the blades hit the water, so I would probably end up upside down under water. However, I had familiarised myself with the position of the doors and windows, so hopefully I could climb out and jump into the life raft.

Weight and Balance One of the most important considerations with the helicopter is not just the amount of weight put in it but "the centre of gravity" position, or the balance of the helicopter. The body of the helicopter is simply dangling on the shaft of the main rotor, so the centre of gravity must be very close to where that shaft is otherwise the tail would hang down too far, or, vice versa, the nose would hang down too far. With the JetRanger the actual centre of gravity position cannot move more than 12 or 15 centimetres forwards or backwards. If a lot of weight is put behind the main rotor drive shaft, such as extra weight in the luggage locker, then an equal amount of weight must be put in the front of the helicopter forward of the main rotor shaft. On my flight I had a large fuel tank in the back where the passengers would normally sit, and most of the tank's weight was behind the centre of gravity position. I had to seat myself in the front with the weight of the VLF

The Instruments and Controls

The first reaction people have when they see *Delta India Kilo's* instruments and controls is to say how complicated they look and how could I possibly keep track of them all and fly too. It becomes much simpler when the function of each instrument is known and how they are grouped together. After spending long hours in *Delta India Kilo* I have become so familiar with every switch, pressbutton, instrument and control that I can reach out and locate them with my eyes closed.

The *flight* instruments are grouped on the right-hand side of the main panel and are directly in front of me. They indicate how the helicopter is flying and, therefore, they are the ones I consult the most.

To the left of these are grouped the *engine* instruments. These are also important but I do not have to look at them as often. The *navigation* instruments are placed to the side of the panel and on the console below it.

FLIGHT

1 *Pressure altimeter* gives the altitude (in feet) above a set pressure datum, usually sea-level.

Omega system and my 14-kilogram life raft with emergency rations. This balanced the helicopter and ensured that it would fly on a level plane.

Technical Information on Bell JetRanger Mk III VH-DIK The helicopter is made mainly of aluminium and fibreglass and is very light. The empty weight, when delivered from the factory, is only about 725 kilograms. The full weight of the aircraft is 1450 kilograms. The main rotor is 10 metres in diameter, made of aluminium, and the tail rotor is made of stainless steel. The normal maximum cruise speed is about 120 knots (about 220 km/h).

The helicopter uses approximately 98 litres per hour of Jet A1, a fuel similar to household kerosene. Aviation gasolene can be used in the helicopter for a limited time for quite satisfactory and reliable operation from the jet engine. The normal tank has 344 litres of usable fuel, so by dividing that by 98 litres per hour you can work out how many hours of range you've got; and then if you multiply that by 115 knots you can see what range in distance you have.

The cockpit of DELTA INDIA KILO showing the Chinon movie camera which rotated on a specially designed camera mount. I could film through the open left-side window, straight ahead, or film myself talking to the camera. Also shown is the special map cabinet with mounted tape-recorder. The pocket in front

holds the Olympus OM2 35 mm still camera. The photographs in this book were taken with this camera with a standard 50 mm lens. The two switches in the thumb position on the control column operate the movie camera and the tape-recorder. The life raft on the floor can be grabbed easily in an emergency

2 *Vertical speed indicator (VSI)* shows the rate of climb and descent and is used with the altimeter to maintain a desired altitude or change to a new one.

3 *Turn and balance indicator* shows when and at what rate the aircraft is turning and if the turn is balanced.

4 *Artificial horizon (AH)* is an important instrument which gives me the attitude of the aircraft when the horizon is obscured.

5 *Airspeed indicator* is also very important as it shows the aircraft's speed and enables me to calculate the distance covered in a given time.

6 *Radar altimeter* measures the distance above the ground. I normally fly at low altitudes and this instrument is crucial if the ground is obscured by cloud or darkness.

7 *Horizontal situation indicator (HSI)* is a gyro-stabilised compass with an input from a small magnetic compass situated in the tail.

NAVIGATION

8 *Automatic direction-finding (ADF) indicator* is a compass-like instrument which gives the direction of a tuned-in ADF station.

9 *Distance-measuring equipment (DME) indicator* shows distance and speed from a tuned station.

10 *Collins navigation receiver* shows the correct bearing for VHF Omni Range (VOR) stations which can be tuned in and displayed on the HSI (7).

ENGINE

11 *Dual tachometer* indicates the speed of the main rotor and power turbine. While the engine is running it should show 100 per cent (394 rpm).

12 *Torque meter* gives the percentage of engine power being applied.

13 *Turbine outlet temperature gauge* indicates the temperature of the engine flame. This gauge and the torque meter are consulted when changing power to make sure the engine limitations are not exceeded.

14 *Gas-producer rpm indicator* shows the rotation speed of the gas-producer turbine and compressor.

15 *Engine oil temperature and pressure* are shown on a dual gauge.

16 *Transmission oil temperature and pressure* are also shown on a dual gauge.

17 *Fuel quantity gauge* indicates remaining fuel in US gallons.

18 *Fuel pressure and load meter gauge* indicates that the pumps are providing sufficient pressure for normal engine operation. This dual instrument also shows the percentage of electrical load.

19 *Voltmeter* is fitted because of the extra navigational equipment in the aircraft. It shows that the generator and the battery system are working correctly.

ELECTRONIC (AVIONIC)

20 *Collins autopilot* enables the aircraft to fly automatically along a set course.

21 *Autopilot enunciator panel* gives information on autopilot operation.

22 *Enunciator lights* give instant warnings of failures or incorrect operation of the aircraft. Lights indicate engine failure, low rotor rpm, temperature and pressure in the transmission, fuel pump and generator failure, and a faulty battery. Chip-indicator lights warn of metal chips in the engine, transmission and tail rotor gearboxes.

23 *Audio switching panel* enables the various transmitters, transceivers and other equipment to be switched to headphones or speaker, or disconnected altogether. The rotary switch on the left allows the microphone to be connected to each piece of equipment as required.

24 *VHF 1 communication transceiver* allows communication with air traffic controllers on the 118 – 132 MHz aircraft band.

25 *VHF 2 communications transceiver* is the exact duplicate of the VHF 1.

26 *Automatic direction-finding (ADF) receiver* is used to tune into the desired station which may be a special non-directional beacon (NDB) or a local radio station.

27 *Collins transponder* is used in air traffic control areas and gives the radar controller positive identification of an aircraft "blip" by transmitting a signal back to the radar controller when the radar beam hits the aircraft.

28 *Switch panel.* The switch on the left-hand side enables the autopilot to sense inputs from the VOR or from the VLF Omega navigational system. The switch below this allows my microphone to be connected to the VHF-FM transceiver (31).

29 *VLF Omega navigation system* determines the aircraft's position accurately anywhere in the world.

30 *Collins HF 220 transceiver* covers 2 – 22 MHz and allows single-side band communication with air traffic control and amateur radio operators virtually anywhere in the world.

31 *VHF-FM transceiver* has fifty-five channels and allows me to talk with ships at sea for shipping weather forecasts, and to make radio telephone calls.

The cyclic control (joystick) has many switches so I can operate various controls without removing my hand from it. The switches are for: overriding the autopilot; the autopilot's complete release; adjusting attitude through the autopilot; remotely changing frequencies on the VHF radios; operating the Collins transponder; selecting radio transceiver and passenger intercom; turning on the movie camera; switching the intercom to the tape-recorder.

Torches are mounted on the left- and right-hand side of the instrument panel so I can light the instruments in case of an electrical system failure at night. Lives have been lost due to such a failure which prevented the pilot from reading his instruments and making a safe landing. A small magnetic compass is mounted on the right-hand side of the cockpit as a standby in case the gyro compass fails. A panel above my head contains thirty circuit breakers and ten switches which control all the electrical and electronic instruments in the aircraft.

A Word for the Sponsors

My sponsors' support and products were a great success. My major sponsors were Qantas, who supplied the air fares for my ground support; and Mobil, who provided the fuel. The help and encouragement from these companies along the track was unexpected. Bell Helicopter representatives along the route were also of valuable assistance.

Bell JetRanger 206 Mk III It is a credit to Bell that my helicopter, wheeled out stock standard from the factory, has performed without fault over a wide range of weather conditions.

The helicopter has now done over 200 hours and has had two 100-hourly services, but no work was required other than oil changes.

Allison engine The manufacturers of this wonderful little engine agreed to supply me with the spares I was most likely to need in case I had a problem in a remote area. I was amazed when their representative turned up at Fort Worth with a packet the size of a pack of cards. The packet has never been opened and the engine only required routine maintenance.

Collins Avionics With such a large variety of complex electronic equipment on board it is normal to expect teething troubles. But everything worked perfectly for the whole journey. Minor problems with the

HF radio were due to paint under the earth of the aerial.

The Collins autopilot was a real godsend in enabling me to film with the one hand and take still pictures with the other. During bad weather I flew manually, but I used the autopilot to ease the long hours of flying. Now, I would not be without one.

The Collins VLF Omega navigation equipment was excellent. After flying hundreds of miles over water, often in very rough conditions, the VLF Omega was never more than two miles out on reaching my destination.

Not only was the Collins HF 220 used for normal HF communications, but over 1000 contacts were made with amateur radio operators around the world. It also enabled me to listen to Radio Australia and keep in touch with the news from home wherever I was.

Perkins Plastics downslides These were very very useful for flying and filming. The slide had to be pushed down so I could use the movie camera or get an unobstructed shot with the still camera for this book. In the past, doors had to be removed to get a clear view. The downslides attracted more attention from other helicopter operators than anything else.

Flying over the freezing North Atlantic I only had to close the downslide to be snug and warm in my survival suit. Over the Saudi Arabian desert in temperatures of 46°C the slides were down and the Perkins airscoop out which kept the cockpit cool.

253

for up to 11 hours without discomfort. The audio quality, important for the filming, has proved to be excellent.

Eastern Aero Marine The only comment I can make about my survival equipment is the best one: "I'm glad I did not need it."

The two-man life raft was fitted with emergency equipment, a water desalination kit and an extra ELT (emergency locator transmitter). It was so compact it could be easily carried and was within easy reach in the helicopter.

The life jacket, model HC2-L8, was easy to put on in flight and so light and comfortable to wear that I would often find myself still wearing it after landing and talking with the press for a couple of hours.

Multifabs survival suit I searched for months to locate a good dry suit for use in the North Atlantic. I eventually found the suit, designed in conjunction with British Airways Helicopters.

It is very warm, and enables the helicopter pilot freedom of action. I wore it constantly over the frozen north and even slept in it during my forced stay on Baffin Island.

Insurance I had intended to carry only third party property insurance because the Australian insurers wanted to charge extra loading as a result of my world solo attempt. Stephen L. Way International Indemnity Company, Texas, offered me a very good rate for full comprehensive cover. No claims were made of course. The only claim that could have been made was for the repair of the bullet holes, but these were fixed so cheaply they were not worth claiming for.

Chinon camera equipment Apart from attempting the first solo helicopter flight the main purpose of my trip was to make documentary films along the way. Because many countries do not allow 16 mm camera equipment all my filming was done with a Super 8 Chinon Pacific 200XL camera. It is a great credit to the manufacturer that there is not one fault in the large amount of film processed.

David Clark headsets Many people commented that the noise level in the helicopter must be very trying, but this was not the case. The David Clark headsets gave excellent noise attenuation and I could wear them

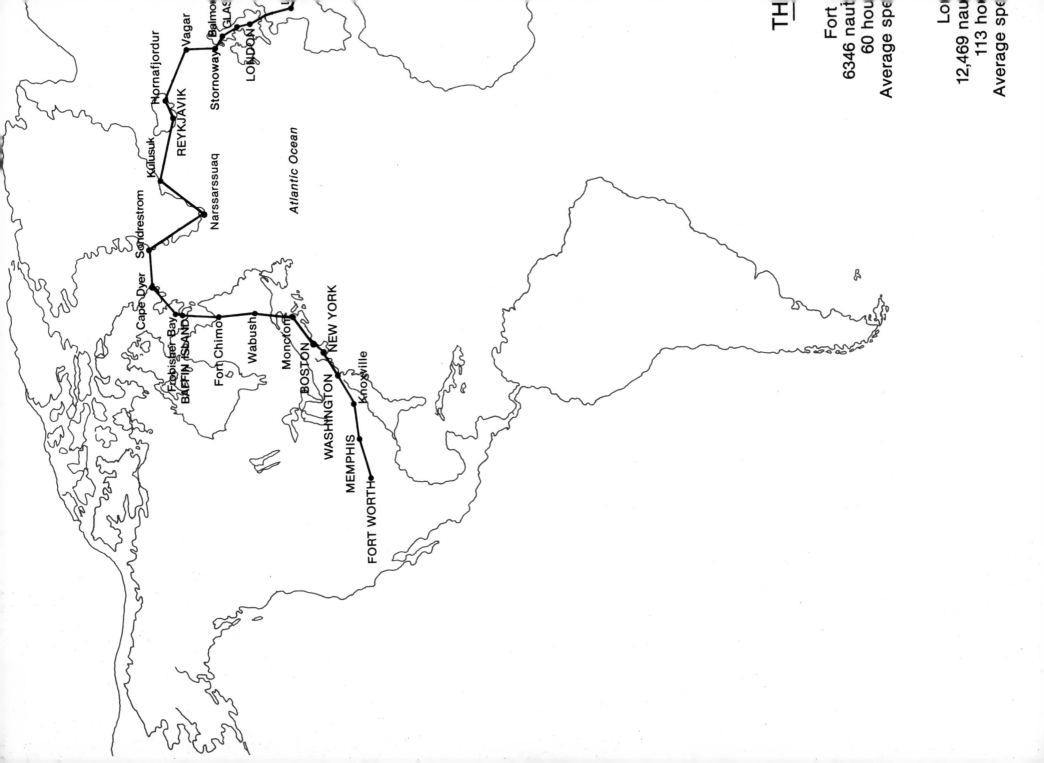

Lu

Balmor

Vagar

GLAS

Hornafjordur

LONDON

Stornoway

REYKJAVIK

Kulusuk

Narssarssuaq

Atlantic Ocean

Søndrestrom

Cape Dyer

Frobisher Bay

BAFFIN ISLAND

Fort Chimo

Wabush

Moncton

NEW YORK

BOSTON

WASHINGTON

Knoxville

MEMPHIS

FORT WORTH

TH

Fort
6346 naut
60 hou
Average spe

Lo
12,469 naut
113 ho
Average spe